# THE ULTIMATE
# BOOK OF
# DRAWING

Hey Gaby,
Hope you pick some mean tips
from this book and draw up
a storm!
(Scan us some of your work!)

Lots of love,
Aunty T.
...d Rana

D1355036

# THE ULTIMATE BOOK OF DRAWING

## Essential Skills, Techniques & Inspiration For Artists

**BARRINGTON BARBER**

ARCTURUS

Arcturus

This edition published in 2011 by Arcturus Publishing Limited/Barrington Barber
26/27 Bickels Yard, 151–153 Bermondsey Street,
London SE1 3HA

ISBN: 978-1-84837-980-0
AD001885EN

Printed in Singapore

# Contents

# Introduction

This book is designed to take you evenly through the different areas of drawing, starting with the basics and dealing gradually with more difficult elements once your confidence has grown. Descriptions of general principles such as perspective and anatomy are included at stages where they will be most helpful to students.

Drawing is an absorbing process and once bitten by the art bug you will discover that it is a most efficient way to take in information and measure your own powers of perception. While drawing, you will learn to observe with the eye of an artist and thus retain so much more of the passing show of the world. But drawing is not only about the technique of recording visual images or enhancing our memories and understanding; it also helps us to appreciate the incredible beauty of the world that we live in, fascinating both in its appearance and its ability to invigorate our existence. Artists, as long as they are awake, are never bored. Familiar places, everyday activities and other people are never quite as ordinary as we think they are. A little extra attention and investigation reveal facets of experience that we would miss completely without the habit of observation. Drawing, in my experience, improves the quality of life; you never stop learning and there are always more projects to pursue. That is why artists never really retire.

There is no doubt in my mind that reproducing the human figure and face from life is the most difficult and, at the same time, the most rewarding part of drawing. After struggling with it for a few weeks, you will probably find that going back to still life or landscape seems relatively easy. However, still life and landscape may also pose all kinds of problems for the artist, especially when she or he is a beginner. In this book, I encourage students to lay good foundations and build from simple to more ambitious and complex compositions. Although this may seem like a hard slog, it is only the procedure that every type of artist must undergo: dancers, musicians and visual artists alike.

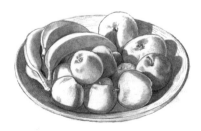

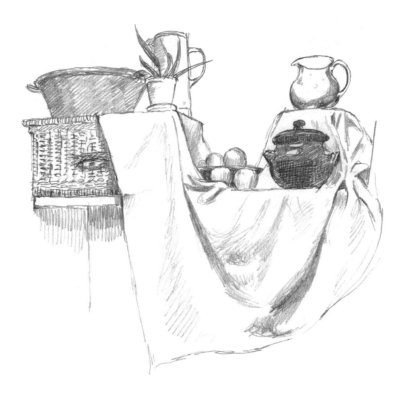

With the step-by-step approach employed in this book, I have tried to demonstrate everything that you need to know. Although there may be areas of this vast subject that have still not been covered, at least the fundamental challenges of drawing are met here in a straightforward sequence of information on technique and exercises.

Don't forget that practice is the way to make continual progress; it polishes any natural skills you possess and your confidence will increase too. Don't despair if you have allowed your drawing to lapse. Start making marks again and anything that you once learned will soon be revived. If you love drawing it won't be too difficult to settle down to practice since it is a very therapeutic activity, and time will fly. Enjoy the exercises that follow, they are the key to the whole business.

Good luck and keep drawing.

## MATERIALS

Any medium is valid for drawing. You will soon come to appreciate that they all have their own identities, which makes some media more valid than others in particular circumstances: their suitability depends on what you are trying to achieve. Try to equip yourself with the best materials you can afford; quality does make a difference. You don't need to buy all the items listed below, and it is probably wise to experiment gradually. Start with the range of pencils suggested, and when you feel you would like to try something different, do so. Don't be too ambitious to begin with, and when you do decide to experiment, persevere.

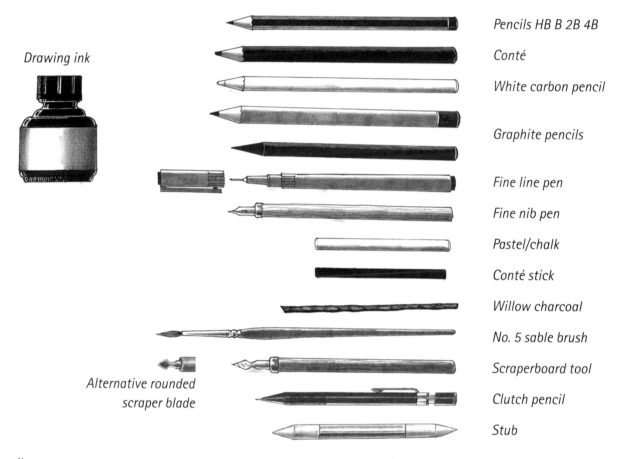

*Drawing ink*

*Alternative rounded scraper blade*

*Pencils HB B 2B 4B*

*Conté*

*White carbon pencil*

*Graphite pencils*

*Fine line pen*

*Fine nib pen*

*Pastel/chalk*

*Conté stick*

*Willow charcoal*

*No. 5 sable brush*

*Scraperboard tool*

*Clutch pencil*

*Stub*

### Pencil
*The pencil is the most versatile instrument at your disposal. You will find that soft black pencils are best. Mostly I use B, 2B, 4B and 6B. Very soft pencils (7B–9B) can be useful sometimes and harder ones (H) very occasionally. Propelling or clutch pencils are very popular, although if you choose this type you will need to buy a selection of soft, black leads with which to replenish them.*

### Conté
*Similar to compressed charcoal, conté crayon comes in different colours, different forms (stick or encased in wood like a pencil) and in different grades, from soft to hard. Like charcoal, it smudges easily but is much stronger in its effect and more difficult to remove.*

### Carbon Pencil
*This can give a very attractive, slightly unusual result, especially the dark brown or sepia, and the terracotta or sanguine versions. The black version is almost the same in appearance as charcoal, but doesn't offer the same rubbing out facility. If you are using this type, start off very lightly because you will not easily be able to erase your strokes.*

### Graphite
*Graphite pencils are thicker than ordinary pencils and come in a wooden casing or as solid graphite sticks with a thin plastic covering. The graphite in the plastic coating is thicker, more solid and lasts longer, but the wooden casing probably feels better. The solid stick is versatile*

because of the actual breadth of the drawing edge, enabling you to draw a line a quarter of an inch thick, or even thicker, and also very fine lines. Graphite also comes in various grades, from hard to very soft and black.

## Pen

Push-pens or dip-pens come with a fine pointed nib, either stiff or flexible. Modern fine-pointed graphic pens are easier to use and less messy but not as versatile, producing a line of unvarying thickness. Try both types.

The ink for dip-pens is black 'Indian ink' or drawing ink; this can be permanent or water-soluble. The latter allows greater subtlety of tone.

## Pastel/Chalk

Your choice of paper is essential to a good outcome with these materials. Don't use a paper that is too smooth, otherwise the deposit of pastel or chalk will tend to skid off and not adhere to the paper properly. A tinted paper can be ideal, because it enables you to use light and dark tones to bring an extra dimension to your drawing.

## Charcoal

In stick form this medium is very useful for large drawings, because the side can be used as well as the point. Charcoal pencils (available in black, grey and white) are not as messy to use as the sticks but are less versatile. If charcoal drawings are to be kept in good condition the charcoal must be fixed with a spray-on fixative to stop it smudging.

## Brush

Drawing with a brush will give a greater variety of tonal possibilities to your drawing. A fine tip is not easy to use initially, and you will need to practise if you are to get a good result with it. Use a soluble ink, which will give you a range of attractive tones.

A number 0 or number 2 nylon brush is satisfactory for drawing. For applying washes of tone, a number 6 or number 10 brush in 'sablette', sable or any other material capable of producing a good point, is recommended.

## Scraperboard

The business side of both the black and white versions of scraper-board is covered with a layer of china-clay. The black version has a thin layer of black ink printed evenly over the whole surface which can then be scraped away

to produce a reverse drawing resembling a woodcut or engraving. White scraperboard is more versatile, allowing you to apply ink which is then scraped with a sharp point or edge when it is dry to produce interesting textures or lines.

## Stub

A stub is a tightly concentrated roll of absorbent paper formed into a fat pencil-like shape. Artists use it to smudge marks made with pencil, pastel or charcoal and thus smooth out shading they have applied and graduate it more finely. It is quite a useful tool if you draw a great deal.

## Paper

You will find a good-quality cartridge paper most useful, but choose one that is not too smooth; 160gsm weight is about right. If you are unsure, you can ask for advice in your local art shop.

Drawing in ink can be done on smoother paper, but even here a textured paper can give a livelier result in the drawing. For drawing with a brush, you will need a paper that will not buckle when wet, such as watercolour paper.

Also see Pastel/Chalk.

## Eraser

The best all-purpose eraser for the artist is a putty rubber. Kneadable, it can be formed into a point or edge to rub out all forms of pencil. Unlike the conventional eraser it does not leave small deposits on the paper. However, a standard soft rubber is quite useful as well, because you can work over marks with it more vigorously than you can with a putty rubber.

Most artists try to use an eraser as little as possible, and in fact it only really comes into its own when you are drawing for publication, which requires that you get rid of superfluous lines. Normally you can safely ignore erasers in the knowledge that inaccurate lines will be drawn over and thus passed over by the eye which will see and follow the corrected lines.

## Sharpener

A craft knife is more flexible than an all-purpose sharpener and will be able to cope with any thickness of lead or charcoal, etc. It goes without saying that you should always take great care when using such an implement and not leave the blade exposed where it may cause harm or damage.

## EXERCISES

Before you begin any kind of drawing, it is necessary to practise the basics. This is essential for the complete beginner, and even for the experienced artist it is very useful. If you are to draw well you must be in control of the connection between eye and hand. There are many exercises to help you achieve this. The following examples are the simplest and most helpful I know.

Complete them all as carefully as you can, drawing freehand, at the sizes shown. The more you repeat them, the more competent and confident you will become – and this will show in your drawing.

As you draw, try to keep your attention exactly on the point where the pencil touches the paper. This will help to keep eye and hand synchronized and in time make drawing easier.

   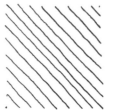 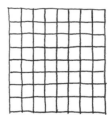

1. Begin with vertical lines, keeping them straight and the same length.

2. Produce a square with a series of evenly spaced horizontal lines.

3. Now try diagonal lines, from top right to bottom left, varying the lengths while keeping the spacing consistent.

4. Next, draw diagonals from top left to bottom right. You may find the change of angle strange at first.

5. To complete the sequence, try a square made up of horizontals and verticals crossing each other.

It is always difficult to draw a circle accurately at first. For this exercise I want you to draw a series of circles next to each other, all the same size. Keep drawing them until the circles on the paper look like the perfect ones you can see in your mind's eye.

When you achieve this, you will know that your eye and hand are co-ordinating.

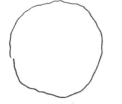 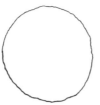    

## EXERCISES IN TECHNIQUE

The following exercises should help you to ease your way into drawing in a range of different styles. There are, of course, many more than the ones we show, but these will serve very well as a basis. You will discover other methods through your own investigations and adapt them to serve your purpose.

The only way you can develop your pencil shading skills is to practise shading in various ways in order to discover the different tones achievable. This exercise is quite difficult but good fun and can be repeated many times over a period of weeks, just to help you get your hand and eye in. You will find the control it gives you over the pencil very valuable.

You will need a very dark pencil (4B), a slightly less dark pencil (2B) and a lighter pencil (such as a B) for this practice. If you wish, you can always use a harder, lighter pencil, such as an H or 2H.

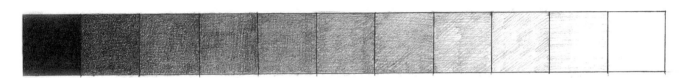

*Draw out a long line of squares about 1in (2.5cm) square. Shade each square, starting with a totally black one. Allow the next square to be slightly lighter, and so on, gradually shading each square as uniformly as possible with a lighter and lighter touch, until you arrive at white paper.*

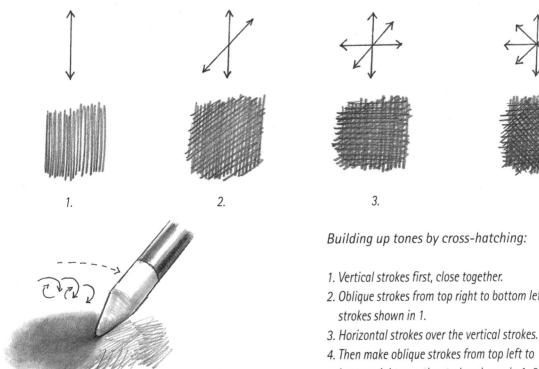

1.          2.          3.          4.

5.

*Building up tones by cross-hatching:*

1. Vertical strokes first, close together.
2. Oblique strokes from top right to bottom left over the strokes shown in 1.
3. Horizontal strokes over the vertical strokes.
4. Then make oblique strokes from top left to bottom right over the strokes shown in 1–3.
5. Smooth and finely graduated tones can be achieved by working over your marks with a stub (see pp 8–9).

## PENCIL AND GRAPHITE

A pencil is the easiest and most obvious implement with which to start an exploration of technique. Try the following series of simple warming-up exercises.

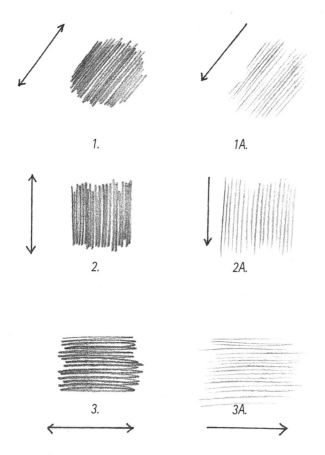

1. 1A.

2. 2A.

3. 3A.

*1. A backward and forward motion of the hand, always in an oblique direction, produces an even tone quickly.*
*2. The same motion vertically.*
*3. The same motion horizontally.*

*1A., 2A. and 3A.*
*Now try a slightly more careful method where the hand draws the lines in one direction only.*

*Try using a graphite stick for the next two exercises; they can also be done with a well-sharpened soft pencil.*

*1. Lay the side of the point of the graphite or pencil onto the paper and make smooth, smudged marks.*
*2. Using the point in random directions works well too.*

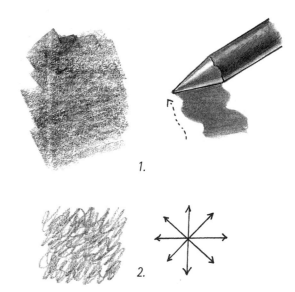

1.

2.

## PEN AND INK

There is a whole range of exercises for pen work but this implement has to be used rather more lightly and carefully than the pencil so that its point doesn't catch in the paper.

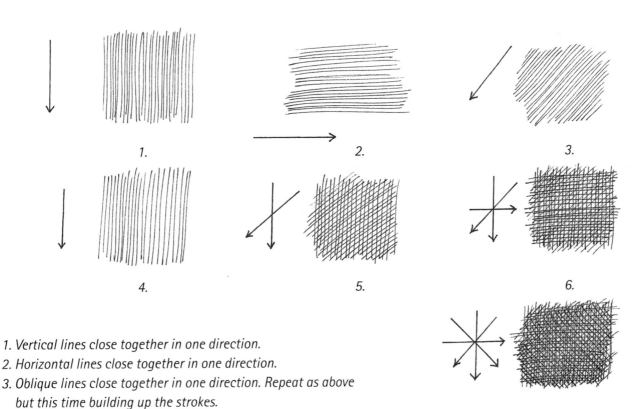

1.　　　　2.　　　　3.

4.

5.

6.

1. Vertical lines close together in one direction.
2. Horizontal lines close together in one direction.
3. Oblique lines close together in one direction. Repeat as above but this time building up the strokes.
4. Draw vertical lines.
5. Draw oblique lines on top of the verticals.
6. Draw horizontal lines on top of the oblique and vertical lines.
7. Draw oblique lines at 90 degrees to the last oblique lines on top of the three previous exercises to build up the tone.

7.

1.　　　　2.　　　　3.　　　　4.

1. Make patches of short strokes in different directions, each time packing them closer together.
2. Draw small overlapping lines in all directions.
3. Draw lines that follow the contours of a shape, placing them close together. For an additional variation, draw oblique lines across these contour lines.
4. Build up myriads of dots to describe tonal areas.

## CHALK

This next series of exercises is similar to the one you have just done but requires extra care not to smudge your marks as you put them down. The key in this respect is not to use a smooth paper. Choose one with a texture that will provide a surface to which the chalk can adhere.

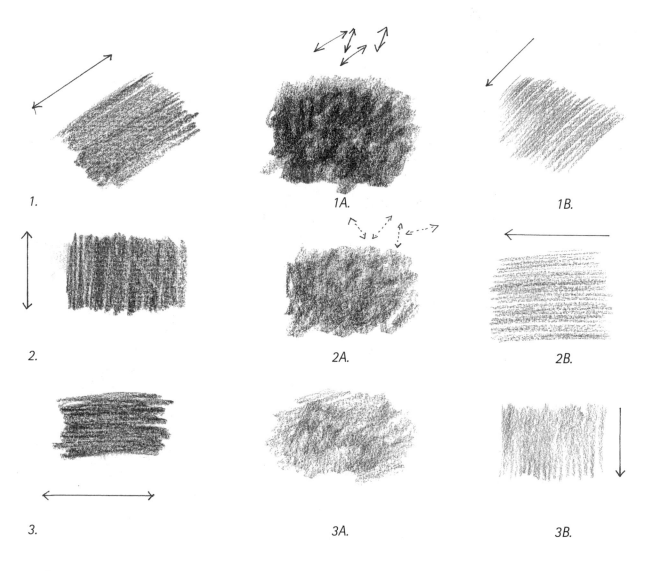

1.　　　　　　　　　　　　1A.　　　　　　　　　　　　1B.

2.　　　　　　　　　　　　2A.　　　　　　　　　　　　2B.

3.　　　　　　　　　　　　3A.　　　　　　　　　　　　3B.

1. Shading obliquely in two directions.
2. Shading vertically in two directions.
3. Shading horizontally in two directions.

1A. Shading in various directions, heavily.
2A. Shading in various directions, more lightly.
3A. Shading in various directions, very lightly.

1B. Shading in one direction obliquely.
2B. Shading in one direction horizontally.
3B. Shading in one direction vertically.

*In a series of squares practise shading of various strengths, progressing from the heaviest to the lightest.*

# THREE DIMENSIONS

Every object you draw will have to appear to be three-dimensional if it is to convince the viewer. The next series of practice exercises has been designed to show you how this is done and for you to familiarize yourself with the technique. We begin with cubes and spheres.

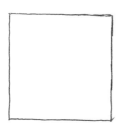

*1. Draw a square.*

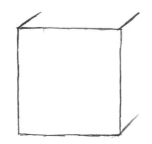

*2. Draw lines that are parallel from each of the top corners and the bottom right corner.*

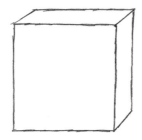

*3. Join these lines to complete the cube.*

This alternative method produces a cube shape that looks as though it is being viewed from one corner.

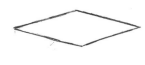

*1. Draw a diamond shape or parallelogram elongated across the horizontal axis.*

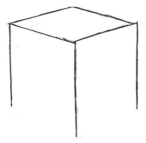

*2. Now draw three vertical lines from the three angles shown; make sure they are parallel.*

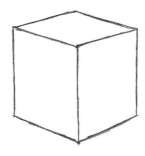

*3. Join these vertical lines with lines parallel to those above them.*

Once you have formed the cube you are halfway towards producing a realistic three-dimensional image. The addition of tone, or shading, will complete the illusion.

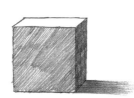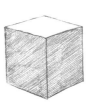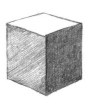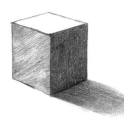

## ELLIPSES

To show a circular object from an oblique angle you need to be able to draw an ellipse. This is a curved figure with a uniform circumference and a horizontal axis longer than the perpendicular axis.

An ellipse alters as our view of it shifts. Look at the next series of drawings and you will see how the perspective of the glass changes as its position alters in relation to your eye level.

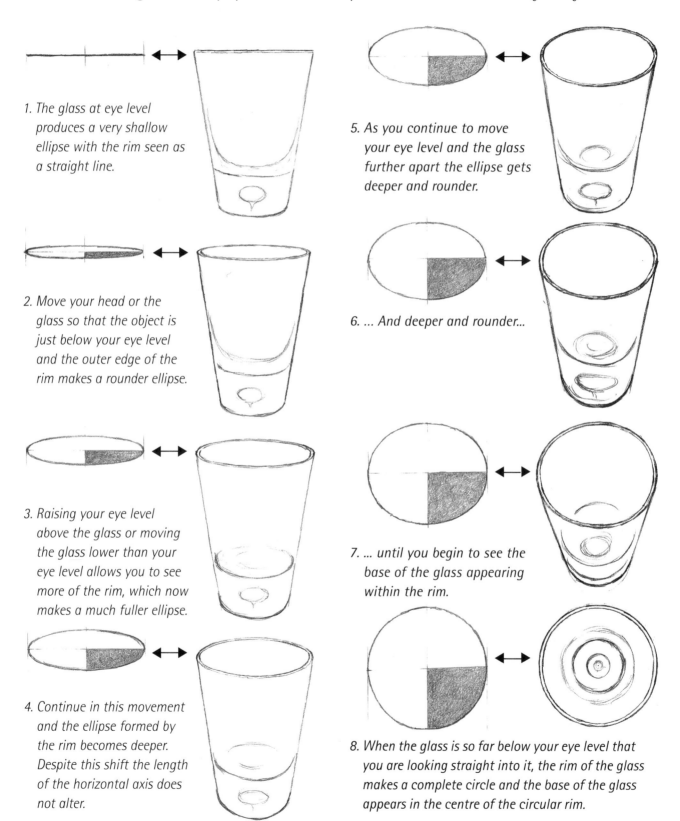

1. The glass at eye level produces a very shallow ellipse with the rim seen as a straight line.

2. Move your head or the glass so that the object is just below your eye level and the outer edge of the rim makes a rounder ellipse.

3. Raising your eye level above the glass or moving the glass lower than your eye level allows you to see more of the rim, which now makes a much fuller ellipse.

4. Continue in this movement and the ellipse formed by the rim becomes deeper. Despite this shift the length of the horizontal axis does not alter.

5. As you continue to move your eye level and the glass further apart the ellipse gets deeper and rounder.

6. ... And deeper and rounder...

7. ... until you begin to see the base of the glass appearing within the rim.

8. When the glass is so far below your eye level that you are looking straight into it, the rim of the glass makes a complete circle and the base of the glass appears in the centre of the circular rim.

## ELLIPSES PRACTICE: Cylinders

Ellipses absolutely come into their own when we have to draw cylindrical objects. As with our previous examples of making shapes appear three-dimensional, the addition of tone completes the transformation.

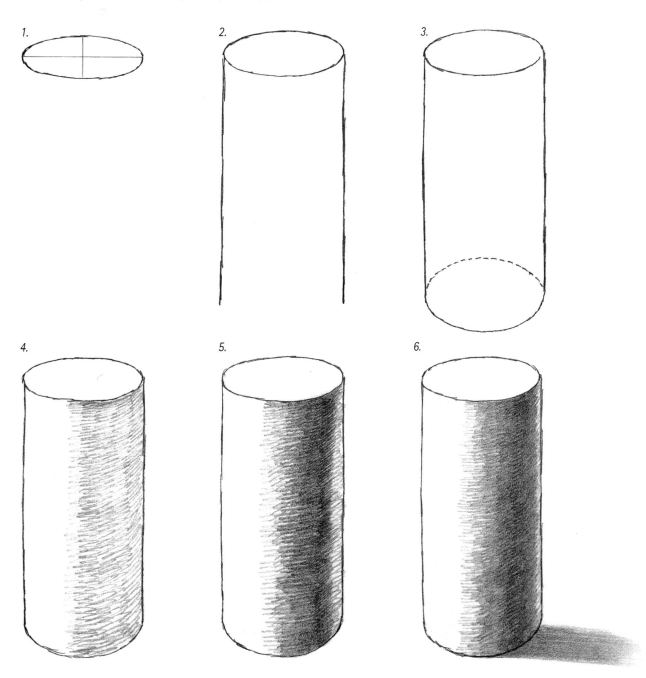

1. *Draw an ellipse.*
2. *Draw two vertical straight lines from the two outer edges of the horizontal axis.*
3. *Put in half an ellipse to represent the bottom edge of the cylinder. Or, draw a complete ellipse lightly then erase the half that would only be seen if the cylinder were transparent.*

4. *To give the effect of light shining from the left, shade very lightly down the right half of the cylinder.*
5. *Add more shading, this time to a smaller vertical strip that fades off towards the centre.*
6. *Add a shadow to the right, at ground level. Strengthen the line of the lower ellipse.*

# Still Life

We begin with still life because object drawing has always been a good starting point, and a highly effective way of training the artistic hand and eye to work together. Within a fairly short space of time, it provides people with the confidence to tackle the complexities that they will encounter when they go on to draw landscapes, faces and figures.

With still life, however, not only are you improving your hand–eye co-ordination, you are upgrading your general observational skills. Sometimes you will be aware that you have been seeing an object in a certain way for hours and then suddenly view it again quite differently. You may want to alter what you have done or correct a mistake. Go ahead. Still-life drawing allows you to do so in a relaxed situation; you will seldom have the same opportunity with landscapes or figure studies, where the weather is constantly changing or people are on the move.

Still life encourages you to look closely before you have even set pencil to paper. Observe how a single object rests upon a surface: what angle will you choose; what texture does it have; are there any highlights or shadows playing upon it? Again, a group of objects makes a different set of demands on your powers of observation, because you are looking at things in relation to one another and considerations of proportion and perspective will come into play.

Don't worry, such things always sound daunting in theory. Start drawing and make your knowledge real. Remember that you are interpreting objects in line and tone, you are in charge of what is included and what is left out. Keep trying and you will discover your own inherent sense of design: learn to trust it.

## SIMPLE OBJECTS

When you are able to complete the exercises in the previous section with confidence, it is time to tackle a few real objects. To begin, I have chosen a couple of simple examples: a tumbler and a bottle. Glass objects are particularly appropriate at this stage because their transparency allows you to get a clear idea of their shape.

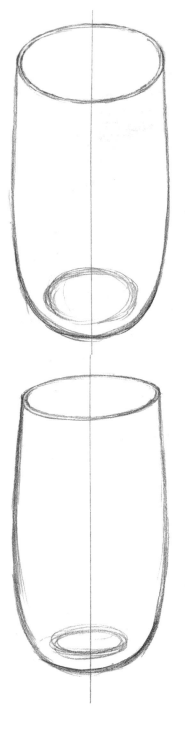

*In pencil, carefully outline the shape. Draw the ellipses at the top and bottom as accurately as you can. Check them by drawing a ruled line down the centre vertically. Does the left side look like a mirror image of the right? If it doesn't, you need to try again or correct your first attempt. The example has curved sides and so it is obvious when the curves don't match.*

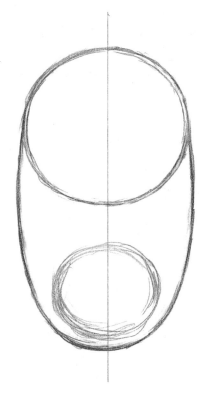

*Now shift your position in relation to the glass so that you are looking at it from higher up. Draw the ellipses at top and bottom, then check them by drawing a line down the centre. You'll notice this time that the ellipses are almost circular.*

*Shift your position once more, this time so that your eye level is lower. Seen from this angle the ellipses will be shallower. Draw them and then check your accuracy by drawing a line down the centre. If the left and right sides of your ellipses are symmetrical, your drawing is correct.*

## RECTANGULAR OBJECTS

Unlike some other types of drawing, you don't need to know a great deal about perspective to be able to produce competent still lifes. You will, however, find it useful to have a basic grasp of the fundamentals when you come to tackle rectangular objects.

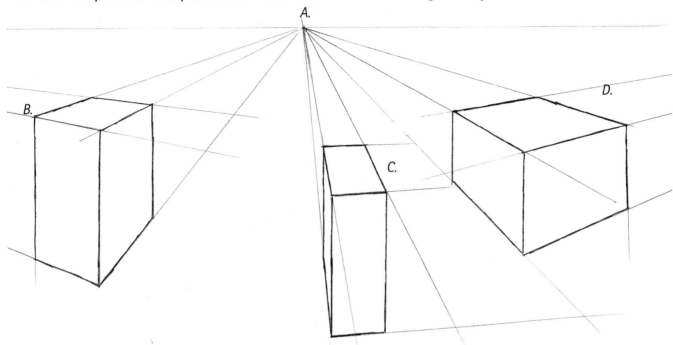

*Perspective can be constructed very simply by using a couple of reference points: eye-level (the horizontal line across the background) and (A.) one-point perspective lines (where all the lines converge at the same point). The perspective lines relating to the other sides of the object (B. C. D.) would converge at a different point on the eye level line. For the sake of simplicity at this stage, they are shown as relatively horizontal.*

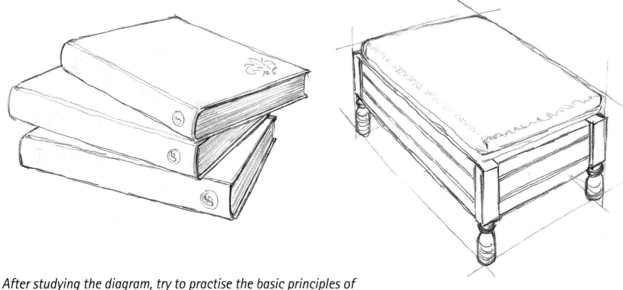

*After studying the diagram, try to practise the basic principles of perspective by drawing a range of rectilinear objects. Don't be too ambitious. Begin with small pieces, such as books, cartons and small items of furniture.*

You will find that different objects share perspectival similarities – in my selection, compare the footstool with the pile of books, and the chair with the carton.

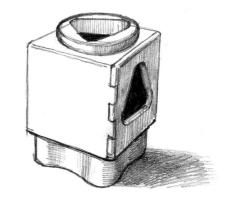

The wicker basket and plastic toy box offer slightly more complicated rectangles than the blanket box. With these examples, when you have got the perspective right, don't forget to complete your drawing by capturing the effect of the different materials.

Part of the skill with drawing box-like shapes comes in working out the relative evenness of the tones required to convince the viewer of the solidity of the forms. In these three examples, use tone to differentiate the lightest side from the darkest, and don't forget to draw in the cast shadow.

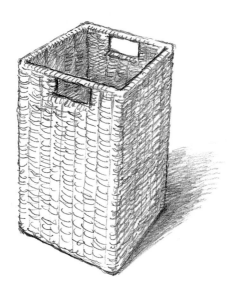

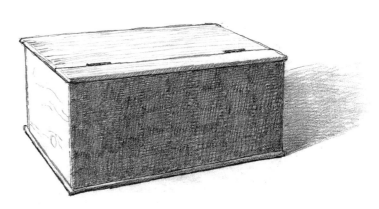

## SPHERICAL OBJECTS

You shouldn't find it difficult to practise drawing spherical objects. Start by looking in your fruit bowl, and then scanning your home generally for likely candidates. I did this and came up with an interesting assortment. You will notice that the term 'spherical' covers a range of rounded shapes. Although broadly similar, none of the examples is identical. You will also find variations on the theme of surface texture. Spend time on these exercises, concentrating on getting the shapes and the various textural characteristics right.

*For our first practice, I chose an apple, an orange and a plum. Begin by carefully drawing in the basic shape of each fruit, then mark out the main areas of tone.*

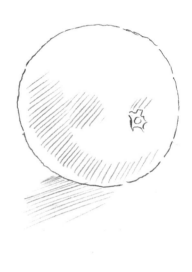

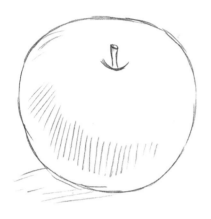

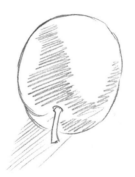

*The orange requires a stippled or dotted effect to imitate the nature of the peel.*

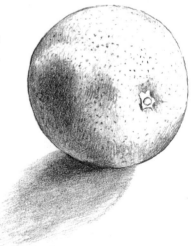

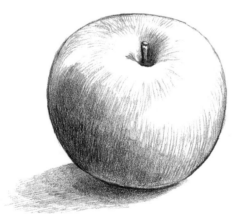

*Take the lines of tone vertically round the shape of the apple, curving from top to bottom and radiating around the circumference. Gradually build up the tone in these areas. In all these examples don't forget to draw the cast shadows.*

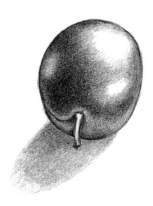

*To capture the silky-smooth skin of a plum you need an even application of tone, and obvious highlights to denote the reflective quality of the surface.*

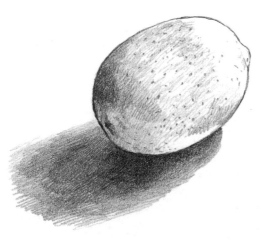

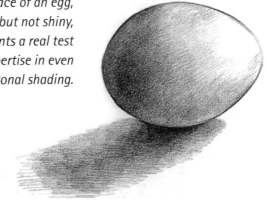

*The surface of an egg, smooth but not shiny, presents a real test of expertise in even tonal shading.*

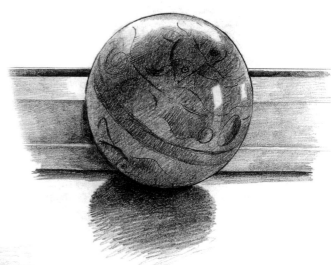

*The texture of a lemon is similar to that of the orange.*

*The shading required for this round stone was similar to that used for the egg but with pronounced pitting.*

*The perfect rounded form of this child's ball is sufficiently shiny to reflect the light from the window. Because the light is coming from behind, most of the surface of the object is in shadow; the highlights are evident across the top edge and to one side, where light is reflected in a couple of smaller areas. The spherical shape of the ball is accentuated by the pattern curving round the form.*

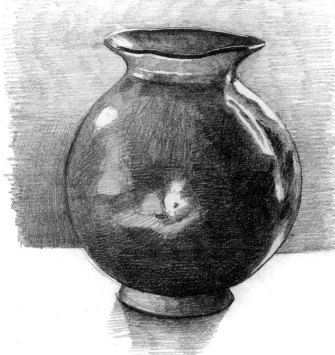

*The texture of this hand-thrown pot is uneven and so the strongly contrasting dark and bright tones are not immediately recognizable as reflections of the surrounding area.*

## INTRODUCING DIFFERENT MEDIA

Taking a single object and drawing it in different media is another very useful practice when you are developing your skills in still life. The materials we use have a direct bearing on the impression we convey through our drawing.

They also demand that we vary our technique to accommodate their special characteristics. For the first exercise I have chosen a cup with a normal china glaze but in a dark colour.

*Drawn in pencil, each tonal variation and the exact edges of the shape can be shown quite easily.*

*Attempt the same object with chalk (below) and you will find that you cannot capture the precise tonal variations quite so easily as you can with pencil. The coarser tone leaves us with the impression of a cup while showing more obviously the dimension or roundness of the shape. A quicker medium than pencil, chalk allows you to show the solidity of an object but not its finer details.*

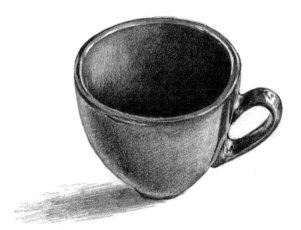

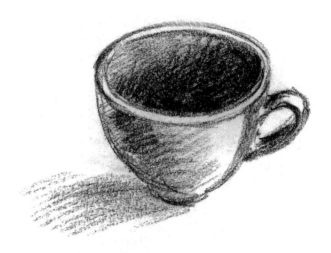

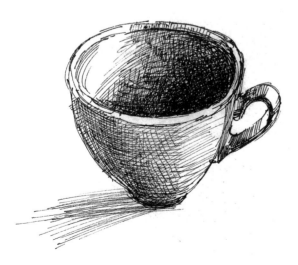

*Although ink (left) allows you to be very precise, this is a handicap when you are trying to depict the texture of an object. The best approach is to opt for rather imprecise sets of lines to describe both the shape and the texture. Ink is more time-consuming than either pencil or chalk but can give a more dramatic result.*

The best result is sometimes achieved by using the most difficult method. This is certainly the case with our next trio, where brush and wash are better at producing the sharp, contrasting tones we associate with glass than either chalk or ink.

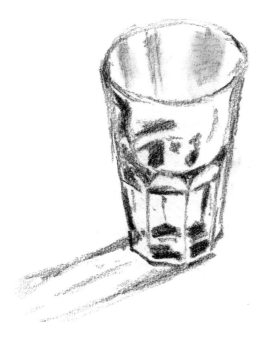

*Although this example in chalk is effective in arresting our attention, it gives us just an impression of a glass tumbler.*

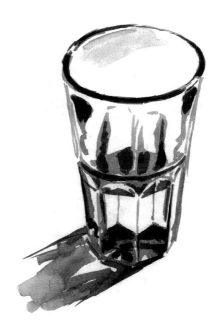

*The quality of the material is most strikingly caught with brush and wash, which produces hard, bright surfaces and the illusion of light coming from behind the object.*

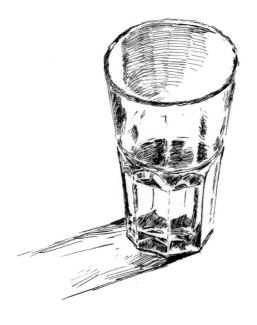

*Pen and ink is a very definite medium to work in. Here it allows the crispness of the glass edges to show clearly, especially in the lower half of the drawing.*

## TEXTILES

The best way to understand the qualities of different textures is to look at a range of them. We'll begin by examining different kinds of textiles: viscose, silk, wool and cotton. Key with each example is the way the folds of cloth drape and wrinkle. You will need to look carefully too at the way the light and shade fall and reflect across the folds of the material, because these will tell you about the more subtle qualities of the surface texture.

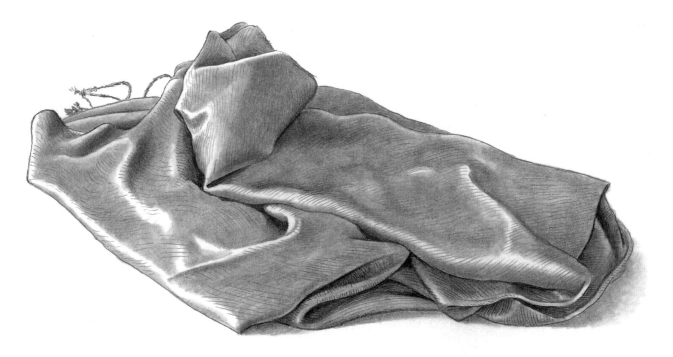

*This scarf or pashmina made of the synthetic material viscose is folded over upon itself in a casual but fairly neat package. The material is soft and smooth to the touch, but not silky or shiny; the folds drape gently without any harsh edges, such as you might find in starched cotton or linen. The tonal quality is fairly muted, with not much contrast between the very dark and very light areas; the greatest area of tone is a medium tone, in which there exists only slight variation.*

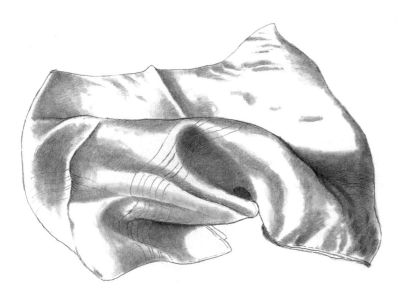

*A silk handkerchief which, apart from a couple of ironed creases in it, shows several smooth folds and small undulations. The tonal qualities are more contrasting than in the first example – the bright areas ripple with small patches of tone to indicate the smaller undulations. We get a sense of the material's flimsiness from the hem and the pattern of stitched lines.*

*A deck shoe in soft leather, with soft edges and creases across the toe area, has none of the high shine of formal shoes. The contrast between the dark inside of the shoe and the lighter tones of the outside help to define the overall texture.*

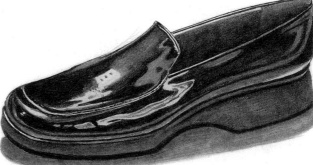

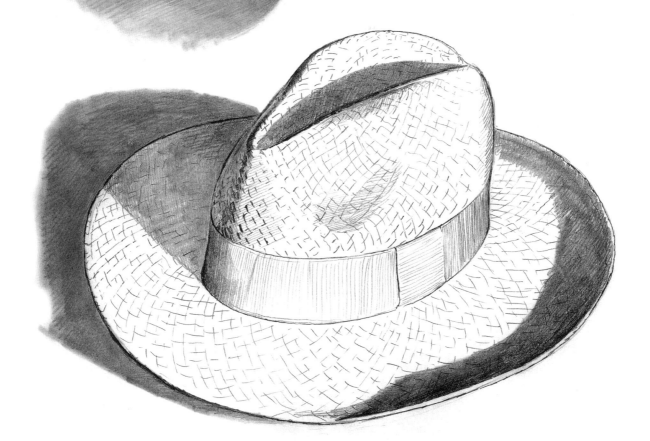

*The shiny black surface of patent leather reflects a lot of light and gives a rather watery effect.*

*A straw hat produces a clear-cut form with definite shadows that show the shape of the object clearly. The texture of the straw, woven across the structure, is very distinctive. Well-worn hats of this kind tend to disintegrate in a very characteristic way, with broken bits of straw disrupting the smooth line.*

## PAPER

Now we have a look at something completely different. Screw up a sheet of paper, and throw it onto a table lit by a single source of light. In fact, it is not as difficult to draw as it looks. Part of the solution to the problem posed by this exercise is to think about what you are looking at. Soon you will realize that although you have to try to follow all the creases and facets, it really doesn't matter if you do not draw the shape precisely or miss out one or two creases. The point is to make your drawing look like crumpled paper, not necessarily achieve an exact copy.

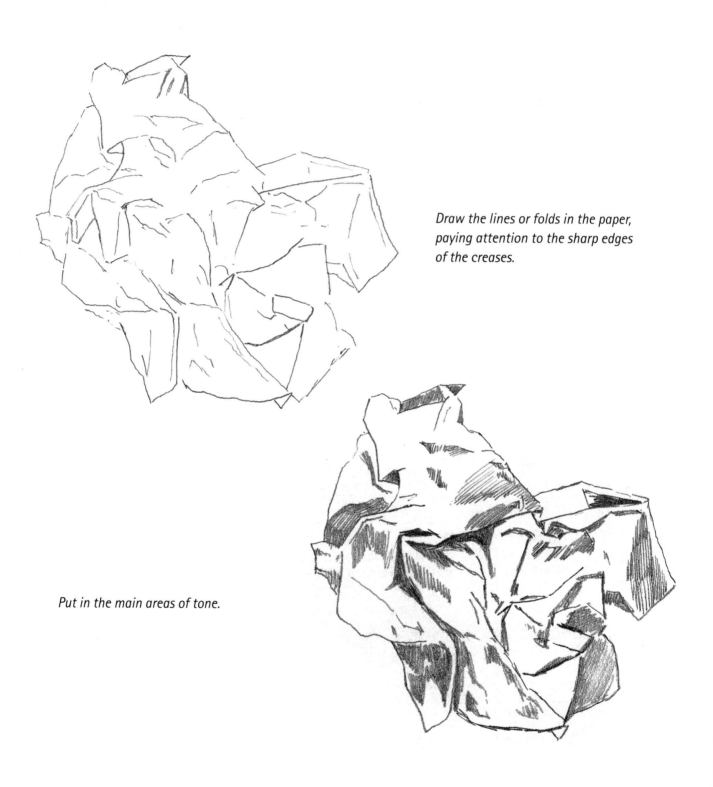

*Draw the lines or folds in the paper, paying attention to the sharp edges of the creases.*

*Put in the main areas of tone.*

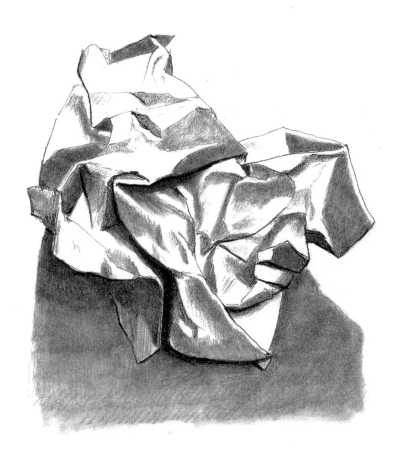

*Once you have covered each tonal area, put in any deeper shadows, capturing the contrasts between these areas.*

*When you have completed the last exercise, try a variation on it. Crumple a piece of paper and then open it out again. Look at it and you will see that the effect is rather like a desert landscape. Before you try to draw it, position the paper so that you have light coming from one side; this will define the facets and creases quite clearly. Follow the three steps of the previous exercise, putting in the darkest shadows last.*

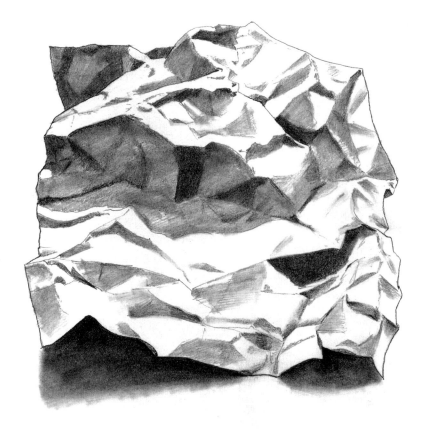

## GLASS

Glass is a great favourite with still-life artists because at first glance it looks almost impossible to draw. What you particularly need to remember is to draw what can be seen behind or through the glass.

*Draw the outline carefully. The delicacy of the glass demands increased precision in this respect.*

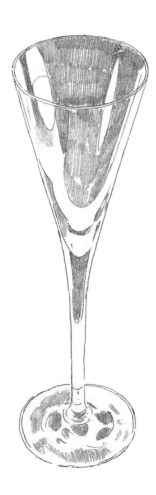

*When you are satisfied you have the right outline, put in the main shapes of the tonal areas, in one tone only, leaving the lighter areas clear.*

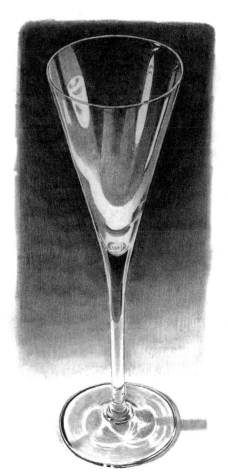

*Finally, put in the darkest tones quite strongly. Each of these three drawings should inform very precisely about the object and its materiality.*

## METAL

Before you start drawing any metal objects, it is worth taking some moments to study their surface textures. The contrast between light and dark reflections will be at a maximum with highly polished objects, whereas with less finished metalware the tonal contrast won't be as strong.

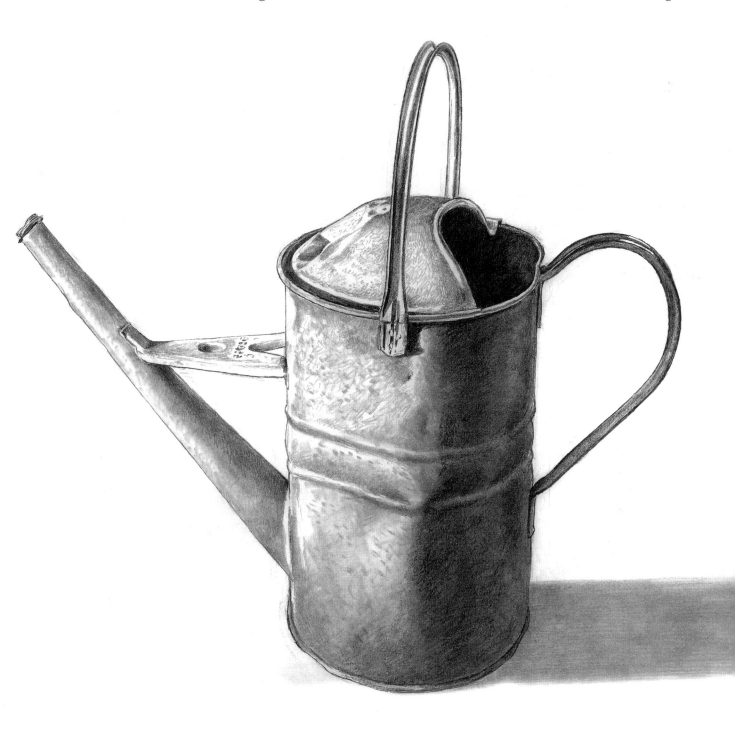

*This battered old watering can made of galvanized metal has a hammered texture and many large dents. The large areas of dark and light tone are especially important in giving a sense of the rugged texture of this workaday object. No area should shine too brightly, otherwise the surface will appear too smooth.*

## BONES AND SHELLS

Skeletons are always interesting to draw because they provide strong clues as to the shape of the animal or human they once supported. They are often used in still-life arrangements to suggest death and the inevitable breaking down of the physical body that is its consequence. Some people may find them rather uncomfortable viewing because of this, but for the artist they offer fabulous opportunities to practise structural drawing, requiring all our skills to portray them effectively.

*This sheep's skull found on a hillside in Wales still retains a semblance of the living animal, despite the extensive erosion. The challenge for the artist is to get the dry, hard, slightly polished effect of the old weathered bone.*

*This is done by keeping the tones mainly light, with only a few very dark tones in the eye socket or under the teeth. This, and the sharp edges of the tonal areas, help to show its hardness and smooth surface, which catches the light.*

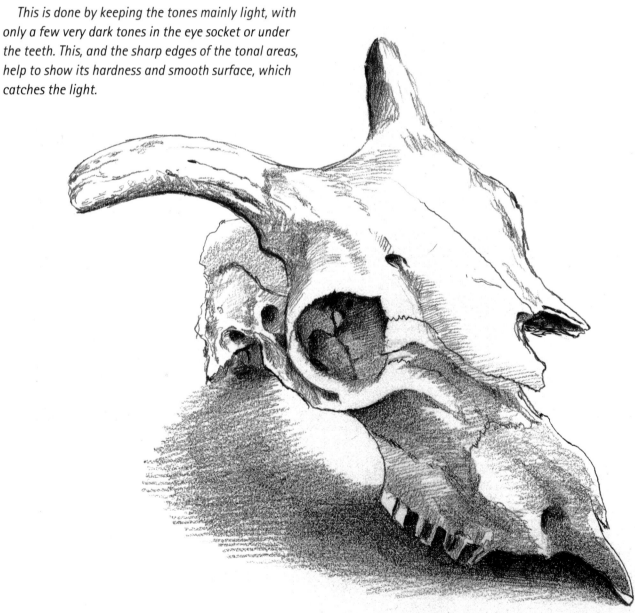

## WOOD

In its many forms, wood can make an attractive material to draw. Here the natural deterioration of a log is contrasted with the man-made construction of a wooden box.

*The action of water and insects over a long period has produced a very varied surface on the sawn-off log; in some places it is crumbling and in others hard and smooth and virtually intact apart from a few cracks. The weathering has produced an almost baroque effect.*

*By contrast, this wooden box presents lines of growth which endow an otherwise uneventful surface with a very lively look. The knots in the thinly sliced pieces of board give a very clear indication of the material the box is made of.*

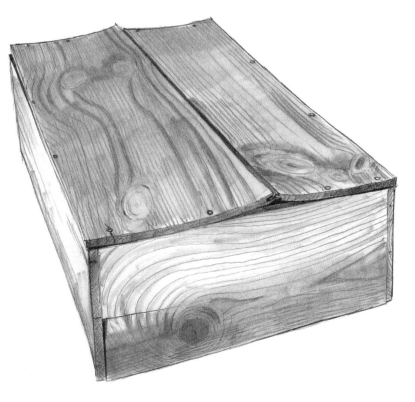

## FOOD

Food is a subject that has been very popular with still-life artists through the centuries, and has often been used to point up the transience of youth, pleasure and life. Even if you're not inclined to use food as a metaphor, it does offer some very interesting types of materiality that you might like to include in some of your compositions.

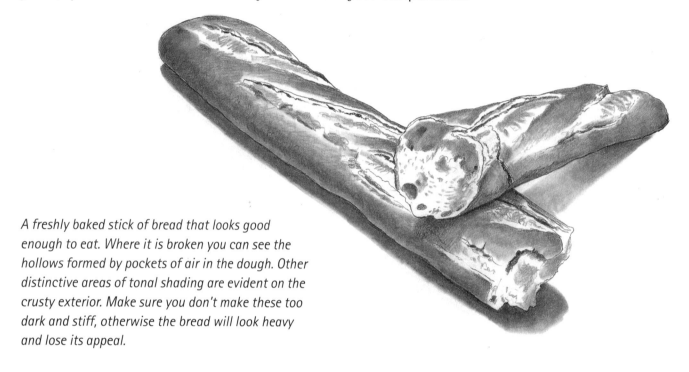

*A freshly baked stick of bread that looks good enough to eat. Where it is broken you can see the hollows formed by pockets of air in the dough. Other distinctive areas of tonal shading are evident on the crusty exterior. Make sure you don't make these too dark and stiff, otherwise the bread will look heavy and lose its appeal.*

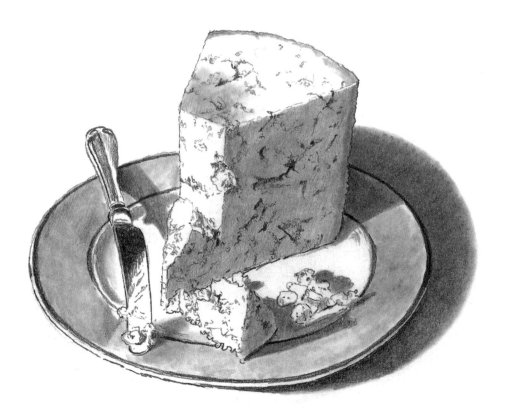

*A piece of Stilton cheese, slightly crumbly but still soft enough to cut, is an amazing pattern of veined blue areas through the creamy mass. To draw this convincingly you need to show the edge clearly and not overdo the pattern of the bluish veins. The knife provides a contrast in texture to the cheese.*

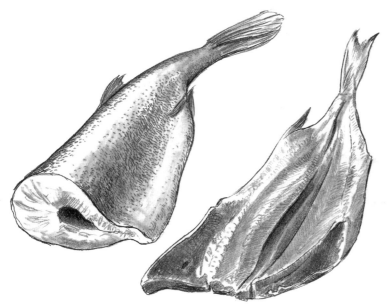

*Two views of fish with contrasting textures: scaly outer skin with bright reflections, and glistening interior flesh. Both shapes are characteristic, but it is the textures that convey the feel of the subject to the viewer.*

*This large cut of meat shows firm, whitish fat and warm-looking lean meat in the centre. Although the contrast between these two areas is almost enough to give the full effect, it is worth putting in the small fissures and lines of sinew that sometimes pattern and divide pieces of meat.*

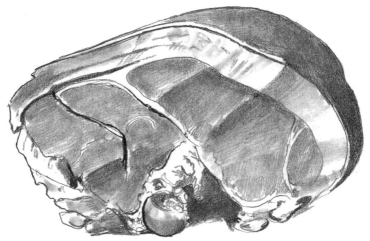

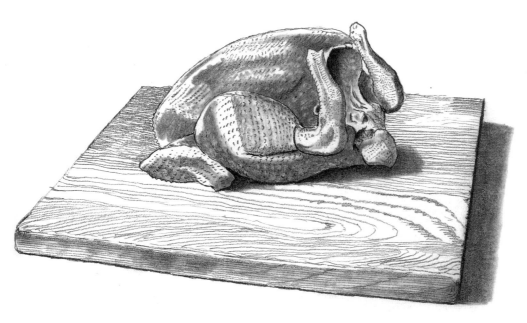

*A marked contrast in textures, with a plump chicken appearing soft against the grained surface of a wooden chopping board. Careful dabbing with a pointed bit of kneadable eraser has given a realistic goose-bump look to darker areas of the chicken's skin and where there are shadows.*

## APPROACHES

In this spread we are going to demonstrate how the number of objects included in an arrangement changes the feel or dynamic of the group. The aim of this exercise is to show how you can slowly build up still-life composition bit by bit. By adding more as you go along, you will begin to see the possibilities of the composition.

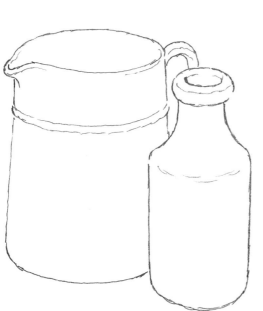

*Two's company ...*

*Three's not quite a crowd ...*

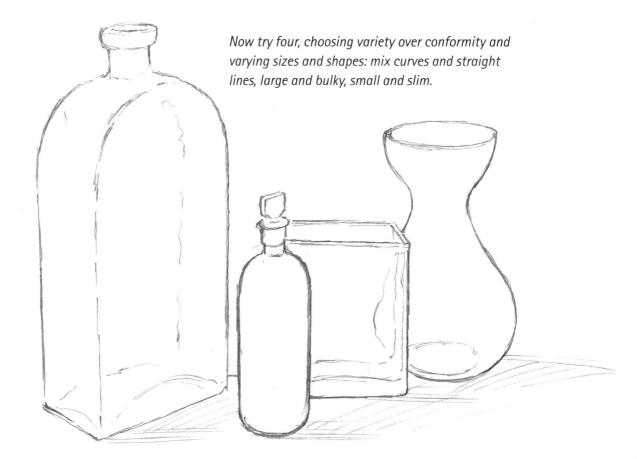

*Now try four, choosing variety over conformity and varying sizes and shapes: mix curves and straight lines, large and bulky, small and slim.*

## ENCOMPASSED GROUPS

Sometimes the area of the objects you are drawing can be enclosed by the outside edge of a larger object. Two classic examples are shown here: a large bowl of fruit and a vase of flowers.

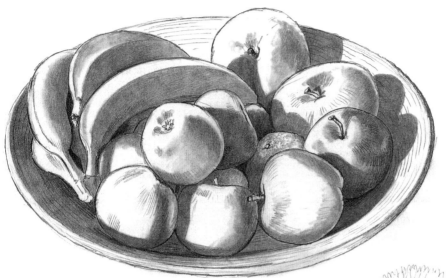

*With this type of still life a variety of shapes is held within the main frame provided by the bowl.*

*These sunflowers in a large jug make quite a lively picture: the rich heavy heads of the blooms contrast with the ragged leaves dangling down the stalks, and the simplicity of the jug provides a solid base.*

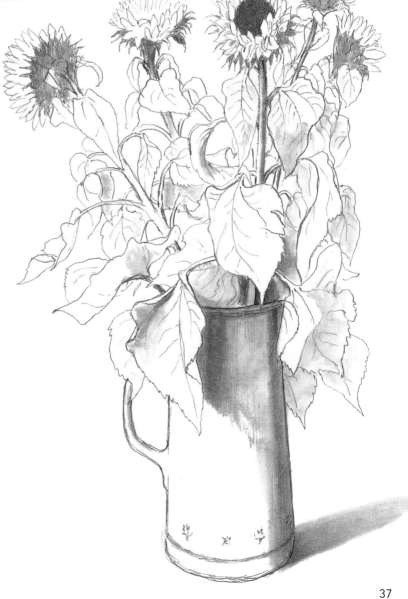

## LIGHTING

The quality and nature of the light with which you work will have a large bearing on your finished drawing. A drawing can easily be ruined if you start it in one light and finish it in another. There is no way round this unless you are adept enough to work very quickly or you set up a fixed light source. In this spread we look at the visual implications of adopting different kinds of lighting, starting with the range of effects that you can obtain by placing a series of objects around a single source of even light.

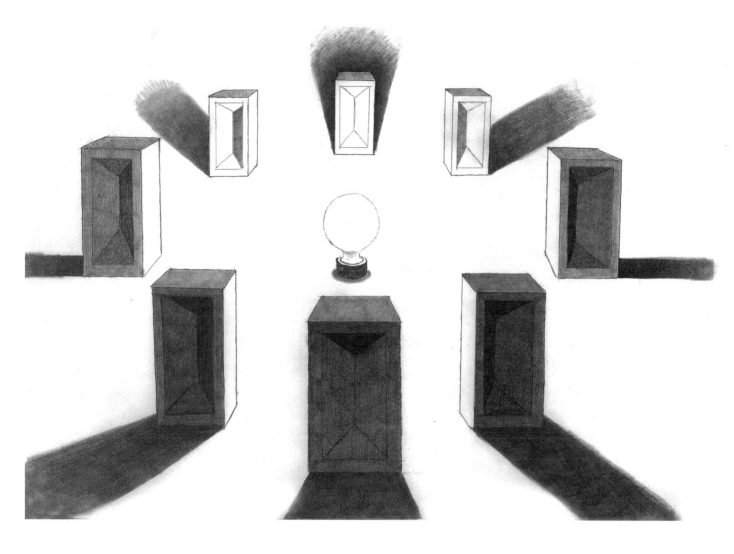

*The most interesting point to take from this exercise is how different the same object can look when light shines on it from different positions. Note how the light plays on the surfaces, and how the effects range from a total absence of shadow to complete shadow,*

*depending on the position of each object in relation to the light. In each case the cast shadow appears to anchor the brick to the surface it is resting on, an effect that is often usefully employed by artists to give atmosphere to their drawings.*

## THE EFFECT OF LIGHT

Many an art student has been put out by the discovery that the natural light falling on their still-life arrangement has changed while they have been drawing. You need to be able to control the direction and intensity of the light source you are using until your drawing is finished. If this can't be done with a natural light source, use an artificial lighting set-up.

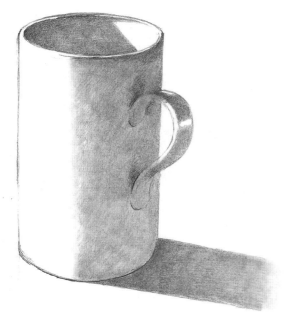

*Lit directly from the side; this produces a particular combination of tonal areas, including a clear-cut cast shadow.*

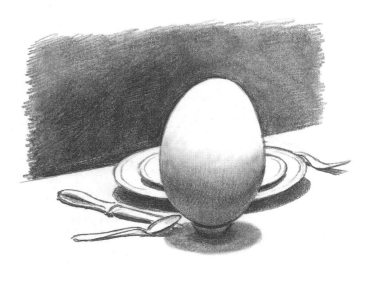

*Lit from above; the result is cooler and more dramatic than the first example.*

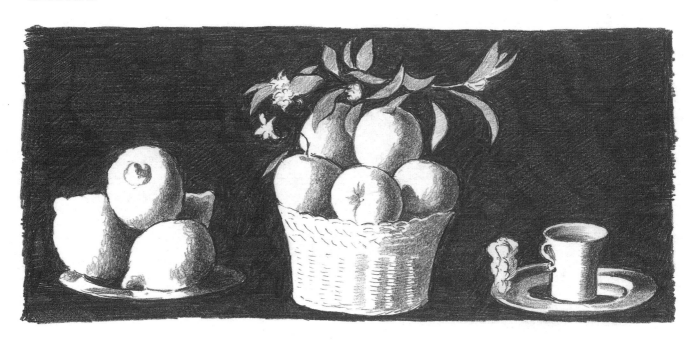

*Lit strongly from the side; the strength of the light and the fact that the arrangement is set against such a dark background produces the effect of spotlighting, and gives a rather theatrical effect.*

## FOOD AND DRINK

A popular form of still-life drawing is the representation of food and drink. The traditional pictures of this subject often show food laid out for the preparation of a meal, rather than the completed dish. This has the effect of creating a more dynamic picture.

*Our first example is of a classic 17th-century still life, by the Italian artist Carlo Magini (1720–1806), of bottles of wine, oil pots, a pestle and mortar and the raw ingredients of onions, tomatoes, pigeon and sausages. Note the balance achieved between the man-made objects and the vegetables, bird and sausages. The hardware is placed towards the back of the kitchen table and the food is at the front.*

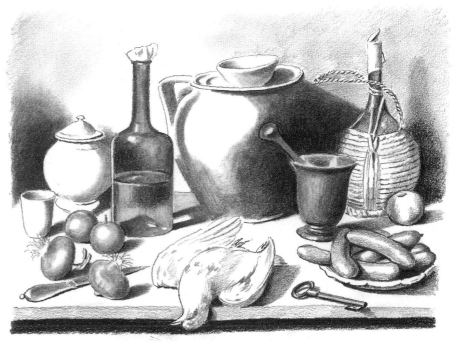

*The still life by Italian artist Filippo de Pisis (1896–1956) is simpler and is drawn in a looser, more impressionistic way. Here the intention of a 20th-century artist is to create a feeling of light glancing off the ingredients of an arrangement of apples and a melon slice.*

## TRAVEL THEMES

These examples on the theme of travelling feature two moments in time. The first is before the journey starts and the second is at the return when unpacking begins, showing not only clothes but also souvenirs and presents. Together they bracket the travelling experience.

*The arrangement of two suitcases accompanied by a hat, umbrella, coat and boots gives an idea of someone about to leave on holiday. It is a compact composition and relies on the solidity of the cases to act as the framework for whatever else is placed with them. The suitcases make the statement but the accessories give a season to the theme.*

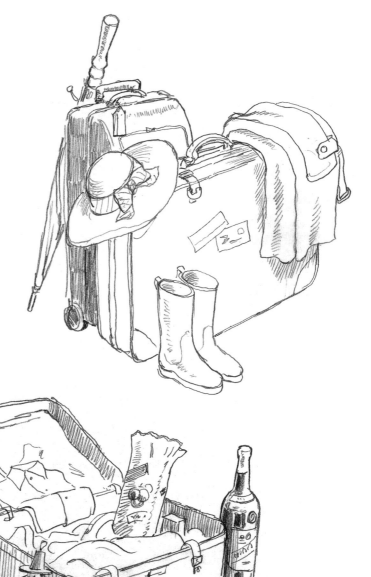

*In this second sketch the clothes are half revealed in the open case and the packages are carelessly spilled around, with souvenirs of statuettes, dolls, bottles, travel guides and presents giving a narrative element of someone having just returned from abroad. Obviously this theme could be adjusted for any country or continent to suit it to the person commissioning the picture.*

## MUSICAL THEMES

The theme of music has always been very popular. It is usually shown by the casual deployment of musical instruments, musical scores and so forth across a table, chairs or the floor.

*A musical still life was a very popular theme in the 17th and 18th centuries. This one, after Baschenis, is rather arbitrary but works mostly because the shapes of the instruments are so interesting that it almost doesn't matter how they are arranged. The great beauty of this sort of theme is that you can't really produce a bad picture if the objects themselves are so satisfying to look at.*

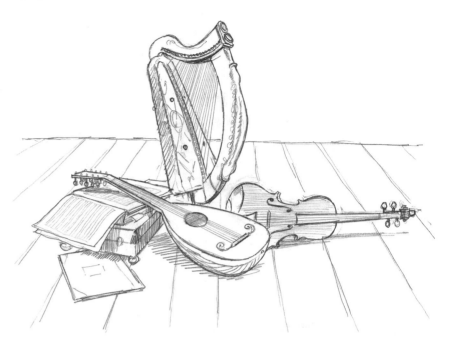

*I've shown this group of instruments depicting a musical theme in simple outline forms to classify the dramatic possibilities of rounded, flattened and cuboid shapes contrasted with each other. Notice how the objects are mostly heaped in the lower half of the composition, contrasting with the blank space above.*

*The rounded shapes of the lutes, the flatter angularity of the violin and bass, the open music score and the black box, which presumably holds music paper, pens and ink create a variety of clearly defined shapes, which in a way mirrors the musical possibilities of contrast and harmony.*

## THE SEA

This picture, redolent of life lived close to the sea, brings the atmosphere of the ocean into a piece of still life. It is a collection of things found on the beach.

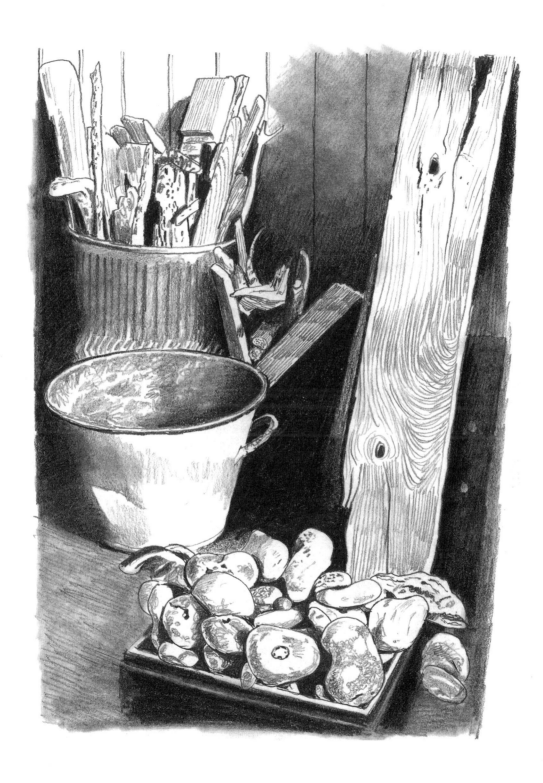

*This still life hints at the sea, with its piles of driftwood and box of large stones. It gives the impression of a corner of the garden shed, with the collected minerals and wood shoved into battered pails and dustbins. The effect of worn wood and stones brings home the idea of time passing, with the wearing down of natural objects by natural forces.*

## SYMBOLISM

Many of the still-life pictures that were painted during the 16th and 17th centuries were careful arrangements of symbolic objects. They were designed to tell some sort of story about the commissioner or to point out a particular moral to the onlooker.

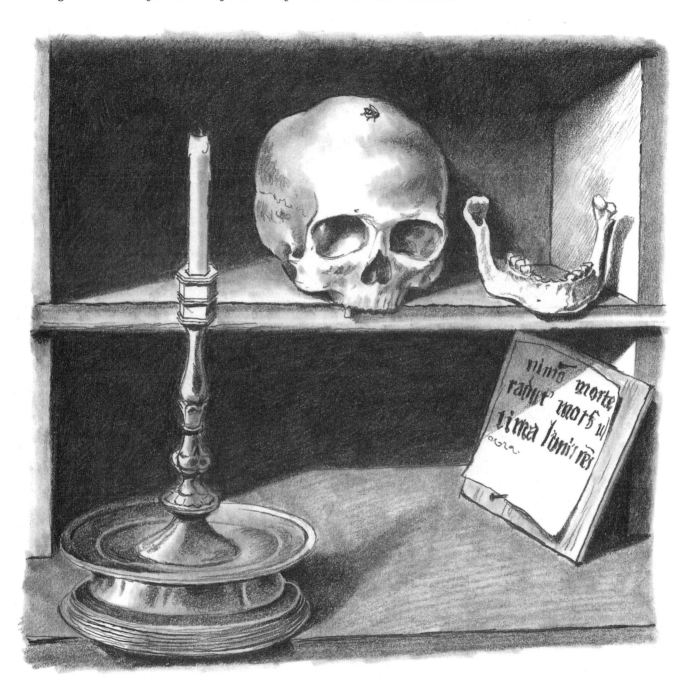

*The most obviously symbolic pictures were concerned with the passing of time and the approach of death. This still life after Bruyn the Elder (1493–1555) is a simple but effective composition with its blown-out candle, the skull with its jaw removed to one side and the note of memento mori on the lower shelf. The dark shadows under the shelf set the objects forward and give them more significance.*

## AN OBSESSION WITH A THEME

Some artists are famous for producing still-life pictures that repeat the same theme over and over again. The Italian artist Giorgio Morandi (1890–1964) spent most of his working life making pictures of pots, bottles and similar ordinary objects of mostly vertical shape, all grouped together against a plain background.

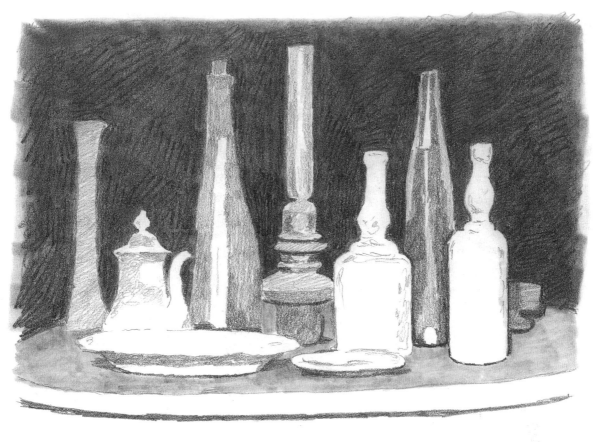

*Here we have a large group of bottles and pots against a dark background with a couple of plates in the foreground. This monumental still life suggests much bigger objects but still has the same constituents that Morandi always used.*

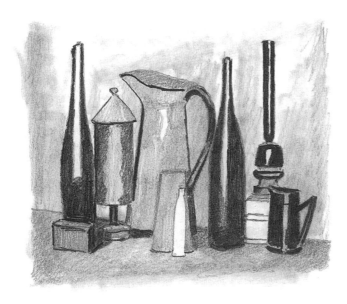

*This Morandi is similar in theme, with the addition of jugs and other items, this time against a paler background.*

## SUGGESTING LARGER SPACES

Sometimes the space does not have to be spelt out, as the inference in the subject matter is of larger spaces even if they are not directly seen in the picture. The outer world may be just suggested by light or the presence of a window, which immediately reduces the closed-in effect that still life can often have. Although the subject is contained it doesn't have a final boundary, as the space stretches beyond the view in some way.

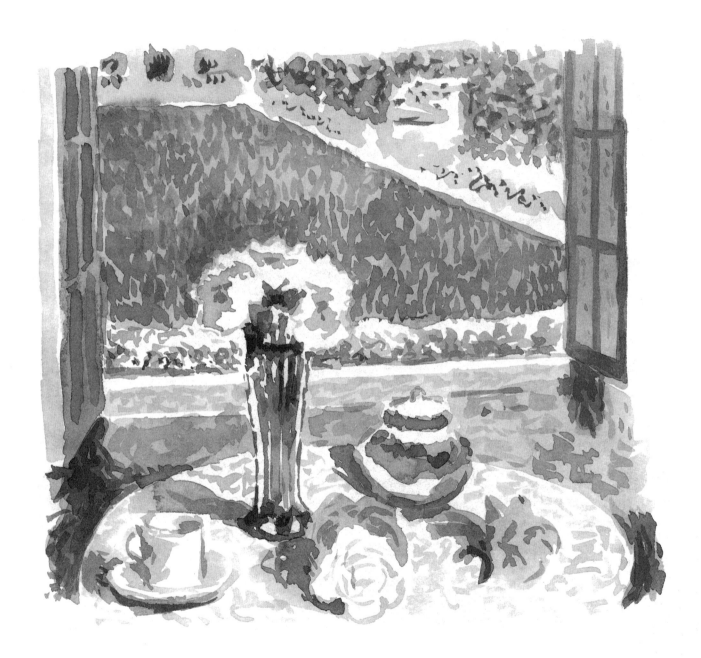

*In this drawing after Henri Le Sidaner, the placing of a table laid for tea in front of a window looking out onto a lawn takes the view out into the open air although the still life is itself in an enclosed area. The flowers on the table link it with the garden beyond.*

## OUT IN THE WIDER WORLD

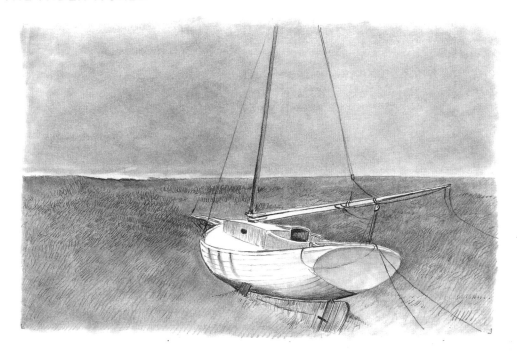

Now the outdoor scene is of unlimited space, and our subject is a still life of a larger nature: a sailing boat beached in a field close to the sea, by Wyeth. The uninterrupted view of the horizon is clearly pointing to a much larger world.

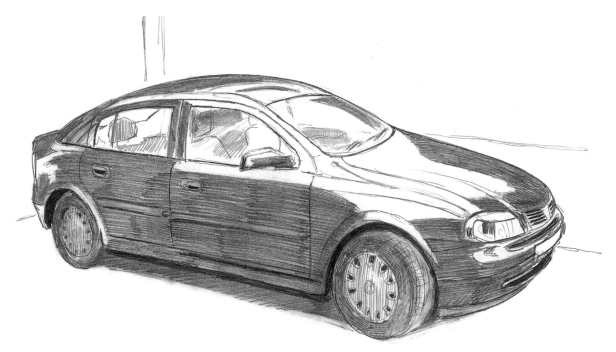

This is another example of the large outdoor still-life subject, which gives the artist a really sizeable object to depict. The main thing is to find an angle to draw it from that will show the automobile in an interesting way and also provide reflections that are challenging to draw. Here, the reflections are seen in the simplest possible way, which is why I chose this angle.

## PENCIL DRAWING

The first thing we look at is the basic use of pencil to produce your still-life drawing. A drawing can function in several ways: as a sketch that acts as a preliminary stage for a painting; as an underdrawing on top of which you then put colour; as a finished piece in itself; or just as a piece of information to use for later work.

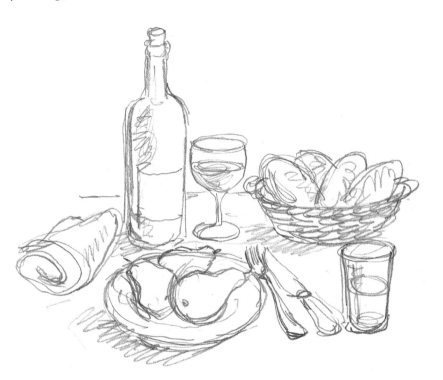

*To start with, try out this loose-line technique, in which there is very little in the way of careful tone or sometimes none at all. The questing, wobbling line, which almost looks as though the point of the pencil never leaves the paper, is a very expressive medium for quickly and elegantly stating the form of the objects it is describing.*

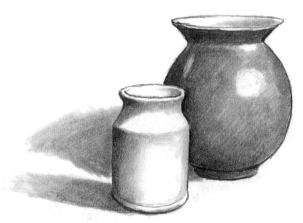

*Shown here is the more careful and deliberate method of drawing quite fine and precise outlines and then carefully shading in the tone until it graduates from dark to light with great subtlety. For this method, the pencil has to be kept finely sharpened at the start, but allowed to become softly blunt when shading.*

*The graduation of tone can be further enhanced by the use of a stump (a rolled, pressed, solid paper stick with a pointed end) which smudges the pencil from heavy to faint shading very effectively.*

## PEN AND INK

As we have seen, there are many types of pen that you can use to draw. The techno graphic pens with fine fibre tips produce lines of uniform thickness and weight. If you use these you will sometimes need more than one calibre, or thickness. Then there is a range of fine-pointed nibs available that are pushed into an ordinary dip-pen holder. Some of these are pointed and rigid, while others are flexible to allow variations in thickness of line. They tend to have a few more variable lines than the techno graphic pens. You can also vary the kind of ink you use with them to get a blacker or greyer tone.

*First, with a pen, try the loose-line technique similar to that of the pencil technique (see p 48). Use a large nib to begin with and draw with large, flowing gestures. You won't create much tone with this but it does produce a lively looking line, which can be very attractive as long as the subject matter is not too detailed.*

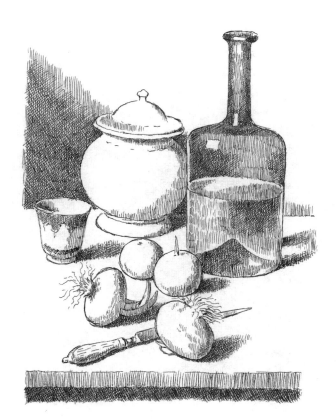

*With a fine-nib pen, you can use a much more carefully organized system of hatching, layered to build up significant areas of darker tone. This demands more precision in the outline shapes and you need to control the way the pen strokes butt onto these finely drawn outlines. Carried out with patience and perseverance, this can produce beautiful velvety textures that seem to create real depth and solidity.*

## BRUSH AND WASH

Drawing with a brush is a very pleasant experience once you have become accustomed to the flexibility of it. This technique has been used brilliantly by artists over the centuries, including Rembrandt and Picasso. Try varying the density of the ink or paint by diluting it with different amounts of water. Hold the brush firmly but with a relaxed wrist so that your hand can flow freely along the shape you require. Allow the tip of the brush to push onto the paper and then pull it off to make thinner, fainter lines as this produces a very attractive effect.

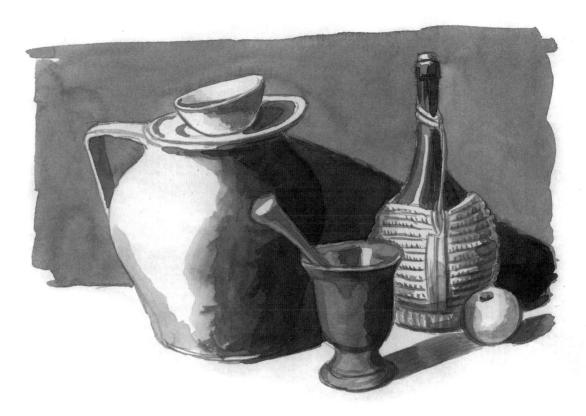

*You can make a very fine pencil outline of your objects first and then proceed to apply layer upon layer of watery tones to get a carefully graduated set of shadows from black to very pale grey. When you employ this technique, try to avoid large areas of one tone unless you are using a good watercolour paper, which makes it easier.*

*Use a large, soft brush (sable are the best) for the larger areas and a slim, pointed brush to draw finer areas and details.*

## CHALK, CONTÉ AND PASTEL

The methods used with chalk can be quite varied and also depend upon the chalk's quality. Some chalks are quite hard and wear down slowly; others are very soft or crumbly. They demand slightly different handling, so try a variety of them to discover which type you prefer to work with.

The easiest way to use chalk or pastel is on a tinted paper, especially one that has a slightly rough or matt surface; a smooth surface refuses the chalk sometimes, so paper with some texture produces a better quality of line.

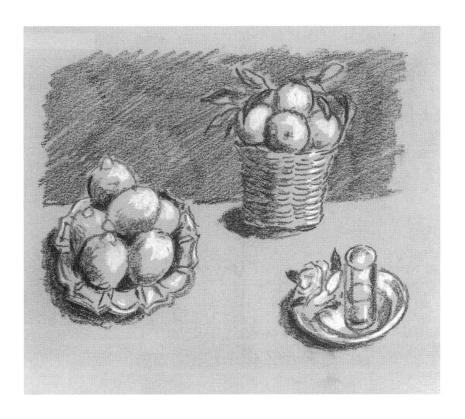

*This still life is on tinted paper in a dark and a white chalk. The paper produces the half-tones, the dark chalk the deeper shadows and outlines and the white chalk the highlights and bright spots. It is a very effective method, with economical amounts of drawing to be done; you let the tone of the paper do the work, just putting in the more extreme shadows and highlights yourself. Fix the final result with a good fixative spray. Use the chalk as shown, very lightly stroking the surface of the paper. A carefully sharpened end will give you finer lines. Applying heavy pressure will always give a coarse effect.*

*Use the chalk as shown, very lightly stroking the surface of the paper. A carefully sharpened end will give you finer lines. Applying heavy pressure will always give a coarse effect.*

## MORE OR LESS?

Take similar objects and look at them in different ways. They can be lined up à la Morandi, making a neat, closely grouped picture, or multiplied *en masse*, creating a crowd of objects without limit. Alternatively, we can get rid of everything except one perfect specimen and set it in a big empty space so that it becomes the focal point.

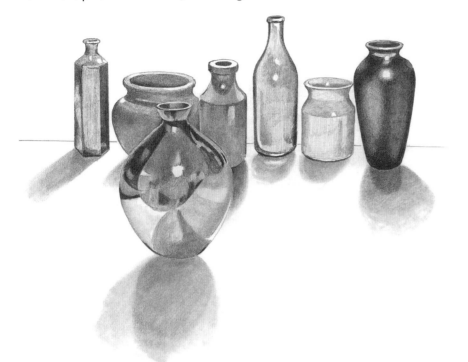

*In this line-up of pots of different types and materials, all are centred on a circular base. Lined up with the light behind them, they present an attractive group with a formal balance. The placing of the brilliantly reflective pot in the front is rather like putting the king in front of his troops.*

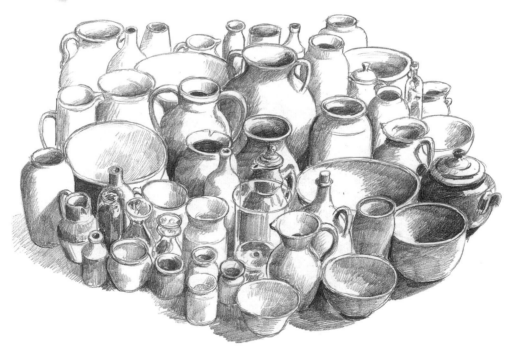

*This composition was arrived at by gathering together most of the vases, jugs, large bowls and other pots from our kitchen, sitting room, hall and garden and pushing them together, large at the back, small at the front, all across the floor. The repetition of these mostly open-ended shapes seen in perspective creates an intriguing picture. One 20th-century English artist produced a composition of 100 jugs – something of a challenge.*

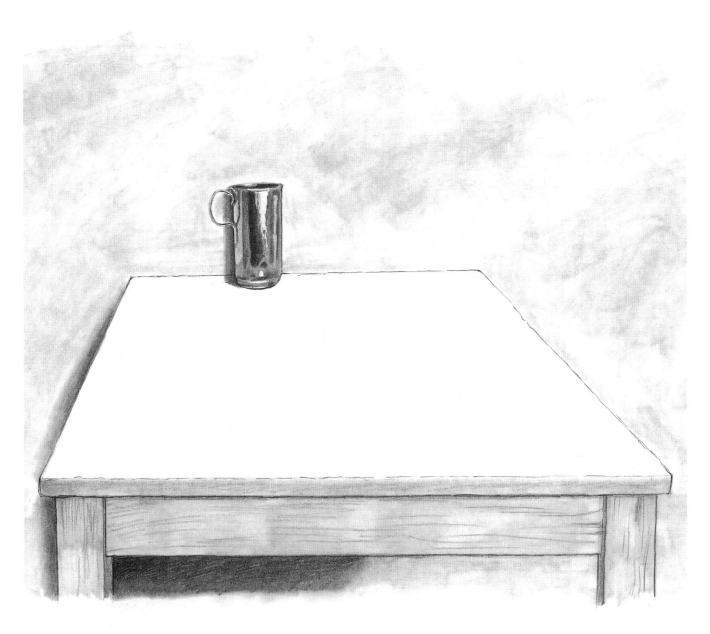

Taking a single object like this golden jug and placing it on a bare, simple table with a blank wall behind it pulls the eye into the picture to concentrate on the lone object. For maximum effect, choose a really strong, unusual object.

## SHALLOW OR DEEP?

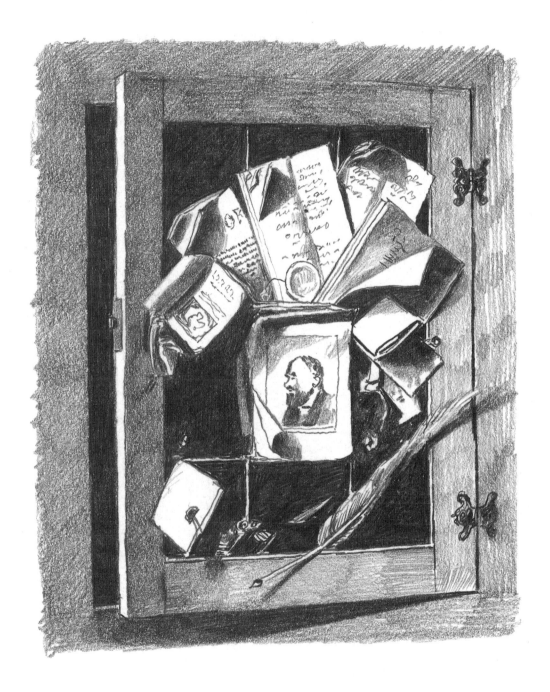

The pinboard with various paper articles pinned and wedged onto it gives a very good display if you want to try out your hand at a little trompe l'oeil. The objects don't have to have much real depth because whatever amount of dimension you manage to get into it pays off quite strongly.

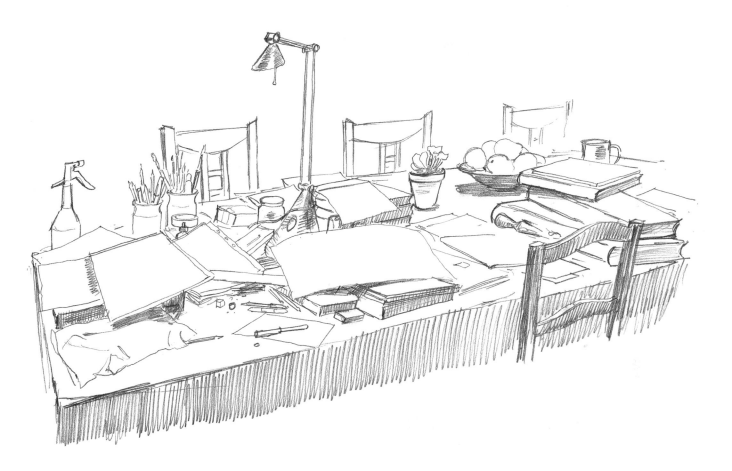

*A large tabletop laden with miscellaneous objects can be intriguing, especially if they are objects that are not familiar in that context. A lot of old pictures of still life were done like this, but usually with a precise theme. This drawing is just of what happened to be there.*

## TACTILE QUALITIES: THE SENSES

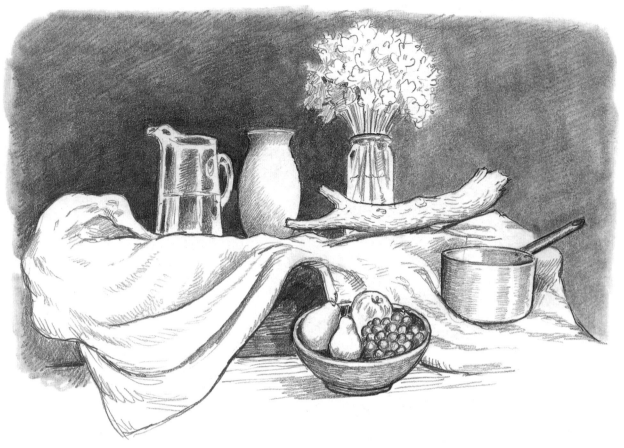

Taking a group of objects each of which is made from a different material is a time-honoured way for a still-life artist to show his skill in depicting the texture of things.

Here we have glass, pottery, flowers, wood, metal, fruit and cloth, all of which need to be drawn differently in order to bring out their texture.

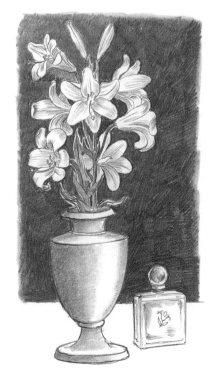

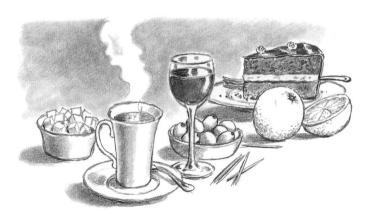

In this composition of a warm drink, a sugar bowl, a glass of wine, some olives, some oranges and a nice rich-looking cake, all the items refer to taste.

A vase of lilies, which have a strong scent, and a bottle of perfume put across the idea of smell.

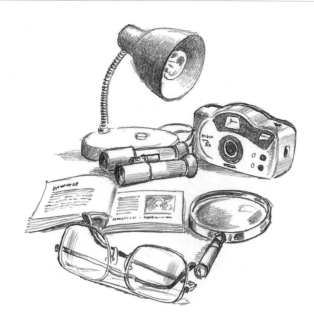

*Here is a group of objects including a lamp, a camera, a pair of binoculars, a book, a magnifying glass and a pair of spectacles, all of which refer to sight.*

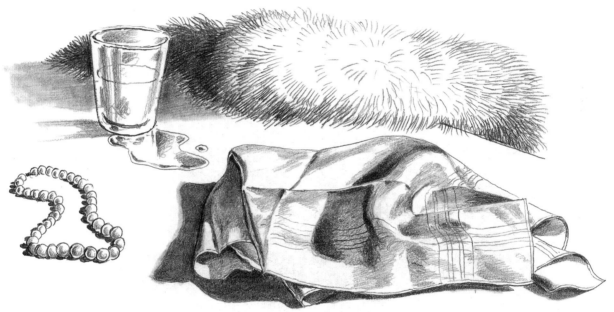

*Taking a theme of the five senses allows us to try to show something that everyone experiences through the medium of drawing. The drawing above refers to touch,* *showing silk, pearls, water and fur, all of which have great tactile values.*

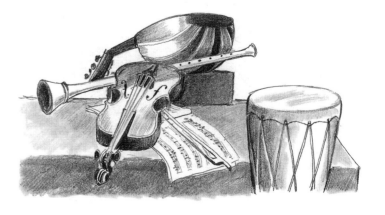

*Finally, a group of musical instruments puts across the idea of sound and hearing – a classical subject.*

## FINDING AN INDIVIDUAL STYLE

Next, we look at unusual still lifes which derive their originality in part from the method of drawing that the artist has used. The rather mechanical outlines of the example below give a different look to these still-life objects that has become almost iconic. Sometimes just the way you draw can produce the individual quality of the picture that gives it particular interest.

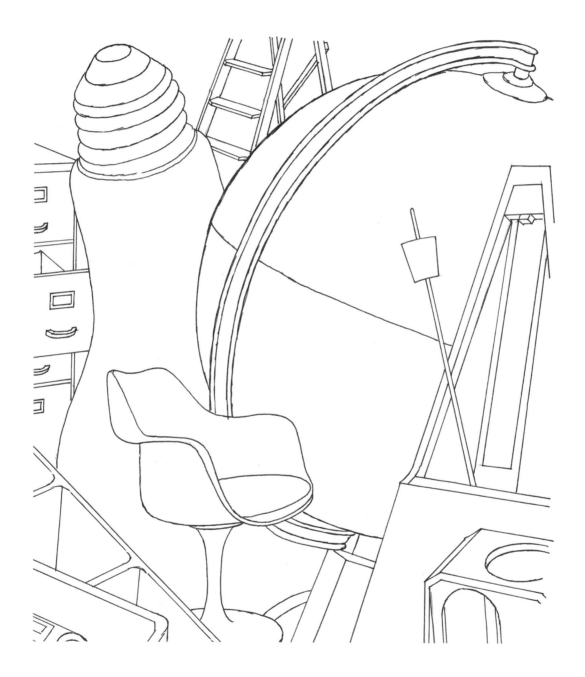

*In the linear drawing shown above, after* Inhale, Exhale *(2002) by Michael Craig-Martin, the ordinary mechanical gadgets of modern living are thrown together in a way that confuses the onlooker by placing large objects such as filing cabinets and stepladders against scaled-up versions of a video cassette, pencil sharpener, light bulb and metronome. The pedestal chair in the middle acts as a focal point, and the whole picture is pulled together by the almost mail-order catalogue style of the impersonal drawn line. Michael Craig-Martin is one of the few artists who use this sort of technical detachment from their subject.*

The humble, worn footwear that Van Gogh drew in the 19th century is an earlier version of the approach of the Kitchen Sink and Ash Can schools of painting. When Gauguin showed the work to some of his friends they were surprised by its apparent banality. Of course what Van Gogh had depicted in his picture is the honesty of hard toil and a sort of sanctified poverty that seems to give an extra psychological depth to his drawing.

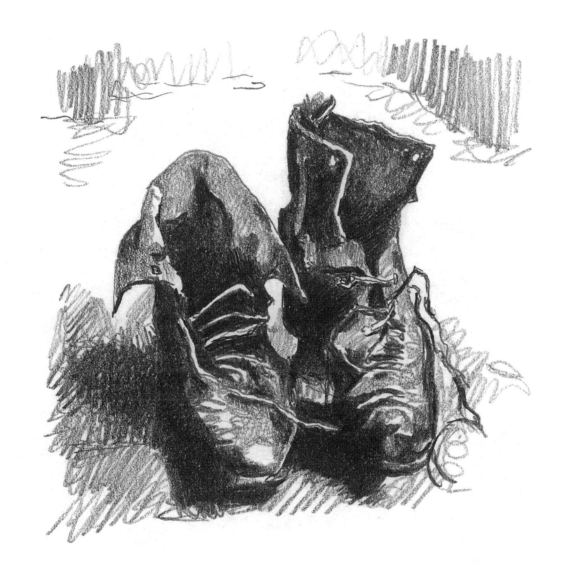

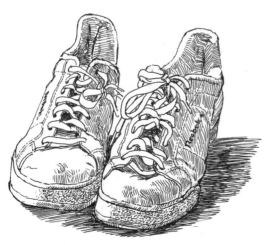

These extremely workaday trainers look similar in nature to Van Gogh's workman's boots, but they are designed for leisure pursuits which only an affluent part of society can afford. Footwear sometimes provides an ambiguous message about its owners and the society in which they live.

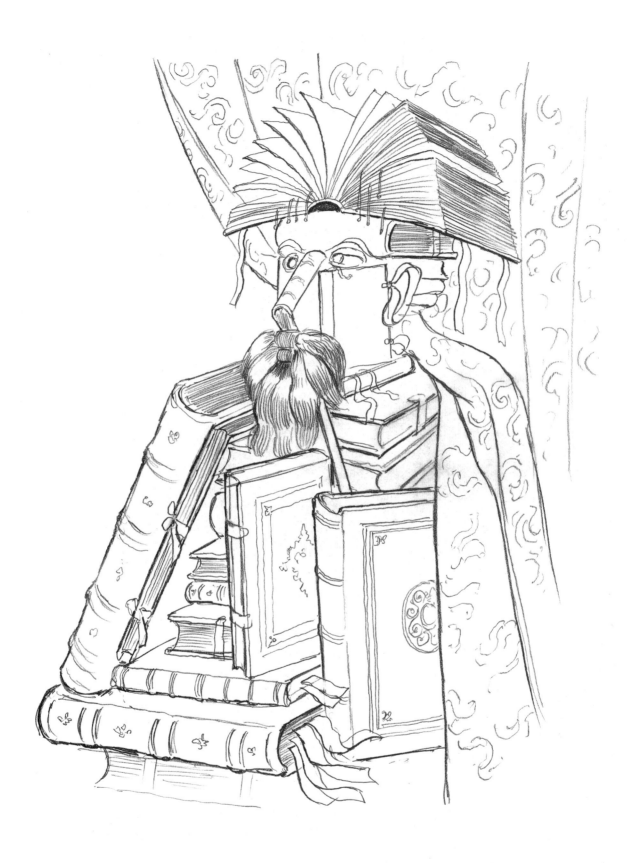

This is after the 16th-century Italian artist Arcimboldo, who specialized in making pictures resembling portraits out of still-life objects. This piled-up stack of open and shut books draped by a background curtain produces an effect of a bearded man sitting for his portrait. It is definitely still life, but also becomes a portrait by virtue of a sort of optical illusion – a clever and very difficult approach to pull off.

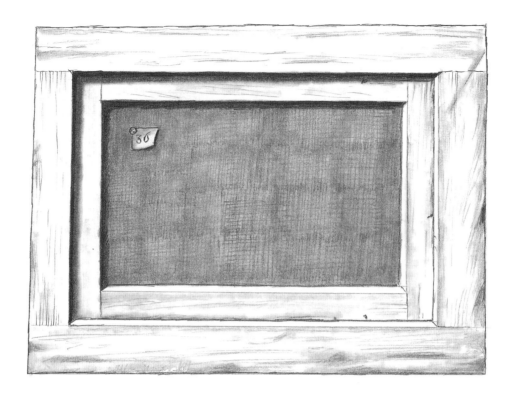

Cornelius Gijsbrecht's picture (c. 1670) is apparently the reverse of a framed canvas, but is in reality a careful drawing in a trompe l'oeil *manner actually painted on* the surface of a canvas. Presumably the other side of it looks the same but is the real back of the picture. A nice joke on the viewer.

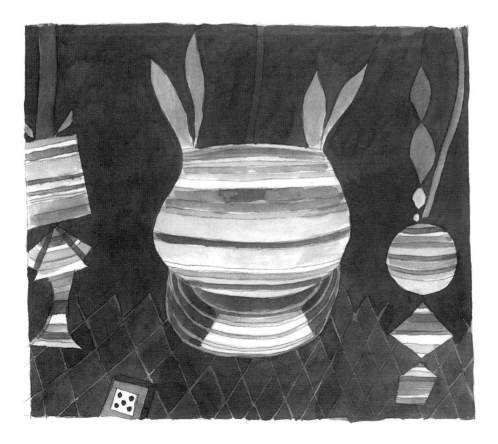

*20th-century artists were interested in the still-life genre, but because of their desire to use a new language in art they produced some unusual variations upon traditional themes. This picture after Paul Klee of potted plants and a die on a paved floor gives a mysterious effect which is very different from the more photographic view of still-life objects.*

## FINDING YOUR OBJECTS

Make a selection of some objects that both appeal to your eye and are sufficiently varied to give you the possibility of creating interesting arrangements. Look around for things that you will not need to use in your day-to-day life during the period that you are drawing them.

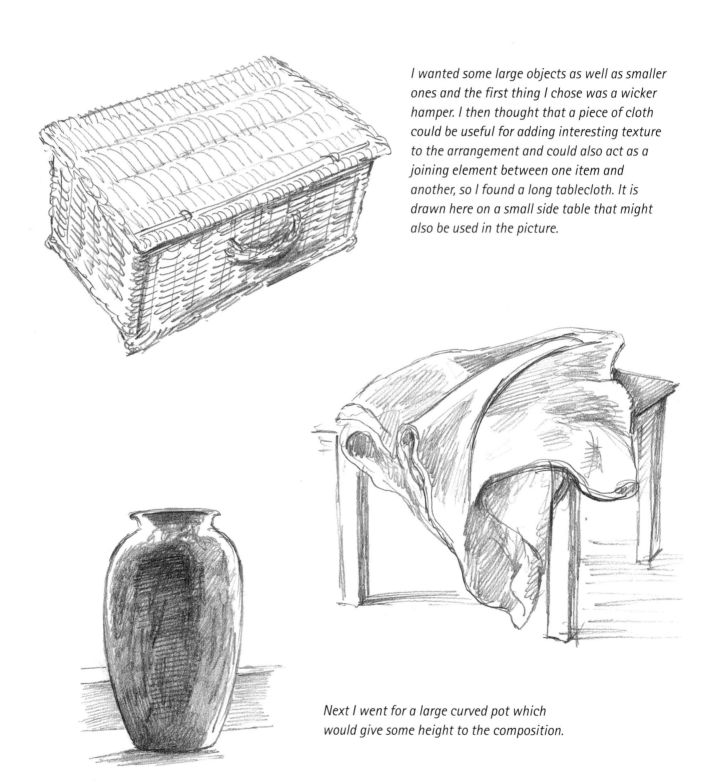

*I wanted some large objects as well as smaller ones and the first thing I chose was a wicker hamper. I then thought that a piece of cloth could be useful for adding interesting texture to the arrangement and could also act as a joining element between one item and another, so I found a long tablecloth. It is drawn here on a small side table that might also be used in the picture.*

*Next I went for a large curved pot which would give some height to the composition.*

I then spotted a heavy casserole dish with a lid, a tall white jug, a large pottery jug and a glass bowl, all of which looked interesting in their shapes and texture.

Now I had collected together a good selection of objects, which I would later whittle down to the final selection for the finished composition.

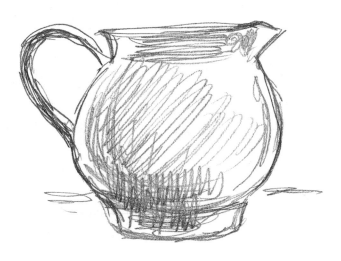

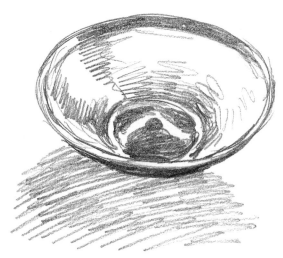

## FINDING YOUR SETTING

The next step was to consider an area in which
all these objects could be set up.

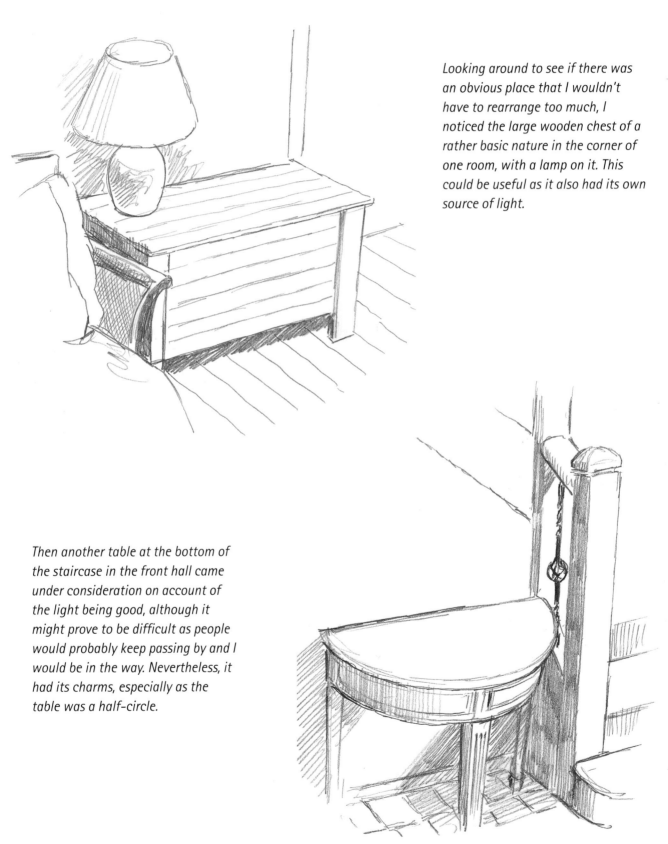

*Looking around to see if there was
an obvious place that I wouldn't
have to rearrange too much, I
noticed the large wooden chest of a
rather basic nature in the corner of
one room, with a lamp on it. This
could be useful as it also had its own
source of light.*

*Then another table at the bottom of
the staircase in the front hall came
under consideration on account of
the light being good, although it
might prove to be difficult as people
would probably keep passing by and I
would be in the way. Nevertheless, it
had its charms, especially as the
table was a half-circle.*

*My gaze then fell on a side table by a wall. It had plenty of space around it, and the wall could act as a backdrop.*

*The last place I considered was a basketwork chair underneath the window, again with plenty of space around it.*

*After all this, I began to think that the best option so far was the area by the side table, which was not only well lit and spacious, but also had a bit of wall and a large, darker space which might be useful to give depth.*

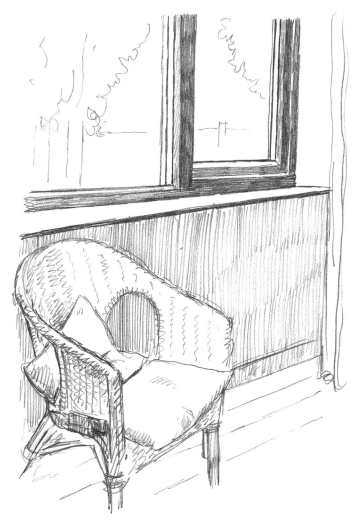

65

## SELECTION TIME

There were too many objects for what I wanted to do, so I carefully looked at them all again and made this selection.

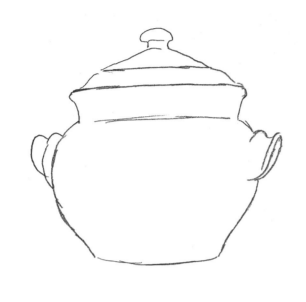

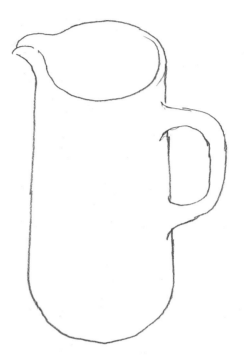

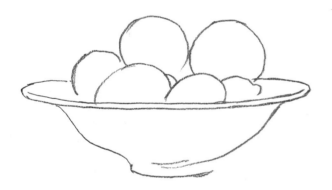

*I chose the heavy pot for its solidity, the tall jug because of its height and simplicity and a bowl of fruit as a classic still-life object. To these I added the glass jug for its light reflection and transparent qualities, and the two apples to act as a sort of loose end to any arrangement.*

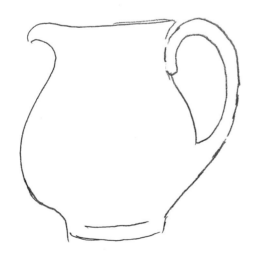

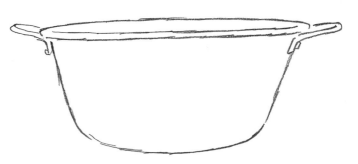

*A big copper pan was retained for a strong, simple shape that would work in either foreground or background.*

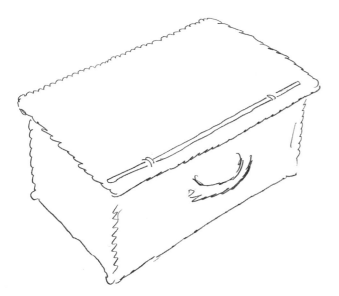

*I added the wickerwork hamper for stability and for putting things on, and the side table with the plain white cloth. The cloth could be used in many ways but was very useful as something to join together all the different elements of the arrangement. And lastly, I added a potted plant.*

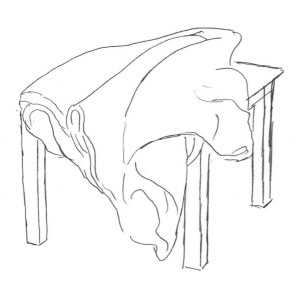

## LIGHTING YOUR OBJECTS

Whatever your still-life arrangement is, there will always be the problem of how the objects within it are lit. There are many ways of doing this using artificial and natural light. Here we look at just two solutions, but many more variations are possible.

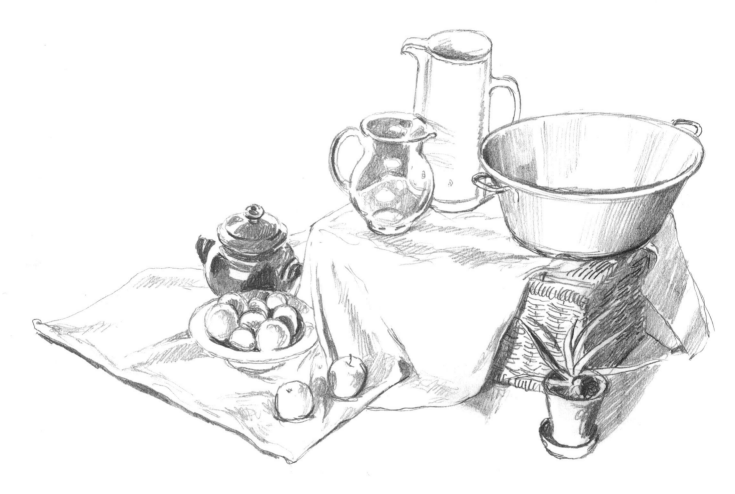

*Now was the time to consider lighting. How would I like my arrangement to look? I placed a few objects around and on the hamper in such a position that the light from the windows lit up the arrangement very brightly. The rather flat front lighting gives a very clear view of the various shapes of the objects.*

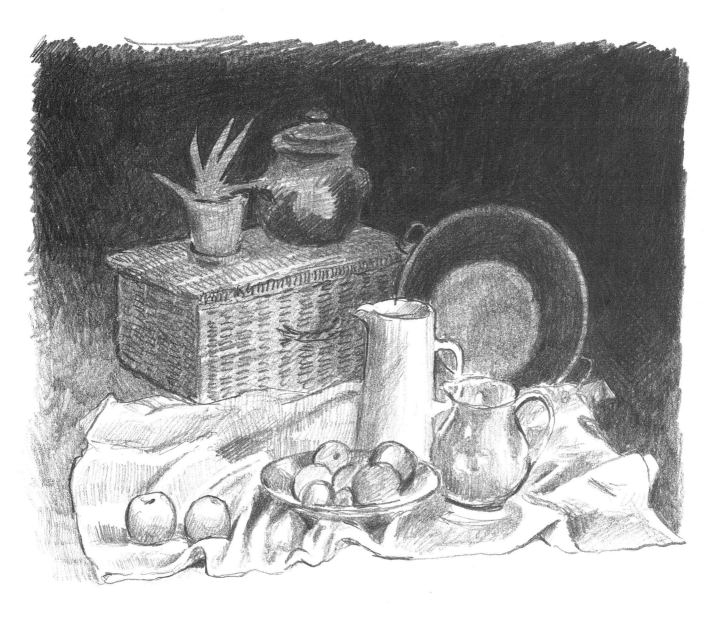

Then I rearranged them against a darker background and put several of the objects well back into the gloom of the space. Only the objects to the front of the composition were well lit, which gave a lot more drama to the picture.

## TRYING DIFFERENT VIEWPOINTS

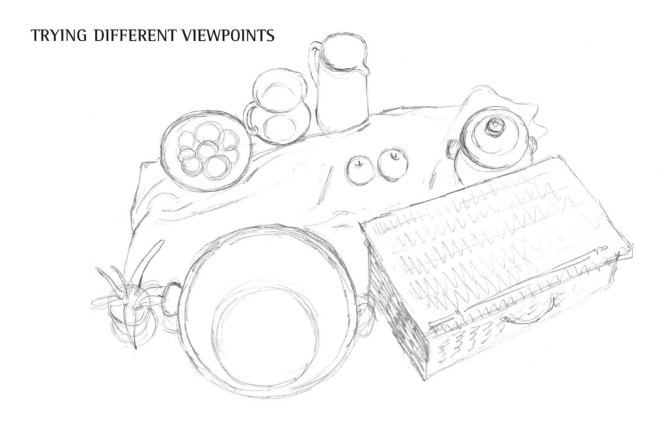

Next I laid out these objects in a loose arrangement on the floor to see what they would look like seen from a higher viewpoint. Looking down on the objects it was almost possible to draw them like a map. So did I want this high-level view?

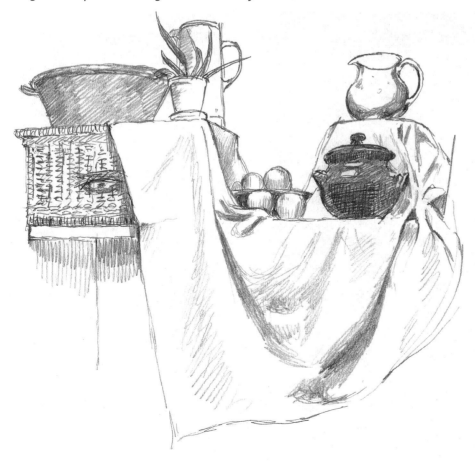

I then had to try the alternative – a low-level view where I would have to look up at all the objects to draw them. So I put them all on a table and sat down on the floor to see the effect. From this position the composition took on a monumental quality.

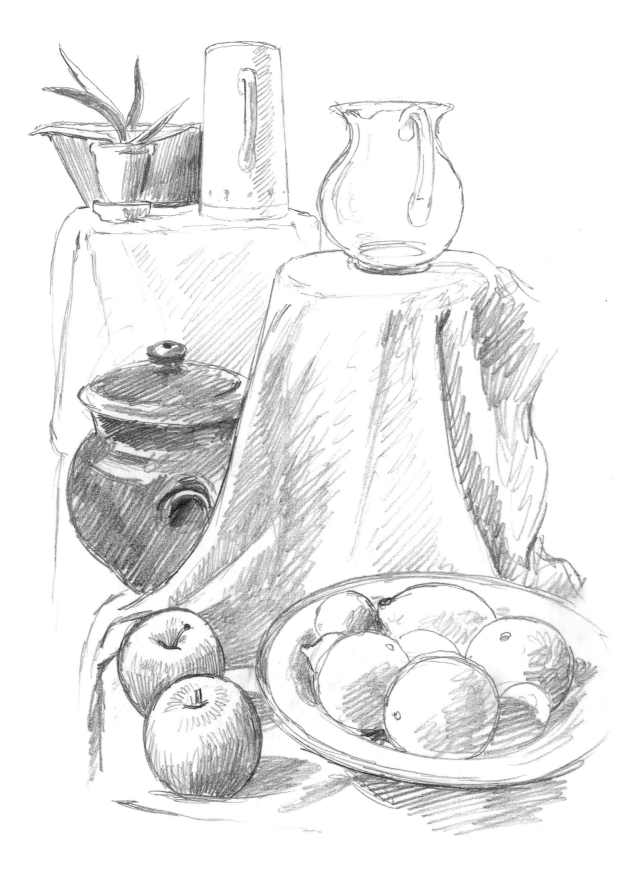

Next I rearranged the objects and walked round them until from one side I got this view of them partly at my eye level and partly below it, which gives an interesting effect and also draws the eye into the picture more easily.

## KNOWING YOUR OBJECTS

Having selected your objects, found a place to put them and made a plan for the composition, the next thing is to understand each object more thoroughly. The best possible way to do this is to draw them separately as many times as you like in order to really get to know them. This is very good practice for the final drawing.

*Drape a cloth over something and observe the sort of folds that the material makes. Each kind of material should be studied; this particular cloth had soft, heavy folds with creases showing up in it.*

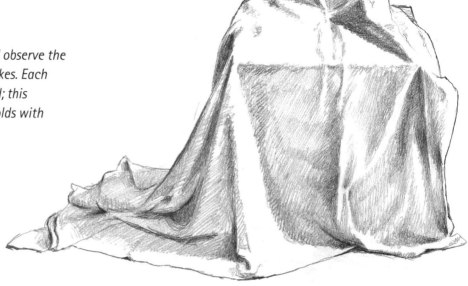

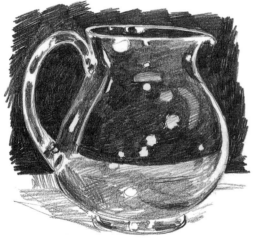

*The clear glass jug was highly reflective. It was not so easy to draw as the cloth, but trying it out soon showed how this object could be effective in the final still life.*

*I drew the plant from several angles in order to get some idea of how it grew. As the only living thing in my composition, it was probably the most subtle object.*

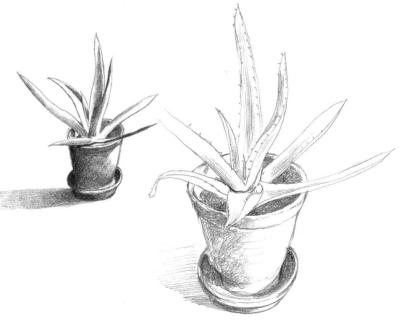

The main thing about drawing the heavy pot was to get the effect of its roundness and bulk. This required a bit of practice so that I could get the shape drawn in swift movements of my pencil without pausing.

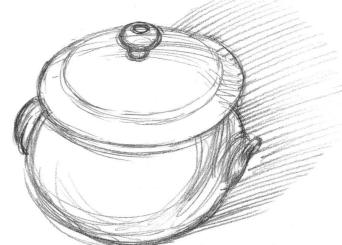

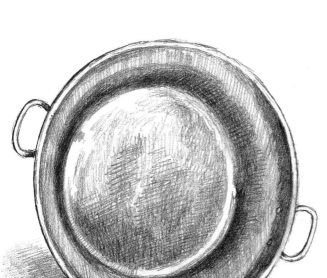

The copper pan had both reflectiveness and solidity and I decided that I would like to look into it, so it required support from behind with a stool or box so that I could see the shinier interior. The round shape also was a good, large form to place behind other things.

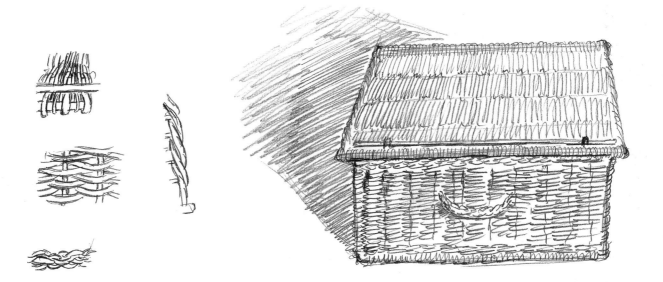

The wickerwork hamper was a nice straightforward shape, but its texture was harder to draw. I made some studies of the way that the pieces of wickerwork were interwoven, especially round the edges and the handle.

## A ROUGH COMPOSITION

With everything else resolved, I had to put together my final idea for the composition of my picture. Here I have drawn a very rough composition of the arrangement of all these different objects that I decided I liked best of all. I settled upon the angle of the light and what sort of background the composition should have.

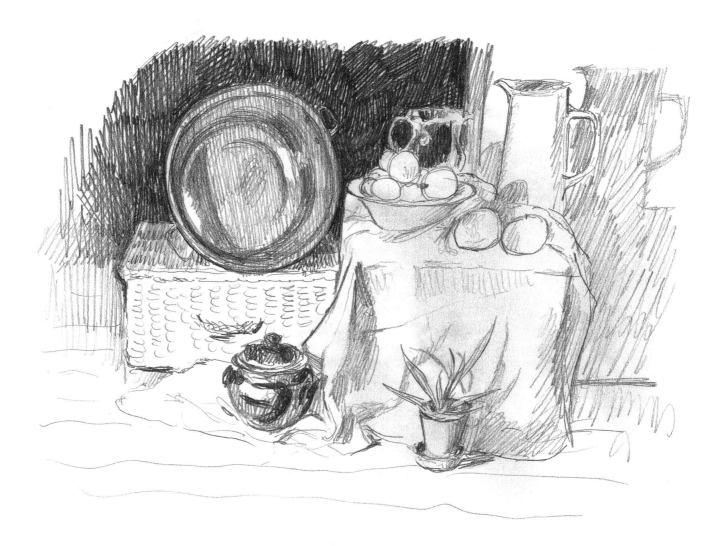

*Here, I have the light coming from the left, fairly low and casting a shadow on some of the objects on the side wall. The main part of the composition is the darkness of the room behind, so the arrangement is well lit but against a dark space. I covered the side table with the cloth but allowed the jug and bowl of fruit to rumple it up a little. The heavy dark pot and the spiky plant are at the base of the foreground. The hamper and the large copper pan act like a backdrop on the left-hand side.*

## MAKING AN OUTLINE DRAWING

Having decided on my arrangement and made a fairly quick sketch of it, I now knew what I was going to do. The first thing I needed to establish was the relative positions and shapes of all the articles in the picture, so I made a very careful line drawing of the whole arrangement, with much correcting and erasing to get the accuracy I wished to convey in the final picture. You could of course use a looser kind of drawing, but for this exercise I was being very precise in getting all the shapes right and their dispositions carefully related. This is your key drawing which everything depends on, so take your time to get it right. Each time you correct your mistakes you are learning a valuable lesson about drawing.

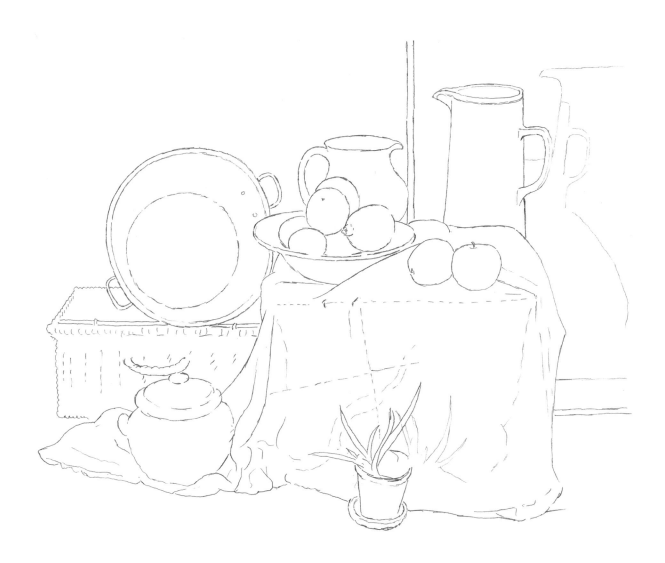

## BLOCKING IN THE TONE

After that I blocked in all the areas of the main shadow. Do not differentiate between very dark and lighter tones at this stage; just get everything that is in some sort of shadow covered with a simple, even tone. Once you have done this you will have to use a sheet of paper to rest your hand on to make sure you do not smudge this basic layer of tone. Take care to leave white all areas that reflect the light.

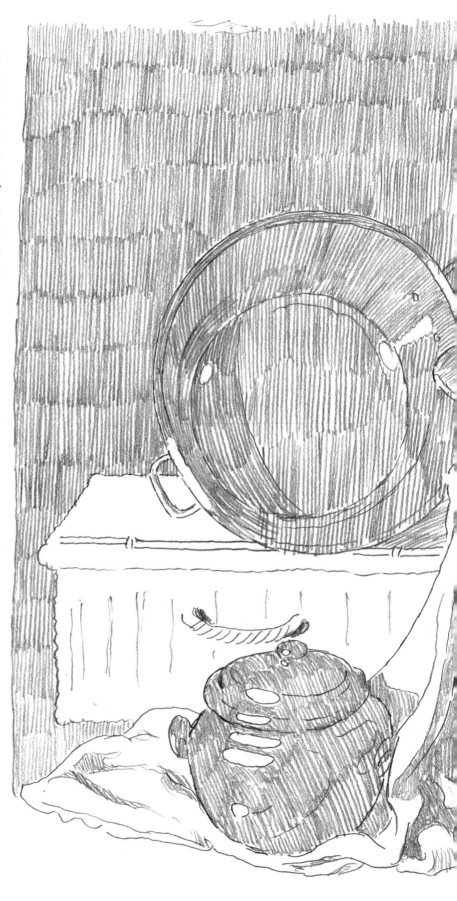

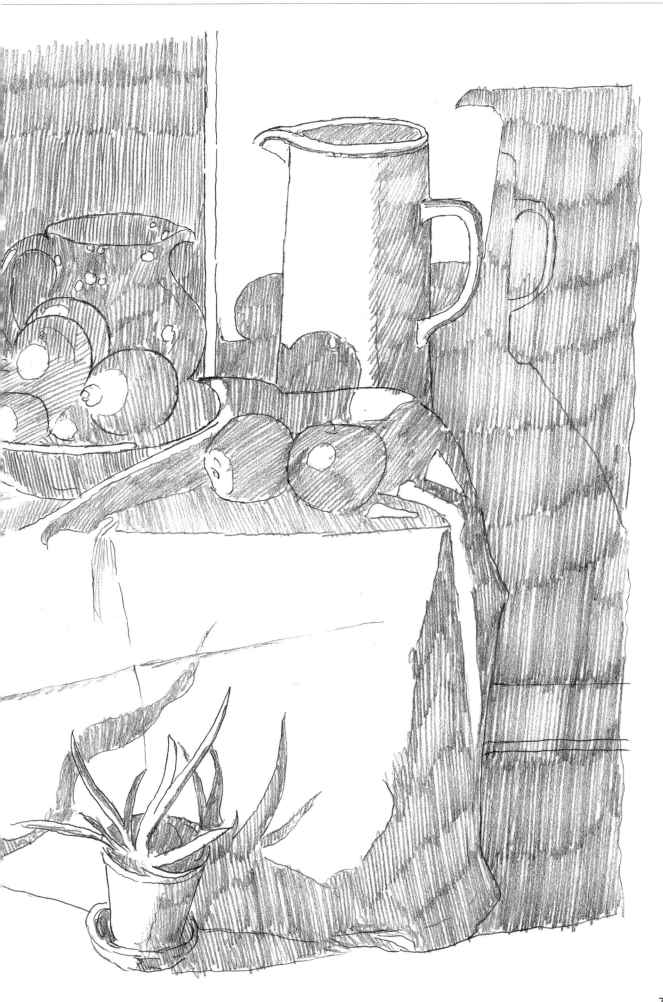

## COMPLETING THE PICTURE

Finally, 1 did the careful working up of all the areas of tone so that they began to show all the gradations of light and shade. 1 made sure that the dark, spacious background was the darkest area, with the large pan, the glass jug and the fruit looming up in front of it. The cast shadows of the plant and where the cloth drapes were put in crisply and the cast shadow of the jug on the side wall required some subtle drawing.

Before 1 considered my drawing finished, 1 made sure that all the lights and darks in the picture balanced out naturally so that the three-dimensional aspects of the picture were clearly shown. This produced a satisfying, well-structured arrangement of shapes with the highlights bouncing brightly off the surfaces.

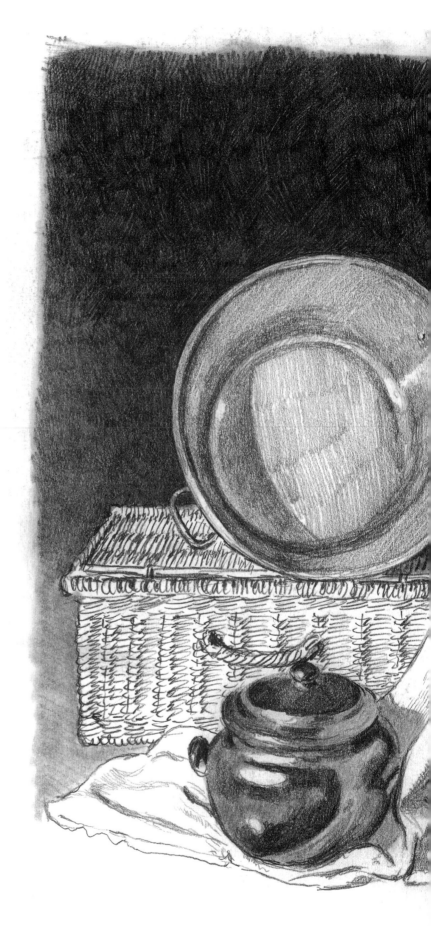

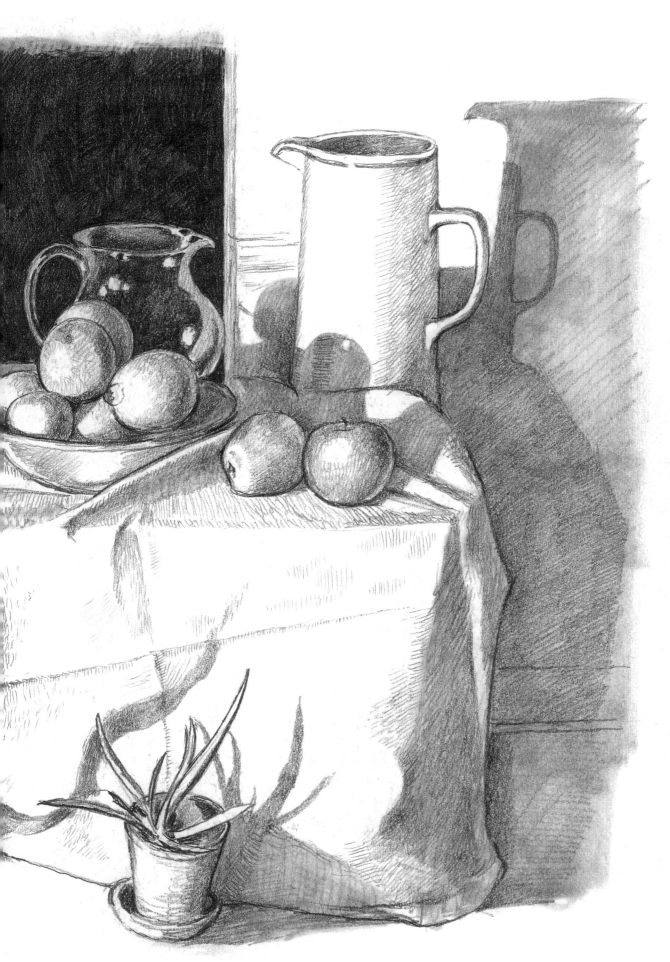

# Figure Drawing

After still life, most people aspire to drawing the human figure. However, being a human oneself loads the artist with all kinds of preconceptions, which can make it very difficult to see a way through to making the first marks on paper.

Studying the old masters is recommended but remember that the genius exhibited in a drawing by Leonardo or Raphael was polished through a long apprenticeship and a top-ranking professional life. For contrast you could turn to the freshness and naivety of a young child's work, where the spontaneity of form and colour can provide us with just as much encouragement to bridge the gap between our perception of the human figure and our ability to draw it.

Some elementary knowledge of anatomy is ours already: we know generally how we are put together; how to move various parts of ourselves; and we know the difference between feeling tense and relaxed. With observation, practice and concentration, we are only a short distance from translating this knowledge into line and tone.

A person's drawing style is as individual as their handwriting. Allow yourself to enjoy the process of producing an image in whatever medium you choose, and let your own style emerge through it without rigidly copying someone else. It is good to study the techniques and interpretations of other artists (one very good way is to join an art class) but there is no substitute for your own response to something as infinitely fascinating as the human figure.

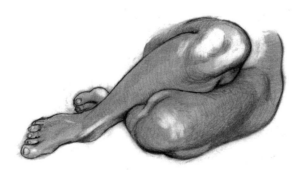

## PROPORTIONS OF CHILDREN

The proportions of children's bodies change very rapidly and, because they grow at different speeds, the drawings here can only give a general guide to children's proportions. The first thing, of course, is that the child's head is much smaller than an adult's and only achieves adult size around 16 years of age. Until then it is larger in proportion to the body.

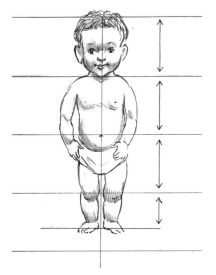

*At the beginning of life the head is much larger in proportion to the rest of the body than it will be later on. Here I have drawn a child of 18 months old, giving the sort of proportion you might find in a child of average growth. The height is only three and a half times the length of the head, which means that the proportions of the arms and legs are much smaller in comparison to those of an adult.*

*At the age of about six or seven, a child's height is a little over five times the length of the head, though again this is a bit variable. At about 12 years, the proportion is about six times the head size. Notice how in the younger children the halfway point in the height of the body is much closer to the navel, but this gradually lowers until it reaches the adult proportion at the pubic edge of the pelvis where the legs divide. What also happens is that the relative width of the body and limbs in relation to the height gradually changes: a very small child looks very chubby and round, whereas a 12-year-old can look extremely slim for their height.*

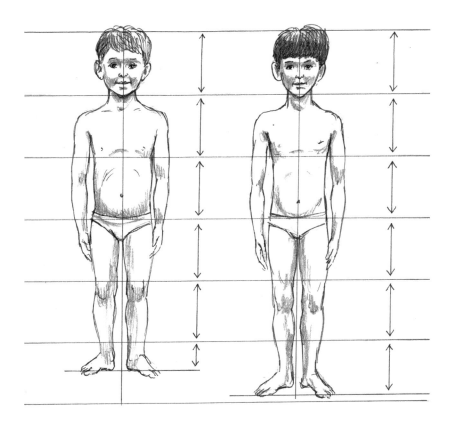

## PROPORTIONS OF THE ADULT FIGURE

Here I have a front view and a back view of the male and female body. The two sexes are drawn to the same scale because I wanted to show how their proportions are very similar in relation to the head measurement. Generally, the female body is slightly smaller and finer in structure than that of a male, but of course sizes differ so much that you will have to use your powers of observation when drawing any individual.

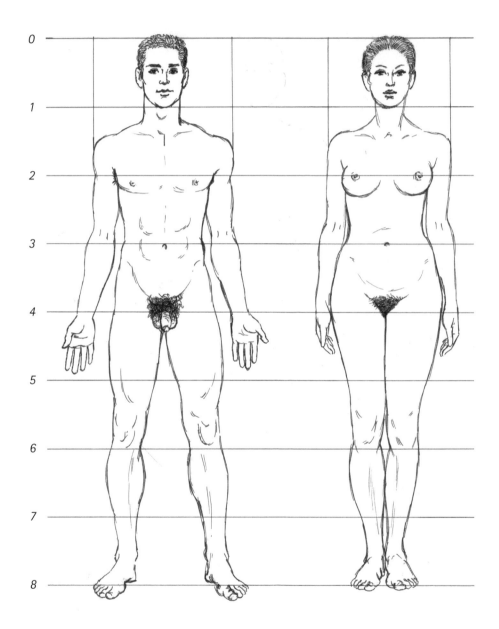

*These drawings assume the male and female are exactly the same height, with both sexes having a height of eight times the length of their head. As you can see, this means that the centre of the total height comes at the base of the pubic bone, so that the torso and head are the upper half of this measure, and the legs alone account for the lower half. Note where the other units of head length are placed: the second unit is at the armpits, the third is at the navel, the fifth mid-thigh, the sixth below the knee joint and the seventh just below the calf. This is a very useful scale to help you get started.*

*These two examples are of the back view of the two people opposite, with healthy, athletic builds. The man's shoulders are wider than the woman's and the woman's hips are wider than the man's. This is, however, a classic proportion, and in real life people are often less perfectly formed. None the less, this is a good basic guide to the shape and proportion of the human body.*

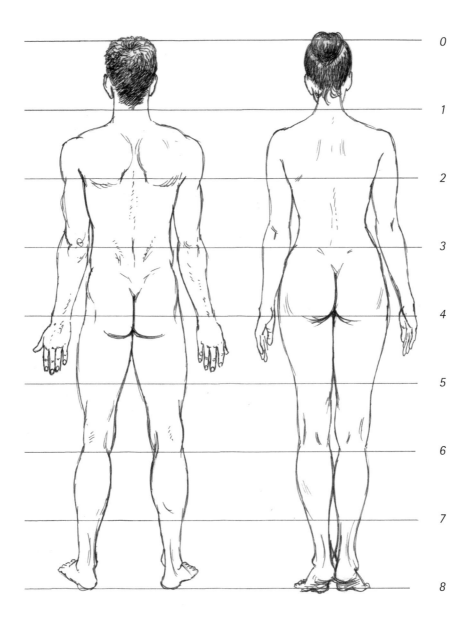

*The man's neck is thicker in relation to his head while the female neck is more slender. Notice also that the female waist is narrower than the man's, the hips are wider and the general effect of the female figure is smoother and softer than the man's. This is partly due to the extra layer of subcutaneous fat that exists in the female body.*

## THE SKELETON

Learning the names of the bones that make up the human skeleton and how they connect to each other throughout the body may seem rather a dry exercise, but they constitute the basic scaffolding that the body is built on and to have some familiarity with this element of the human frame will really help you to understand the figures you draw.

Just making the attempt to copy a skeleton, especially if you get a really close-up view of it,

Front View (Anterior)

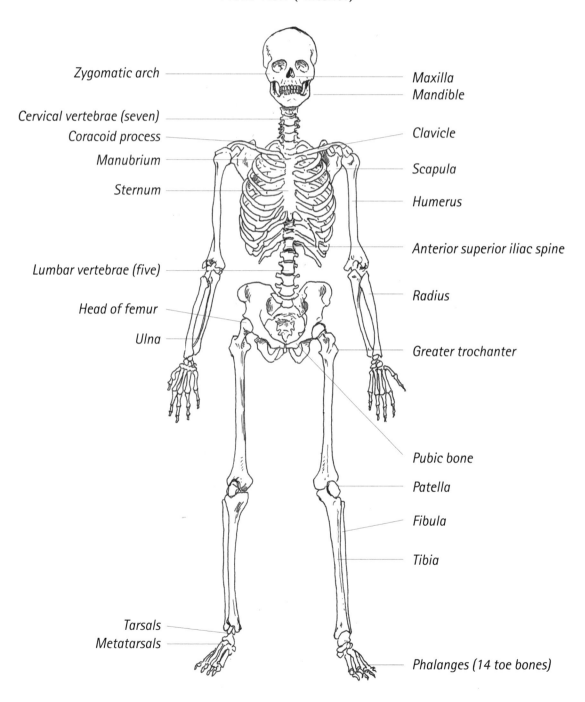

Zygomatic arch

Cervical vertebrae (seven)
Coracoid process
Manubrium
Sternum

Lumbar vertebrae (five)
Head of femur
Ulna

Tarsals
Metatarsals

Maxilla
Mandible

Clavicle

Scapula

Humerus

Anterior superior iliac spine

Radius

Greater trochanter

Pubic bone
Patella
Fibula
Tibia

Phalanges (14 toe bones)

will teach you a lot about the way the body works. It is essential that you can recognize those places where the bone structure is visible beneath the skin and by inference get some idea about the angle and form of the bones even where you can't see them. Most art schools and school science laboratories have carefully-made plastic skeletons to draw from.

Back View (Posterior)

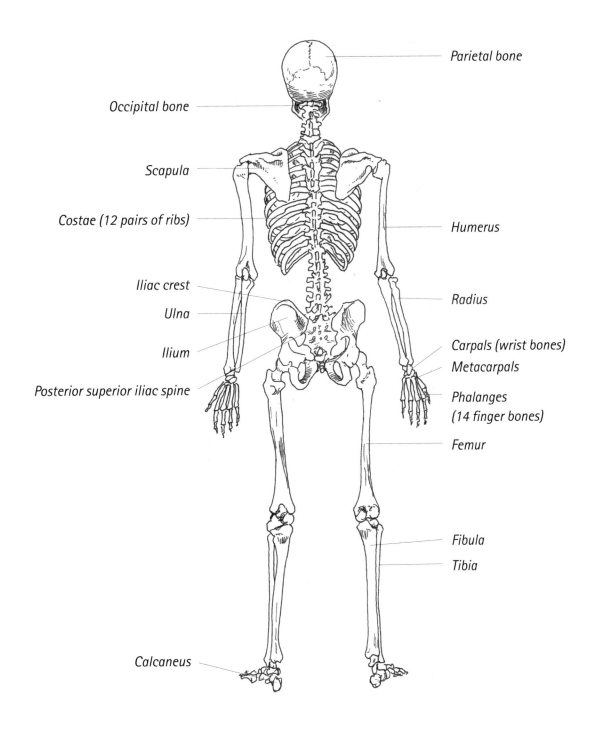

- Parietal bone
- *Occipital bone*
- *Scapula*
- *Costae (12 pairs of ribs)*
- *Humerus*
- *Iliac crest*
- *Radius*
- *Ulna*
- *Ilium*
- *Carpals (wrist bones)*
- *Metacarpals*
- *Posterior superior iliac spine*
- *Phalanges (14 finger bones)*
- *Femur*
- *Fibula*
- *Tibia*
- *Calcaneus*

## MUSCULATURE

After studying the skeleton, the next logical step is to examine the muscle system. This is more complicated, but there are many good books showing the arrangement of all the muscles and how they lie across each other and bind around the bone structure, giving us a much clearer idea of how the human body gets its shape.

As artists, our primary interest is in the structure of the muscles on the surface. There are two types of muscles that establish the main

Front View (Anterior)

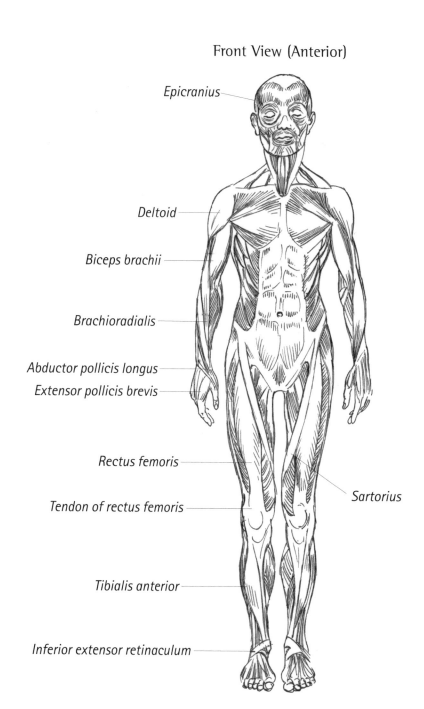

Epicranius

Deltoid

Biceps brachii

Brachioradialis

Abductor pollicis longus

Extensor pollicis brevis

Rectus femoris

Sartorius

Tendon of rectus femoris

Tibialis anterior

Inferior extensor retinaculum

shape of the body and they are either striated, or more like smooth cladding. The large muscles are the most useful ones for you to know about, and once you have familiarized yourself with these it is only really necessary to investigate the deeper muscle structures for your own interest. If you can remember the major muscles, that is good enough for the purposes of drawing figures.

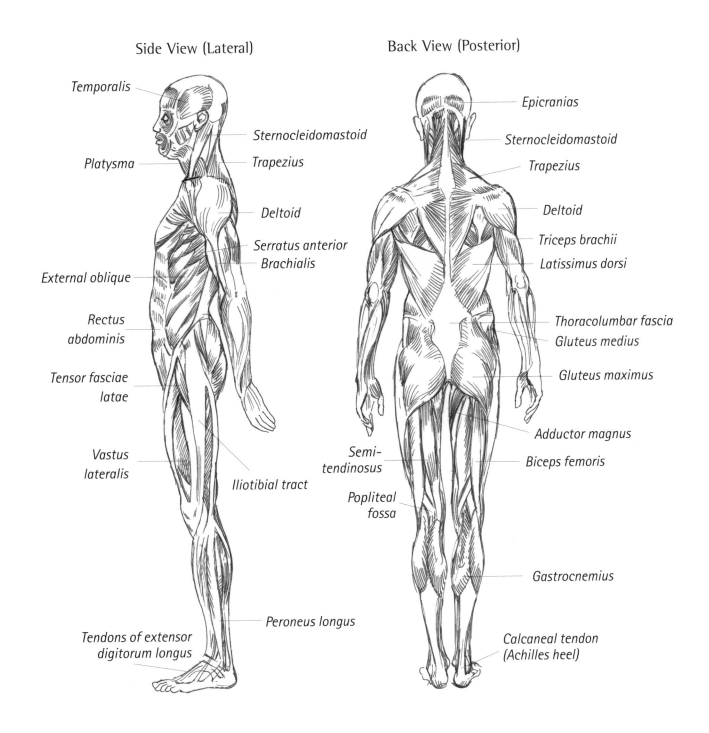

Side View (Lateral)

Temporalis

Platysma

External oblique

Rectus abdominis

Tensor fasciae latae

Vastus lateralis

Sternocleidomastoid

Trapezius

Deltoid

Serratus anterior

Brachialis

Iliotibial tract

Tendons of extensor digitorum longus

Peroneus longus

Back View (Posterior)

Epicranias

Sternocleidomastoid

Trapezius

Deltoid

Triceps brachii

Latissimus dorsi

Thoracolumbar fascia

Gluteus medius

Gluteus maximus

Adductor magnus

Biceps femoris

Semi-tendinosus

Popliteal fossa

Gastrocnemius

Calcaneal tendon (Achilles heel)

## THE MUSCLES OF THE TORSO

The drawings here show the major muscle groups, the visibility of which will depend upon the fitness of the figure you are drawing. The fashion for working out in the gym to achieve a toned body means that you should not find it too hard to find someone with a well-developed torso to pose for you so that you can make the most of the musculature shown here.

Front View

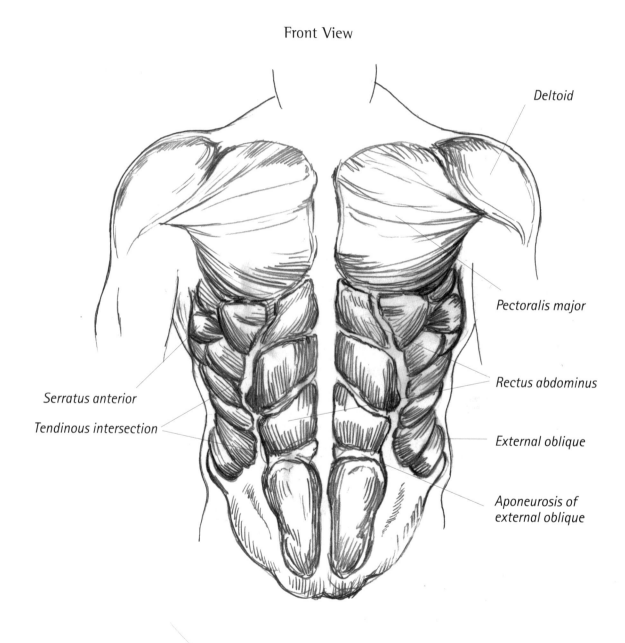

Deltoid

Pectoralis major

Rectus abdominus

Serratus anterior

Tendinous intersection

External oblique

Aponeurosis of external oblique

Back View

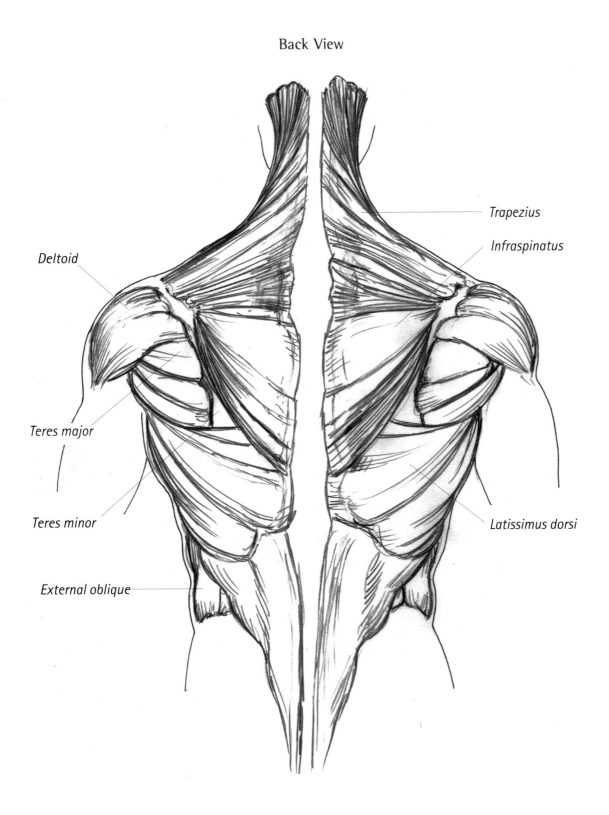

Trapezius

Infraspinatus

Deltoid

Teres major

Teres minor

Latissimus dorsi

External oblique

## THE TORSO

Male and female torsos present very different surfaces for the artist to draw. Because most men are more muscular than women, light will fall differently upon the angles and planes of the body and there will be more shadowed areas where the skin curves away from the light. The viewer will immediately understand these darker areas as showing muscular structure. In the case of the female torso, the shadowed areas are longer and smoother, because the planes of the body are not disrupted by such obvious muscle beneath the skin.

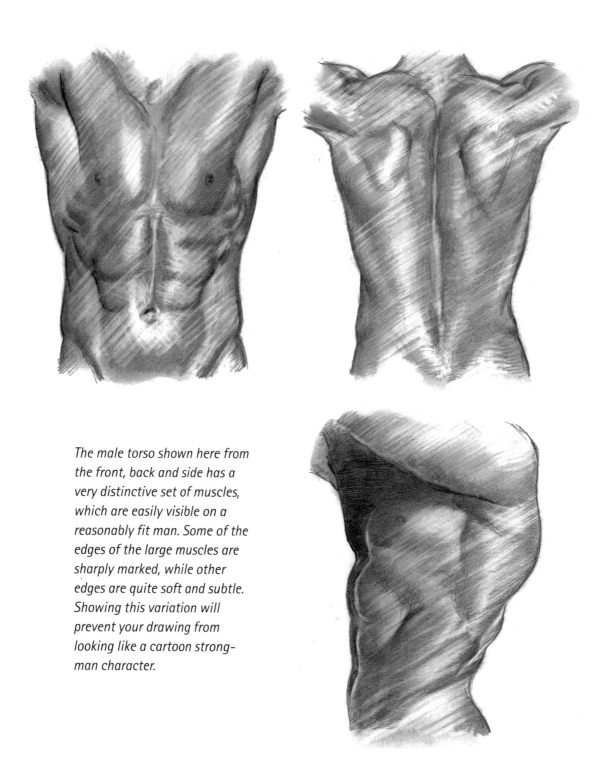

*The male torso shown here from the front, back and side has a very distinctive set of muscles, which are easily visible on a reasonably fit man. Some of the edges of the large muscles are sharply marked, while other edges are quite soft and subtle. Showing this variation will prevent your drawing from looking like a cartoon strong-man character.*

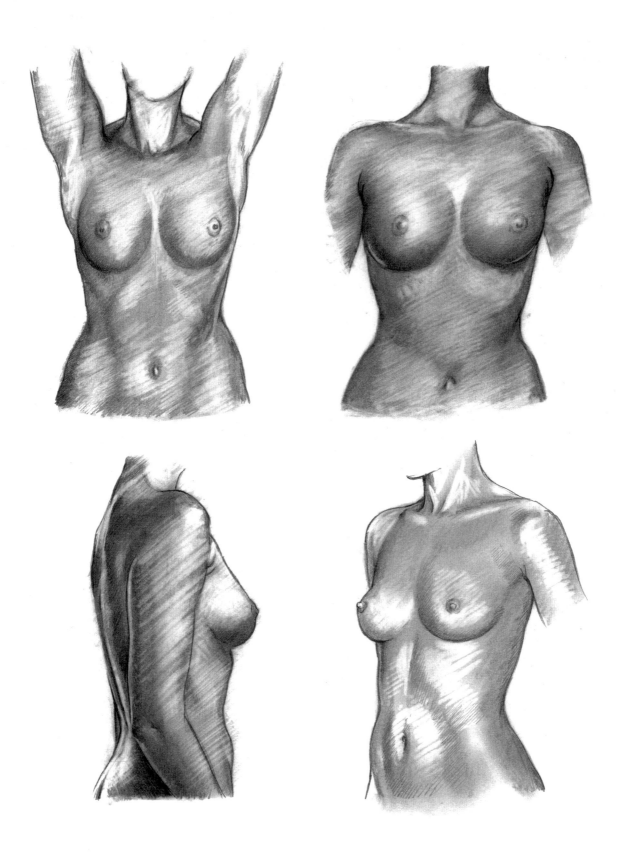

The female figure shows less of the muscle structure because of the layer of subcutaneous fat that softens all the harsh edges of the muscles. This is why women generally look rounder and softer than men do.

Here I show two classical interpretations of the human physique at its most beautiful and powerful: the first example, by the great Renaissance artist Michelangelo, shows the torso of Adam, the first man; and the second, the body of the goddess Venus, is a Roman copy of a Greek original.

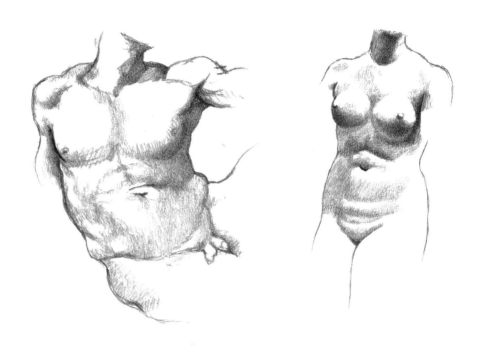

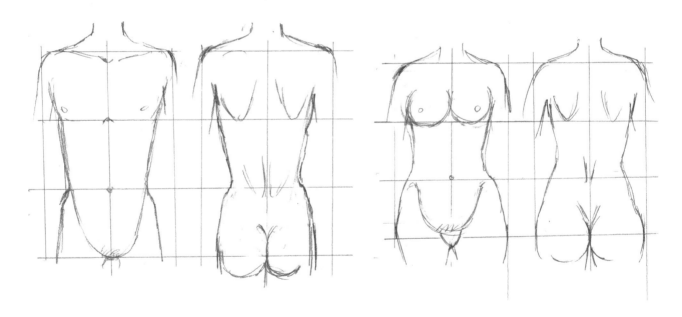

These diagrams of the male and female torso show their proportions. The central vertical line is divided horizontally by four lines which denote, from top to bottom, the top edge of the clavicles (collar bones), the lower end of the sternum, the level of the navel and the lower edge of the pubic bone. Seen from the back, the same lines mark the top of the clavicles, the lower edge of the shoulder blades, the small of the back at the level of the navel, and the base of the sacrum of the iliac. The latter is hidden by the fleshy part of the buttocks. The female proportions are the same, but generally on a slightly smaller scale. The main difference is the widest point, which on the man is invariably the shoulders and on the woman may be the hips instead. The divisions are all one head length apart from each other, so there is a proportion of about three head lengths to the torso.

*The side views indicate the other differences between male and female torsos.*

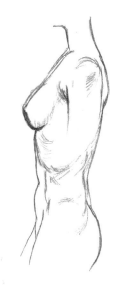
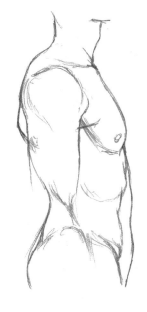

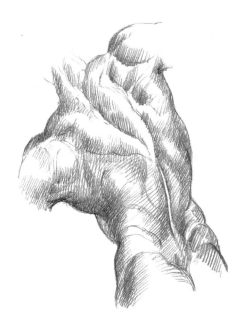

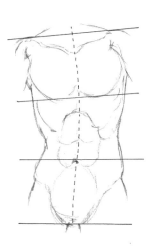

*This detailed drawing of the back of a male torso shows the disposition of the muscles, and a diagram of what happens to these divisions when the body bends.*

*The female back view shows a smoother-looking figure because a woman's muscles are usually less pronounced than a man's and this produces more harmonious, gentle changes from plane to plane. When looking at the divisions from the back, notice the curving of the spine, which can change the proportion of the torso.*

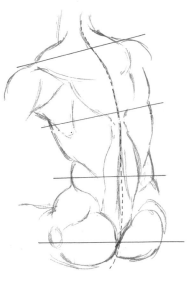
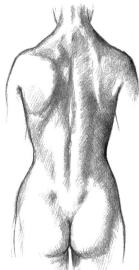

## ANATOMY OF THE HAND, ARM AND SHOULDER

**Forearm and Hand Bone Structure**

Humerus

Head of ulna

Medial epicondyle

Shaft of ulna

Shaft of radius

Styloid process of radius

Radial tuberosity

Carpal bones (eight)

Capitate

Triangular

Pisiform

Base

Fifth metacarpal

Phalanges (14)

**Forearm and Hand Musculature**

Brachialis

Tendon of triceps brachii

Lateral epicondyle

Brachioradialis

Olecranon

Extensor carpi ulnaris

Anconeus

Extensor carpi radialis brevis

Extensor digitorum communis

Tendon of extensor pollicis longus

Extensor pollicis brevis

Extensor retinaculum

Extensor digiti minimi

Adductor pollicis longus

First dorsal interosseous muscle

## Shoulder and Upper Arm Bone Structure

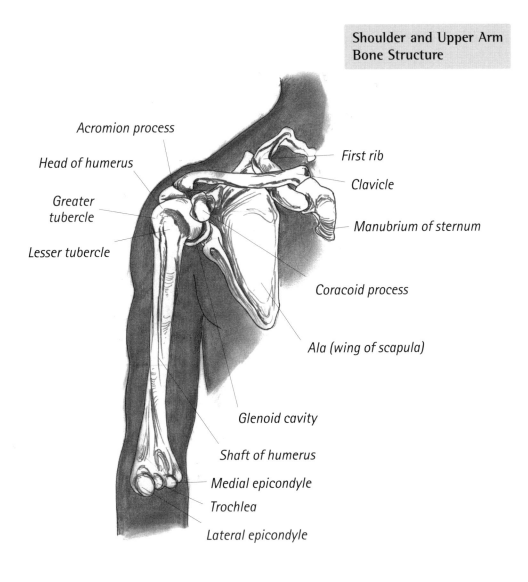

Acromion process

Head of humerus

Greater tubercle

Lesser tubercle

First rib

Clavicle

Manubrium of sternum

Coracoid process

Ala (wing of scapula)

Glenoid cavity

Shaft of humerus

Medial epicondyle

Trochlea

Lateral epicondyle

## Musculature of Shoulder and Upper Arm

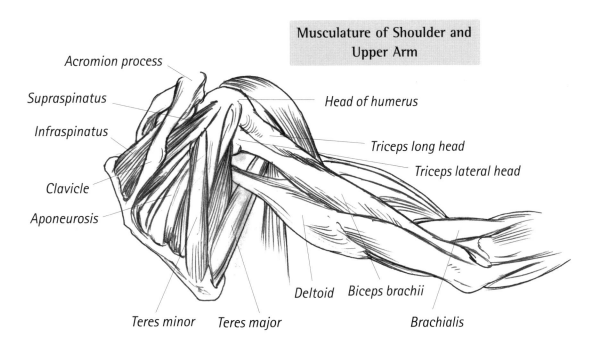

Acromion process

Supraspinatus

Infraspinatus

Clavicle

Aponeurosis

Head of humerus

Triceps long head

Triceps lateral head

Teres minor

Teres major

Deltoid

Biceps brachii

Brachialis

## ARMS AND HANDS

The narrowness of the limb makes the musculature much more obvious than in the torso, and at the shoulder, elbow and wrist it is even possible to see the end of the skeletal structure. This tendency of bone and muscle structure to diminish in size as it moves away from the centre of the body is something that should inform your drawings. Fingers and thumbs are narrower than wrists; wrists are narrower than elbows; elbows narrower than shoulders: a surprisingly large number of students draw them the opposite way round. As always, it is a matter of observing carefully and drawing what you actually see before you.

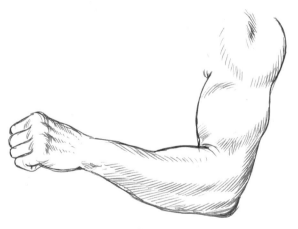

*In these examples, notice how when the arm is under tension in the act of grasping an object or bearing weight, the muscles stand out and their tendons show clearly at the inner wrist. When the arm is bent the larger muscles in the upper arm show themselves more clearly and the shoulder muscles and shoulder blades are more defined.*

## HANDS

Many people find hands difficult to draw. You will never lack a model here as you can simply draw your own free hand, so keep practising and study it from as many different angles as possible. The arrangement of the fingers and thumb into a fist or a hand with the fingers relaxed and open create very different shapes and it is useful to draw these constantly to get the feel of how they look. There is inevitably a lot of foreshortening in the palm and fingers when the hand is angled towards you or away from your sight.

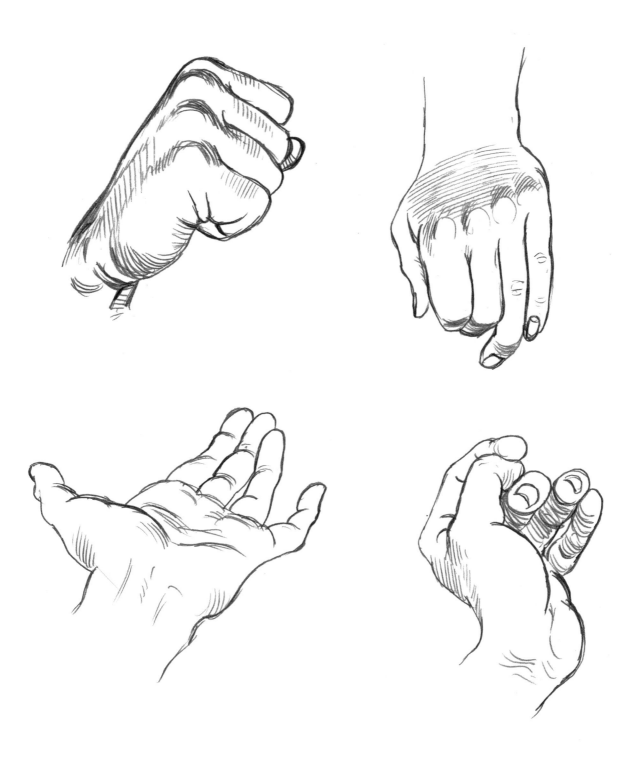

## ANATOMY OF THE UPPER LEG

The upper part of the leg is similar to the upper arm in that the bone that supports it is single and very large; in the case of the leg it is the largest in the body, and the muscles are large and long in shape. The hip area is defined by the pelvis, the upper edges of which can usually be seen above the hip bones. One of the longest muscles is the sartorius, which stretches from the upper pelvis to below the knee joint.

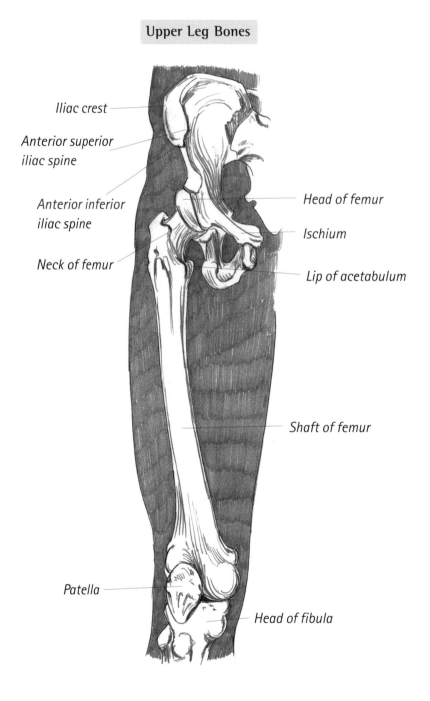

**Upper Leg Bones**

*Iliac crest*

*Anterior superior iliac spine*

*Anterior inferior iliac spine*

*Neck of femur*

*Head of femur*

*Ischium*

*Lip of acetabulum*

*Shaft of femur*

*Patella*

*Head of fibula*

## Front Upper Leg Muscles

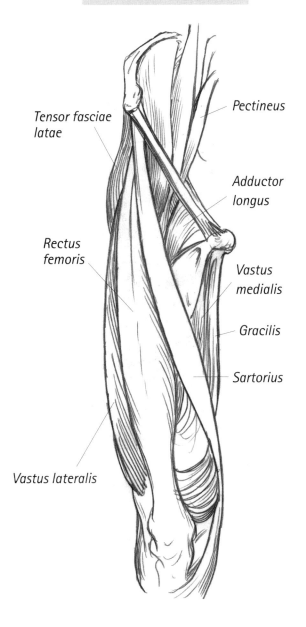

Tensor fasciae latae

Pectineus

Adductor longus

Rectus femoris

Vastus medialis

Gracilis

Sartorius

Vastus lateralis

## Back Upper Leg Muscles

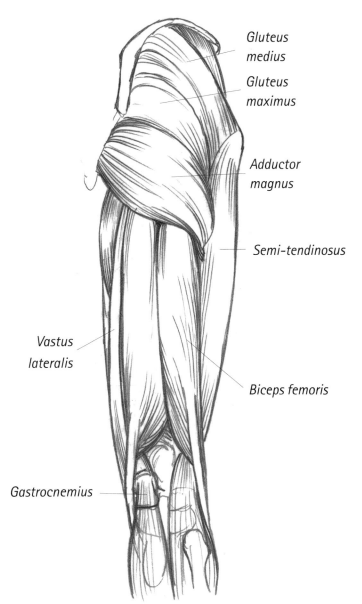

Gluteus medius

Gluteus maximus

Adductor magnus

Semi-tendinosus

Vastus lateralis

Biceps femoris

Gastrocnemius

99

## ANATOMY OF THE LOWER LEG AND FOOT

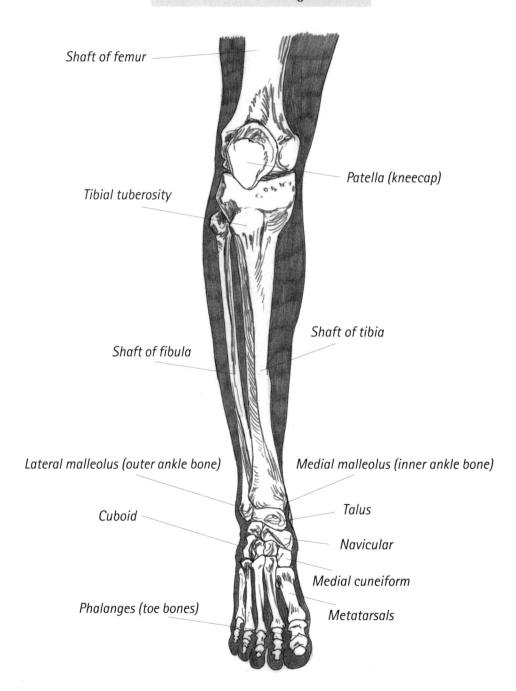

Bones of the Lower Leg and Foot

Shaft of femur

Patella (kneecap)

Tibial tuberosity

Shaft of tibia

Shaft of fibula

Lateral malleolus (outer ankle bone)

Medial malleolus (inner ankle bone)

Cuboid

Talus

Navicular

Medial cuneiform

Phalanges (toe bones)

Metatarsals

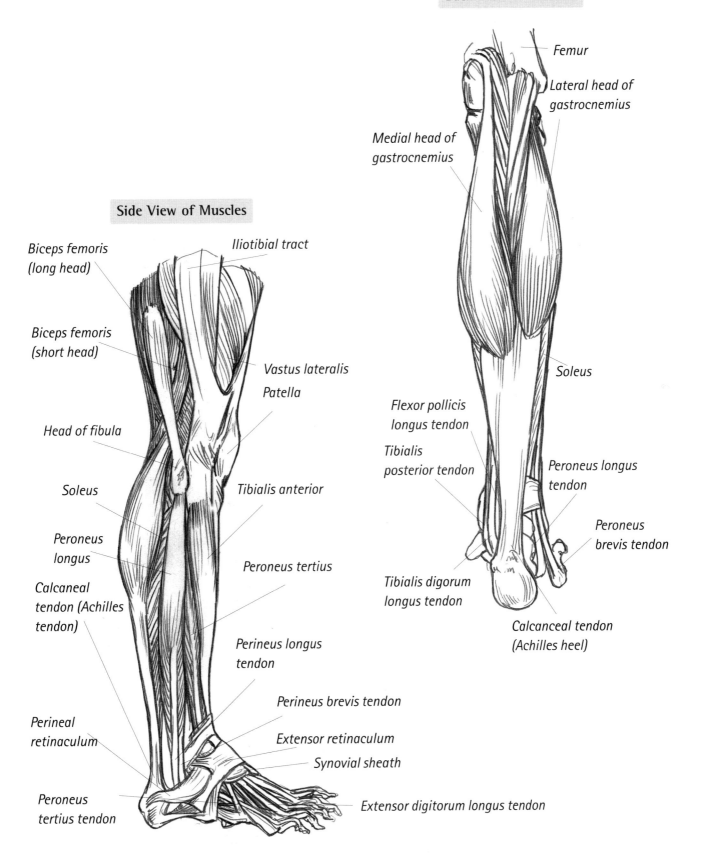

**Back View of Muscles**

Femur

Lateral head of gastrocnemius

Medial head of gastrocnemius

Soleus

Flexor pollicis longus tendon

Tibialis posterior tendon

Peroneus longus tendon

Peroneus brevis tendon

Tibialis digorum longus tendon

Calcanceal tendon (Achilles heel)

**Side View of Muscles**

Biceps femoris (long head)

Iliotibial tract

Biceps femoris (short head)

Vastus lateralis

Patella

Head of fibula

Soleus

Tibialis anterior

Peroneus longus

Peroneus tertius

Calcaneal tendon (Achilles tendon)

Perineus longus tendon

Perineus brevis tendon

Perineal retinaculum

Extensor retinaculum

Synovial sheath

Peroneus tertius tendon

Extensor digitorum longus tendon

## LEGS

The back view of the legs shows the interesting reverse of the knee joint and looks quite round and smooth, particularly in the female form.

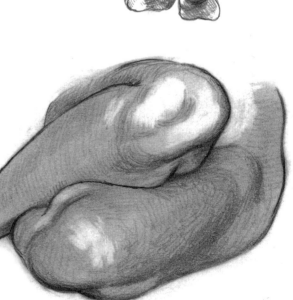

*The legs when bent show the distinctive effect that this has on the knee joint, emphasizing the flat area of the kneecap. A foreshortened view of the legs produces all sorts of interesting views of the larger muscles, which are less well defined.*

## FEET

The bone structure of the foot is quite elegant, producing a slender arch over which muscles and tendons are stretched.

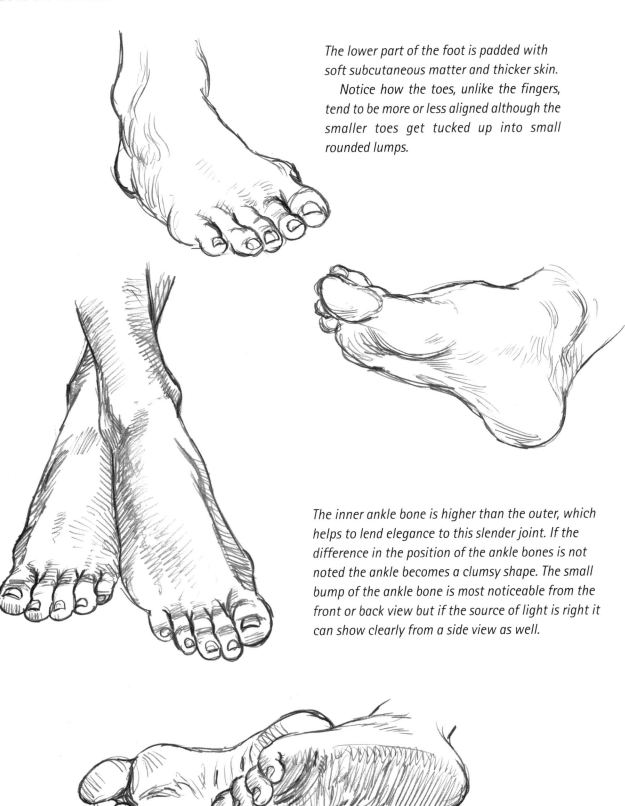

*The lower part of the foot is padded with soft subcutaneous matter and thicker skin.*

*Notice how the toes, unlike the fingers, tend to be more or less aligned although the smaller toes get tucked up into small rounded lumps.*

*The inner ankle bone is higher than the outer, which helps to lend elegance to this slender joint. If the difference in the position of the ankle bones is not noted the ankle becomes a clumsy shape. The small bump of the ankle bone is most noticeable from the front or back view but if the source of light is right it can show clearly from a side view as well.*

## BASIC STAGES OF DRAWING A FIGURE

For a beginner first embarking on drawing the whole figure, the tendency is to become rather tense about the enormity of the task. The presence of a real live model, as opposed to a still-life object, can make you feel not only that your work may be judged and found wanting by your subject, but also by the life class you are in and also that you perhaps cannot work at your leisure.

To begin with, just think in terms of simple shapes rather than visualizing a finished drawing that you feel you are not capable of achieving. You can stop your drawing at any stage – there is no need to feel that you have to press on to a conclusion that you are not ready for. Starting very simply, for example with a seated male figure, there are some easy ways to work your way into the task of drawing it.

*The first stage is to see the basic shape that the disposition of the body and limbs make in the simplest geometric way. This figure is sitting with one knee up, leaning on the lower knee with the elbow of one arm. This produces a triangular shape between the torso and head and the arm and lower leg. Set against that is the additional triangle of the bent leg, which creates another triangular shape cutting into the first. With very simple lines, sketch in the position and proportion of the shapes.*

*The next stage is to make the shape more solid by drawing curved outlines around each limb and the head and torso. I have left out the original lines of the above drawing so that you can see how much there is to draw in this stage. This drawing needs to be done quite carefully as it sets the whole shape for the finished piece of work.*

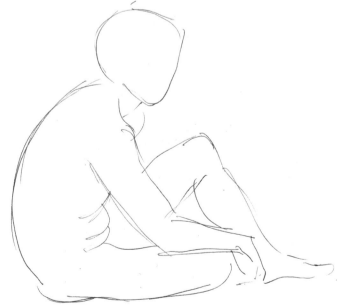

The next step is to block in the changes in the planes of the surface as suggested by the light and shade on the body. This process needs only to be a series of outlines of areas of shadow and light. At the same time, begin to carefully define the shapes of the muscles and bone structure by refining your second outline shape, adding subtleties and details. Now you have a good working drawing that has every part in the right place and every area of light and shade indicated.

At this stage you will want to do quite a bit of correcting to make your shapes resemble your model. Take your time and work as accurately as you can, until you see a very similar arrangement of shapes when you look from your drawing to the model.

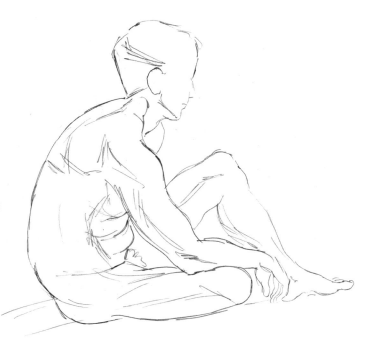

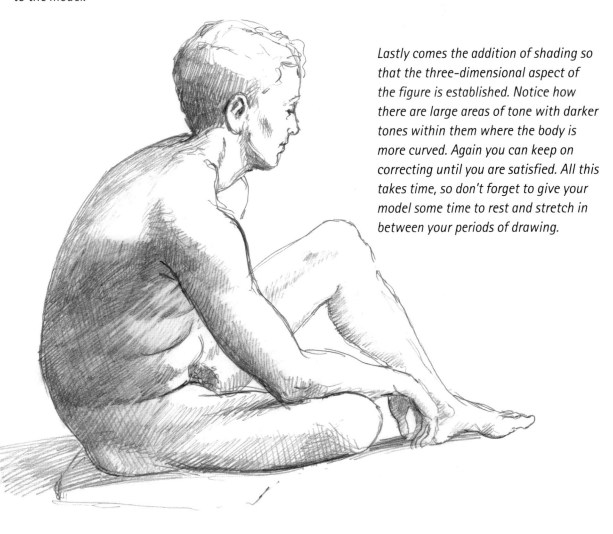

Lastly comes the addition of shading so that the three-dimensional aspect of the figure is established. Notice how there are large areas of tone with darker tones within them where the body is more curved. Again you can keep on correcting until you are satisfied. All this takes time, so don't forget to give your model some time to rest and stretch in between your periods of drawing.

## FIGURES IN PERSPECTIVE

Once you feel confident with the early stages of getting figures down on paper, you are ready to tackle the bigger challenge of seeing the figure in perspective where the limbs and torso are foreshortened and do not look at all like the human body in conventional pose.

To examine this at its most exaggerated, the model should be lying down on the ground or a low platform or bed. Position yourself so that you are looking from one end of the body along its length and you will have a view of the human figure in which the usual proportions are all changed. Because of the laws of perspective, the parts nearest to you will look much larger than the parts farther away.

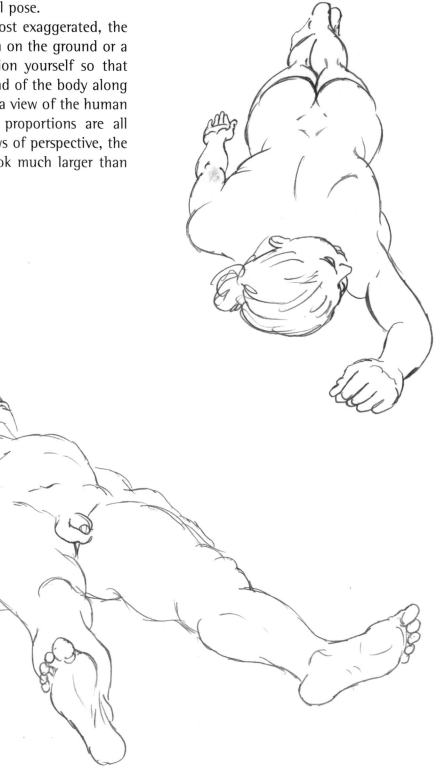

## CHANGING ENDS

Standing at the head end, you will find that everything has to be reassessed. This time the head is very large but you see just the top of it and the shoulders and chest or shoulder blades.

*As the eye travels down towards the legs, the most noticeable thing is how short they look from this angle. The feet may stick up if the model is on his or her back, but the legs themselves are just a series of bumps of thighs, knees and calves.*

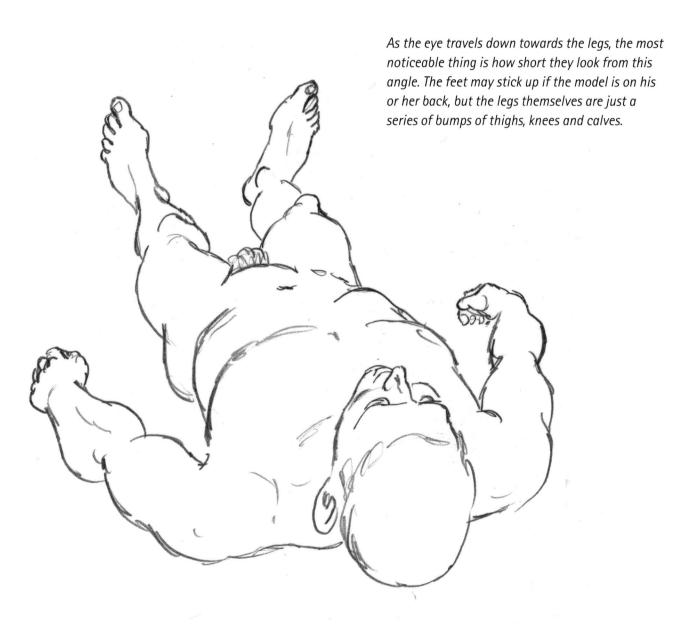

*Try measuring the difference between the legs and the torso and you will find that although you know the legs are really half the length of the whole figure, from this angle they are more like a quarter of the full length. Not only that, the widths of the shoulders and hips are vastly exaggerated so that the body looks very* short in relation to its width. Most students new to this view of the figure draw it far too long for its width because they have in mind the proportions of the standing figure. Make sure you observe the figure carefully to avoid this.

## EXPRESSING VOLUME

Expressing the volume of the figure will make your drawings convincingly solid. You can make a small figure appear weighty by blocking in areas of tone, a technique used by artists when the drawing is to be painted, as it clarifies how the areas of tone and colour should be painted. Contour lines also emphasize the roundness of the head and body.

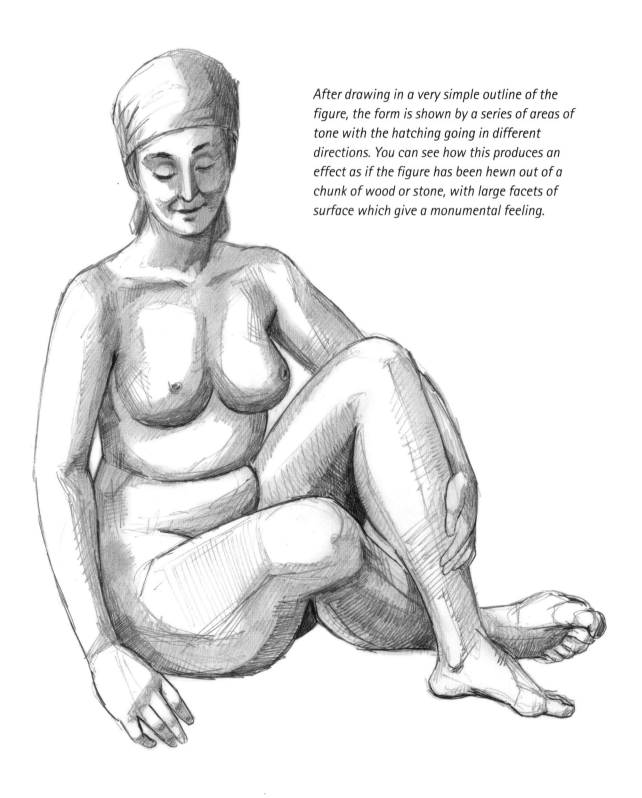

*After drawing in a very simple outline of the figure, the form is shown by a series of areas of tone with the hatching going in different directions. You can see how this produces an effect as if the figure has been hewn out of a chunk of wood or stone, with large facets of surface which give a monumental feeling.*

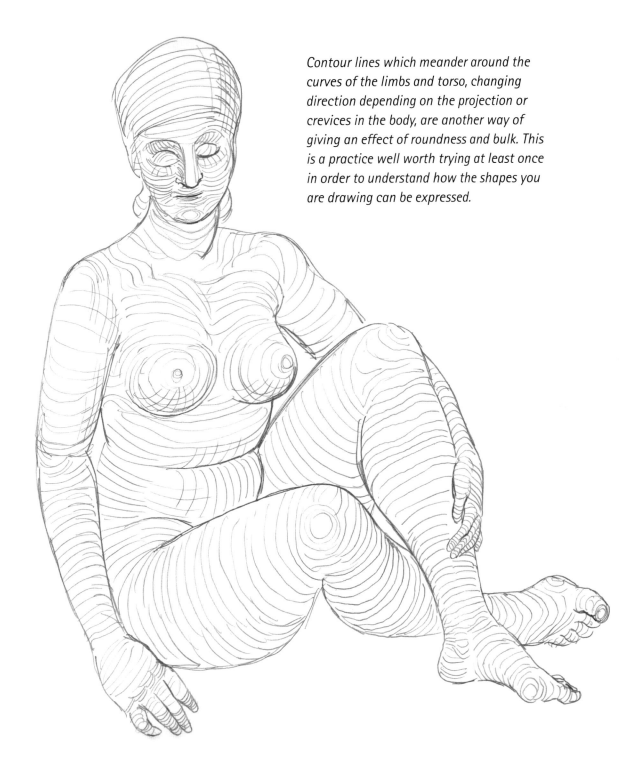

Contour lines which meander around the curves of the limbs and torso, changing direction depending on the projection or crevices in the body, are another way of giving an effect of roundness and bulk. This is a practice well worth trying at least once in order to understand how the shapes you are drawing can be expressed.

## HARD AND SOFT LINES

Even in a line drawing with no attempt at tone you can influence the way the viewer will see and understand your figure. Producing a hard, definite line requires a steadier nerve on the part of the artist than a softer, more tentative line, but both are an equally valid way of describing the human form and lending feeling to the image.

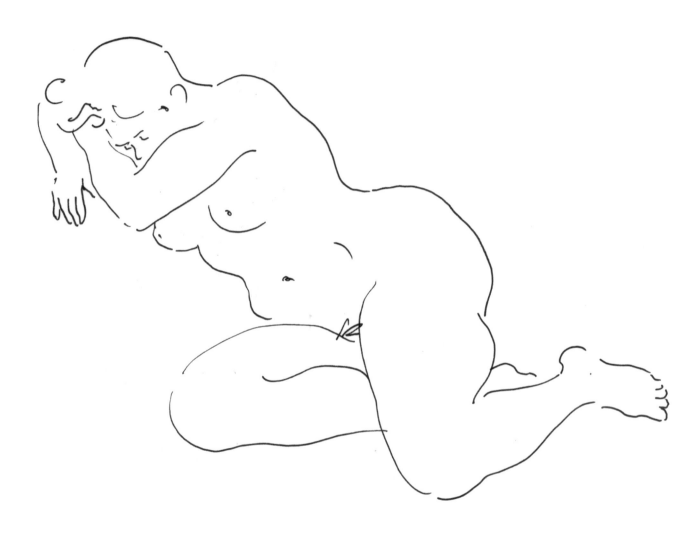

*A harder and very confident way of producing the form of the body is to go for absolute minimum line. You will have to make up your mind about a whole passage of the figure and then, as simply and accurately as you can, draw a strong, clear line without any corrections to produce a vigorous, clearly defined outline shape. Only the very least detail should be shown, just enough to give the effect of the human figure you see in front of you. This requires a bold approach and either works first go or not, but of course you can have as many shots at it as you have time for. It really teaches economy of both line and effect and also makes you look very carefully at the figure.*

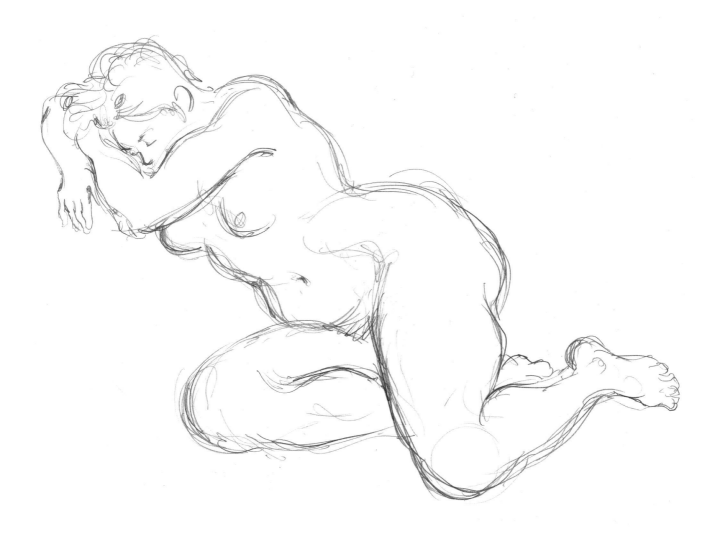

Allowing your pencil or pen to loosely follow the model's form in such a way that you produce a mass of weaving lines around the main shapes helps to express the softness and fluidity of the figure. This allows you to gradually discover the shape by a series of loosely felt lines that don't pin you down too tightly. What it loses in sharpness it gains in movement and flow of form.

## MAPPING THE BODY

A more gradual and time-consuming approach, which many artists have used, is to decide exactly where each point of the figure appears to be in relation to all the other points around the figure from your viewpoint. Thus a mark is made, for example, at the top of the head; then, very carefully, another mark at the back of the head, then the point where the eyes are, all in relation one to another. It is a very time-consuming method but most artists who use it are assured of producing very accurate renderings of the forms in front of them.

Conversely, you can map the body very fast with scribbles that delineate the form quite accurately but without much detail. Experiment as to which technique suits you best.

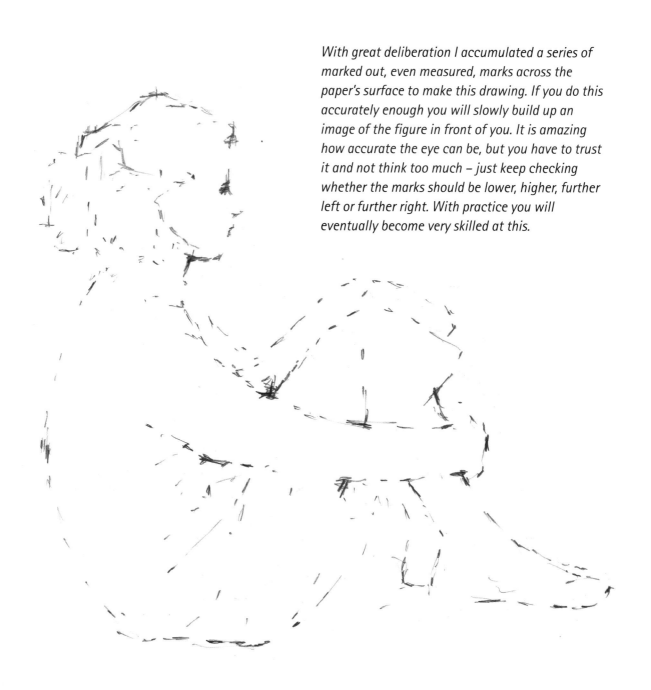

*With great deliberation I accumulated a series of marked out, even measured, marks across the paper's surface to make this drawing. If you do this accurately enough you will slowly build up an image of the figure in front of you. It is amazing how accurate the eye can be, but you have to trust it and not think too much – just keep checking whether the marks should be lower, higher, further left or further right. With practice you will eventually become very skilled at this.*

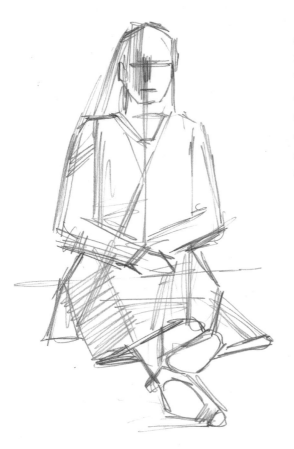

*A quicker way is to use geometric marks to define the shape and proportion of the figure in front of you in very simple and basic strokes. No details are necessary for this method until all your main strokes are put in to your satisfaction. You will build up the marks and textures quite fast and sometimes you will have to rub out some marks to put in greater detail, but it does teach you to sum up shapes quickly.*

*A fast way that can work very well if you are sketching people who are in motion is to draw with a scribble technique, hardly taking your pencil off the paper while you scrawl in marks that give some idea of the form in front of you without going into too much detail. What these drawings lack in details they often gain in vigour and liveliness.*

## THE DRAPED FIGURE

With a draped figure the artist has to look for the points that help to reveal the shape of the figure. Although it may be entirely hidden by opaque fabric, the arrangement of the fabric can still inform you of the form beneath. Notice what happens to the cloth as it drapes across the figure and the effect of the weight of the cloth on its folds.

*This figure draped with a soft woollen-type cloth has many points that give clues about the proportions of the body. (1) and (2) are the points where the main weight of the material is hanging over the shoulders and so the angle and width of the shoulders are easily seen.*
*The model has her weight mainly on her right leg, which has the effect of producing a contra-posto position where as the hip on one side is pushed up, the shoulder on the other side is also raised. Consequently, in this case the model's left shoulder is higher than the right. This also means that the right hip is thrust further forward than the left hip and the arm resting on the hip pushes out the material on that side (point 4). The model's right breast also pushes out the cloth, albeit more softly (point 3). On the other side, at point 5, the bent elbow of the arm which is raised to grip the material as it is draped around the neck also creates a pushed-out fold. The bent left leg of the model catches the long fold as it drapes around the body at the knee (point 6). Then the weight of the cloth produces folds around the feet where it touches the ground on either side of the toes, which protrude beyond the hem of the material.*

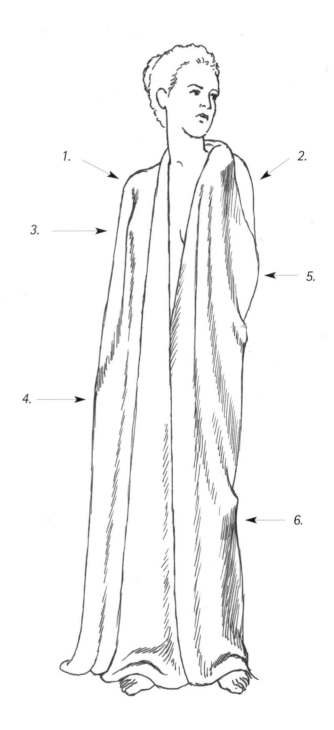

*Looking at the second figure with its shaded area showing the outline of the figure under the cloth, it is easy to see how the weight and downward pull of the material creates the heavier folds at points (7), (8) and (9).*

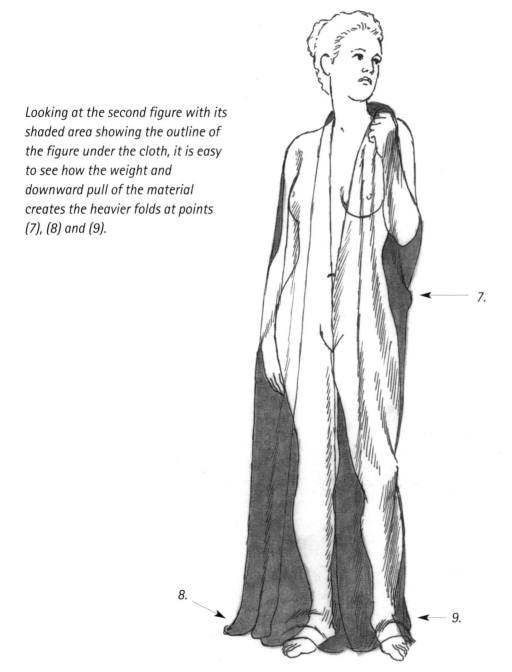

7.

8.

9.

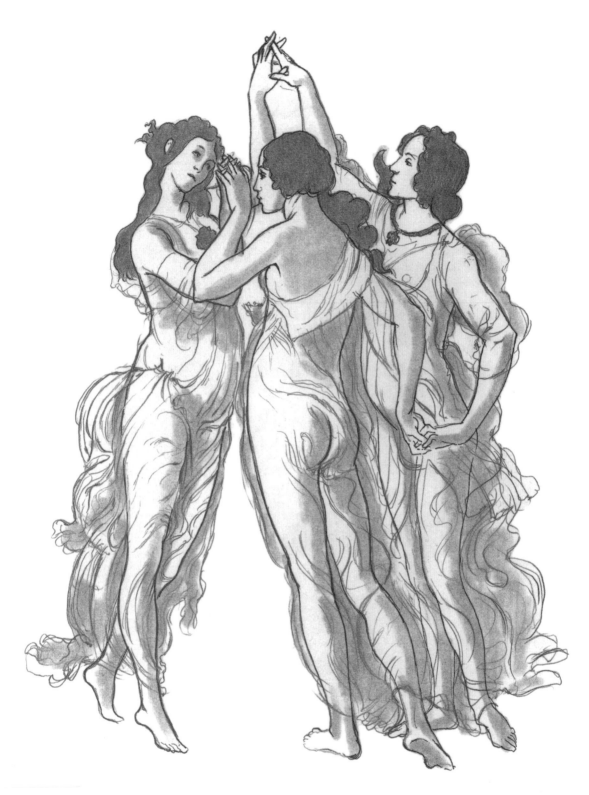

This famous trio of Graces from Botticelli's Primavera *shows a variant on the clothing where, instead of hiding the limbs, the flimsy chiffon-like garments show quite clearly the shape of the body. I have simplified the picture by making the hair one tone and outlining the figures in black. The folds of* the robes are drawn in very lightly, as they are in the painting. A good reproduction of this will give you a better idea of the subtlety of the concept, but the drawing here does give some idea of the way the fine folds float around the limbs and are formed by their substance.

The drawing from a Greek statue (4th century BC) shows how the folds of cloth drape down from the head to the neck and then around the shoulders and back. You can see how the bent arm pulls the folds across the body.

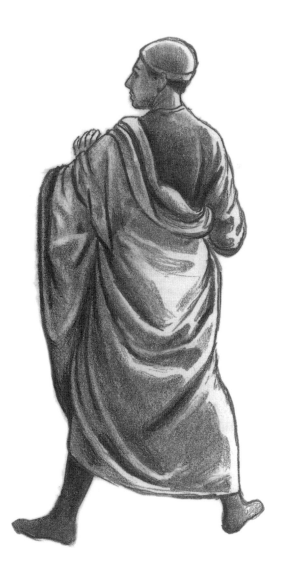

The man from Ghirlandaio's Stories of the Virgin *fresco is a much more substantial piece of materiality, the heavy, probably woollen, cloak hanging in large solid folds that swing from side to side across the stalwart figure of the man. It is easy to conceive of the three-dimensional figure under the substantial material.*

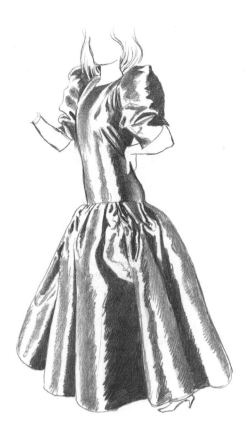

The stiff taffeta dress shows only the upper part of the body, but this is almost reduced to a tube shape. The skirt is so bouffant that it could disguise anything underneath and the only clue to the legs would be where the feet might be seen.

With the shirt and trousers, the lateral folds give a clear indication of the fairly bony arms under the shirtsleeves while the loose flopping folds of the lower part of the trousers define the knee. The thigh is shown because the leg is bent and the trouser is stretched across its muscles.

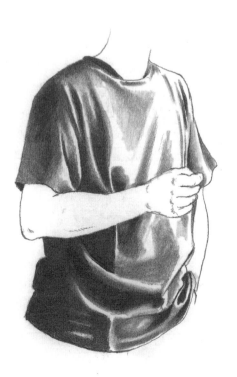

The garment here has very obvious materiality, part disguising and part revealing the shape underneath. The T-shirt shape is loose and floppy, and the solidity of the shoulders and chest is obvious. The way the folds hang down around the lower part of the torso leaves very little to go on to accurately describe the figure beneath. The only noticeable feature is the slight curve of the shirt around the hips.

The graphic painting style of Toulouse-Lautrec gives a clear understanding of the creases and folds in the girl's thin cotton petticoat, drawn with the minimum of modelling but expressing very clearly the solidity of the body under the garment.

Lucian Freud's curled-up sleeping figure with its cotton dressing gown wrapped closely around it also gives a very unvarnished vision of the bulk of the body under the soft towelling material. The cluster of small, almost angular folds behind the back of the legs contrasts well with the pulled-out areas across the haunch and back, which again contrast with the cinched-in folds at the waist. This is a well-drawn way of depicting the modelling of the body disguised by the wrappings of clothing.

## DESCRIBING AND DISGUISING

These two pages contrast how the human body can be represented quite graphically by the way the form is dressed or, at the opposite extreme, disguised to appear very different from its real form. The use of clothing to portray or distort the figure has been noticeable throughout history, with costume moving from one extreme to the other over the centuries.

*In this example the artist Otto Greiner dressed his model in such a way as to show clearly how the female figure looks wrapped in thin cloth which accentuates the shape. The lateral wrinkles and folds pulled tightly around the body give a very sharply defined idea of the contours of the torso, while the softer, larger folds of the cloth around the legs show their position but simplify them into a larger geometric shape so that the legs form the edges of the planes of cloth.*

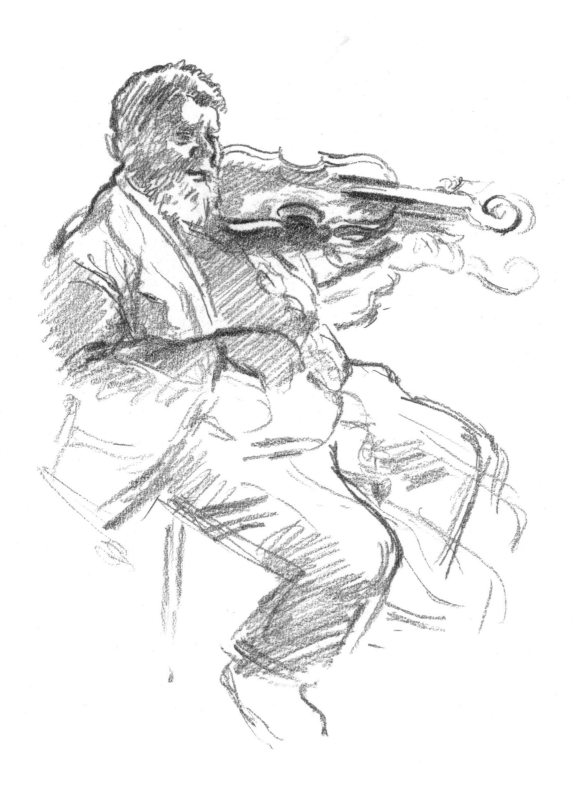

*Despite the sketchy nature of this charcoal study after Degas, we gain an immediate idea of the bulk of the violinist enveloped in his sturdy 19th-century suit. Although the suit is cut to hide the figure, the solidity of the man is not hidden from us; the rounded quality of the sleeves and legs of the garments and the generous protuberance in front make it very obvious that the clothing is covering a sizeable body.*

## MAKING QUICK SKETCHES

One of the best ways to draw figures without worrying about the results is to take your sketchbook to a busy event in the summer where people are enjoying their leisure time. You will see all sorts of characters, both stationary and in motion, and if they are engrossed in their doings you will not feel self-conscious about sketching them.

Draw in as few lines as you possibly can, leaving out all details. Use a thick, soft pencil to give least resistance between paper and drawing medium and don't bother about correcting errors. Keep drawing almost without stopping. The drawings will gradually improve and what they will lack in significant detail they will gain in fluidity and essential form. Only draw the shapes that grab the eye. Don't make choices; just see what your eye picks up quickly and what your hand can do to translate this vision into simple shapes. This sort of drawing is never a waste of time and sometimes the quick sketches have a very lively, attractive quality.

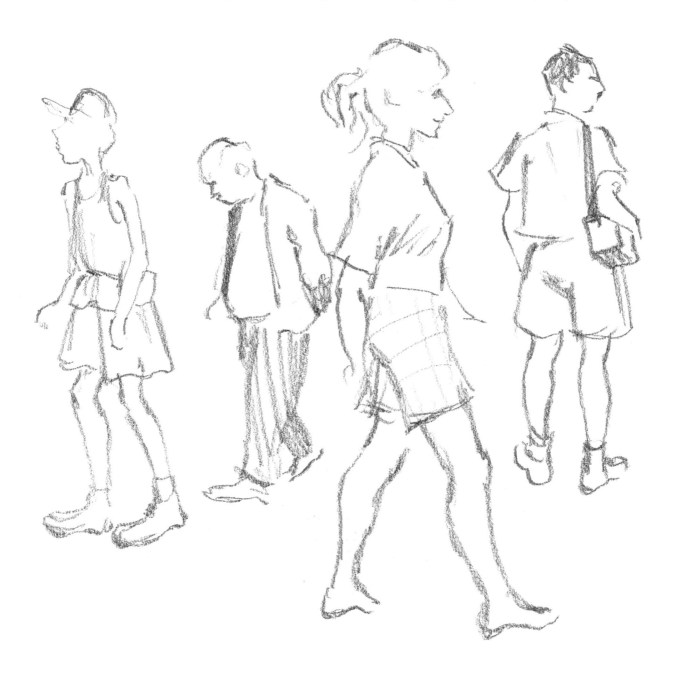

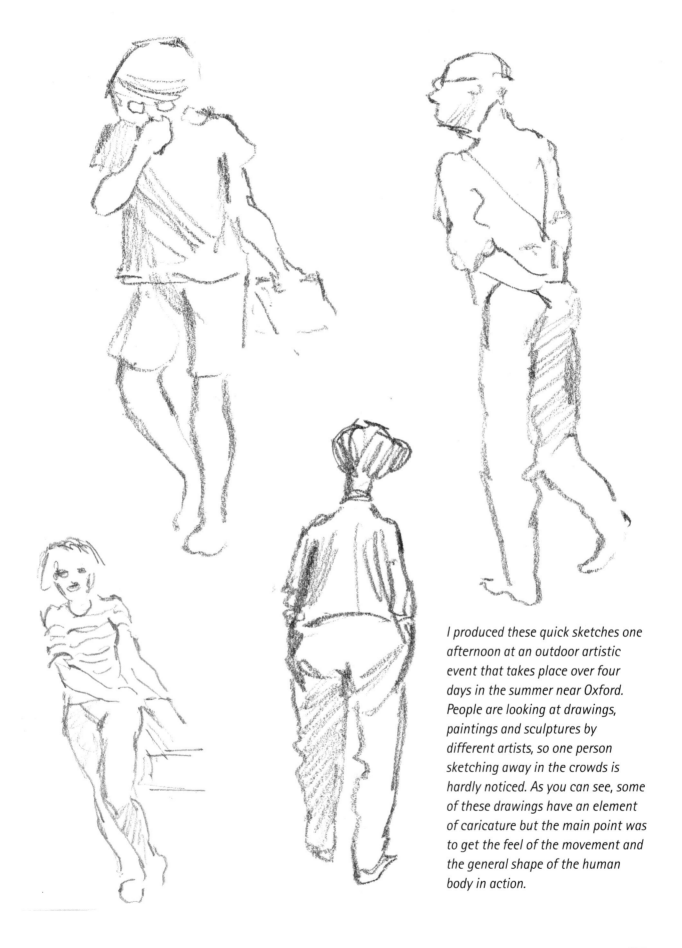

I produced these quick sketches one afternoon at an outdoor artistic event that takes place over four days in the summer near Oxford. People are looking at drawings, paintings and sculptures by different artists, so one person sketching away in the crowds is hardly noticed. As you can see, some of these drawings have an element of caricature but the main point was to get the feel of the movement and the general shape of the human body in action.

## LIFE DRAWING CLASSES

Drawing from life is a major aspect of all drawing and this is particularly so in the case of figure drawing. The human body is the most subtle and difficult thing to draw and you will learn more from a few lessons in front of a nude model than you ever could when drawing from photographs.

In most urban areas, life classes are not too difficult to come by and if there is an adult education college or an art school that offers part-time courses it would be an excellent way in which to improve your drawing. Even professional artists will attend life classes whenever possible, unless they can afford their own models. These classes are however limited to people over the age of 16 because of the presence of a nude model.

One advantage is that there is usually a highly qualified artist teaching the course. The dedication and helpfulness of most of these teachers will enable you to gradually improve your drawing step by step, and the additional advantage of working with other students, from beginners to quite skilful practitioners, will encourage your work.

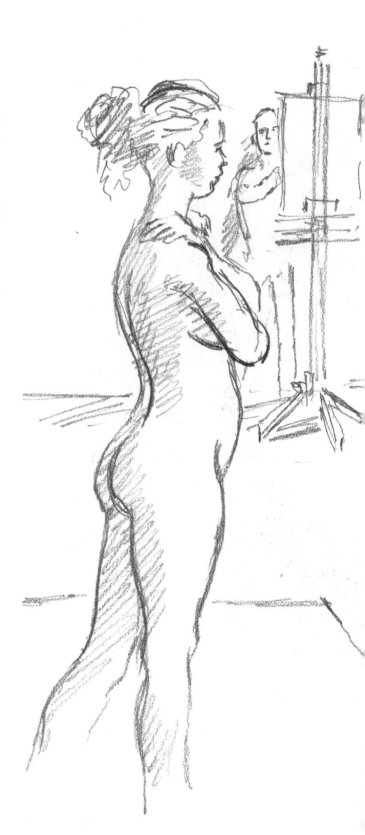

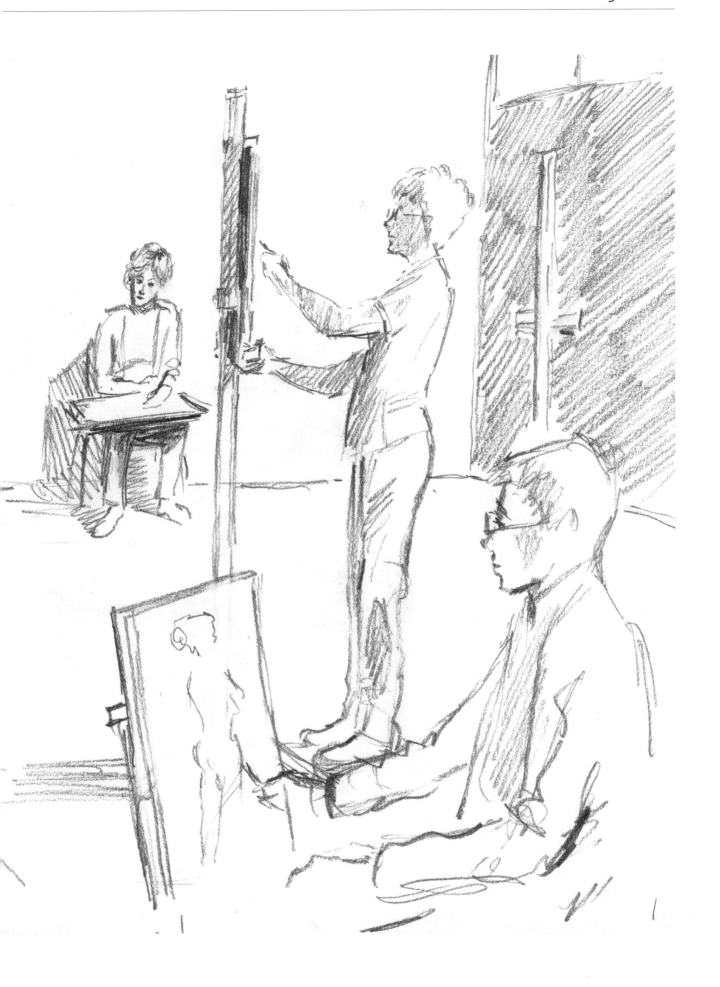

## DRAWING FRIENDS

The greatest difficulty when drawing your friends is to persuade them to sit still for long enough. A professional model is accustomed to holding a pose for quite a while, but you may need to offer your friends some inducements to get them to do the same. Don't try to make them remain still for too long, though – even professional models get rests in between posing and someone not used to it may find it difficult to sit still for longer than 20 minutes. Nevertheless, in that time you should be able to take in the whole figure, even if it is not very detailed, and you will gain excellent drawing practice.

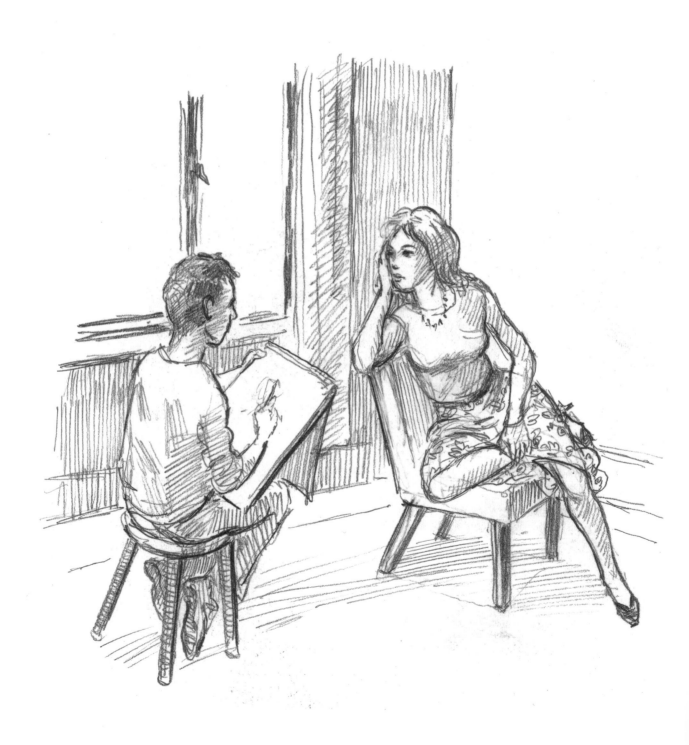

Indoors, make sure that you sit near a large window but again without direct sunlight falling into the room. Place yourself side on to the window and get your friend to sit in an interesting but comfortable pose – not too complicated or they will find it difficult to maintain the position.

Draw outdoors as well when you are able to because the light is different and you can often see much more clearly when the light is all around the figure. Try to do it on a day on which the sun is not strong: a cloudy warm day is best, because the light is even and the forms of the figure show more clearly.

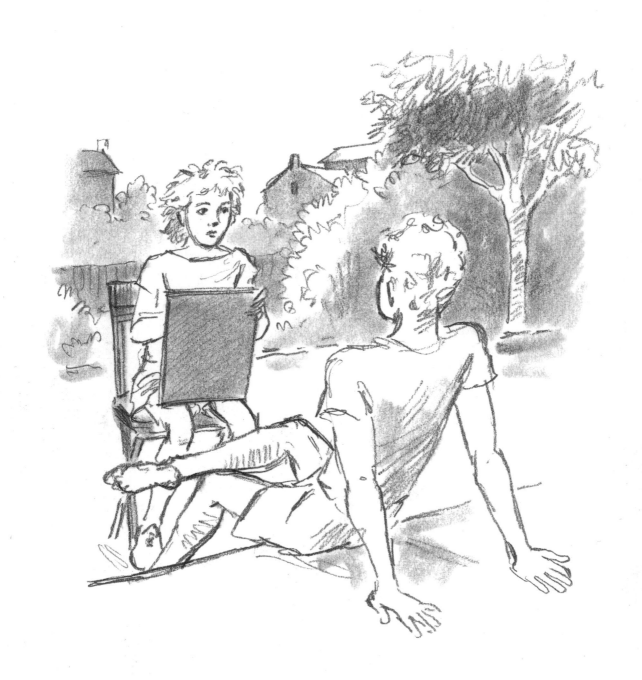

## LIGHTING THE MODEL

Natural light is the norm in life drawing, except in winter when it may not be available for sufficient hours in the day. Most artists' studios have north-facing windows because they give light, without the harsh shadows caused by sunshine. With north light the shadows tend to be even and soft, showing very clearly quite small graduations in tone so that the changes of surface direction can be quite easily seen.

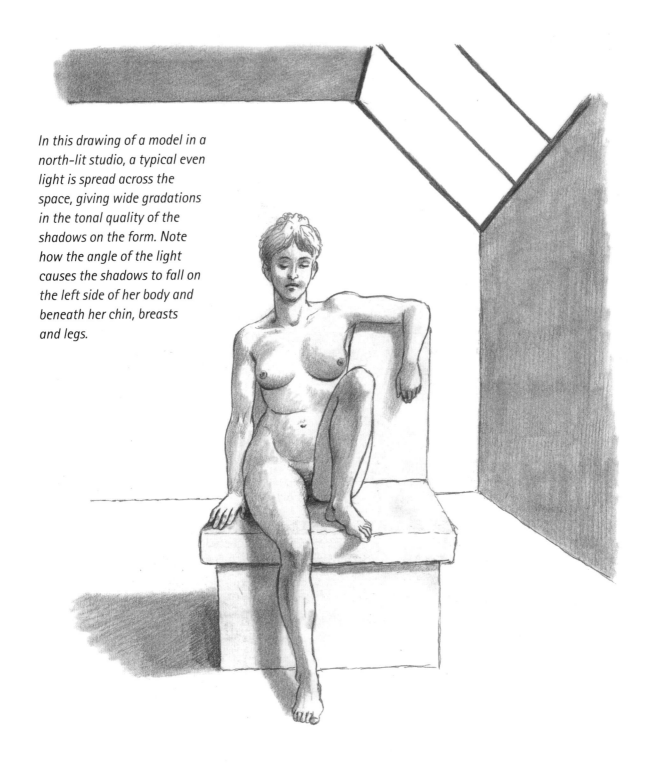

*In this drawing of a model in a north-lit studio, a typical even light is spread across the space, giving wide gradations in the tonal quality of the shadows on the form. Note how the angle of the light causes the shadows to fall on the left side of her body and beneath her chin, breasts and legs.*

This picture gives a clear indication of how strong directional light produces harsh shadows and very brightly lit areas. This can produce dramatic effects: the Italian artist Caravaggio, for example, was known to have had massive arrays of candlepower to light his models, in order to produce the extreme contrasts in light and shade, known as *chiaroscuro*.

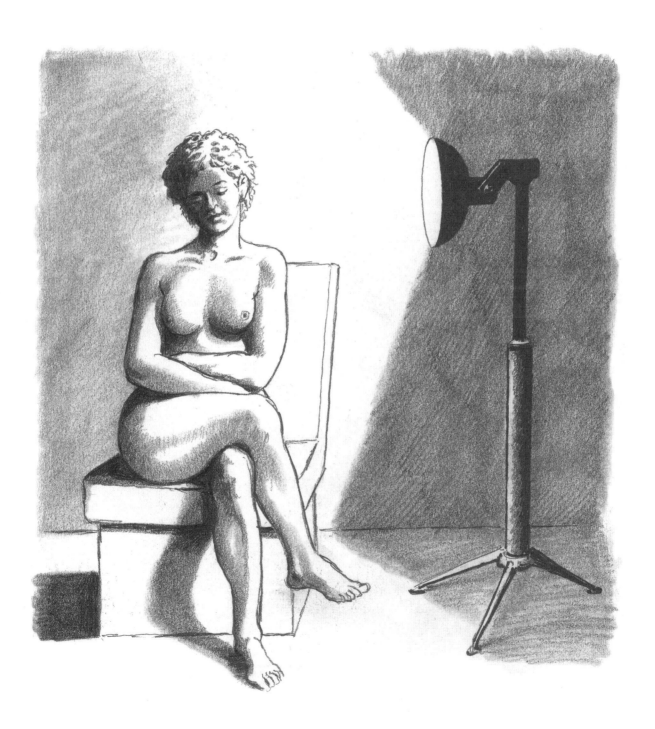

## LIGHTING FROM ABOVE

In most cases even light is the best for accurate drawing, and it is very useful if you can achieve it. However, there may be occasions when this is not what you want and then you will either have to wait for sunlight to give you sharp clean-cut shadows and very brightly lit surfaces or invest in some powerful directional lamps which you can adjust to suit your purpose.

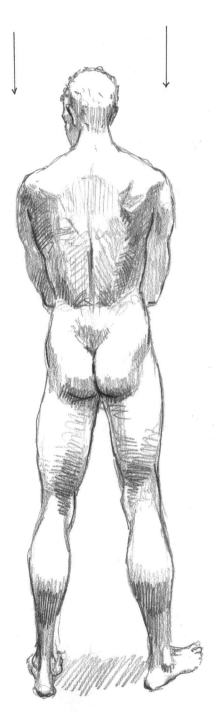

*Light from directly above the model has a very strong dynamic, but when the model is standing heavy shadows form under the shoulder blades and down the length of the back, under the buttocks and on the lower thighs and calves of the legs. Light coming only from above does not occur frequently, so the standing figure will also look unfamiliar. When the model is lying down the effect is not quite so dramatic and looks more natural.*

## LIGHTING FROM BELOW

Lamps will give you the chance to explore dramatic lighting effects that strongly influence the mood of your drawings, but light that is diffused shows more graduation of tone than direct light. Soft candlelight gives a very different effect from floodlight. Explore a range of different light sources, using different angles and strengths of light, and noting how they affect how the shadows appear on the model's body.

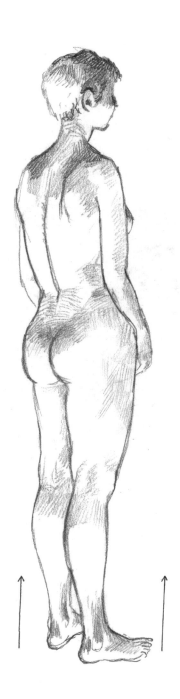

*Lighting from below is very unusual and looks rather unnatural. The calves, buttocks and middle back get most of the light, but it also falls on the back of the head and, at the front, the lower belly, ribcage and breasts. There is also a lot of light under the chin, which gives a rather ghostly look. This kind of dramatic lighting from below was often used for the demonic characters in old horror films.*

## FRONT AND BACK LIGHTING

Light sources coming from behind or in front of the model present the most difficult challenge to the artist in terms of drawing the form and substance of the figure. When the light is directly in front of the model the effect is to flatten the form so that the obvious planes of light and shade tend to disappear into the overall light tone. Consequently, this lighting will result in a drawing that is more of an outline, with just a few subtle tonal areas shown. Lighting from behind has a similar effect, but in reverse. This time the only area with light shining on it is the edge of the form – usually the top edge.

*With the model lit from the front there is a large area of light tone, with a few tiny edges of darker tone where a curve of the body turns away from the light.*

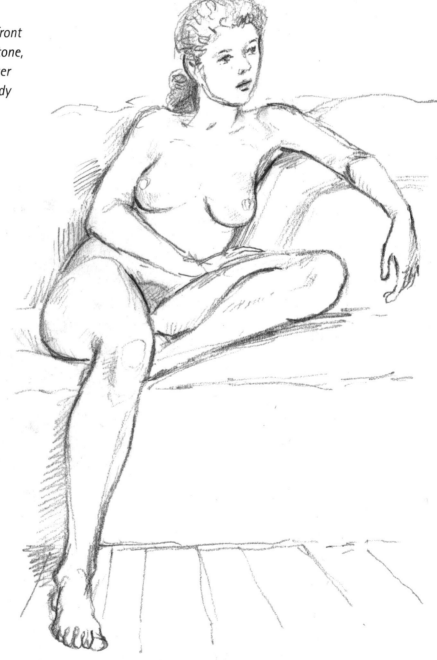

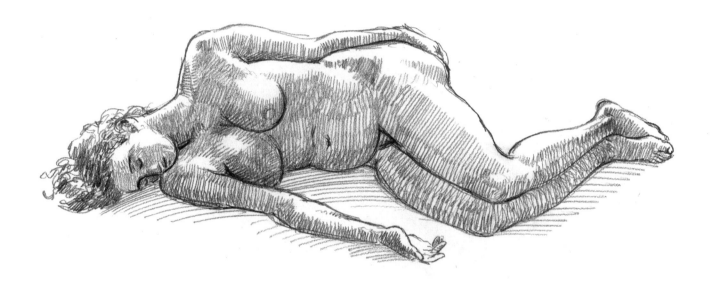

In this reclining model I have depicted slightly more line along the edge than you might see when the drawing is entirely contre jour *(against the light)* so that it is easier to understand the point. Sometimes you might only see an outline silhouette with bright light all around. The effect is exactly the opposite of frontal lighting in that the large area is of a dark tone with light edges appearing where the light hits. With both types of lighting the outline drawing is the key, so it is important to get the outline shape as accurate as is possible.

## FRAMING THE PICTURE

The framing device shown here is a very useful tool to help you to achieve interesting and satisfying compositions. It can be made cheaply by cutting it out of card to any size and format that you wish to work on. Holding it in front of you to look through it and moving it slightly up and down and from left to right will allow you to examine the relationship between the figure and the boundaries of the paper and visualize your composition before you actually begin to draw. It will also help you to see the perspective of a figure at an angle to you, as the foreshortening becomes more evident. Dividing the space into a grid will assist you in placing the figure accurately within the format when you draw it.

*To make a grid, attach four threads to the card: one from centre top to bottom, one from centre left to centre right and two diagonally from corner to corner. Make sure they are pulled tight so that they all meet in the centre of this space. Alternatively, stick a piece of acetate across the central space with black marker lines drawn in the same way. Either method works, although the latter device sometimes reflects the light, which stops you seeing your model so easily.*

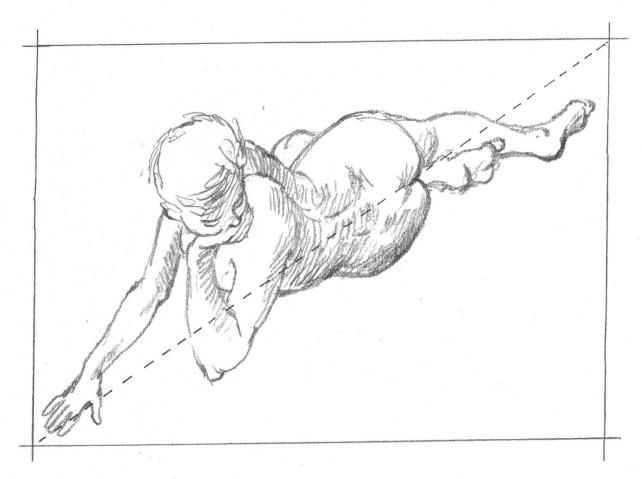

Here the edges of the frame are placed so that the figure appears to stretch from the upper right-hand corner to the lower left-hand corner. The centre of the picture is taken up by the torso and hips and the figure is just about balanced between the upper and lower parts of the diagonal line. This would give you a picture that covered the whole of your surface but left interesting spaces at either side. You will find that it is quite often the spaces left by the figures that help to define the dynamics of your picture and create drama and interest.

## USING SIMPLE GEOMETRY

The two figures shown here still fill the whole area effectively but now leave rather less space and create different effects. Both have a triangular composition. Looking for simple geometric shapes such as triangles and squares will help you to see the overall form of the figure and achieve a cohesive composition within your format.

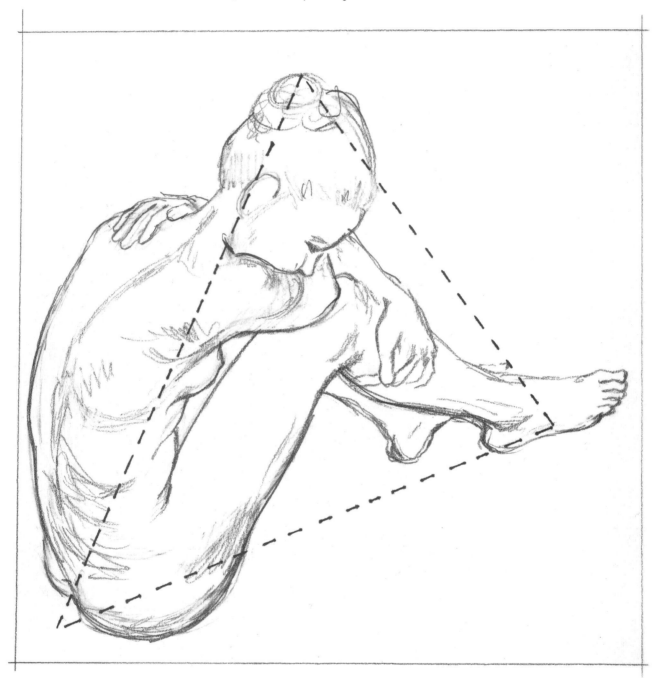

*This female figure, from a drawing by the famous medical illustrator Louise Gordon, is emotionally less obvious, but the simple triangular composition between her feet, her buttocks and the top of her head creates a calm, restful effect, with some depth of thought emphasized by her cheek resting on her upper arm. The torso, being pushed over to the left-hand lower half of the space, creates a more upward movement than is seen in the drawing of the man and the two spaces to the upper-right and lower-right corners seem to make the figure look light and almost floating in space.*

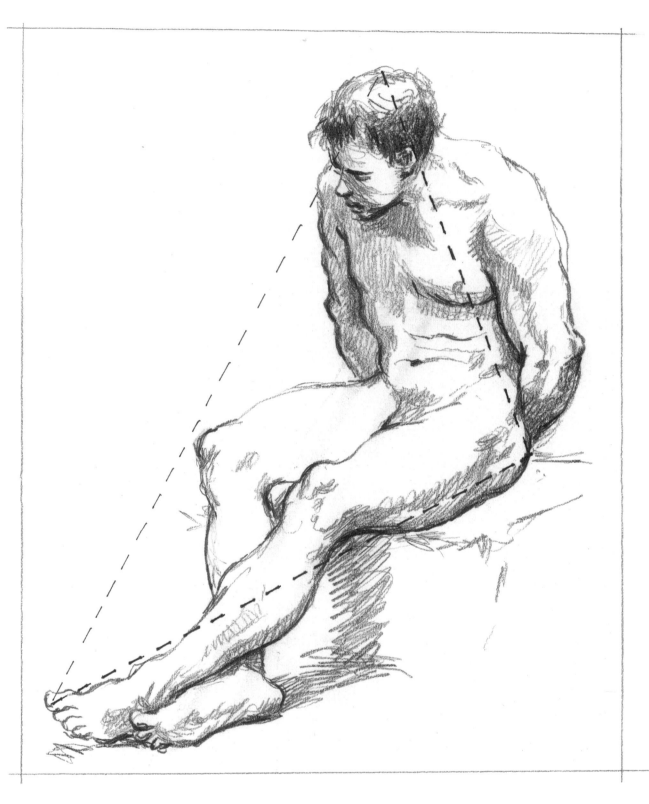

This seated man with his hands behind his back, based on a drawing by Natoire in the Louvre, fits into an elongated triangle with the corners at the top of his head, the back of his hip and the end of his toes. The bulk of his body is between the sides of the triangle, and because the emphasis is on the stretch of his legs to the bottom left-hand corner of the picture there is a strong dynamic that suggests he is under some duress – perhaps a prisoner. This simple device produces an emotional effect in the drawing.

## GEOMETRIC GROUPS

The use of geometry to compose and 'control' a group of figures is a well-tried method of picture composition. It can become a straitjacket if it is taken too seriously, but it is a good method to use as a guide because it puts a strong underlying element into the picture. All the obvious geometric shapes can be used – a circle, a triangle, a rectangle, a parallelogram – although it can lead to a rather forced composition if you are not careful.

*The triangle here is formed by two figures, the female reclining to produce the base of the triangle and her head and forearm one of the corners, and the male figure producing an apex with the top of his head and an indication of one side with his arm.*

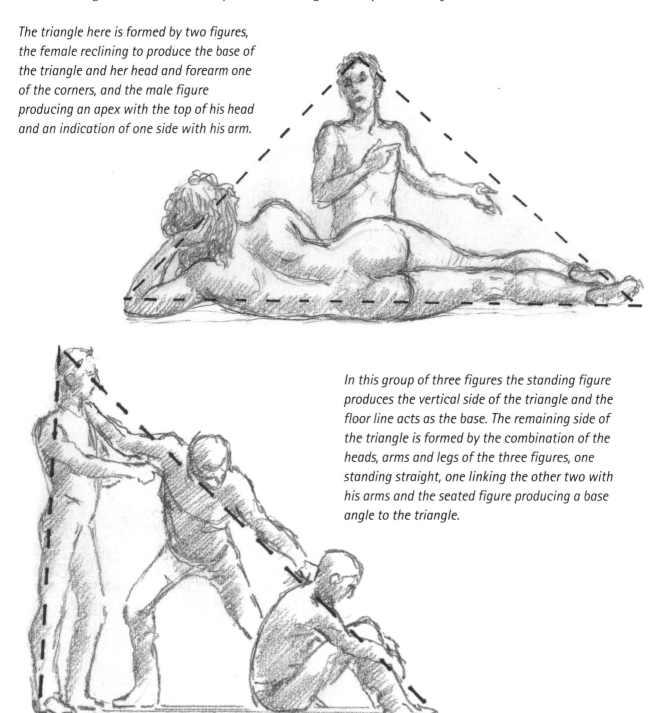

*In this group of three figures the standing figure produces the vertical side of the triangle and the floor line acts as the base. The remaining side of the triangle is formed by the combination of the heads, arms and legs of the three figures, one standing straight, one linking the other two with his arms and the seated figure producing a base angle to the triangle.*

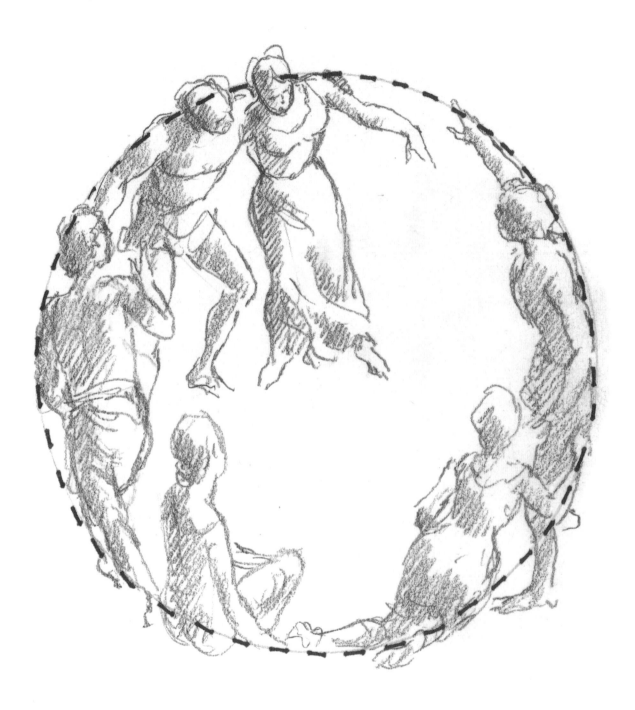

A circular composition is unusual and lends itself mostly to dance movements of groups of figures. This group of three couples suggests some formal movement which could develop into a dance, with the lower edge of the circle indicated by two females about to stand up but still sitting or kneeling. The gestures of two of the male and female figures with their outstretched arms help to create the circle and the beginning of a dynamic, dancing movement.

## DYNAMIC POSES

When you are determining your composition you will have some theme in mind that will influence the way you pose and draw the model. Generally, the pose falls into one of two types: the dynamic, energetic pose or the relaxed, passive pose. Shown here are four examples of ways to produce the former, showing power, energy or movement. We understand the message they carry partly because of the associations we have with particular movements of the body and partly because of the activities the figures are engaged in; the drawings of a footballer kicking a ball and of the runner starting from the starting blocks immediately inform the eye of the dynamics involved.

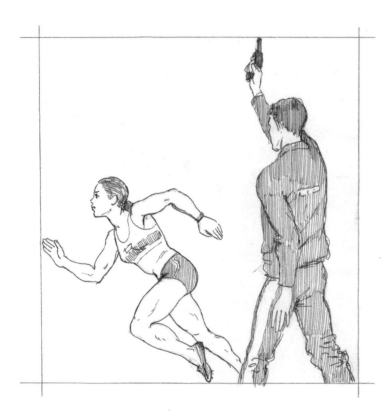

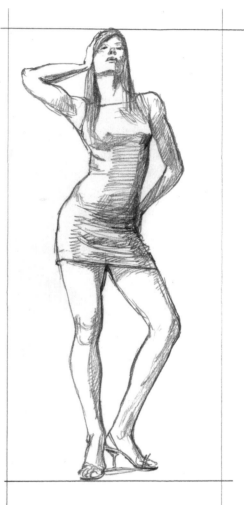

*The runner exploding off the starting blocks is a sharp diagonal towards the edge of the picture, also helped by the hand and feet being right on the frame. The man with the starting gun gives a strong, stretched form from top to bottom of the picture from which the runner is angled off in a very dynamic shape.*

*In a classic fashion pose, the model is thrusting out one hip and both her elbows and bent knee are also pushed out to create strong angles all along the length of the body. Although we are aware that this is a static pose, it has the movement implicit in the angled, arched torso, the uneven bending of the arms, one to the head, one to the hip, and the attitude of head, feet and shoulders. It has the look of a dance movement, which helps to maintain the dynamic. Again the framing of the figure helps by being as close in as seems effective.*

These two figures are apparently startled, turning to see something that may be alarming or surprising. They are looking above the head of the artist, bending towards each other, their arms seeming to indicate disturbance. There is some feeling of movement about to take place, but there isn't a real source of activity; it is just a pose. However, the movements of the bodies, their juxtaposition to each other and the apparent focus of their attention outside the picture frame helps to produce a dynamic, energetic set of forms, which we read as movement. The way the figures are framed also helps this feeling, with the outstretched arm of the man almost touching the top edge and their legs being out of sight below the knees. The diagonal forms of the two torsos, leaning in towards each other away from the lower corners of the frame, also help this appearance of action.

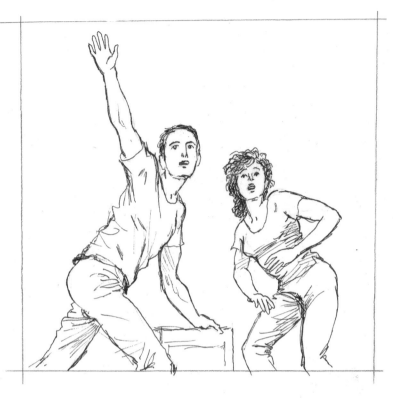

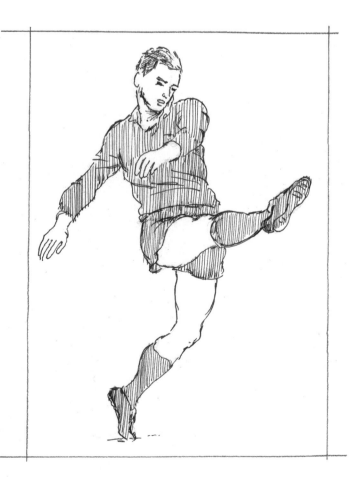

This straightforward drawing of a footballer kicking a ball with his body twisted, head down, shows that an individual figure can also produce dynamics. Again, the frame of the picture cuts in very close to the extended arms, legs and top of the head. This close framing helps to produce the movement, which seems to continue outside the frame.

## RELAXED POSES

Here the basis of the pose is more relaxed, without the active dynamism of the earlier poses. This is of course a much easier way to pose a model, because most people can keep still in a comfortable reclining or sitting position. When you want to do longer, more detailed drawings you will always have to rely on more static poses.

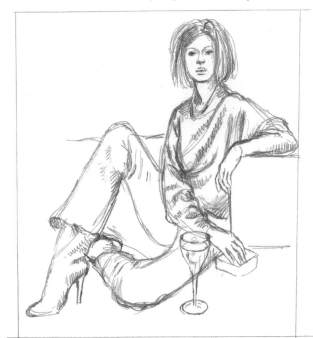

*Sitting upright on the floor, the model has her legs bent, one tucked underneath the other. Her fashionable appearance and the wine glass on the floor in front of her helps to give a static easy-going composition which looks as if she is engaged in a conversation at a party. The arrangement of the legs crossing each other and the arms bent around the torso help to give a fairly compact appearance to the arrangement.*

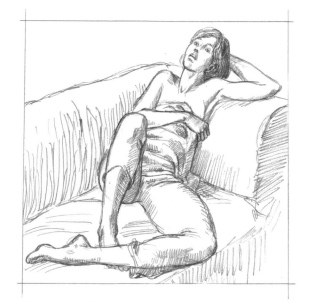

*The second figure is even more relaxed and literally laid back, with the head supported on one bent arm resting on the side of the couch and the other arm bent across the torso, holding a garment across the body. The legs are tucked around each other in a way similar to the previous pose but even more loosely arranged. The viewpoint from the foot end of the body does give a certain dynamic, but the energy is reduced to give an effect of rest. The head bent back onto the hand and the arm of the couch helps this passivity.*

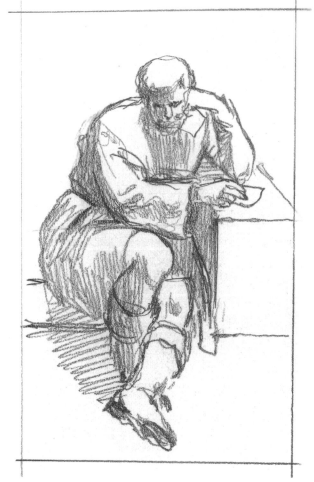

*This sitting figure, taken from a Raphael design in the Vatican, is in a pose that looks both thoughtful and relaxed. The figure is of a philosopher about to write his thoughts, a pose that is obviously going to be static for some while.*

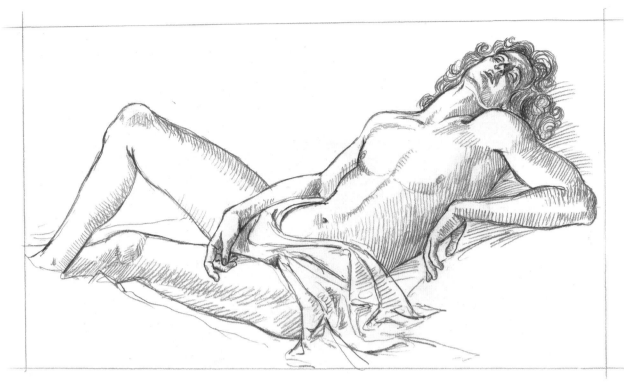

I based this drawing on Botticelli's picture Venus and Mars, *which can be seen in London's National Gallery, in which the reclining figure of Mars is* totally surrendered to sleep. As a reclining figure it is one of the most relaxed-looking examples of a human figure.

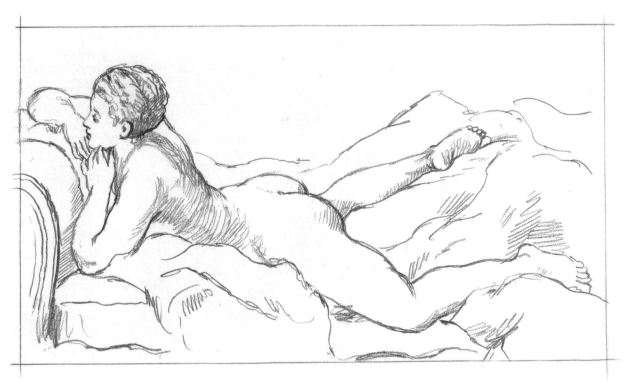

In this drawing, based on a work by the French 18th-century painter François Boucher, a nude girl is reclining on a couch, posing for the artist. Although her head is erect, supported by her hands, and her back is hollowed, she is in a pose that doesn't suggest action on her part at all. The side view of a reclining pose is always the most calm and peaceful in effect.

## FIGURES IN INTERIORS AND EXTERIORS

When you are drawing figure compositions the scene has to be set in some location, either inside or outside, or your figures will appear to be floating in limbo. Two of the most famous Dutch painters of the 16th century were Vermeer and de Hooch, both of whom excelled at interiors that depicted the orderly calm of the households occupied by the bourgeoisie. The main difference for the artist between interior and exterior scenes is that the former tend to have more directional light, often from just one window. Studying the work of Vermeer and de Hooch, two masters, will help you to consider ways to use light to explain your composition to the viewer. Even with very few objects to set the scene, the way the light falls on your figure will indicate whether it is set inside or outdoors.

*Vermeer always placed his figures very carefully in a specific interior with light coming from a window and musical instruments or other appurtenances of the household included in the composition. He would place large pictures or maps on the wall to act as a foil to the human figure. The furniture was arranged to make the spatial element in the picture more evident.*

*De Hooch often included quite a large area of the inside of a house, particularly the family rooms. In this example, his interior spaces are very considered and help to create an aspect that goes through the room into the next and then out of the window to the outside world. The little dog sitting opposite the doorway draws the eye through to the larger space. The mother and daughter placed well over to one side sit in front of a cupboard in which the bed is set, making a dark, enclosed interior area. This juxtaposition of light open space and dark inner space gives the composition a lot of interest, apart from the presence of the figures.*

*In the Peter Kuhfeld composition shown here, the nude girl in his studio faces towards the window, casting a reflection in a large mirror behind her that shows her opposite side and the window looking out across gardens. In effect we see two figures from different angles. This creates depth and added interest in the picture and we feel we only need to see a little more to one side to view the artist also mirrored in the scene.*

*In this outdoor scene, also by Peter Kuhfeld, a girl is seated reading at a table in the garden. She is surrounded by flowers and foliage and there is just the indication of a window in the background. The table has been used for refreshments and perhaps once again the presence of the artist is hinted at in the utensils on the table. As with the nude girl in the studio, this is a very intimate scene but the enclosed space is now outside and we understand the open-air feel with the expanse of white tablecloth, iron chairs and abundant surrounding vegetation.*

## DANCING FIGURES

The figures here show what happens when the body is projected off the ground with necessary vigour; in some cases informally and in others in more stylized poses.

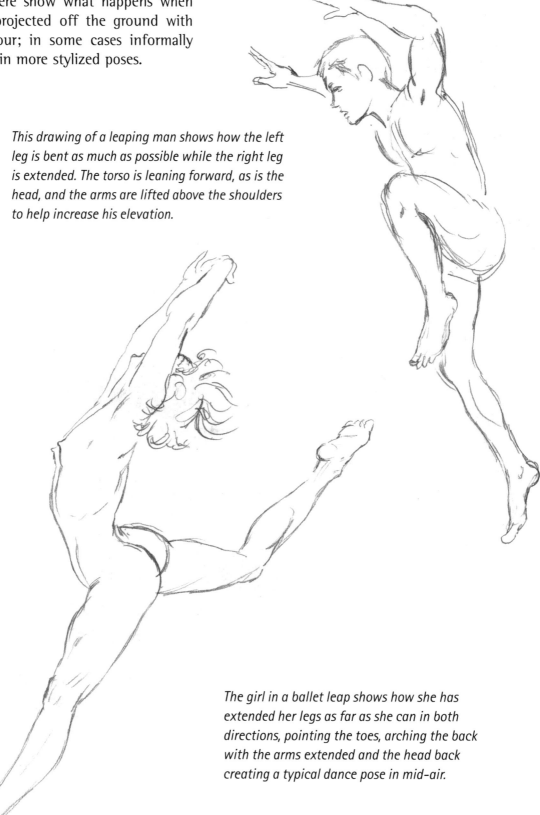

*This drawing of a leaping man shows how the left leg is bent as much as possible while the right leg is extended. The torso is leaning forward, as is the head, and the arms are lifted above the shoulders to help increase his elevation.*

*The girl in a ballet leap shows how she has extended her legs as far as she can in both directions, pointing the toes, arching the back with the arms extended and the head back creating a typical dance pose in mid-air.*

## BALANCE AND IMBALANCE

It is an interesting exercise to try to draw someone at the point where they have lost their balance and have begun to fall over. It is not easy to do, because even if the occasion presents itself your reaction will probably be to try to help rather than take advantage of the situation. However, an accident such as this is often clearly imprinted on your memory for a short time, so you can sometimes remember enough to make a sketch shortly afterwards. Asking someone to adopt a falling pose is never quite the same, but it is worth trying.

Conversely, people engaged in an activity such as throwing a ball or climbing rocks and trees are usually in a state of perfect balance. Here the body is under tight control, with deliberate movements – note how careful pencilling reflects this control.

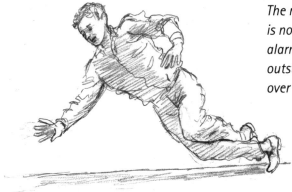

*The main thing about drawing the figure falling is to show that it is not in balance. There are obvious things to note, such as the alarm or surprise on the face, the attempt to save oneself with outstretched arms and other details. Here a man who has tripped over his own leg has thrust out his hands to save himself.*

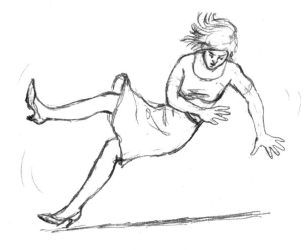

*A girl who has slipped over is trying to turn to protect herself from a bruising. Again, there is an instinctive attempt to cushion the fall with the arms, and her untidy hair and alarmed face reinforce the message that she has temporarily lost control of her body.*

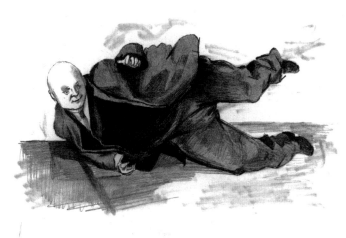

*This example is from a painting by Michael Andrews. The expression on the rather rotund businessman's face as he crashes to the ground, probably about to roll over; the ineffectual movement of the arms and hands which will obviously not save him from the bump; and the movement of the coat and trousers indicating the passage through the air of his descent all go to make this a remarkable piece of work. In the original there is in the background a woman with her hands to her face, shocked by the accident, which helps to increase the effect of the falling body.*

## SOCIAL SETTINGS

Figures in social settings are much simpler to draw than those engaged in energetic sports. Their movements are slower and calmer and they will stay in one spot for longer. Their gestures and body language will tend to be repeated again and again, giving you plenty of time to observe them and draw them accurately. Notice how they may change as people begin to relax in the company of someone they have only just met.

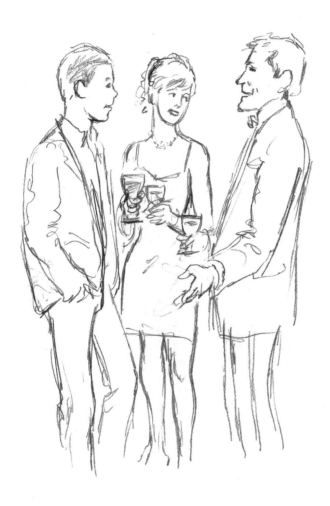

*These three figures engaged in conversation look relaxed and are fairly still. The animation tends to be in the hands and faces while the bodies take on poses of comfortable balance rather than energetic shapes.*

*A group around a table at a meal is even more static and here you will probably see only the upper half of the bodies with any clarity. Again all the animation will be in the faces and it is the glances and direction of the turning heads that help to create the dynamic. Lighting helps here and drama can be enhanced by candlelight, which tends to obscure details.*

Social settings outside tend to be more dynamic in terms of body movements and poses. Here, at a garden party, a group of young people are seen eating and talking. One leans aside to replenish his plate, while the girl with her back towards us gestures to the table. The man opposite her is partially obscured but one can get the effect of some rather direct expression from him. The other woman points to herself with hand on hip, all this against the background of foliage and roofs.

Street scenes are less easy to draw because people don't tend to linger much and it is difficult to find places where you can obtain a good view. However, the dynamics of this group of shoppers as they pass each other, commenting on their purchases, makes an interesting balance of figures across the pavement with other figures lightly indicated in the background.

## BODY LANGUAGE

The human figure will usually bring some emotional context to a picture. This is mostly shown by the way the figure is depicted moving in the scene and quite often requires the juxtaposition of two figures – for example, a figure waving its fists in the air and confronting a cowering figure would obviously suggest some disagreement or aggression going on. However, the moods indicated are usually more subtle than this and, particularly when there is only one figure present, the artist has to understand and master the conventions of body-language before the picture will tell the desired story. On these pages you will find some examples of the moods that different poses evoke.

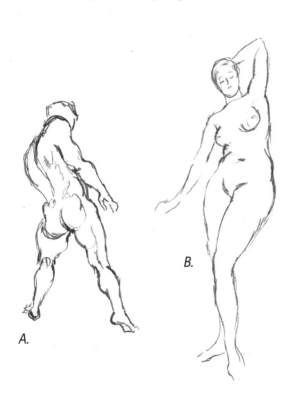
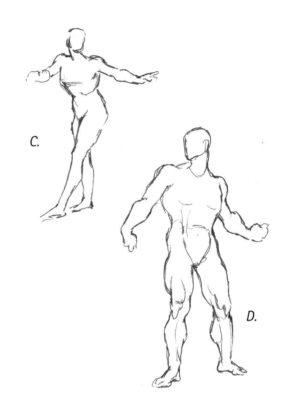

A. The pose of this masculine figure suggests some effort possibly related to pulling or pushing, shown by the braced legs, straight arm and twisted spine.

B. The female figure seems to stretch out in dreamy languor, emphasized by the sinuous quality of her arms and legs.

C. Another female figure, this time one who looks startled by something behind her, with a slightly theatrical gesture.

D. This male figure is obviously aggressive, with his pulled-back fist and fighting stance, reinforced by his heavily muscled form.

E. A female figure with arms aloft appears to be crowing with delight or jubilation, as though she has just won a prize.

F. Turning to look at something behind and at her feet, this figure shows her surprise in a rather dramatic gesture.

G. In a crouching position with head down, this man appears to be moving hastily away from something causing fear or a similar emotion.

H. The kneeling figure shows mental strain of some sort which, with his hand to his head, suggests the conventional pose for agonized thought.

I. This female figure seems to be protecting herself with a pose suggesting the foetal position.

J. A male character sitting back as though on the beach enjoying the sunshine evokes a feeling of simple relaxation.

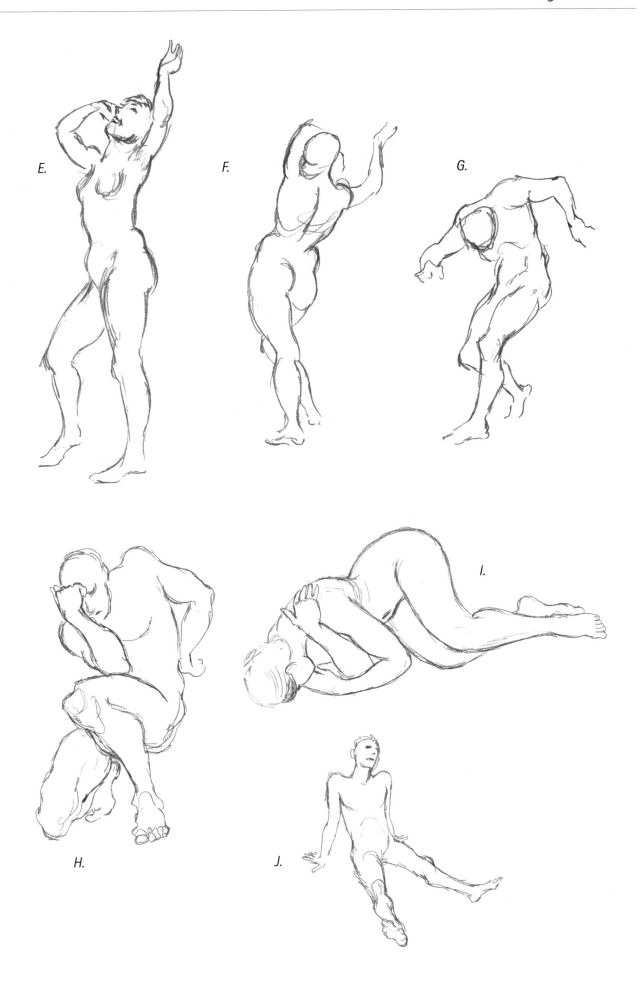

E.

F.

G.

H.

I.

J.

## PENCIL AND LINE DRAWING IN INK

The techniques of drawing with different materials are shown on the following pages, which will give you some idea of just how they are done. David Hockney is a major draughtsman of the modern art scene. The examples of his work illustrated on this page show a quite straightforward way of drawing the human figure.

*This portrait of film director Billy Wilder (right) was drawn by Hockney in 1976. He is sitting in a director's chair, the script in his hands underlining his profession. The body is skewed slightly sideways with one leg on a support. The drawing is mostly just a pencil line with some carefully chosen areas of fine-toned hatching. The whole is a tour de force of almost classical pencil drawing.*

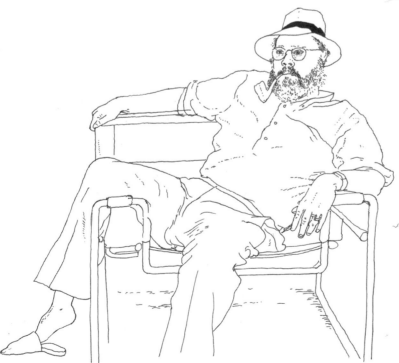

*Hockney's picture of Henry Geldzahler (left), drawn in Italy in 1973, shows his friend relaxing in a big tubular steel chair out in the garden, straw hat and all. Geldzahler liked posing for his portrait and so was always keen to arrange himself in an interesting attitude. The thin, even pen line has a precision about it, but is also quite sensitive to the quality of the material of the clothes and the hair. The slightly cautious, meandering quality of the line gives a feeling of care and attentiveness in the drawing. This style is simple but extremely effective.*

## PEN AND WASH AND PASTEL

The use of different mediums is very much a question of choice by the artist working, but it is a good idea to try out the different mediums to give you an idea about which techniques you may want to use when confronted by decisions in drawing.

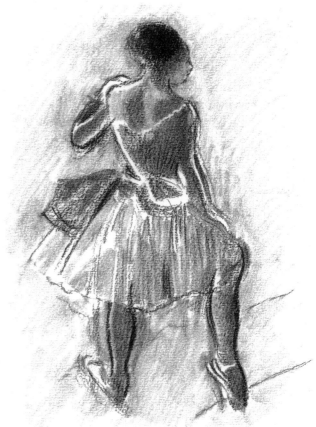

*Degas's pastel drawing of a ballet dancer practising point exercises is one of many he produced during the 1860s. His brilliant use of pastel gives great softness and roundness to the form and his masterly draughtsmanship ensures that not a mark is wasted. This is a very attractive medium for figure studies because of its speed and the ability to blend the tones easily.*

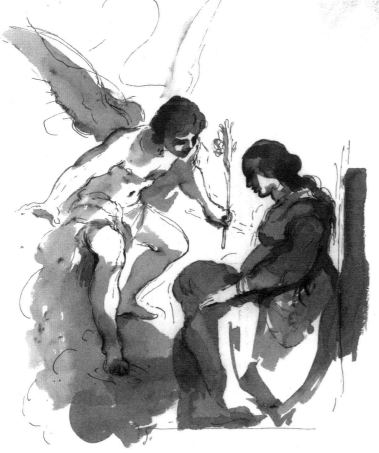

*This drawing made by the Italian master Guercino in 1616 was a sketch for a small devotional picture of the Annunciation with the Archangel Gabriel descending from heaven bearing a lily, symbol of Mary's purity. The line in ink which Guercino uses to trace out the figures is very attractive, because although it is sensitive it also has a confidence about it which shows his great ability. The drawing has areas of tone washed in with watered-down ink and the wet brush has also blurred some of the lines, as the ink is not waterproof. His handling of dark areas contrasting with light is brilliant, and shows why his drawings are so much sought after by collectors.*

## FOLLOWING THE ARTISTIC PROCESS

Now we have come to the final hurdle – putting all the things that you have learnt into a complete figure composition. By starting from the very beginning and proceeding through to a carefully finished piece of drawing you should be able to produce a convincing scene with human figures in it, if not a great work of art.

Remember that you have to walk before you can run and so even if the final result is not inspired it should be effective enough to show how to construct the final presentation of figures in a scene that is within your capabilities and interesting enough to carry some conviction.

*STEP ONE*

*The format: what shape and size will this composition be? The format will be landscape, square, portrait or panoramic. Within these categories the size will make a lot of difference. Your choice is up to you and what you think you are capable of drawing. For the sake of this exercise I decided that a landscape format would be the right one.*

*STEP TWO*

*The number of figures: there should be at least two figures to make a composition, but it could be three, four, five or even more. For the sake of simplicity and precision I elected to have three figures in the composition. Added to this the choice had to be made as to whether they would be male, female or both. My initial decision was to have one female and two males, though in this I was open to change along the way.*

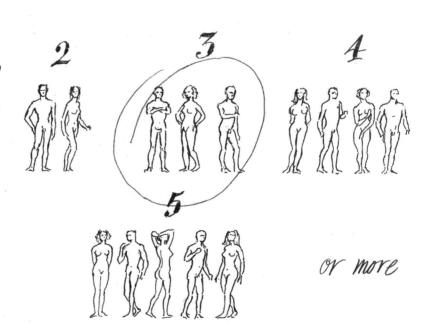

A.

B.

C.

D.

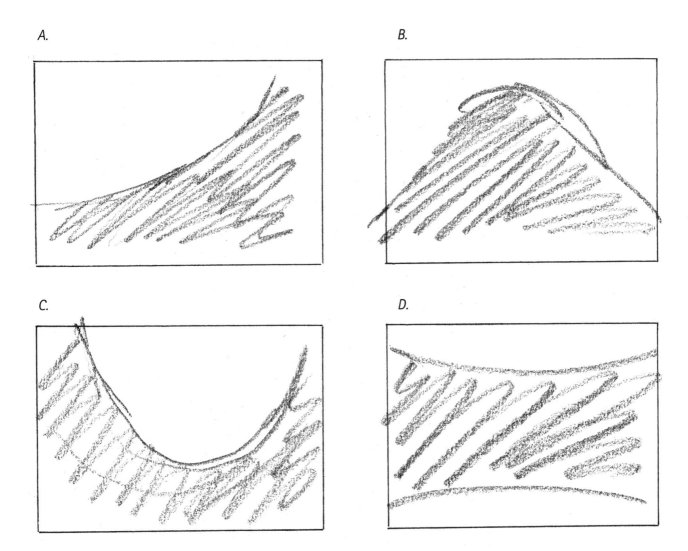

## STEP THREE

*What space will the figures occupy? Will the composition have a large upper space and the figures in the lower area sweeping up to the right side towards the top (see A)? Or will there be a more central shape like a hill with small spaces either side in the upper half (see B)? A sort of valley shape with a large central space and figures at the lower edge and up either side might work well (see C). Or why not have a complete sweep of figures across the whole scene covering most of the space (see D)? Because there are only three figures I opted for something that is weighted to one lower side sweeping up to the other higher side.*

**STEP FOUR**

*Choosing the main poses: having investigated a range of poses, the next thing is to draw up rather more considered sketches of the poses that you think will work together and try them out in a series of frames of the same size and format. You will then begin to get an idea of how the composition might be most successful.*

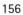

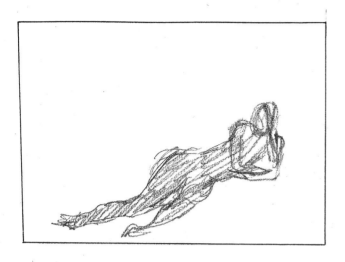

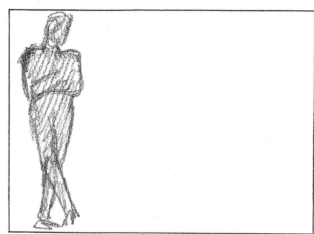

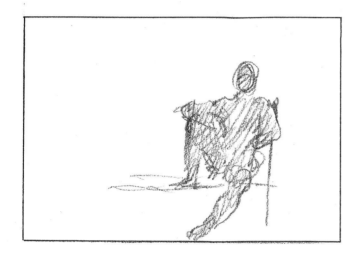

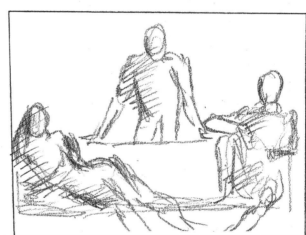

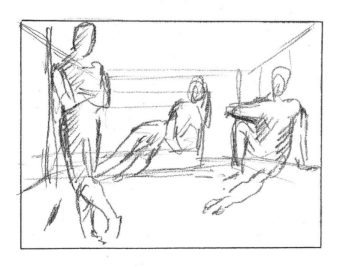

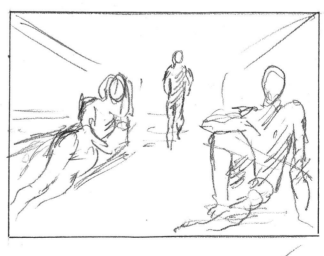

*STEP FIVE*
Exploring the setting: relaxing in the park in summer is the theme, so you will need to make some drawings of background scenes in your nearest parkland or gardens. With your drawings of the three characters to work on, place them in the scene in as many ways as you think fit to get the best effect you require. When you have considered some options, make a choice. All these stages are about making decisions that gradually limit your picture to a pattern that you find aesthetically satisfying.

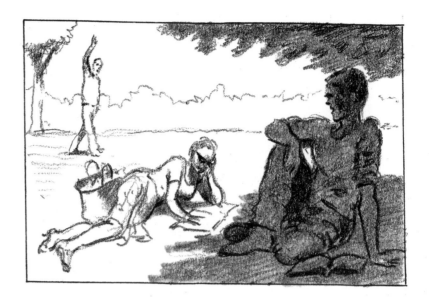

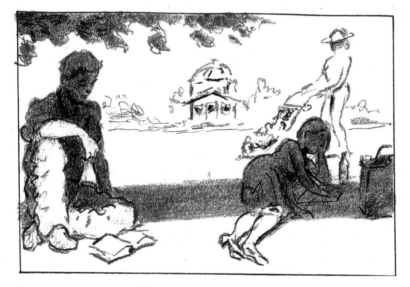

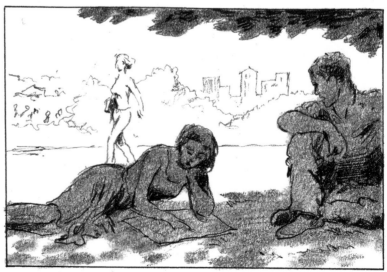

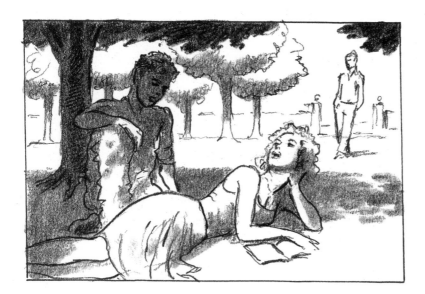

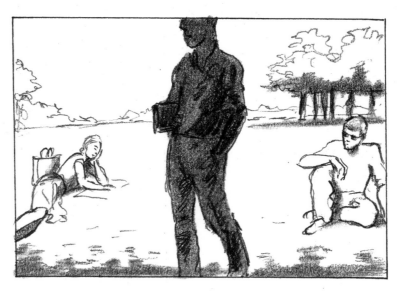

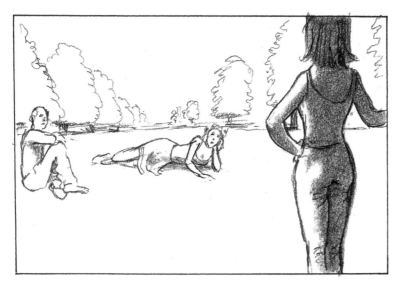

In all these scenes the dynamics are different although the scene is similar. Each could work and my choice is just that I liked the contrast between the girl lit up in the foreground and the man sitting in the shade behind.

*STEP SIX*

*Detailed figure drawings: having chosen your composition you will now have to do detailed drawings of your three figures. This time you can take them one at a time and make a more careful drawing that will have all the information you want in it. This means that now you have to notch up the level of your drawing to something more developed and finished. Take your time at this stage; it is worth getting these drawings absolutely right. It doesn't matter if it takes several days or even weeks to complete them, it will be worth it in the long run and the end result will be all the better for it.*

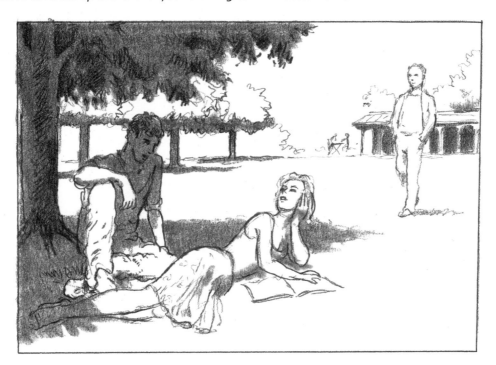

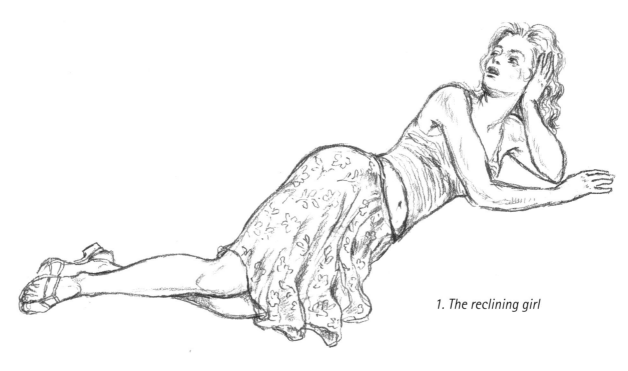

*1. The reclining girl*

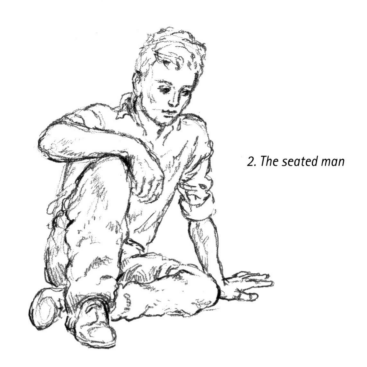

*2. The seated man*

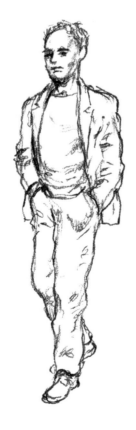

*3. The strolling man*

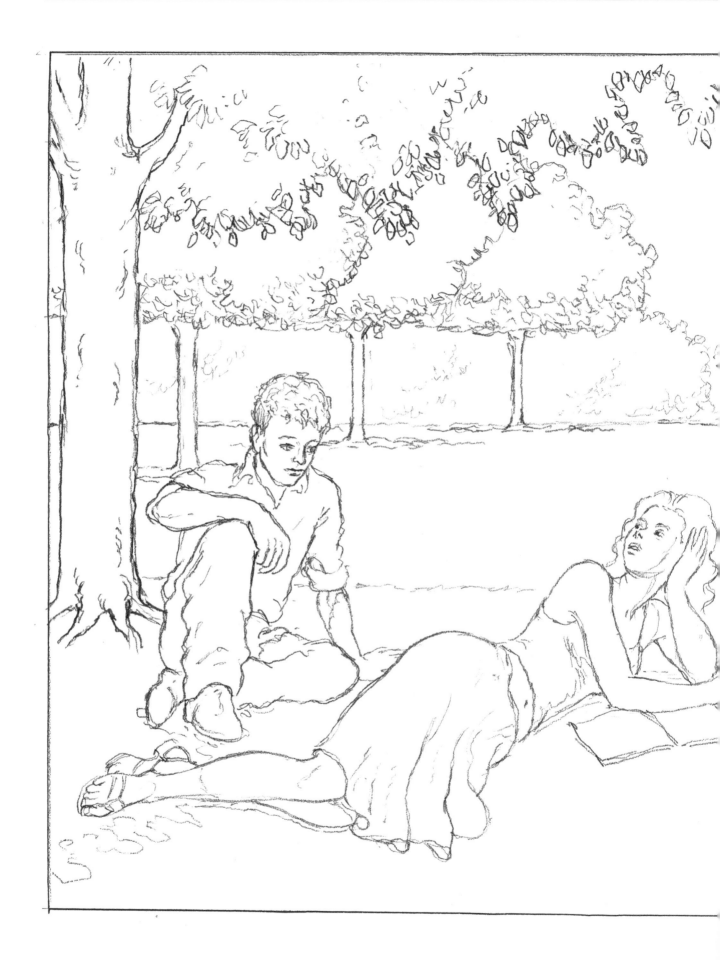

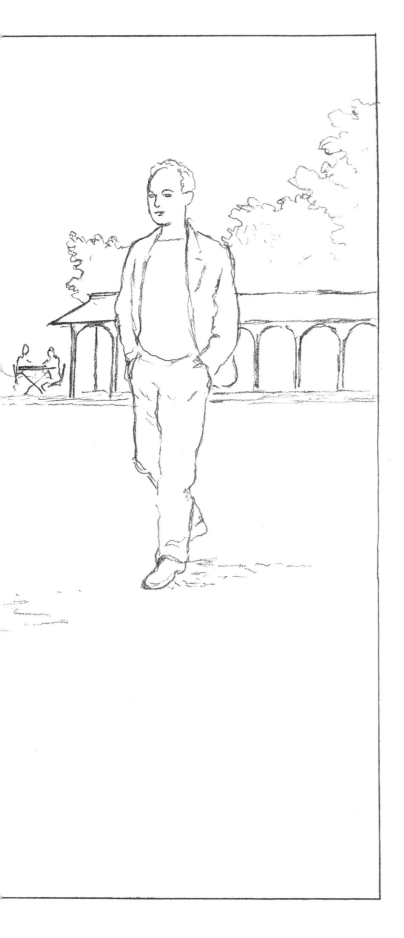

**STEP SEVEN**

*Putting it all together: now you have three excellent drawings of your characters, you have to fit them convincingly into your scene. You may have to reduce or increase their size as you set the relationship of the three figures for the final piece. Draw them up very carefully, tracing them off in line, and placing them in an outlined drawing of the setting. This is your 'cartoon' in which everything is going to be drawn as the final picture requires. It has to be the same size as the finished drawing and everything should be in it except for tone and texture. At this stage what is required is a full-size complete line drawing in pencil of your composition.*

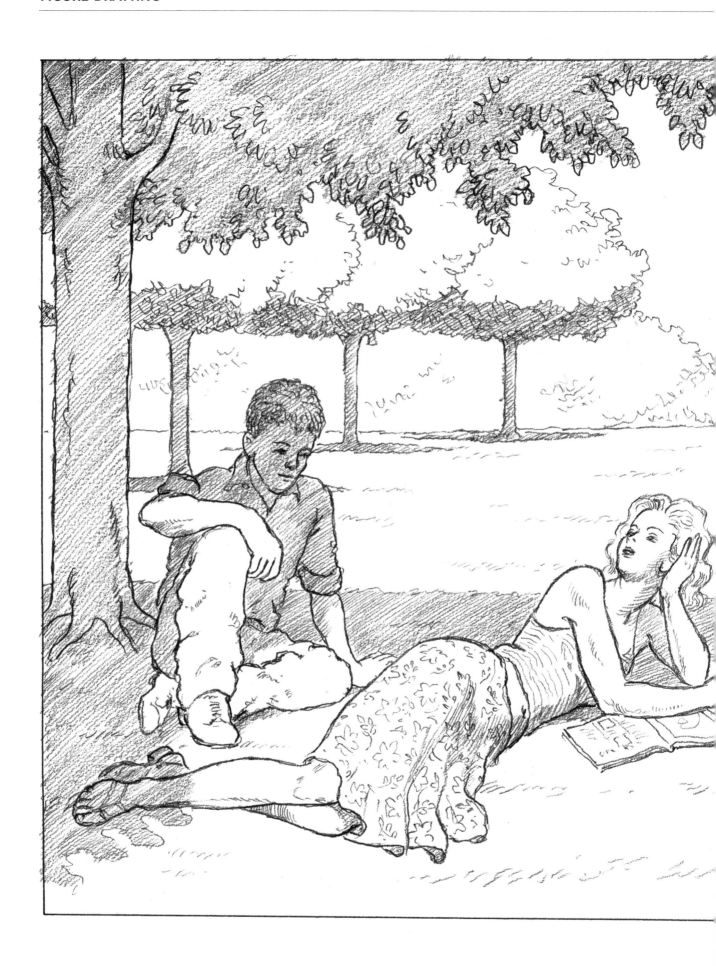

*STEP EIGHT*

*Blocking in the tone: the next stage is to put in every bit of tone, but in one tone only – the lightest you are going to use. At this stage you can also begin drawing in your final technique (for example pen and ink, or line and wash). All heavier tones can be worked in later and even the texture of each area can be left until after this stage. So you should at the end of this stage have a complete drawing in line and tone, but only one bland tone.*

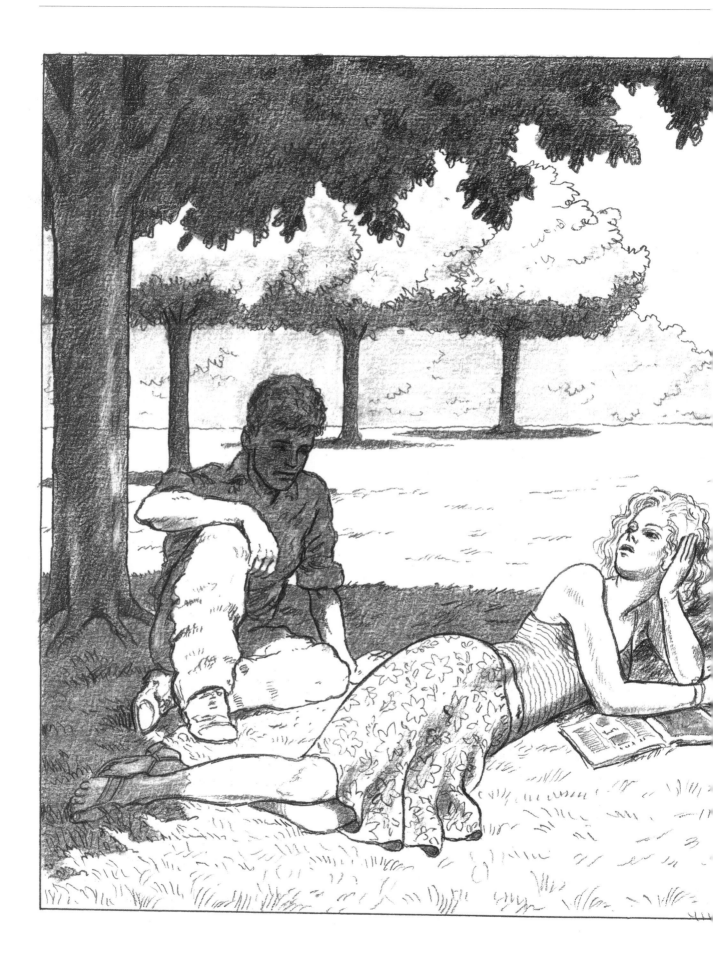

## THE COMPLETE PICTURE

*Tone and texture in depth: having made all the necessary decisions which have produced a convincing picture, you can now let rip with light and shade, the textural qualities of the scene and the subtleties of outline. Work into your shaded areas so that darker, bigger areas of shade have more variety of tone from very dark to light. The objects and people further away should have lighter and less varied tones to give a feeling of recession. Show the textural qualities such as grass and leaves, again making those in the foreground more textured and more obvious. The figures themselves are dealt with in a similar fashion, the further figures being less strongly toned and textured while the nearer ones are more varied and stronger in detail. Even the outlines of the foreground figures should be stronger in the front of the picture and fainter as they recede.*

*Now you have accomplished a complete figure composition on the theme of summer in the park with three figures. Well done! You will no doubt have realized how necessary it is to have a system of working your way through a picture, and while you may wish to adapt it, this system has stood the test of time.*

# Landscape

When we study something in order to make a picture of it we chiefly use our eyes. However, surveying a landscape involves all our senses. Out in the open, we are suddenly aware of the prevailing weather and the sounds and smells around us. From the narrow focus of a still-life group or reclining figure, we switch to the view of distant horizons, big skies and stretches of water, and so we apply ourselves to the consideration of composition, scale and perspective all over again.

The awesome grandeur of scenes painted by the American 'Sublimes', and the tumbled rocks and gnarled trees of the English Romantics, are just two examples of the bond that exists between landscape and the artist. But earlier on, landscape was a mere backdrop to the main feature of a painting, as we see if we peer over the shoulder of Leonardo's Mona Lisa, or look beyond the stable walls in any Renaissance Nativity scene. It was the northern European artists, notably Joachim Patinir (c.1485–c.1525) and Albrecht Altdorfer (c.1480–1538) who enlarged the landscape subject to dominate the entire picture area, literally setting the scene for the master of their tradition, Pieter Bruegel (c.1525-69). Much later on, John Sell Cotman (1782–1842) from the English Norwich School, found a new expression with abstract patterning in areas of shade and reflection; and J.M.W. Turner (1775–1850) and the Impressionists (1867–86) broke new ground with their astonishing handling of light and colour.

Landscape drawing does not mean representing everything as precisely as a camera might, any more than the Impressionists did with their paints. The power of the marks that you make with your pencil, pen or brush lies with their ability to tap into our most fleeting memories and our boundless imaginations.

## THE WORLD AROUND US

To begin to draw landscapes, you need a view. Look out of your windows. Whether you live in the countryside or in the town, you will find plenty to interest you. Next go into your garden and look around you. Finally step beyond your personal territory, perhaps into your street.

Once we appreciate that almost any view can make an attractive landscape, we look at what lies before us with fresh eyes.

The three views shown here are of the area around my home.

*When I look out of the window into my garden, I see a large pine tree of the Mediterranean type. It is a graceful tree and obscures most of the rooftops of the houses backing onto the garden. The window frame usefully restricts my angle of vision so that I have an oblique view of the left-hand fencing with its climbing ivy. Across the back of the garden is a fence with some small bushes under the tree. Plants grow right under the window and their stalks cut across my view. Apart from a few details of the house behind ours, this landscape is mostly of a large tree and a fence, and a few smaller plants.*

In this outside view of the garden we are looking away from the pine. Behind the fence can be seen the roof of a neighbour's house and some trees growing up in the next-door garden. In the corner of my own garden there is a small shed with two small fir trees growing in front of it with a large log at their foot. The flowerbed to the right is full of plants, including a large potted shrub, with ivy growing over the fence. Closer in is the edge of the decking with flowerpots and a bundle of cane supports leaning against the fence. A small corner of the lawn is also visible. The main features in this view are a fence, two trees and a garden hut.

The third drawing is of the view from my front gate. Because all the houses in my road have front gardens and there is a substantial area of trees, shrubs and grass before you reach the road proper, the scene looks more like country than suburb. We see over-hanging trees on one side and walls, fences and small trees and shrubs on the other, creating the effect of a tunnel of vegetation. The general effect of the dwindling perspective of the path and bushes either side of the road gives depth to the drawing. The sun has come out, throwing sharp shadows across the path interspersed with bright sunlit splashes. The overall effect is of a deep perspective landscape in a limited terrain.

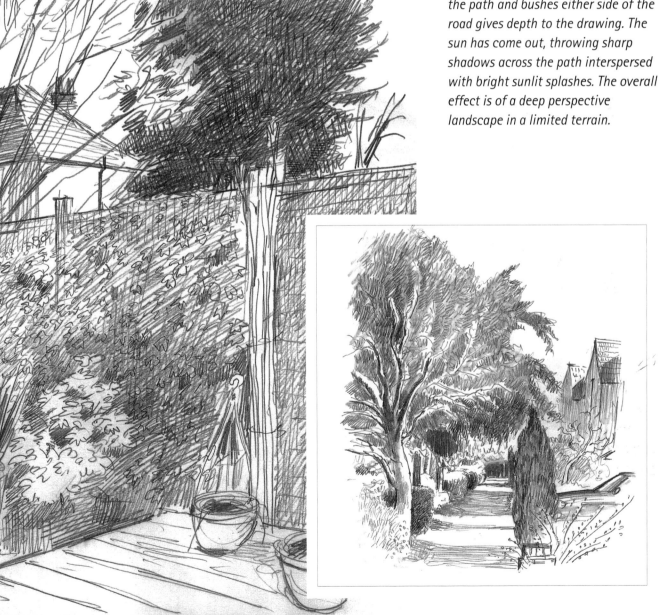

## FRAMING A VIEW

One way to get a better idea of what you are going to draw when you attempt a landscape is to use a frame. The drawing on page 170 was isolated in this way by the ready-made frame of the window. Most artists use a frame at some time as a means of limiting the borders of their vision and helping them to decide upon a view, especially with large landscapes.

In the first example below a very attractive Lakeland view has been reduced to a simple scene by isolating one part of it. With landscape drawing it is important to start with a view you feel you can manage. As you become more confident you can include more. You will notice how the main shapes are made more obvious by the framing method.

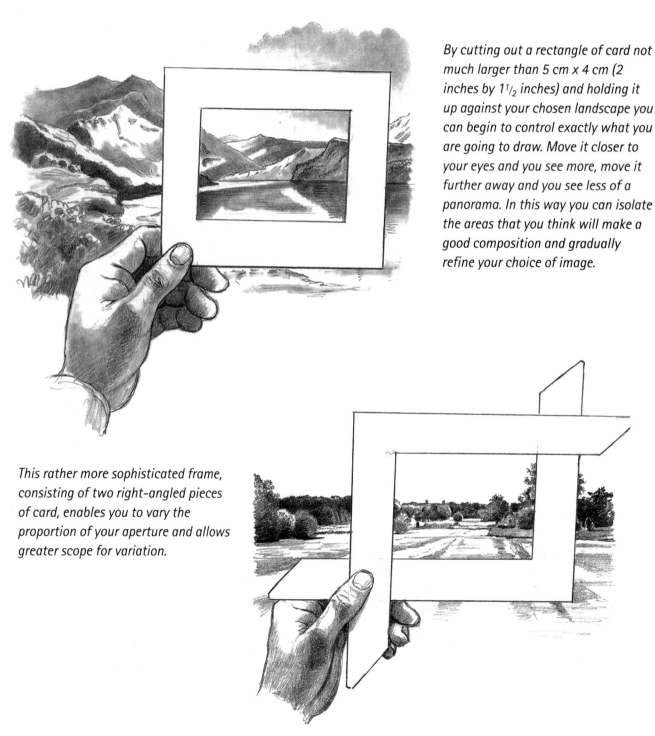

*By cutting out a rectangle of card not much larger than 5 cm x 4 cm (2 inches by 1½ inches) and holding it up against your chosen landscape you can begin to control exactly what you are going to draw. Move it closer to your eyes and you see more, move it further away and you see less of a panorama. In this way you can isolate the areas that you think will make a good composition and gradually refine your choice of image.*

*This rather more sophisticated frame, consisting of two right-angled pieces of card, enables you to vary the proportion of your aperture and allows greater scope for variation.*

## CHOOSING A SIZE

At some point you will have to decide how large your picture is going to be. In the beginning you may only have a small pad at your disposal, and this will dictate your decision. Starting small and gradually increasing the size of your picture is advisable for the inexperienced, but you will quickly get beyond this stage and want to be more adventurous.

Ideally you should have a range of sketchbooks to choose from: small (A5), medium (A4) and large (A3). If this seems excessive, choose one between A5 and A4 and also invest in a larger A3. A5 is a very convenient size for carrying around but isn't adequate if you want to produce detailed drawings, so a hybrid between it and A4 is a good compromise. The cover of your sketchbook should be sufficiently stiff to allow it to be held in one hand without bending while you draw.

The grade of paper you use is also important. Try a 160gsm cartridge, which is pleasant to draw on and not too smooth.

When it comes to tools, soft pencils give the best and quickest result. Don't use a grade harder than B; 2B, 4B and 6B offer a good combination of qualities and should meet most of your requirements. See Materials for additional information (pp 8–9).

*It is not too difficult to draw a landscape on an A5 pad, but it does limit the detail you can show.*

*When you are more confident, try a larger landscape on an A2 size sheet of paper. This can be placed on a board mounted on an easel or just leant against a convenient surface.*

*When you are really confident it is time to look at different types of proportion and size. One very interesting landscape shape is the panorama, where there is not much height but an extensive breadth of view. This format is very good for distant views seen from a high vantage point.*

## VIEWPOINTS

Finding a landscape to draw can be very time-consuming. Some days I have spent more time searching than drawing. Never regard search time as wasted. If you always just draw the first scene you come to, and can't be bothered to look around that next corner to satisfy yourself there is nothing better, you will miss some stunning opportunities. Reconnaissance is always worthwhile.

Let's look at some different kinds of viewpoint and the opportunities they offer the artist.

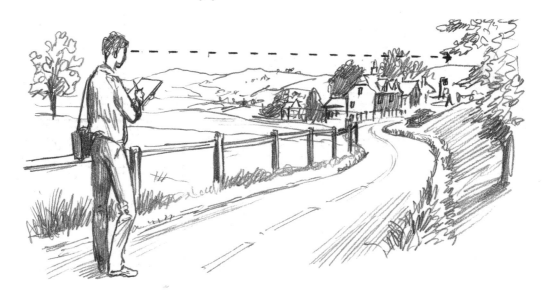

*A view along a diminishing perspective, such as a road, river, hedge or avenue, or even along a ditch, almost always allows an effective result. The change of size gives depth and makes such landscapes very attractive. Well-drawn examples of this type suggest that we, the onlookers, can somehow walk into them.*

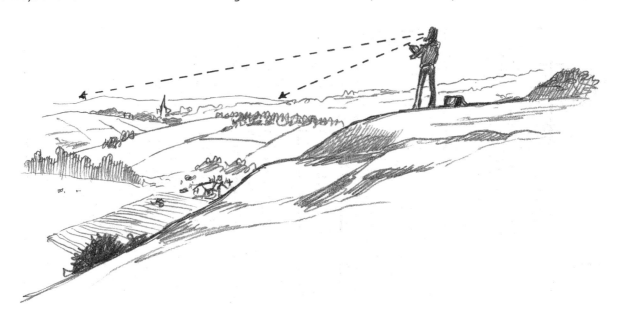

*A landscape seen from a high point is usually eye-catching, although not always easy to draw. Look for a high point that offers views across a valley to other high points in the distance. From such a perspective the landscape is somehow revealed to the viewer. If you try this approach, you will have to carefully judge the sizes of buildings, trees and hillsides to ensure the effect of distance is recognized in your picture.*

## EDITING YOUR VIEWPOINT

A good artist has to know what to leave out of his picture. You don't have to rigorously draw everything that is in the scene in front of you. It is up to you to decide what you want to draw. Sometimes you will want to include everything, but often some part of your chosen view will jar with the picture you are trying to create. Typical examples are objects that obscure a spacious view or look too temporary, or ugly, for the sort of timeless landscape you wish to draw. If you cannot shift your viewpoint to eliminate the offending object, just leave it out. The next two drawings show a scene before and after 'editing'.

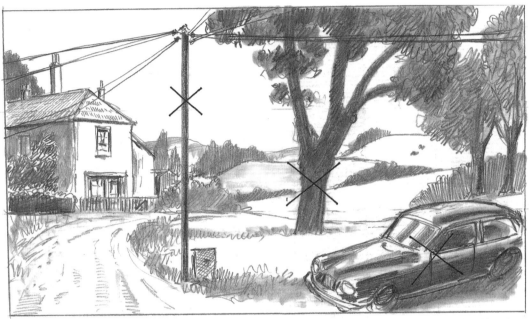

*In this view a telegraph pole and its criss-crossing wires, a large tree and a car parked by the road are complicating what is an attractive landscape.*

*Eliminate those offending objects and you are left with a good sweep of landscape held nicely between the country cottage and unmade road, and the coppice of trees over to the right.*

## TYPES OF LANDSCAPE

Put very simply, there are four possible types of landscape to be considered in terms of the size and shape of the picture you are going to tackle.

Your landscape could be large and open, small and compact, tall and narrow or very wide with not much height.

*Small and compact: The emphasis here is on the close-up details and textures in the foreground, with a good structural element in the middleground and a well defined but simplified background. The direction of the light helps the composition, showing up the three-dimensional effects of the row of small cottages with the empty road between them and the solid-looking hedges and walls in the foreground. Look at the way the pencil marks indicate the different textures and materiality of these various features.*

*Open and spreading: The most impressive aspect of this example is the sculptural, highly structured view of the landscape. This has been achieved by keeping the drawing very simple. Note that the textures are fairly homogenous and lacking in individual detail. The result is a landscape drawing that satisfies our need for a feeling of size and scope.*

*Tall: Because most landscapes are horizontally extended, generally speaking, the vertical format is not appropriate. However, where you are presented with more height than horizontal extension the vertical format may come into its own, as here. The features are shown in layers: a road winding up a hill where a few cypresses stand along the edge of the slope, sharply defined; behind it another hill slanting off in the opposite direction; and above that the sky with sun showing through mist.*

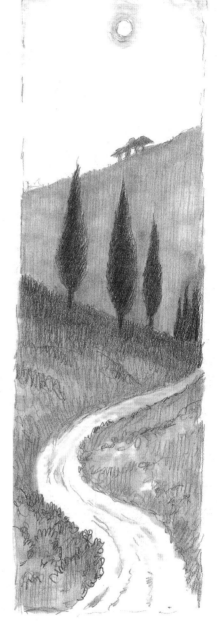

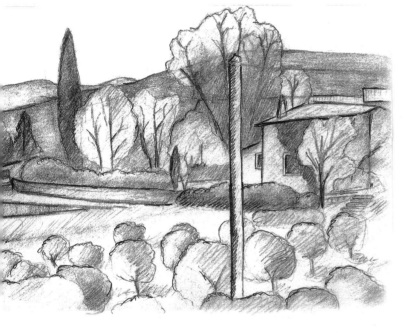

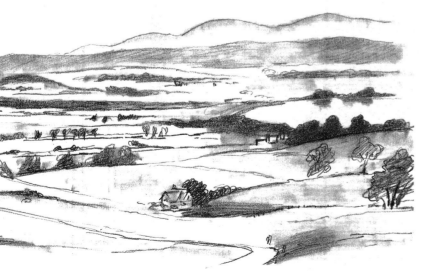

*Panoramic: The basis of landscape is the view you get when you rotate your head around 90 degrees and cover a very wide angle of vision. However, this type is not easy to draw because you have to keep changing your point of view and adjusting your drawing as you go. Remember: the vertical measurement of a panoramic drawing is always much less than the horizontal measurement.*

## VIEWING THE GROUND

All landscapes have, at most, three layers of depth or vertical development: background, middleground and foreground.

How well you manipulate the space occupied by these areas is very important (see pp 232–239 for more on this).

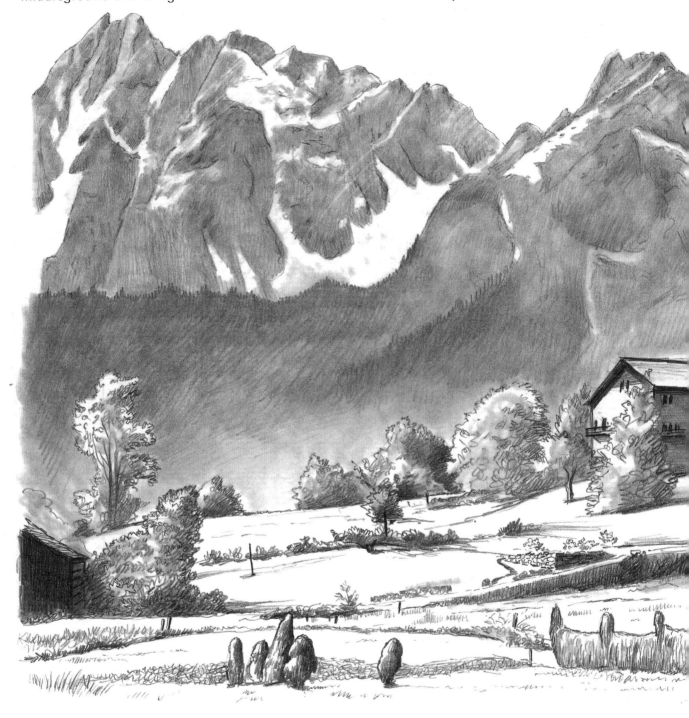

*The foreground is important to the overall effect of a composition, its details serving to lead the eye into a picture, and also to the observation of the more substantial statement made by features in the*

*middleground. Intentionally there is usually not much to hold the attention. The few features are often drawn precisely with attention given to the textures but not so much as to allow them to dominate the picture.*

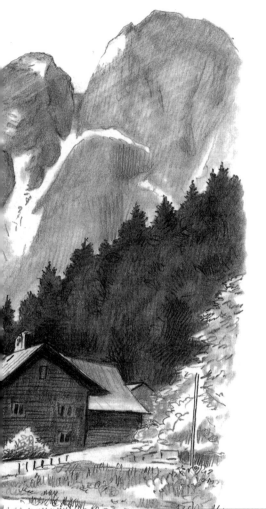

*The background is the most distant part and is usually less defined, less textured and softer in effect.*

*The middleground forms the main part of most landscapes, and gives them their particular identity. The structure of this layer is important because the larger shapes produce most of the interest. However, any details can vary in clarity.*

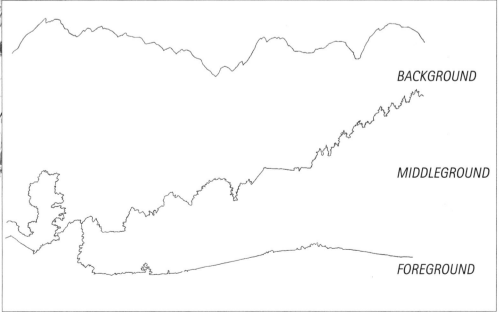

BACKGROUND

MIDDLEGROUND

FOREGROUND

## SKIES AND HILLS

Any landscape will be made up of one or more of the features shown on the following pages. These are sky, hills, water, rocks, vegetation (such as grass and trees), beach and buildings. Obviously each grouping offers enormous scope for variation. For the moment I want you to look at each set of comparative examples and note how the features are used.

*A very simple landscape/seascape is brought to dramatic life by the contrast of dark and light tones. The moon shines through clouds that show up as dark smudges around the source of light. The lower part of the picture features calm water reflecting the light, and the dark silhouette of a rocky shore.*

*A halcyon sky takes up almost three-quarters of this scene and dominates the composition, from the small cumulus clouds with shadows on their bases to the sunlight flooding the flat, open landscape beneath.*

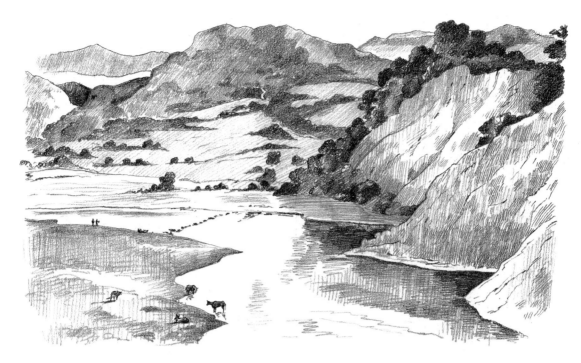

In this example the high viewpoint allows us to look across a wide river valley to rows of hills receding into the depth of the picture. The tiny figures of people and cattle standing along the banks of the river give scale to the wooded hills. Notice how the drawing of the closer hills is more detailed, more textured. Their treatment contrasts with that used for the hills further away, which seem to recede into the distance as a result.

The myriad layers of features make this type of landscape very attractive to artists. This example is after Leonardo. Notice the way details are placed close to the viewer and how the distance is gradually opened up as the valleys recede into the picture. Buildings appear to diminish as they are seen beyond the hills and the distant mountains appear in serried ranks behind.

## WATER AND ROCKS

The reflective qualities of water make it a very useful addition to a landscape. It can also introduce movement to contrast with stiller elements on view. Below we look at two of the possibilities given by the addition of water. On the opposite page we consider the raw power that the inclusion of rocks can bring to a picture.

*The impact of this wintry scene (after Monet), is made by the contrasts in darks and lights. These are noticeable between the principal features and especially within the river. Contrast the dark of the trees on either bank of the river with the white of the snow-covered banks; the inky blackness where the tall poplars on the far bank reflect in the water; the grey of the wintry sky reflecting in other areas of the river; and the brilliance of the white ice floes. On the bank a few smudgy marks help to define the substance of the snowy landscape.*

*The River Oise in summer (after Perrier) looks more inviting than Monet's depiction of the Seine. The leafy trees are presented as a solid mass, bulking up above the ripples of the river, where the shadowed areas of the trees are strongly reflected. The many horizontal strokes used to draw these reflections help to define the rippling surface of the calmly flowing river.*

The turbulence of the water and its interaction with the static rocks is the point of this small-scale study. Note how the contrast between the dark and light parts of the water intensifies nearer to the shore. As the water recedes towards the horizon the shapes of the waves are less obvious and the tonal contrast between the dark and light areas lessens.

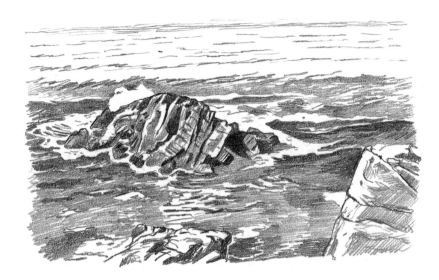

This close-up of a rocky promontory shows starkly against a background of mountaintops drawn quite simply across the horizon. The rock wall effectively shadows the left-hand side of the hill, creating a strong definite shape. In the middleground large boulders appear embedded in the slope. Smaller rocks are strewn all around. Note how the shapes of the rocks and the outline of the hill are defined by the intelligent use of tone.

The main feature in this landscape is the stretch of rocky shoreline, its contrasting shapes pounded smooth by heavy seas. Pools of water reflect the sky, giving lighter tonal areas to contrast with the darker shapes of the rock. This sort of view provides a good example of an important first principle when drawing landscapes: include more detail close to the viewer, less detail further away.

## GRASS AND TREES

Grass and trees are two of the most fundamental elements in landscape. As with the other subjects, there are many variations in type and in how they might be used as features.

*Tufts and hummocks of grass mingle with flowers in this close-up of a hillside. The foreground detail helps to add interest to the otherwise fairly uniform texture. The smoothness of the distant hills suggests that they too are grassy. The dark area of trees just beyond the edge of the nearest hill contrasts nicely with the fairly empty background.*

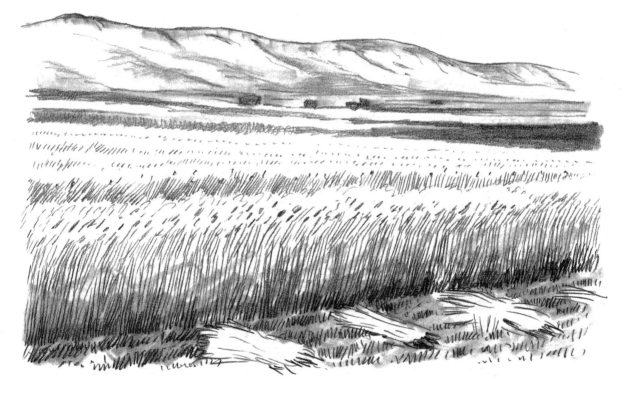

*Cultivated crops produce a much smoother top surface as they recede into the distance than do wild grasses. The most important task for an artist drawing this kind of scene is to define the height of the crop – here it is wheat – by showing the point where the ears of corn weigh down the tall stalks. The texture can be simplified and generalized after a couple of rows.*

When you tackle trees, don't try to draw every leaf. Use broad pencil strokes to define areas of leaf rather than individual sprigs. Concentrate on getting the main shape of the tree correct and the way the leaves clump together in dark masses. In this copy of a Constable the trees are standing almost in silhouette against a bright sky with dark shadowy ground beneath them.

The trees in this old orchard were heavy with foliage when I drew them, on a brilliant, sunny day. Nowhere here is there a suggestion of individual leaves, just broad soft shapes suggesting the bulk of the trees. They presented themselves as textured patches of dark and light with a few branches and their trunks outlined against this slightly fuzzy backdrop. An area of shadow under the nearest trees helps define their position on the ground. At left some old beehives show up against the shadow. In the immediate foreground the texture of leafy plants in the grass helps to give a sense of space in front of the trees.

## BEACHES

Beaches and coastline are a rather specialized example of landscape because of the sense of space that you find when the sea takes up half of your picture.

Our first view is of Chesil Bank in Dorset, which is seen from a low cliff-top looking across the bay. Our second is of a beach seen from a higher viewpoint, from one end, and receding in perspective until a small headland of cliffs, just across the background.

*This view looks very simple. A great bank of sand and pebbles sweeping around and across the near foreground with a lagoon in front and right in the foreground, and hilly pastureland behind the beach at left. Across the horizon are the cliffs of the far side of the* bay and beyond them the open sea. Notice the smooth tones sweeping horizontally across the picture to help show the calm sea and the worn-down headland, and the contrast of dark tones bordered with light areas where the edge of sand or shingle shows white.

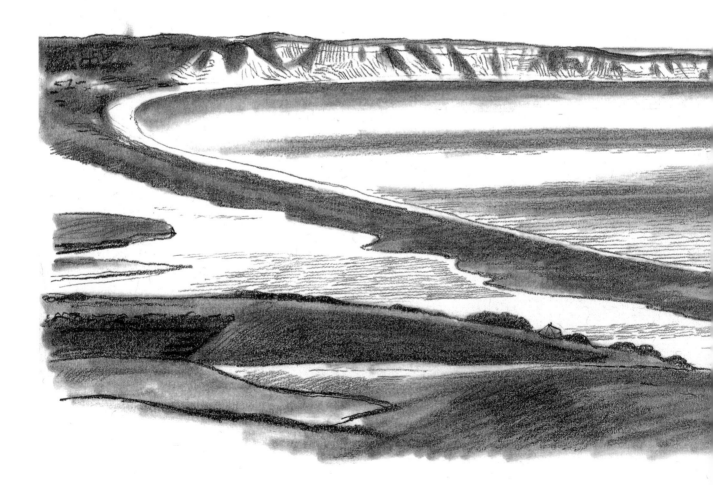

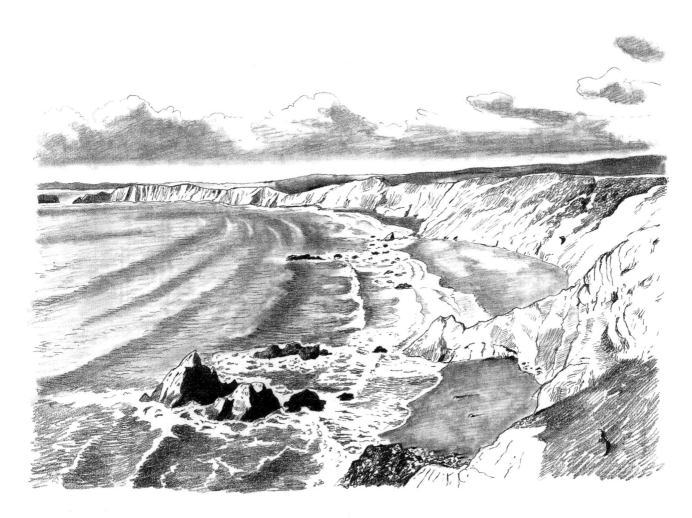

Here the dark, grassy tops of the cliffs contrast with the lighter rocky texture of the sides as they sweep down to the beach. The beach itself is a tone darker than the cliff but without the texture. The hardest part of this type of landscape is where the waves break on the shore. You must leave enough white space to indicate surf, but at the same time intersperse this with enough contrasting areas of dark tone to show the waves. The tone of the rocks in the surf can be drawn very dark to stand out and make the surf look whiter. The nearest cliff-face should have more texture and be more clearly drawn than the furthest cliff-face.

## UNDERSTANDING PERSPECTIVE

The science of perspective is something with which you will have to become acquainted in order to produce convincing depth of field. This is especially important if you want to draw urban landscapes. The following diagrams are designed to help you understand how perspective works and so enable you to incorporate its basic principles in your work.

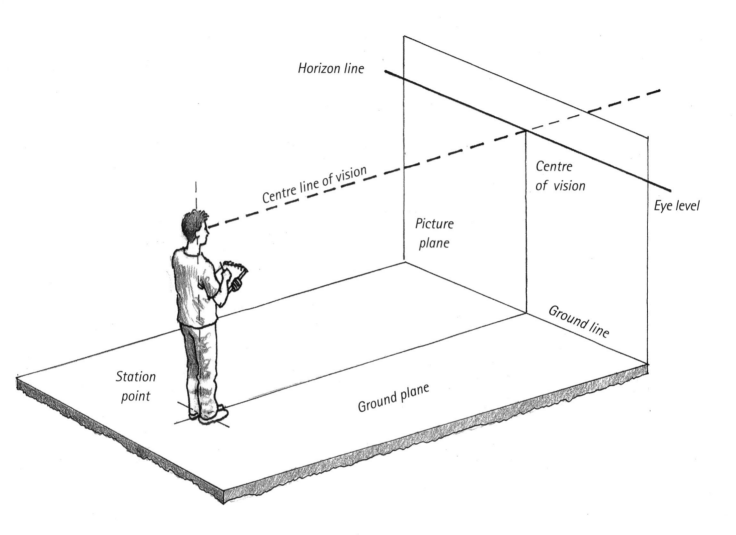

*Like any science, perspective comes with its own language and terms. This diagram offers a visual explanation of the basic terms as well as giving you an idea of the depth of space. The centre line of vision is the direction you are looking in. The horizon line or your eye level produces the effect of the distant horizon of the land or sea. The picture plane is effectively the area of your vision where the landscape is seen. The other terms are self-explanatory.*

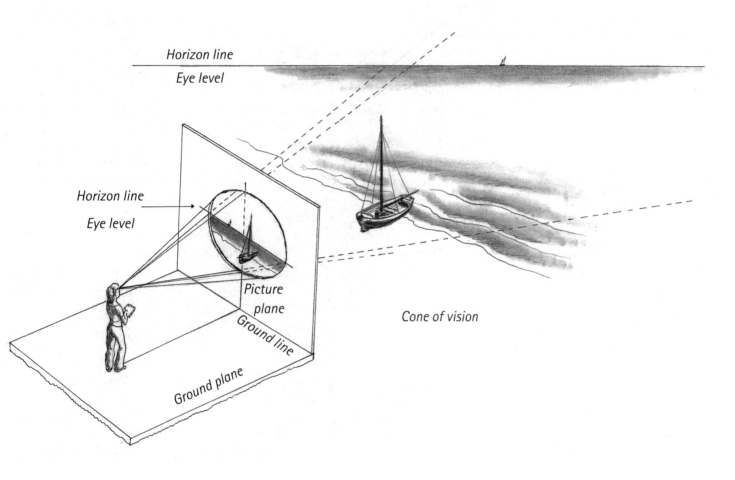

The cone of vision is a sort of mental construct of how much you can draw without the effects of distortion appearing in your picture. In practice it is what you can take in of a scene without turning your head; it extends to about 60 degrees across. The cone of vision in our illustration encompasses the whole view right to the distant horizon. When you look through the lens of a camera, you may have noticed that the shapes of the objects on the periphery of your vision appear to be slightly different than when you look directly at them. Here, the impression of the scene through the cone of vision is that the nearer areas are much larger than the distant areas, whereas in reality the reverse is true. The cone of vision is of necessity a narrow view of a scene.

189

## TYPES OF PERSPECTIVE

Because the eye is a sphere it comprehends the lines of the horizon and all verticals as curves. You have to allow for this when you draw by not making your perspective too wide, otherwise a certain amount of distortion occurs. Below we look at three types of perspective, starting with the simplest.

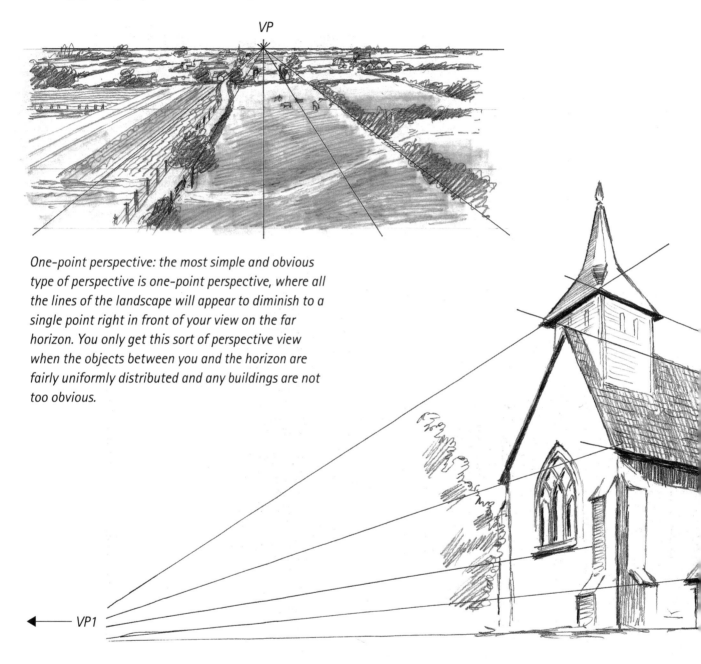

*One-point perspective: the most simple and obvious type of perspective is one-point perspective, where all the lines of the landscape will appear to diminish to a single point right in front of your view on the far horizon. You only get this sort of perspective view when the objects between you and the horizon are fairly uniformly distributed and any buildings are not too obvious.*

*Two-point perspective: where there is sufficient height and solidity in near objects (such as houses) to need two vanishing points at the far ends of the horizon line, two-point perspective comes into play. Using two-point perspective you can calculate the three-dimensional effect of structures to give your picture convincing solidity and depth. Mostly the vanishing points will be too far out on your horizon line to enable you to plot the converging lines precisely with a ruler. However, if you practise drawing blocks of buildings using two vanishing points you will soon be able to estimate the converging lines correctly.*

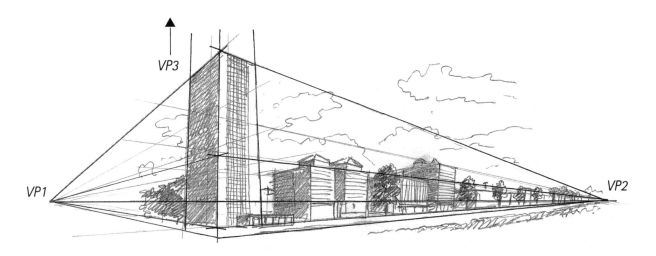

Three-point perspective: when you come to draw buildings that have both extensive width and height, you have to employ three-point perspective. The two vanishing points on the horizon are joined by a third which is fixed above the higher buildings to help create the illusion of very tall architecture. Notice in our example how the lines from the base of the building gently converge to a point high in the sky. Once again, you have to gauge the rate of the convergence. Often, artists exaggerate the rate of convergence in order to make the height of the building appear even more dramatic. When this is overdone you can end up with a drawing that looks like something out of a comic book.

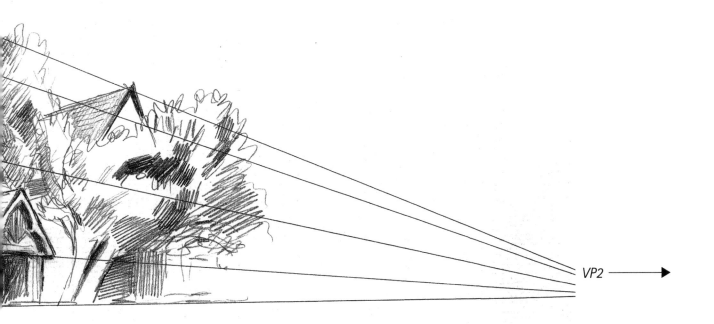

## USING PERSPECTIVE

This drawing of the entrance to the mountain town of Boveglio in Tuscany gives many clues to our position and that of the buildings in front of us. The angle of the steps and the change in size of the windows provide information that helps us to detect how the path winds up into the old town.

A classic image of perspective is instantly shown in this drawing of railway lines. The drama of the curve as the rails sweep around to the left where they merge and disappear takes us into the picture and shows us the clarity of perception of the viewer. All that we see beyond the rails are softly silhouetted buildings about half a kilometre away.

The chaos of signs and telephone wires along a
Melbourne street give us a sense of the texture of
Australian city life. The sweep of the road and
the diminishing sizes of the vehicles certainly convince
us of the distance observed, and yet the signs and
posts flatten out the depth, making it difficult to
judge distances.

## ENCLOSED LANDSCAPES

An enclosed landscape is characterized by a limitation of the spread of land. This limitation occurs either out of choice – i.e. the artist choosing a viewpoint that purposely excludes a wider or deeper spread – or in a landscape where the number of features cuts off a view that might otherwise be more expansive. Artists sometimes choose enclosed landscapes when they want us to concentrate on a feature – perhaps a figure or figures – in the foreground, as in our first example, after Giorgone's painting *Tempest*.

*Without the two figures in Giorgone's original we can concentrate on how the artist succeeds in limiting the extent of our vision while achieving an impressive effect of depth. The composition is carefully framed by dark trees on the right and a tower-like edifice surrounded by trees and bushes on the left. The effect is to funnel our view towards the centre of the picture. The bridge and the buildings also ensure that our attention doesn't wander beyond the left bank of the stream and the broken pillars (where the figures are placed in the original).*

## OPEN LANDSCAPES

As you will see from the following examples, an open landscape is one in which an effect of space combines with a feeling that we are looking at a view that has no limits. All that is visible goes into the horizon and beyond.

In the examples of an enclosed landscape we saw how the artists had chosen to focus the viewer's attention on features in the foreground by restricting their vision. Here you will see how exactly the same effect can be achieved seemingly by doing precisely the opposite.

*In Agony in the Garden (after Bellini) the figures of Christ praying and three of his apostles sleeping are set in a landscape of immense vistas and spaciousness. The original painting is quite small, but the artist's understanding of the use of perspective suggests a much larger format.*

*The large rocks and figures are set against a flat, open landscape. A road or path can be seen winding back into the middle distance. To the left is a large hill sloping up to a town or village with cliffs and paths along its side. To the right in the middle distance is a high cliff. Beyond that in the far distance is a hill*

*sweeping up towards another town or village with a tower at the top as a focal point. The figure of Christ, who is placed so that his head is above the skyline, appears to be pointing towards this distant focal point.*

*The feeling of immense space in the landscape is beautifully suggested by this contrast between the close-up figures and landscape around them and the distant views of hilltop buildings and open spaces between. The careful graduation of highly detailed features in the foreground and diminishing detail as the landscape moves away from our gaze is masterly.*

## DIVIDING A PANORAMA

A large panorama can be very daunting to the inexperienced artist who is looking at it with a view to making a composition. There can appear to be a bewildering amount to think about.

The first point to remember is that you don't have to draw all you see. You can decide to select one part of the landscape and concentrate on that area alone. This is what I have done with the drawing below, dividing it into three distinct and separate compositions.

See the next spread for assessments of the individual drawings.

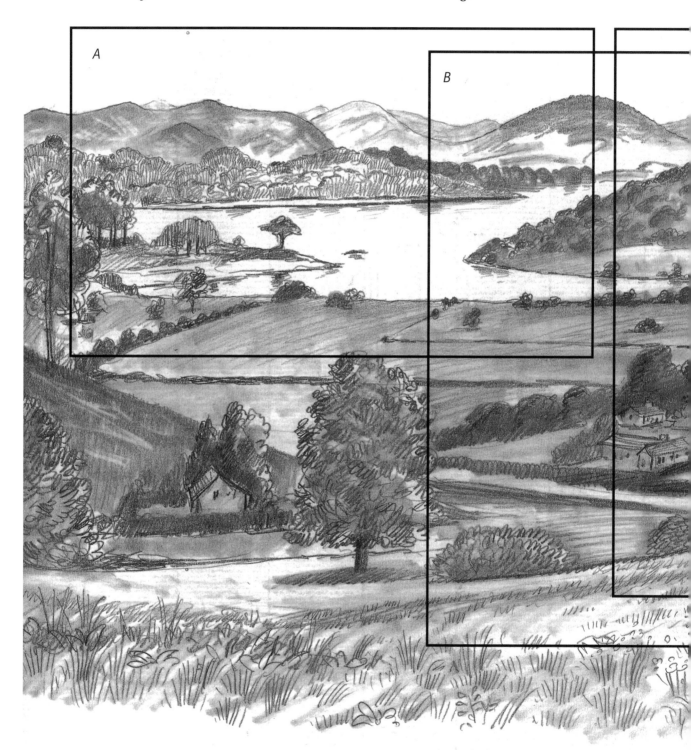

A

B

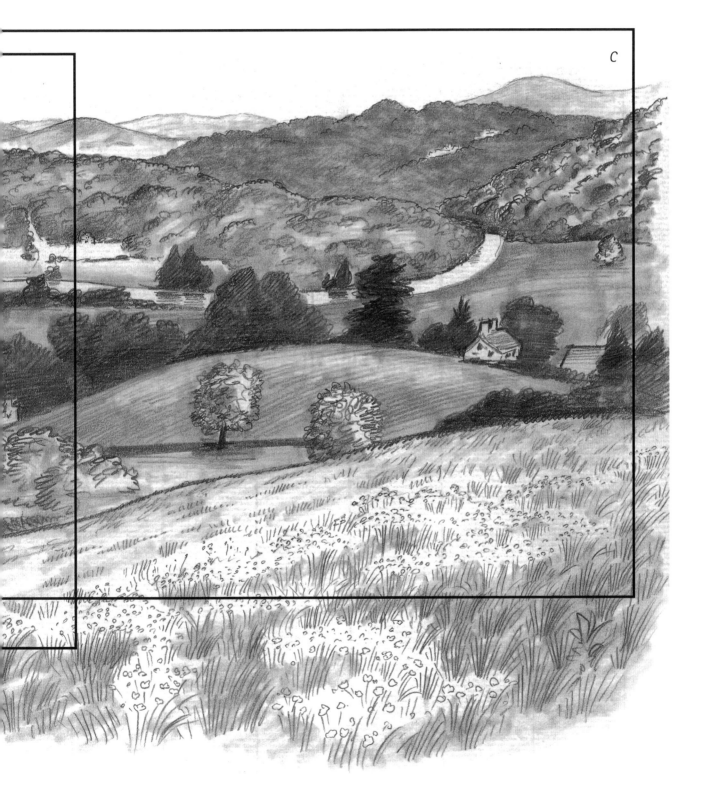

*c*

I have extracted three views from the large landscape on the previous spread, each of them equally valid. Read the captions to find out how they work compositionally.

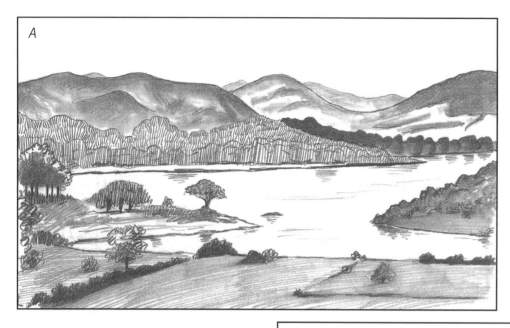

A: The main feature in this part of the landscape is a large area of water that extends right across the whole composition. The large hills in the background provide a backdrop to the more open landscape on the near side of the water. Two small spits of land jut out from either side just above the foreground area of open fields with a few hedges and trees.

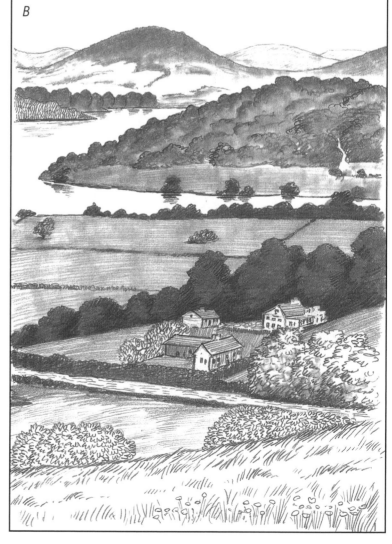

B: With its more vertical format this composition gives just a hint of the open water beyond the stretch of river in the middle ground. The extensive foreground contains hedges, trees, bushes and cottages. The wooded hill across the river provides contrast and the slope of hillside in the near foreground also adds dimension. The distant hills provide a good backdrop.

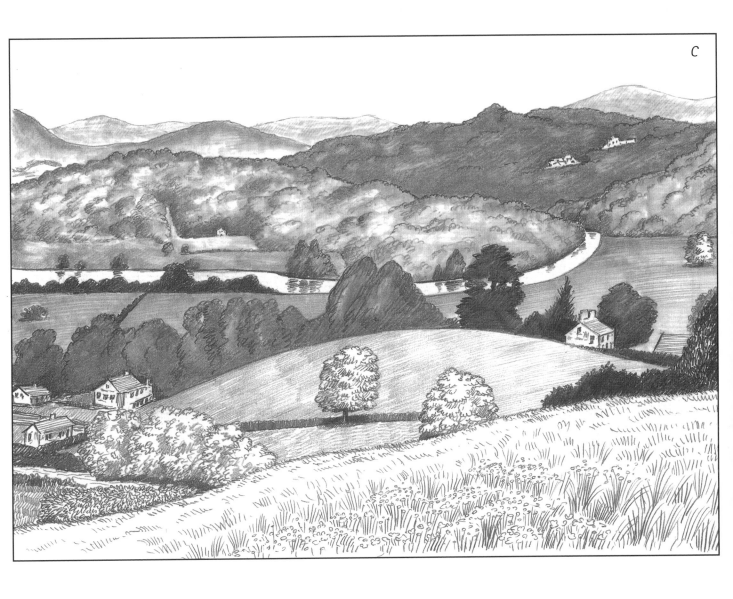

C

C: Here we have a horizontal layered set of features receding back into the picture plane. In the foreground is a close-up of hillside sloping across from right to left. Just beyond is a low rounded hill-form surrounded by trees and in the left lower corner some houses. Beyond the low hill is the river curving around a large bend and disappearing into wooded banks on the right. The banks slope up either side into wooded hills, and beyond these into another layer showing a larger darkly wooded hill with a couple of villages or properties to the right. At upper left is layer upon layer of hills disappearing into the distance.

## SAME LANDSCAPE: DIFFERENT WEATHER

One very significant feature in any landscape is the weather. In every season there are different effects. These can be as basic as the change in the look of the sky. More dramatic events will demand that you change the way you draw and perhaps use different techniques. We shall look at these techniques in detail later. For now, just note the shifts from sunshine to rain, and from snowfall to mist.

Shown here are four versions of the same landscape, of Fiesole in Tuscany, drawn almost in the same way, without the application of any special techniques, but merely adapting the same medium to the changing scene.

*Intense sunlight is very typical of this region in summer. Everything in the picture is clearly defined with a lot of contrast between black and white. Shadows tend to be sharp-edged and strong. Where there is a medium shadow it is a smooth all-over tone. Even the distant hillsides are sharply defined with the trees darkly marked and clearly silhouetted against the skyline.*

*For the visual effect of rain, I've used downward strokes of the pencil. You'll notice the tones are rather soft overall and similar; the darkest shadows are not very much darker than the lighter ones, and even the lightest areas have some tone. The distant hillsides just become simple areas of tone in vertical strokes. The pattern of raindrops on the path helps to maintain the effect.*

With the landscape covered in snow, there is a great deal of contrast between the snow and other features; here it is between the brightness of the snow lying on the ground, roofs and amongst foliage and the dark tones of the vertical walls of the buildings and the sky. The line of trees on the horizon stands out starkly against the snow-covered hills below it. The overall effect is almost like a negative photograph.

Seen in mist the same landscape is almost unrecognizable, with its contours softened and the tonal areas simplified. Shapes seem to loom up out of the background rather than show themselves clearly. The pencil tones have been smudged with a stump or stub to soften the contrasts.

## SAME SCENE: DIFFERENT VIEWPOINT

The view we get of a landscape is determined by our position. Take the same landscape and view it from three different positions and you will get three different compositions. In the next three drawings we view the landscape across the valley of the River Stour (after Constable), from three different positions. Compare the three and note how the change in position alters the balance of the elements as well as the overall appearance of the scene.

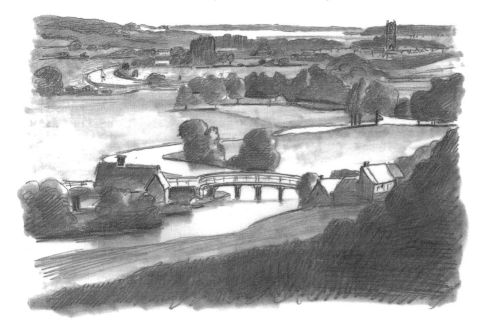

*This is quite literally taking the highest viewpoint, which was where Constable chose to position himself to record the scene. From here we get a very broad, expansive view.*

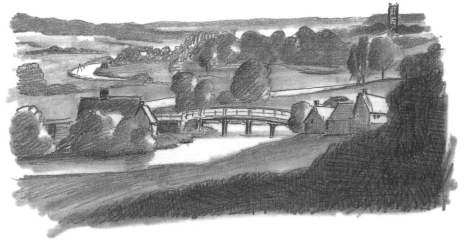

*If we come down the hill a short way, although we still get quite a broad view, the land in the distance is greatly compressed. Our eye is drawn to the dominant nearer and middleground.*

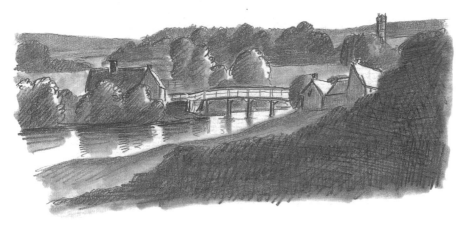

*Lower still and the distant horizon is almost completely blocked out by the houses and trees in what is now the middleground. The only distant feature visible is the tower of the church.*

## SAME SCENE: DIFFERENT TECHNIQUE

There is more than one way of drawing landscapes. People often think, erroneously, that everything has to be drawn exactly as it would be seen by the eye or lens of a camera, and if a high degree of verisimilitude is not achieved a drawing is worthless. Below are two different approaches to the same landscape. Beginners who are not confident of their drawing skills might find the technique used in the second of these worth considering.

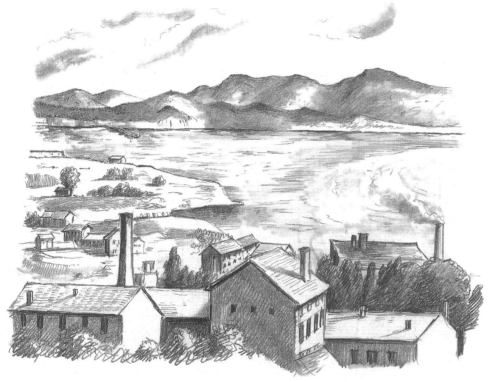

*The difference between distant and close-up objects is made obvious by means of texture, definition and intensity. The weight and thickness of line varies to suggest the different qualities of features and their distance in relation to each other and the viewer.*

*Here an attempt has been made to create an extremely simple scheme of solid forms. The only difference between the treatment of nearer forms and further ones is in intensity. Every detail has been subsumed in the effort to describe the solidity of the forms in a very simple way. The result is a sort of sculptural model universe where the bulk of the form is clearly shown but the differences in texture or detail are greatly reduced. The effect is of a very strong three-dimensional landscape, albeit one that is rather detached from the way our eyes would really see it. Nevertheless many artists have used this increase in total form successfully.*

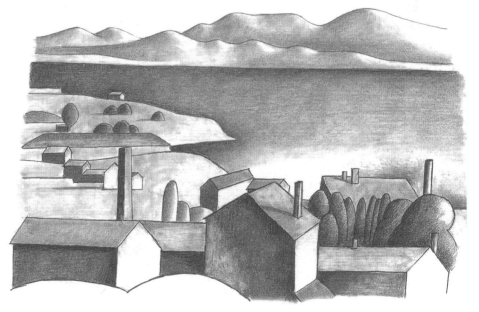

## CENTRING A LANDSCAPE

Every landscape has particular features that can be used to focus the onlooker's attention. A road, building, mountain or river can serve to draw the eye into the heart of a composition. At the same time these methods of engaging the interest are what persuade the viewer to explore the depths and texture of a composition and evoke a similar response to that experienced when surveying a real landscape.

*A road snakes across a fairly featureless rolling open landscape almost devoid of contrast in vegetation or form. The eye is drawn by the line of the road to the distant horizon and then is allowed to scan out either side to take in the rest.*

*A building isolated in flat marshland which, except for the foreground fence, is largely featureless; even the canal is hidden by its banks. But the church immediately catches the eye and engages the attention within the picture.*

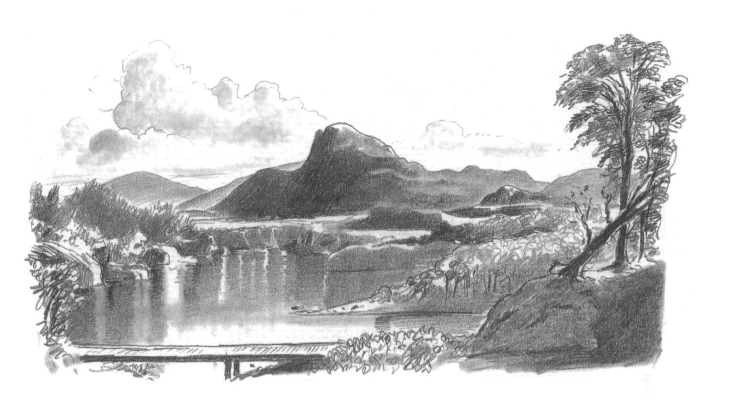

There are plenty of interesting contrasts in this example: water, trees, hills and a jetty in the front. However, the most dominant feature is the rocky hill in the middle distance standing out starkly against the skyline. This holds the attention and helps us to consider the depths shown in the picture.

The river in this view of the Catskill Mountains (after S.R. Gifford) serves a similar purpose to the road in the first drawing. The contrast between the dark tree-clad contours of the land and the brightly reflecting river draws us into the composition and takes us right to the horizon.

## PENCIL TECHNIQUES

The pencil is, of course, easily the most used instrument for drawing. Often though our early learning of using a pencil can blunt our perception of its possibilities, which are infinite.

*In* Road to Middelharnis *(after Hobbema) we see a fairly free pencil interpretation of the original, using both pencil and stump. The loose scribble marks used to produce the effect in this drawing will seem simple by comparison with our next example.*

*American artist Ben Shahn was a great exponent of drawing from experience. He advocated using gravel or coarse sand as models to draw from if you wanted to include a rocky or stony place in your drawing but were unable to draw such a detail from life. He was convinced that by carefully copying and enlarging the minute particles, the artist could get the required effect.*

*When you tackle a detailed subject, your approach has to be painstaking and unhurried. If you rush your work, your drawing will suffer. In this drawing, after putting in the detail, I used a stump to smudge the tones and to reproduce the small area of sea.*

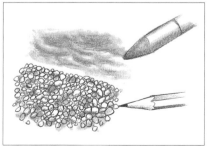

The pencil work used for this large old tree in a wood (after Palmer) is even looser in technique than that for the Hobbema. At the same time, however, it is very accurate at expressing the growth patterns of the tree, especially in the bark. It is best described as a sort of carefully controlled scribble style, with lines following the marks of growth.

## MATERIALS: PEN AND INK

The chief characteristics of pen and ink are precision, intensity and permanence. When using ink you have to make up your mind quite quickly and be sure of what you are doing – you can't change your initial decision halfway through. The medium can be used in a very decorative and formal way, in loose, flowing lines or scribbly marks. Any of these approaches can work well, but not if you mix them. The illusion you are trying to create will shatter if ink marks vary too greatly, with the formal lines becoming too rigid and the scribbled lines looking messy. In order to convince the eye and the mind, you have to decide whether your drawing is to be formal or loosely drawn.

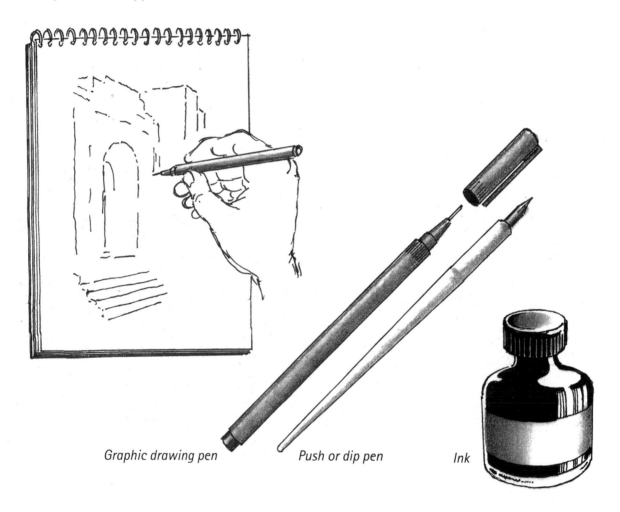

*Graphic drawing pen*     *Push or dip pen*     *Ink*

*Pen and ink is an even more linear medium than pencil and particularly lends itself to the linear qualities of architecture. There are two main types of pen for the artist: the push or dip pen and the graphic drawing pen.*

*Graphic line pens give a consistent black line and come in varying thicknesses: 0.1, 0.5, 0.8, etc. Usually you will need only two line pens: one very fine and the other about twice that thickness.*

*The ordinary push or dip pen used with Indian ink is more flexible than the graphic drawing pen and allows you to vary your line width just by altering the pressure.*

*Some pen nibs are very flexible, others stiffer, but you will need several different types, ranging from the finest point to a more flexible but rather thicker point.*

*There are various kinds of ink. The really black draughtsman's ink is consistent in quality and the non-waterproof Indian ink is easier to water down if you require lighter strokes. Art shops stock a range of inks; you just have to experiment to find out which you like best. I have found Chinese stick ink or that made from burnt oak apples most useful.*

Pen-line is very good for hard-edged subject matter such as this Roman arch at Pompeii. Notice how the tonal areas are made up of cross-hatched lines drawn closely together to create an area of tone. The brighter areas you leave almost untouched.

## PEN TECHNIQUES

Generally speaking any fine-pointed nib with a flexible quality to allow variation in the line thickness is suitable for producing landscapes. For his original of Mount Fuji (below) the Japanese artist Hokusai probably made his marks with a bamboo calligraphic nib in black ink. We have made do with more conventional pen and ink, but even so have managed to convey the very strong decorative effect of the original.

*Note how the outline of the trunk of the tree and the shape of the mountain is drawn with carefully enumerated lumps and curves. Notice too the variation in the thickness of the line. The highly formalized shapes produce a very harmonious picture, with one shape carefully balanced against another. Nothing is left to chance, with even the clouds conforming to the artist's desire for harmonization. With this approach the tonal textures are usually done in wash and brush, although pencil can suffice, as here.*

## MATERIALS: BRUSH AND WASH

The medium of tonal painting in brush and wash is time-honoured and beloved of many landscape artists, largely because it enables the right effect to be created quickly and easily. It also enables you to cover large areas quickly and brings a nice organic feel to the creative process. The variety of brushstrokes available enable the artist to suggest depth and all sorts of features in a scene. This imprecision is especially useful when the weather is a prominent part of the structure of your landscape and you want to show, for example, misty distance, rain-drenched trees or windswept vegetation.

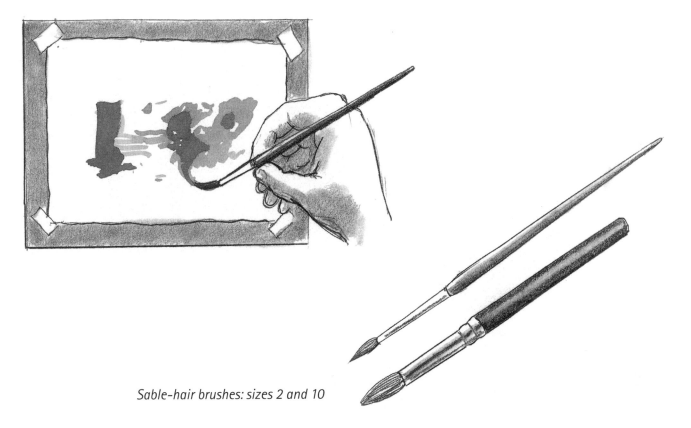

*Sable-hair brushes: sizes 2 and 10*

*You need at least two very good brushes for this technique. Resist the temptation to buy cheap brushes: they don't last, they lose their ability to keep a point and the hairs fall out. Sable makes the best type of brush. You don't have to spend a fortune, and you certainly don't need to invest in a whole range of brushes. The largest brush you will need for anything of sketchbook size is probably a No 10. The No 2 is small enough to paint most subjects finely. These two are essential.*

*You can use either water-soluble ink or just some black watercolour. To go out sketching with this medium, you will need a screw-cap pot for water and some kind of palette to thin out your pigment. I use a small china palette that will go in my pocket or just a small box of watercolours with its own palette. You can get these in many sizes, but the smallest ones are very useful. As a water pot I generally use a plastic film roll canister with an efficient clip-on lid, or a plastic pill-bottle with a screw cap. These are small enough to put in a pocket and easy to use in any situation. Laying on a wash of tone is not always easy, so you will need to practise.*

*If you like this method of drawing, invest in a watercolour sketchbook; its paper is stiff enough not to buckle under the effect of water, whereas regular heavy cartridge paper can buckle slightly. A good-quality watercolour paper (such as Arches or Bockingford) makes it very easy to get an effective wash of tone without too many brush marks showing.*

## BRUSH AND WASH TECHNIQUES

Beginners generally do not get on well with brush and wash. Watercolour, even of the tonal variety, demands that you make a decision, even if it's the wrong one. If you keep changing your mind and disturbing the wash, as beginners tend to do, your picture will lose its freshness and with it the most important quality of this medium.

*In* Gretna Bridge *(after English watercolourist John Sell Cotman) the approach is very deliberate. The main shapes of the scene are sketched in first, using sparse but accurate lines of pencil, not too heavily marked. At this stage you have to decide just how much detail you are going to reproduce and how much you will simplify, in the cause of harmony in the finished picture. Once you have decided, don't change your mind; the results will be much better if you stick to one course of action. The next step is to lay down the tones, being sure to put in the largest areas first. When these are in place, put in the smaller, darker parts over the top of the first, as necessary. You might want to add some finishing touches in pencil, but don't overdo them or the picture will suffer.*

## MATERIALS: CHALK

Chalk-based media, which include conté and hard pastel, are particularly appropriate for putting in lines quite strongly and smudging them to achieve larger tonal effects, as you will see from the example shown below, after Cézanne. In this case the heavy lines try to accommodate the nature of the features and details they are describing.

*The similarity of style over the whole rocky landscape in this drawing helps to harmonize the picture. Compare the crystalline rock structures and the trees. Both are done in the same way, combining short, chunky lines with areas of tone.*

## TREES IN THE LANDSCAPE

Drawing trees can be quite daunting when first attempted. When tackling a landscape with trees, artists just starting out often make the mistake of thinking they must draw on every leaf. Survey such a scene with your naked eye and you will discover that you can't see the foliage well enough to do this. You need to be bold and simplify. If you understand the general outline and appearance of different trees, you will convey a sense of the unity that exists in the landscape space.

The following series of drawings is intended to help you to capture the shapes of a range of common trees seen in full foliage and from a distance. You can see that differences in leaf type are indicated by marking the general texture and shape. Let's look at these examples.

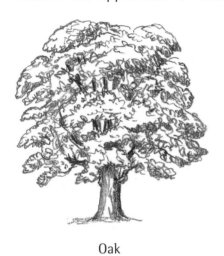

Oak

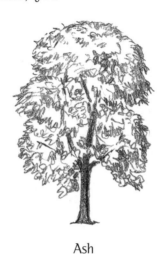

Ash

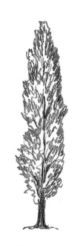

Lombardy poplar

*The oak makes a compact, chunky cloud-like shape, with leaves closely grouped on the mass of the tree.*

*By contrast the ash is much more feathery in appearance.*

*The poplar is indicated by long, flowing marks in one direction.*

Horse chestnut

Elm

Lime

*Some trees, such as the horse chestnut, can be blocked in very simply, just needing a certain amount of shading to indicate the masses.*

*The elm and lime are very similar in structure. The way to tell them apart is to note the differences in the way their leaves layer and form clumps.*

Cypress

Walnut

Sycamore

*The cypress holds itself tightly together in a flowing, flame-like shape; very controlled and with a sharp outline.*

*The walnut requires scrawling, tight lines to give an effect of its leaf texture.*

Holly

Weeping willow

Cedar of Lebanon

*The holly tree is shaped like an explosion, its dark, spiky leaves all outward movement in an expressive organic thrust.*

*You will also have to take note of where a darker or lighter weight of line or tone is required. Compare, for example, the weight of line needed for trees with dense dark leaves, such as the cypress and holly, with the light tone appropriate to the willow and cedar.*

*Although they are of a similar family, the cedar of Lebanon and yew are easily told apart. Whereas the yew is dense and dark the stately cedar is open-branched with an almost flat layered effect created by its canopies of soft-edged leaves.*

## ROCKS: ANALYSIS

Viewed from a considerable distance the details of a mountain range recede and your main concern is with the overall structure and shape of the mountains. The nearer you get the softer the focus of the overall shape and the greater the definition of the actual rocks.

Below we analyse two examples of views of rocks from different distances.

*In our first example, from a mountain range in Colorado, the peaks and rift valleys are very simply shown, giving a strong, solid look to the landscape. The main shape of the formation and the shadow cast by the light defines each chunk of rock as sharply as if they were bricks. This is partially relieved by the soft misty patches in some of the lower parts. The misty areas between the high peaks help to emphasize the hardness of the rock. Let's look at it in more detail.*

1.

1. Sketch in with a fairly precise line the main areas of the mountain shapes, keeping those in the background very simple. For the foreground shapes, clearly show the outlines of individual boulders and draw in details such as cracks and fissures.

2. The real effect comes with the shading in soft pencil of all the rock surfaces facing away from the light. In our example the direction of the light seems to be coming from the upper left, but lit from the back. Most of the surfaces facing us are in some shade, which is especially deep where the verticals dip down behind other chunks of rock. The effect is to accentuate the shapes in front of the deeper shade, giving a feeling of volume. In some areas large shapes can be covered with a tone to help them recede from the foreground.

2.

*All the peaks further back should be shaded lightly. Leave untouched areas where the mist is wanted. The result is a patchwork of tones of varying density with the line drawing emphasizing the edges of the nearest rocks to give a realistic hardness.*

*You will find this next example, drawn exclusively in line, including the shadows, a very useful practice for when you tackle the foreground of a mountainous landscape or a view across a valley from a mountainside.*

*The cracks in the surfaces and the lines of rock formation help to give an effect of the texture of the rock and its hardness. The final effect is of a very hard textured surface where there is no softness.*

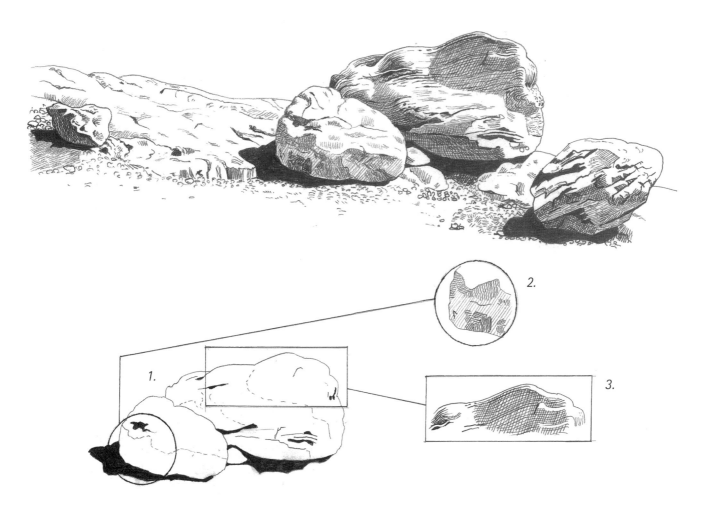

1. Draw in the outline as in the previous example, then put in areas of dark shadow as a solid black tone. Indicate the edges of the shaded areas by a broken or dotted line. Now carefully use cross-hatching and lines to capture the textured quality of the rock.
2. These particular rocks have the striations associated with geological stratas and as these are very clearly shown you can draw them in the same way. Be careful that the lines follow the bending shape of the stone surface and when a group of them change direction, make this quite clear in your drawing. This process cannot be hurried, the variation in the shape of the rock demanding that you follow particular directions. Some of the fissures that shatter these boulders cut directly across this sequence of lines. Once again they should be put in clearly.
3. Now we come to the areas of shadow which give extra dimension to our shapes. These shadows should be put in very deliberately in oblique straight lines close enough together to form a tonal whole. They should cover the whole area already delineated with the dotted lines. Where the tone is darker, put another layer of straight lines, close together, across the first set of lines in a clearly different direction.

## WATER FEATURES NEAR AND FAR

Water gives the landscape an added dimension of space, rather as the sky does. The fact that water is reflective always adds extra depth to a scene. The drawing of reflections is not difficult where you have a vast expanse of water flanked by major features with simple outlines, as in our first example. Use the technique shown, which is a simple reversal and you will find it even easier.

*Here the water reflects the mountains in the distance and therefore gives an effect of expanse and depth as our eyes glide across it to the hills. The reflection is so clear because of the stillness of the lake (Wastwater in the Lake District), and the hills being lit from one side. Only the ripples tell us this is water.*

*The mountains were drawn first and the water merely indicated. The drawing of the reflection was done afterwards, by tracing off the mountains and redrawing them reversed in the area of the water (see inset). This simple trick ensures that your reflection matches the shape of the landscape being reflected, but is only really easy if the landscape is fairly simple in feature. The ripple effect was indicated along the edges of each dark reflection, leaving a few white spaces where the distant water was obviously choppier and catching the sun.*

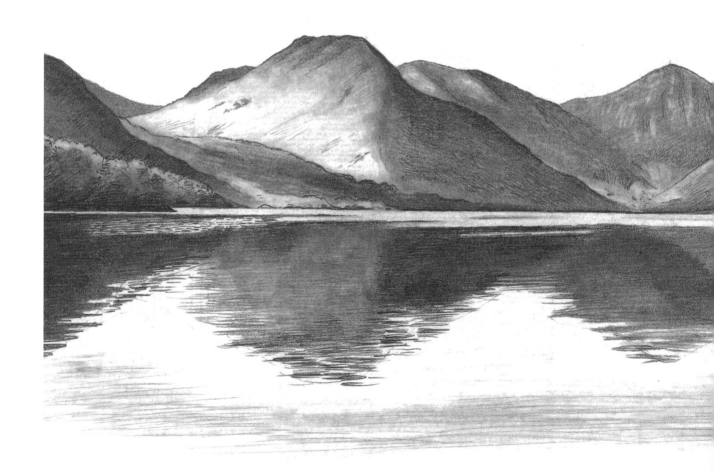

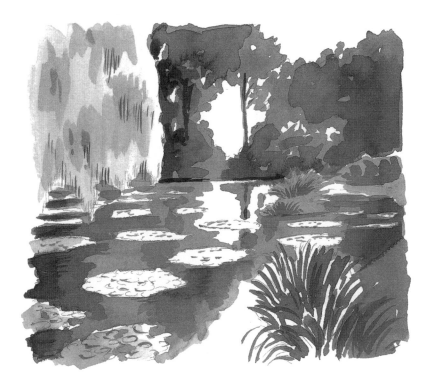

This view of Monet's pond at Giverny is seen fairly close up, looking across the water to trees and shrubs in the background. The light and dark tones of these reflect in the still water. Clumps of lily pads, appearing like small elliptical rafts floating on the surface of the pond, break up the reflections of the trees. The juxtaposition of these reflections with the lily pads adds another dimension, making us aware of the surface of the water as it recedes from us. The perspective of the groups of lily pads also helps to give depth to the picture.

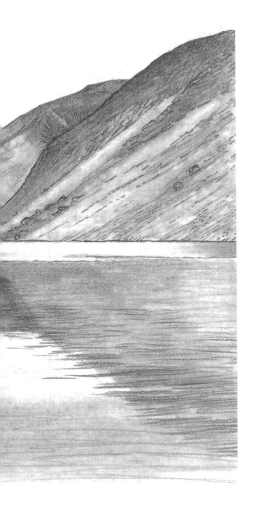

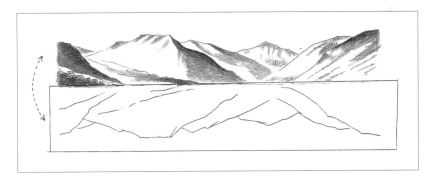

How to draw in a reflection – see main caption, left.

## WATER ON THE MOVE

You need time to capture accurately the swirls and shifting reflections in moving water. Leonardo da Vinci is said to have spent many hours just watching the movement of water, from running taps to torrents and downpours, in order to be able to draw the myriad shapes and qualities which such features present. So a bit of study is not out of place here. If you are able to draw still reflections, that is a good start. You will find the same reflections, only rather more distorted, in moving water.

We look next at a representative range of types of moving water for you to study.

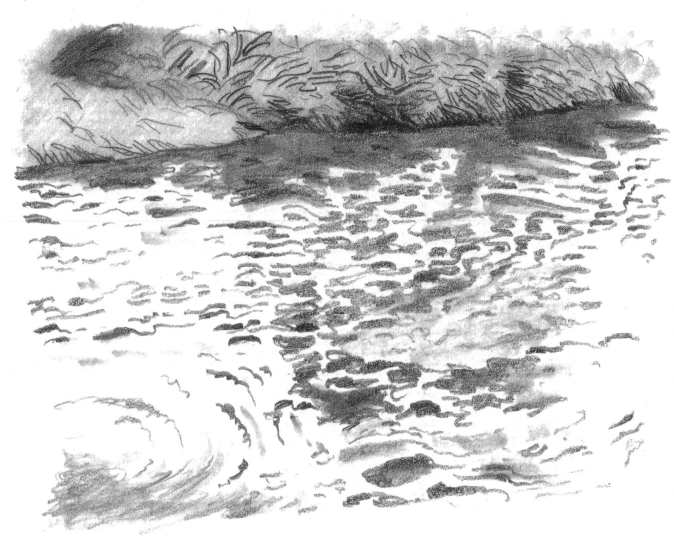

*Notice how in this moorland stream the surface of the water is broken up into dark and light rippling shapes that come about from the proximity of the stony bed of the stream to the surface. Everything that is reflected falls into this swirling pattern. After a few attempts you will find it is not that difficult to draw. The trick is to follow the general pattern rather than trying to draw each detailed ripple to perfection. With this type of stream the ripples always take on a particular formation which is repeated in slightly differing forms over and over again. Once you see the formation, it is just a question of putting down characteristic shapes and allowing them to fit together over the whole surface of the water, taking note of the dark tones in order to give structure to the whole scene.*

## FALLING WATER

One of the problems with drawing waterfalls is the immense amount of foam and spray that the activity of the water kicks up. This can only be shown by its absence, which means you have to have large areas of empty paper right at the centre of your drawing. Beginning artists never quite like this idea and usually put in too many lines and marks. As you become more proficient, however, it can be quite a relief to leave things out, especially when by doing so you get the right effect. The spaces provide the effect.

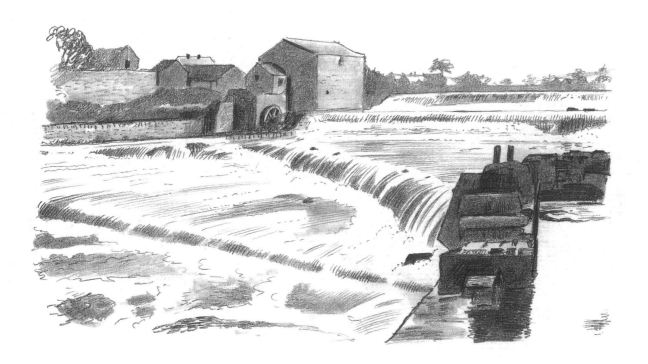

*The rapids at Ballysadare produce the most amazing expanse of white water. Most of the drawing has gone into what lies along the banks of the river, throwing into sharp relief the white area of frothing water. These features were put in fairly clearly and in darkish tones, especially the bank closest to the viewer. The four sets of small waterfalls are marked in with small pencil strokes, following the direction of the river's flow. The far bank is kept simple and the farthest part very soft and pale in tone.*

## FALLING WATER: PRACTICE

The scale of High Force waterfall in the Pennines is of a different order to that of Ballysadare, and presents other challenges. Where Ballysadare is broad, High Force is narrow and, of course, the volume of water that rushes down its steep sides and over its series of steps is much less. As with drawing Ballysadare, it is mostly the strong tones of the banks that provide contrast with the almost white strip of the waterfall.

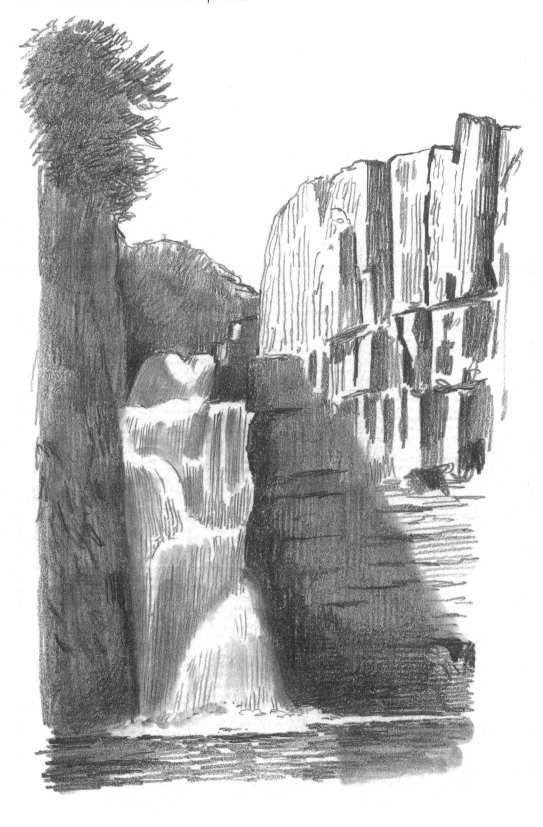

*1. Start with the cliffs on either side. Where they are in shadow, use dark tone to block them in. Where they are not, draw them in clearly. In our view the area all around the falls is in shadow and it is this deep tonal mass that will help to give the drawing of the water its correct values. Leaving the area of the falls totally blank, put in the top edges of each ledge in the cliff-face. Draw in the plunge pool and the reflection in the dark water at the base of the falls.*

*2. Leaving a clear area of white paper at the top of the ledges, indicate the downward fall of the water with very lightly drawn, closely spaced vertical lines. Don't overdo this. The white areas of paper are very important in convincing us that we are looking at a drawing of water.*

## SEA IN THE LANDSCAPE: PRACTICE

The sea takes up two-thirds of this picture, which shows a wide bay with rocky cliffs enclosing a flat beach on Lanzarote. The sweep of the sea from the horizon to the surf on the beach creates a very pleasant and restful depth to the drawing. The close-up of rocky boulders adds a touch of connection to the onlooker, as does the viewpoint, which suggests we are viewing the scene from high up on the cliff. As with the previous drawing, it is the area of calm sea that sets the mood.

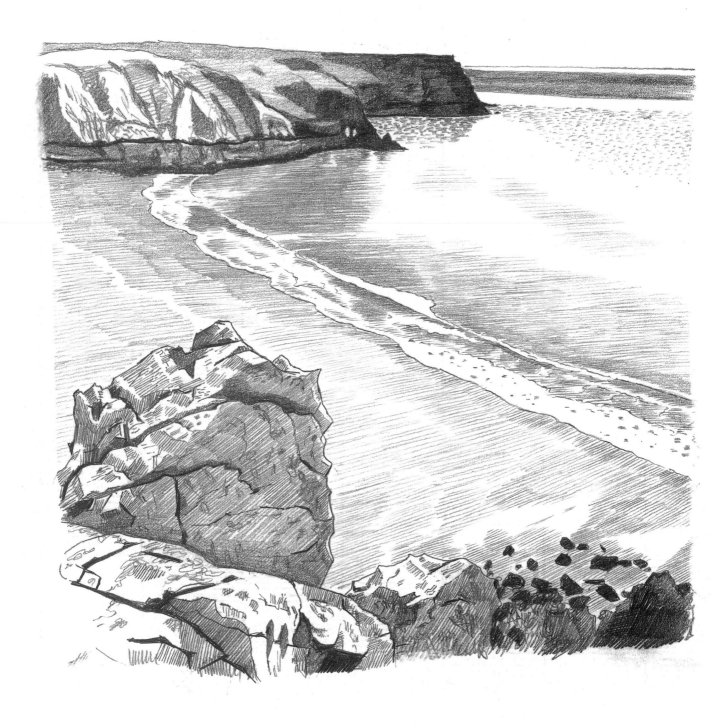

1. *Outline the main areas, starting with the horizon and the cliffs in the background, then the edge of the water across the bay, and finally the close-up of the nearest rocks on the clifftop.*

   *When the outline is in place, put in the very darkest areas of the background. This will establish the values for all the other tones you will be using. Keep it simple to start with, just blocking in the main areas. Then add the lighter tones to the background, including the furthest layers of tone to designate the sea near the horizon.*

2. *Add tones to the beach in two stages. First, mark in very gently and carefully the tone along the line of the surf. Keep this fairly light and very even and follow the slope of the beach with your pencil marks. Next, draw the slightly darker areas of the sea where it is closest to the surf line. The contrast between this tone and the white paper left as surf is important to get a convincing effect. Lastly, put in* the larger areas of tone in the sea. Use dotted or continuous lines, but don't overdo them. Leave plenty of white space to denote reflections of light. Tonal lines similar to those already put in can be carefully stroked in all over the beach area. Don't vary your mark-making too much or you may end up with the effect of deep furrows, which would not look natural on a flat beach.

3.

4.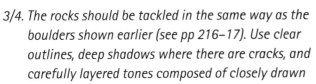

3/4. *The rocks should be tackled in the same way as the boulders shown earlier (see pp 216–17). Use clear outlines, deep shadows where there are cracks, and carefully layered tones composed of closely drawn* lines all in the same direction. Some of these should be in small patches, others in larger areas. Leave all well-lit surfaces as white paper, with only marks to show texture.

225

## SEA IN THE LANDSCAPE: PRACTICE WITH BRUSH AND WASH

One of the most effective, and fun, ways of capturing tonal values is to do them in brush and wash. In this view of the Venetian lagoon in early morning, looking across from the Guidecca to the island of San Giorgio, its Palladian church etched out against the rising sun, the use of wash makes the task of producing a successful result much simpler. Getting the areas of tone in the right places is the key to success. It doesn't matter if your final picture is a bit at variance with reality. Just make sure the tones work within the picture. More confidence is needed for this kind of drawing, and it is advisable to practise your brush techniques before you begin to make sure the wash goes on smoothly. Don't

worry if you make a mistake. You certainly won't get it right first time, but over time you will come to appreciate the greater realism and vividness this technique allows.

Begin by sketching out very lightly the outline shape of the background horizon and the buildings. Don't overdo the drawing; keep it to a minimum. If you are feeling very confident, use the brush for this first stage.

First the main shape of the island and its church was brushed in with a medium tone of wash. Then while it dried the far distant silhouette of the main part of Venice was brushed in with the same tone. Then the darker patches of tone on the main area were put in,

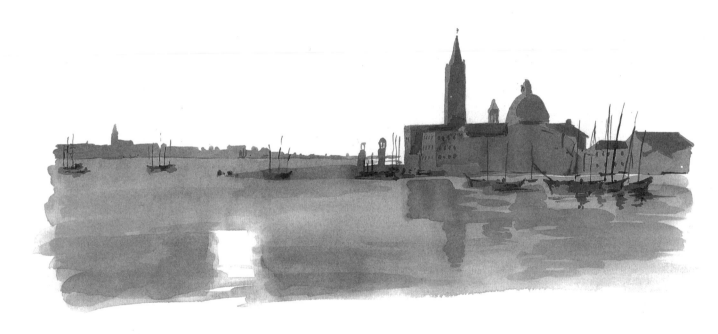

1. The first tone to put in is the lightest and most widespread which shows us the horizon line and the basic area of the buildings with differentiation except where they jut up above the horizon and are outlined against the sky. Leave a patch of white paper to indicate the lightest reflection in the water. Don't worry if your patch doesn't quite match the area that you can see.

2. Your second layer of tone should be slightly heavier and darker than the first. This requires more drawing ability, because you have to place everything as close as possible to effectively show up the dimension of

the buildings. Also with this tone you can begin to show how the reflections in the water repeat in a less precise way the shapes of the buildings. Once again, try to see where the reflections of light in the water fall.

3. The third layer of tone is darker still. With this you can begin to sharply define the foreground areas. The parts of the buildings strongly silhouetted against the sky are particularly important. Now put in the patches showing the boats moored near the quay and the dark, thin lines of their masts jutting up across the sky and buildings.

keeping it all very simple. Now it was possible to wash in a fairly light all-over tone for the water, leaving one patch of white paper where the reflected sun caught the eye. Even darker marks could now be put in with a small brush to define the roofs, the windows and the boats surrounding the island. The reflections in the water are put in next. After that, when all is dry, add the very darkest marks such as the details of the boats, to make them look closer to the viewer than the island and background.

1.

2.

3.

*You can go on adding detail but these first three stages are the most important. If they're correct the rest will work. If they're badly out the additions won't redeem your picture.*

## SKY – ITS IMPORTANCE

As with the sea in a landscape, the sky can take up much of a scene or very little. We consider some typical examples and the effect they create. Remember, you control the viewpoint. The choice is always yours as to whether you want more or less sky, a more enclosed or a more open view.

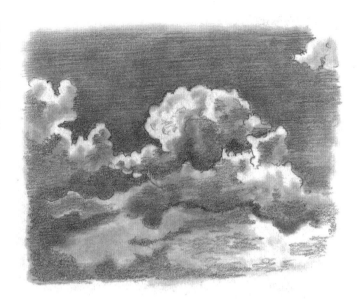

*After Willem van de Velde II*
*Some studies were of interest to scientists as well as artists and formed part of the drive to classify and accurately describe natural phenomena.*

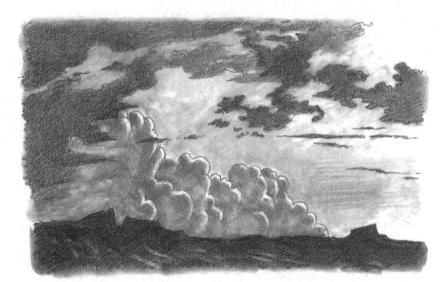

*After Alexander Cozens*
*The cloud effects are the principal interest here. The three evident layers of cloud produce an effect of depth, and the main cumulus on the horizon creates an effect of almost solid mass.*

*After J. M. W. Turner*
*Together with many other English and American painters, Turner was a master of using cloud studies to build up brilliantly elemental landscape scenes. Note the marvellous swirling movement of the vapours, which Turner used time and again in his great land- and seascapes.*

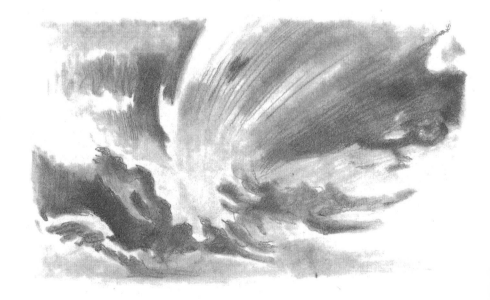

## THE SKY AT NIGHT

One difficulty of drawing at night is the dark. For this reason a townscape is a more obvious choice because you can position yourself under a lamp-post and draw from there. In the first of our two examples light provided by the moon is spread across the scene by the expedient device of the reflective qualities of a stretch of water. In the second, moonlight also comes into play, although less obviously. Night scenes are always about the lit and the unlit, the reflective and the non-reflective.

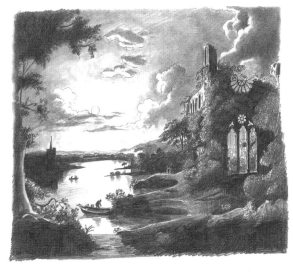

*The classic picturesque scene was for many years the whole point of landscape painting. Artists would find a rugged, untamed spot that would appeal to Romantic sensibilities and would draw it at a dramatic moment. In this copy of a Harry Pether painting of Anglesey Abbey, a ruin in the best Gothic taste is shown against gleaming water and moonlit sky. The clouds are almost as carefully designed as the position of the ruins. All elements in the picture combine to create an atmosphere of delight in the airy qualities of the nocturnal scene.*

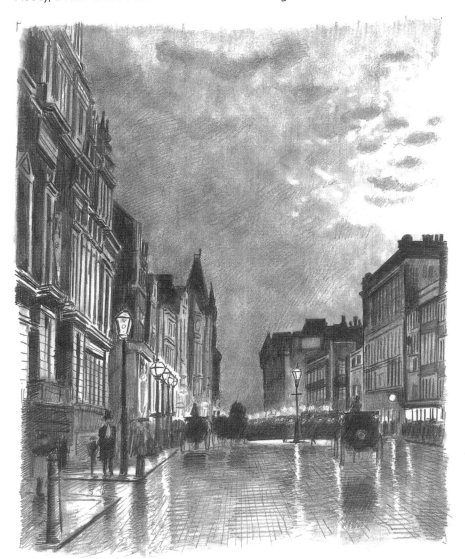

*The British artist Atkinson Grimshaw was known for his depictions of the city after dark. After* Piccadilly at Night, *this image captures the effects of a dark cloudy sky with the hint of moonlight and dark, looming buildings lit by street lamps, windows and cab lights. A recent downpour helps to emphasize the brilliance of the light.*

*Study the two stages opposite that lead up to the final drawing.*

## PLANTS AND ROCKS

Plants drawn in close-up detail help to impart a sense of depth and space to a scene, especially when you contrast the detail of the leaves with the more general structure of whole trees further away.

A very good practice, when you are unable to find a satisfying landscape view, is to draw the leaves of plants in your garden or even in pots in your house. This exercise is always useful because it helps to keep your eye in and your hand exercised. The information you gain from it about growth patterns will also help when you attempt a full-blown landscape.

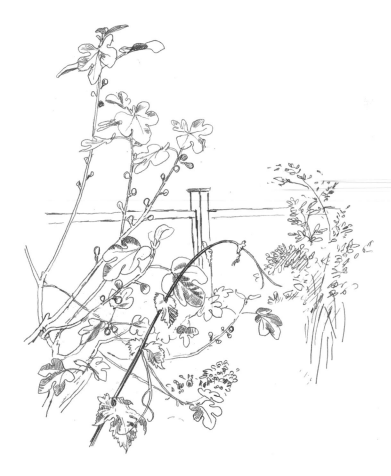

*Our first example is of a fig bush with some vine leaves growing up from below a window and across the view of the fig. An exercise of this type gives you the chance to differentiate the closer plant from the further by altering your drawing style.*

*Tall grass, either ornamental or wild varieties, or cereal crops, can give a very open look in the forefront of a scene. The only problem is how much you draw – putting in too much can command all the attention and take away from the main point in a scene.*

Now we turn to the rock formations that lie under the vegetation and help form the bone-structure of the landscape. First of all, find a few chunks of rock from a garden, a beach or a park. My examples are actually geological samples, but you don't need to go to the same trouble. Most well tended flowerbeds will have a few stones in them. If you are really stuck, dig a hole in a piece of wasteland or your backyard. You won't have to dig very deep before stones show themselves.

*Dunite*

*Comendite*

*Pumice*

*These examples of rock were obtained from the geological section of a museum where they sell small pieces to help you learn to identify the various types. They were chosen for their clearly defined differences. Note the differences in regularity and holes in the surface.*

## FOREGROUND: FRAMING THE PICTURE

Here is one sketch drawn in Greece. Note how in each picture elements in the foreground combine to provide a perfect frame for the view. I was not aware of this natural frame until I started to consider the view and how best to draw it. Allowing us to see what is in front of our eyes is one of the aspects of drawing that never fails to delight.

*The man-made world of the holiday beach of Tolon is the main subject here. In the foreground there is a suggestion of a pergola, and sun loungers, pedaloes, a solid post for lighting and a sturdy veranda wall are in evidence. Framed between these details is a strip of sea with its moored pleasure boats and rafts. Across the stretch of water we can see an island, which rises steeply from the sea. The carefully built foreground helps to create the feeling of serenity and well being.*

## PRACTISING FOREGROUND FEATURES

Urban environments offer opportunities for practising drawing all sorts of objects you may want to include in your compositions as foreground details. A garden table and chairs or machinery such as a bicycle are found in most households and can be used creatively to make satisfying mini-landscapes. It is amazing how ordinary objects can add drama to a picture.

*The houses to one side of this village green in southern England are useful visual indicators of size, but even more effective is the lone car parked on the pathway, because this tells us something about the distance between it and us. It also gives us a good idea of the space behind the trees in the middle distance and the hedges and house behind.*

*The bicycle lends an air of habitation to the blank corner on which it is leaning, with the vine curving around and up the brickwork. If a small garden could be seen past the corner it would give an effect of space. If the landscape was a street the contrast would be even more dramatic.*

## INDICATING DISTANCE

In most landscapes there will be man-made objects that can work in your picture as an instant pointer to the distance beyond or the distance between the viewer and the object. In this next series of drawings the subtler aspects have been purposely left out in order to show how foreground objects give definite clues as to size and distance.

*A picket fence looks simple enough but to draw it is quite an exercise if you are to get the structure correct and capture its tones and texture. Placed in the*

*foreground of a picture, it can be used as an indicator for the rest of the view, enabling us to relate to the size of the pickets and so judge the distances behind.*

*Now let's look at a fence alongside a country road with an open field and trees behind it. The fence must stand at waist-height at least, so giving the trees and spaces behind it a sense of distance, although these are drawn without any real effort to show distance variations. The croquet hoop in front of the fence provides another size indicator, but it is the fence that shapes our idea of depth in the picture.*

*A little way past the fence in this drawing you will notice three trees which act as a sort of frame for the landscape behind. We can tell by the line of the turf in which the trees are standing that they are a few yards from the fence and so we get some idea of their size. The field and simple depiction of tree lines behind the trees in the foreground give an indication of not only the space behind the fence and trees but also the slope of the landscape, dipping away from us and then rising up again towards the horizon.*

## THE MIDDLEGROUND

If a foreground has done its job well, it will lead your eye into a picture, and then you will almost certainly find yourself scanning the middleground. This is, I suppose, the heart or main part of most landscape compositions and in many cases it will take up the largest area or command the eye by virtue of its mass or central position. It is likely to include the features from which the artist took his inspiration, and which encouraged him to draw that particular view. Sometimes it is full of interesting details that will keep your eyes busy discovering new parts of the composition. Often the colour in a painting is strongest in harmony and intensity in this area. The story of the picture is usually to be found here, too, but not always; some notable exceptions will be among the examples shown. The eye is irresistibly drawn to the centre and will invariably return there no matter how many times it travels to the foreground or on to the background. The only occasion when the middleground can lose some of its impact is if the artist decides to reduce it to very minor proportions in order to show off a sky. If the proportion of the sky is not emphasized the eye will quite naturally return to the middleground.

Let us now look at a couple of treatments of the middleground. In order to emphasize the area of the middleground, I have shaded the foreground with vertical lines and the extent of the background is indicated by dotted lines.

*The centre of this picture (after John Knox) contains all the points of interest. We see a beautiful valley of trees and parkland, with a few buildings that help to lead our eyes towards the river estuary. In the centre, there is a tiny funnelled steamship, the first to ply back and forth along Scotland's River Clyde, its plume of smoke showing clearly against the bright water. Either side of it on the water, and making a nice contrast, are tall sailing ships. Although the middleground accounts for less than half the area taken up by the picture, its interesting layout and activity take our attention.*

## POINTING OUT THE SPACE

Careful selection of your picture's composition can make all the difference to the impact it has. Picking out focal points such as the spur of land (below), or using framing devices like leafy branches (opposite) work brilliantly to concentrate the eye.

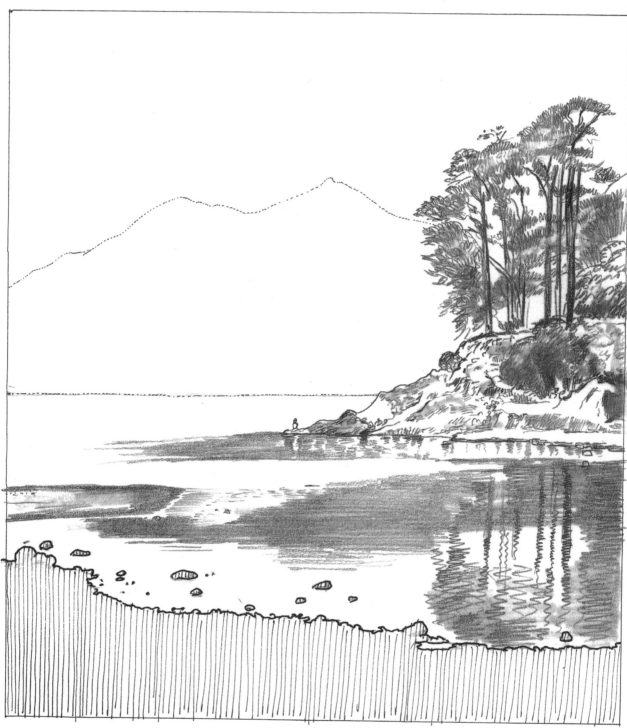

*This view of Derwentwater in the Lake District offers a very simple yet effective way of highlighting the importance of the middleground. The majority of this area is taken up with one feature – water. However, a jutting spur of rock to the right acts as a focal point and keeps our attention well into the centre of the lake. The spur is almost like a finger pointing to the water to make sure we don't miss it. The reflections in the water also give the expanse of lake a little more liveliness, although the smooth surface is untroubled.*

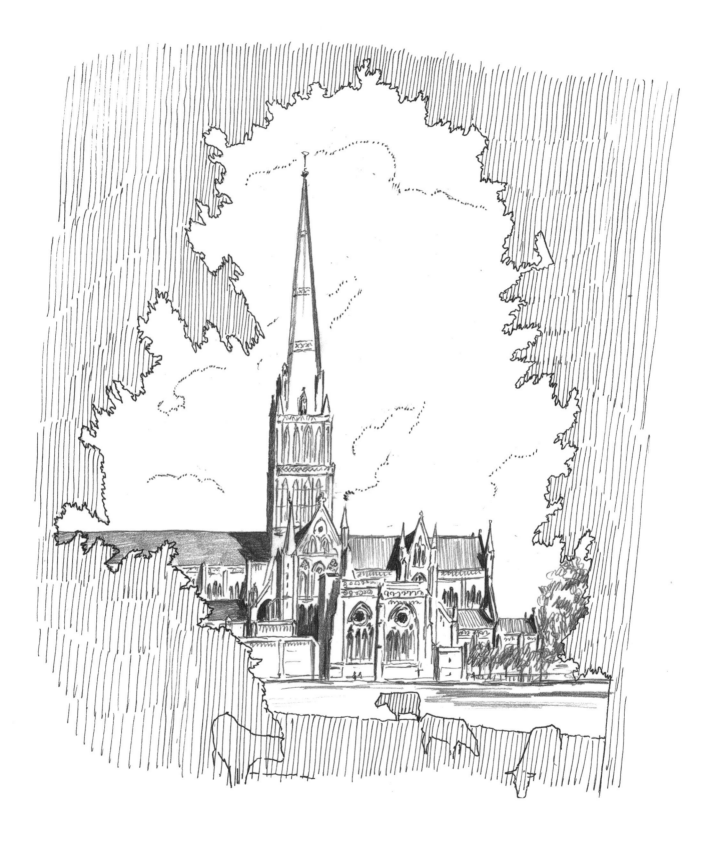

Another picture after a master of landscape, John Constable, this time from his later years. The subject of the picture is Salisbury Cathedral. The foreground is a frame of leaves and a few cows grazing, brilliantly vignetting the building. The background is all sky, but a lively one. The magnificent spire and long nave of the cathedral account for the whole of the middleground.

## THE BACKGROUND

A brief examination of the way artists use the background soon changes the misconception that it is a passive part of any scene. Obviously treatments differ. Some artists make the background so important that it begins to take over the whole picture, while others may reduce it to minimal proportions. However, whether its proportions are large or small, the background is important and the only means you have of stopping the main parts of the picture being isolated. Always remember that the background, however simple, is the stage on which the action of your picture takes place. Without it, your picture will look stilted and without depth.

NB: Only the background is drawn up; the foreground and middleground are shown as toned and blank outlines respectively.

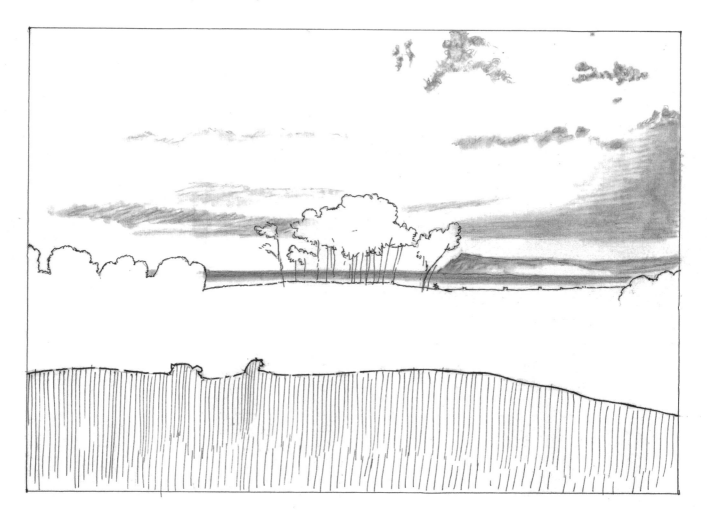

This background (after Turner's picture of Pevensey Bay) is most retiring and unassuming. All the interest in the picture is in the fore- and middlegrounds. Neither the very slim layer of sea and cliff on the horizon nor the peaceful-looking sky insists on being noticed. This background exists solely to provide a backdrop to the interest in the main parts of the picture.

This example (after Monet's picture of a small cabin on the rocky coast at Varengeville) does away completely with the middleground and places the foreground against an immense, serene space of sea and sky that merge into each other. The curve of the edge of the coast frames this rich-looking tone with just a couple of tiny spots of white that we read as sails. The overall texture of the background makes a very effective surface on which to place the rocks, vegetation and cabin of the foreground.

Here, in a scene of a wet Paris street (after Caillebotte), is a strange arrangement of foreground, middleground and background. Large buildings or busy streets often make up the backgrounds in pictures of town- or cityscapes. These backgrounds often seem much closer than those of open landscapes. Caillebotte reduced his foreground effectively to one side of the picture and made his middleground form a deeper frame around the picture. The large blocks of apartments become very strong statements, but are still very much a background to the people and activity in the streets. In effect the background is brought much closer to us as viewers and yet does not take our attention away from the figures. The background has the effect of showing us what cities do to humanity.

## MONUMENTAL PLACES

1 would love to have visited these two great landmarks, but as even intrepid travellers would face formidable difficulties trying to get access to them, 1 was content to make do with photographs. You would need to be a very committed and brave person indeed to get these views. Both are stunning natural features presenting great dramatic possibilities which 1 have tried to capture by using bold yet quite detailed tonal mark-making.

*After the explorer Shipton discovered this dramatic natural feature in China, everyone wanted to see it. However, it was almost impossible for people who did not live in the area to locate it and the wild, rocky terrain in which the arch is situated put off even the local people from going to see it.*

Another natural feature not known to many is the great Colca Canyon among the Andes in Peru, with its amazing river full of dangerous rapids running through it. The lure of places untouched by tourism is great. However, I suggest you serve your apprenticeship as a landscape artist in the suburbs or in the comparatively manicured countryside closer to home. You will find countless places of interest, albeit on a smaller scale, on your doorstep. Out of these you should be able to make very effective pieces of art.

The Romantic artists of the 19th century vied with each other to produce dramatic landscapes of towering crags and toppling mountains. Gordale Scar by James Ward belongs to this great tradition, its effect so powerful as to almost overwhelm the first-time viewer. Many other painters at this time in Europe, and 'the Sublimes' in America, were producing works of staggering size and powerful dramatic effect; painters such as John 'Mad' Martin, Friedrich, Church and Bierstadt.

## PERFECT WORKS OF ART

All of the following were made with the hand of man, not Mother Nature, and yet they have been part of our consciousness for so long that they are almost accepted as natural landmarks. Age-old, they have impressed people for hundreds of years. If we can convey something of this sense, our drawings of them will be all the more interesting.

*Ancient places seem to possess both power and drama even if we are not sure of why they were built or the purpose they once served, as in the case of Stonehenge.*

*Like Stonehenge, the famous figures sculpted out of raw rock on Easter Island in the South Seas present an enigma. The fact that nobody knows their meaning does not detract from their extraordinary presence. This monument demands to be noticed.*

The Taj Mahal with its amazingly balanced pristine beauty is one of the most well-known pieces of architecture in the world. When you see the actual building, its beauty and harmony far exceed anything captured by a camera. It is very difficult to give full value to a piece of architecture of this nature in a drawing, even if you are lucky enough to go to India and draw it from life.

## GARDEN LANDSCAPES

The tamed landscape of a garden can sometimes seem a rather limiting space for the artist. However, if a garden has been designed with some flair, you will notice that the division of spaces in it creates a new dimension of landscape. This may be smaller but it can be just as interesting to draw as a more open, spacious view.

In these three examples, the gardeners have brought a clever aesthetic quality to the manipulation of plants, walls, hedges and so on, which can be very rewarding to draw.

*Here the hedges and bushes have been carefully trimmed to produce edges to pathways and more open spaces. The effect created is of an enclosed paradise garden. Seen from beneath an overhanging vine, the formal bushes clipped into large cushions define a route towards the end of an old wall, behind which stand tall clipped hedges. Planted among all this formality are clumps of flowers, potted plants, bushes and places to sit. Rather like a beautiful room without a roof, it offers the artist options for drawing from many angles.*

*One of the main features here is the topiary, which appears like chess pieces set out around a lawn with larger trees behind and a terrace with steps leading up to it. More formal than the first example, the garden is carefully contrasted against the larger trees in the background. The total effect is of a sort of natural sculpture.*

*In both these drawings, the rows of clipped bushes give a good illusion of perspective and space.*

We go from the immense, almost still-life arrangements of the first two examples to a garden that looks like a mini-wilderness. The view I have chosen gives the impression of a wooded glade that somehow has managed to have a Japanese bridge built in it. The garden has been carefully designed to look both natural and attractive, with the moon-bridge creating a stylish reflection in the lake.

## INDUSTRIAL MONUMENTS

Places such as factories and power stations, while not built for their aesthetic values, are nevertheless very powerful statements of architecture. The very functionalism of such buildings usually gives them interesting shapes.

The best examples don't look like any other buildings in history and stand as unique structures. They represent a rewarding challenge for artists interested in portraying the urban landscape.

*Set as it is on the edge of the River Thames, the Chelsea power station stands out as a landmark among the rest of the buildings in this area. Its brickwork looks very dark against the other buildings around it and the plumes of smoke belching from its two chimneys are very unusual in London today.*

*This special gas-tank is also now a rather obsolete piece of engineering, although I find its shape and size particularly interesting. Almost futuristic in appearance, it would not look out of place on the set of a science fiction film. It looks good from almost any angle and both close-up or from further away gives a very satisfying shape to the usual urban environment.*

*Now derelict, Battersea power station once supplied electricity to a large area of London. The vast towers of chimneys on their enormous plinths look very much like special columns for a temple. Because of its immense size the building can be seen from many angles and features as a striking urban focus, although it is difficult to see the whole structure except from a distance. I deliberately chose to leave out some of the structure and get a close-in view in order to intensify the monumental effect.*

*This building was a temple to commerce when it was first built and now is listed as a masterpiece of Art Deco industrial design. The pseudo-Egyptian appearance of the factory makes it look like a place of worship rather than a site dedicated to the production of vacuum cleaners.*

The Bow-Moon *(after Hiroshige)*

*The Japanese landscape painter Hiroshige took his forms from nature but was more interested in the spirit or essence of his scenes as works of art. He didn't want to produce simple facsimiles of what he saw. He looked for the key points and balance in elements of his choosing and then carefully designed the landscape to influence our view. Only the most important shapes and how they related to each other were shown.*

*Usually their position and place was adjusted to imbue the picture with the most effective aesthetic quality. The landscape was really only a starting point for the artist, whose understanding, perception and skill were used both to bring the picture to life and to strike the right vibration in the onlooker. The experience was not left to accident.*

Tower of Babel *(after Pieter Brueghel)*
*This is a marvellous piece of imaginative architecture-dominated landscape. The great mass of the tower with its multiplicity of structures rises out of a plain, although apparently constructed on a rocky outcrop.*

*The amazing completeness of the architectural concept and the landscape laid out behind it, with a port and sea or lake to one side, is a brilliant evocation of the Biblical story.*

*Start and Finish*

## LOOKING FOR THE VIEW

First choose an area that you would like to draw. Most people prefer to draw a country scene, but if that is not very convenient maybe there is a large park or country house with extensive grounds near where you live.

The countryside nearest my home is Richmond Park, which has within its boundaries magnificent woods, hills, a stream and ponds. I knew I would find good views across the landscape, this being the highest point of the land in the area. I decided at the outset to ignore the park's decorative lodges because they might complicate matters.

As you can see from the plan of my route, I undertook quite a hike to assess the various viewpoints. It was a lovely summer day, just right for drawing in the open. Part of the fun of this type of exercise is searching for scenes and details that spark your interest.

All the views and details referred to in the following pages are included in the key below. You will need to draw up a similar map to ensure that you have a record of what you have done when you return to the scene later. Don't think you can rely on memory alone – you can't. If you try you will only succeed in ruining what is an immensely enjoyable and rewarding experience.

**Key to Viewing Points and Features**

| | |
|---|---|
| VP1 | View across parkland |
| VP1A | Detail of ferns |
| | |
| VP2A | View to left across park from hilltop |
| VP2B | View to half left across park |
| VP2C | View to centre across park |
| VP2D | View to centre right across park |
| VP2E | View to right across park |
| | |
| VP3 | Shattered oak tree |
| VP4 | Large chestnut tree near café where I stopped for lunch |
| VP5 | Large log |
| VP6 | View of ponds in distance from hill |
| VP7 | View of ponds from lower down |

## SETTING OUT

As you can see from my map-diagram, I started from the gates of the park and walked slowly up the hill, looking back occasionally to see what the view was like. About halfway up the hill I thought the view looked quite interesting and so I sat down and sketched the main parts very

*From Position 1*

simply (1). Much of the drawing is very minimal, like a sort of shorthand. This is because I am just looking for possibilities. The purpose is not to produce a finished picture. Some ferns caught my eye and I drew them as a possible detail to provide local colour (1a).

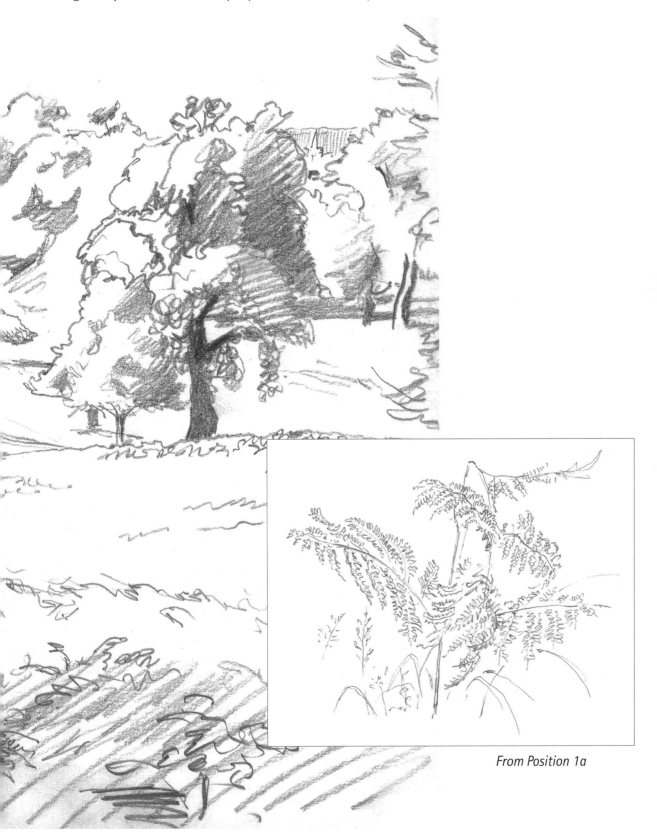

*From Position 1a*

## VIEW FROM THE TOP

When I reached the top of the hill there was a natural viewing platform offering an enormous sweep of panoramic proportions, more than could possibly be put in one picture. However, I didn't want to miss anything and so I made a series of sketches (2a, b, c, d, e), showing the layout of the whole view in extremely simple outline forms. Arranged edge to edge with some overlaps, these drawings presented me with a whole range of views for later consideration.

When you come to do this exercise, include written notes on your sketches to remind yourself of specific subtleties that you would need to include in a proper drawing. In these examples, the trees are put in as blobs of shape with only a rough indication of the darks and lights. Buildings in the distance are rendered as mere blocks to show their size and prominence. I would make detailed notes about the tonal values evident in all these features, including the various trees.

*From Position 2a*

*From Position 2b*

*From Position 2c*

*From Position 2d*

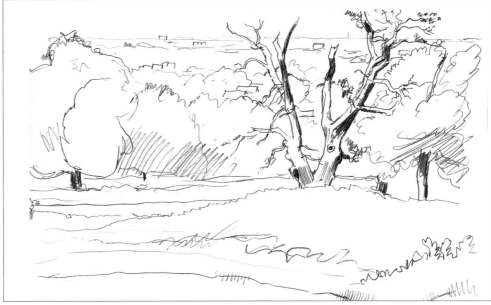

*From Position 2e*

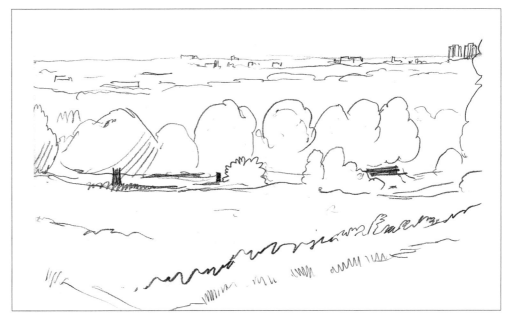

## AN EYE FOR DETAIL

In any landscape you need to pay attention to details that might be included in the foreground. In the plantation area of the park I came across a superb blasted oak, its angular branches stabbing up into the sky. As you can see it makes a good focal point, but would you place it centrally in your picture or to the right or left side? Compositional and structural aspects will strike you even at this stage when your main aim is to decide where to draw from.

I went across to the café in the park which has a very good view from its windows. Fortified by a tasty lunch and cold drink, I returned to my task.

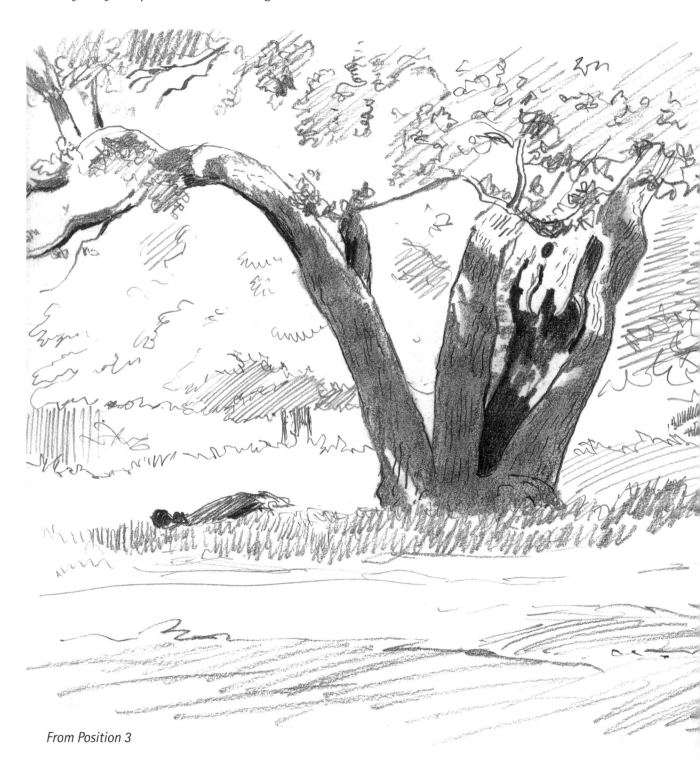

*From Position 3*

As I walked through the gardens surrounding the café, a superb group of chestnut trees set up on a mount presented themselves. I couldn't resist doing another tree portrait (4). This sort of close-up is useful in a composition that includes a long-distance view because it helps to give an illusion of space. This time I produced a more finished sketch. Drawings of groups of trees are always useful and the more information I have about them the greater is the likelihood of including them in one of my landscapes.

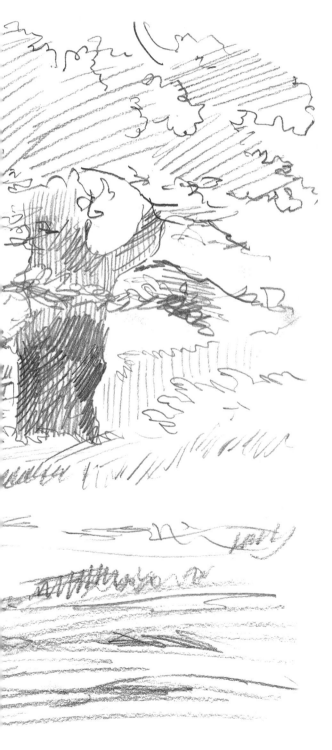

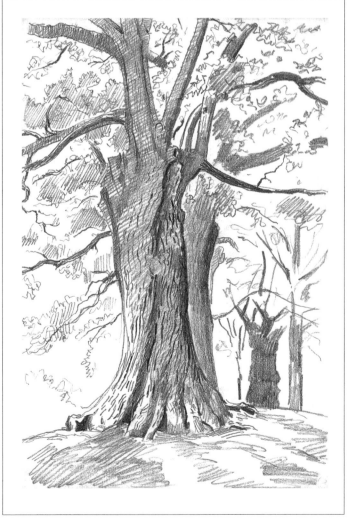

*From Position 4*

## NEAR AND FAR

Not far from the café was a wood on top of another hill. Woods are often great providers of interesting foreground details, and so in I went. After a few minutes of wandering around, I noticed an enormous log that had obviously lain there for at least a year (5). Stripped of bark it had weathered to a beautiful silvery grey. On the cut end you could see the rings of growth and saw-marks. I made a fast but quite detailed drawing before continuing on my way.

As I rounded the wood I could see from the top of the hill a great sweep of countryside framed between two large plantations of trees. In the middle distance was the gleam of two large ponds, which added extra interest to the view. Paths led from my position down the hill towards the ponds, between which ran a sort of causeway. In a quick, simple sketch I put in the main shapes and gave some idea of the sweep (6).

Curious to see what the ponds looked like closer up, I descended the hill to a point where the path to the causeway and the water of the right-hand pond were much more obvious. The view from here looked rather good, and so I quickly made a sketch of it (7). Now that I had a long view and a nearer view, I had the information necessary to include more detail of the distant parts of the view, if I wanted to. The more viewpoints you have of a scene the greater are your options.

By this time I was fairly hot, my feet ached and my bag with my sketchbooks, pencils, pens, sharpener and rubbers was beginning to feel heavy. Keeping to the shady parts of the park, I slowly made my way home.

So that is the first stage of the exercise. Allow yourself a day, even if you draw only for half that time, because you never know what you are going to discover.

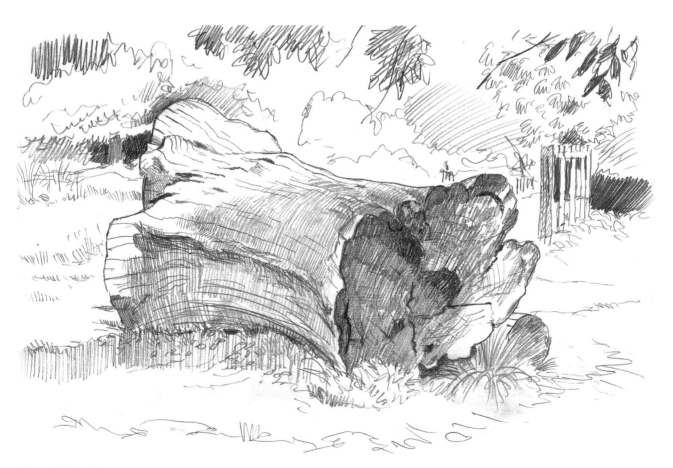

*From Position 5*

*From Position 6*

*From Position 7*

## DECISION TIME

Now comes the decision making, which will be based on your sketches and memory. You might want to consider taking photographs as well as making sketches.

Looking at all my sketches I decided to opt for two particular views, but including one of the large trees or the log somewhere in the foreground.

I quite liked the look of the two centre views (2b and 2c) from the panorama plus the river to the left. I considered shortening the view slightly, keeping the left-hand edge as a finial point and placing the central area with the blasted oak towards the right-hand edge of the picture. Then I thought it would be an effective touch to introduce something nearer to the foreground –

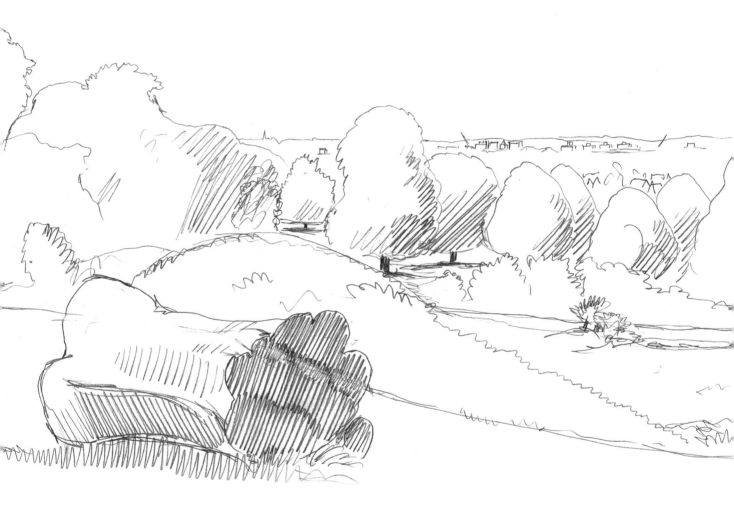

*Created From 2a, 2c, 2d and 5*

here is where one of my large trees or the large log would come in handy (5).

Now for my second option, I considered the long view of the ponds first. The trees on either side gave it a good frame, but it needed something else to give it interest. I decided to extend the central area with details taken from the closer view. But what about the foreground,

should I add anything there? I thought not, to avoid the picture looking crowded.

Which of these two possibilities did I go for? Or perhaps I decided to do both of them. In the end I opted for the part-panoramic view. The next stage was to draw up a diagram of how I thought this view might work.

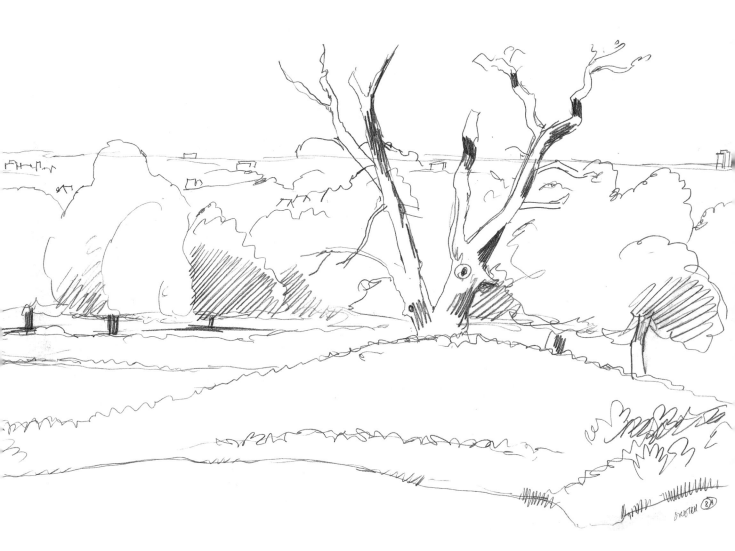

## THE OUTLINE DRAWING

The penultimate stage is to produce a full-size outline drawing of the whole scene as you intend to produce it. You need to include in it all the details that are to go in your final picture. These can be taken from your sketches, but only if you have all the information you need. If you find yourself lacking in information, you will have to go back to your location, only this time taking your original sketches and the diagrammatic drawing with you.

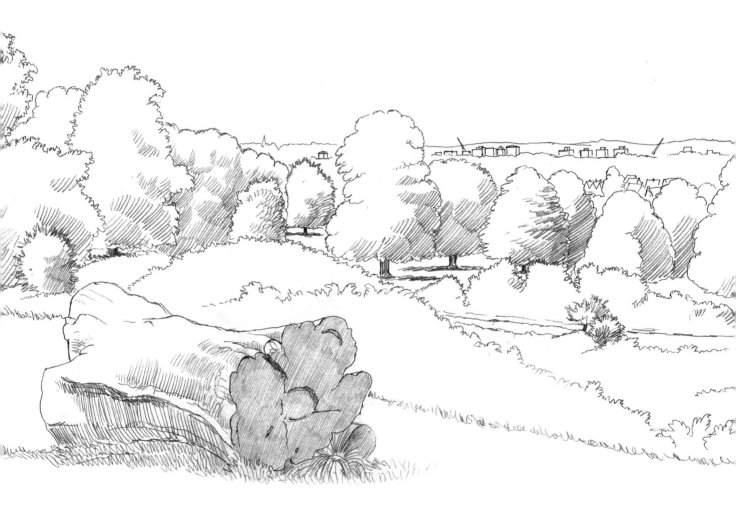

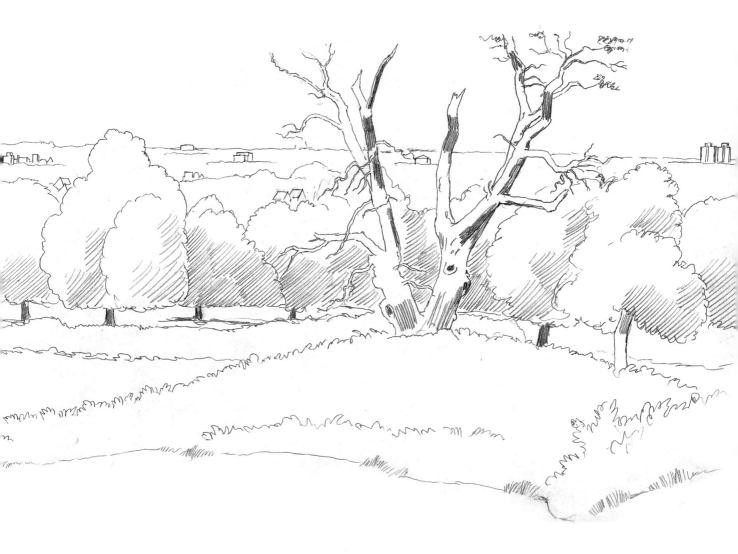

## THE FINISHED DRAWING

Now comes the final effort. This must not be hurried, and if it takes longer than one day, so be it. Recently 1 completed a picture of the interior of a studio 1 work in, just for practice, and it took me two full days. 1 used pencils of various grades, a stick of charcoal for soft shadows, and a stump to smudge some of the mark-making to keep it subtle. The second day was taken up with doing a colour sketch in oils. Never allow time to be a problem.

Everything at this stage depends on your artistic development and your attitude. A large

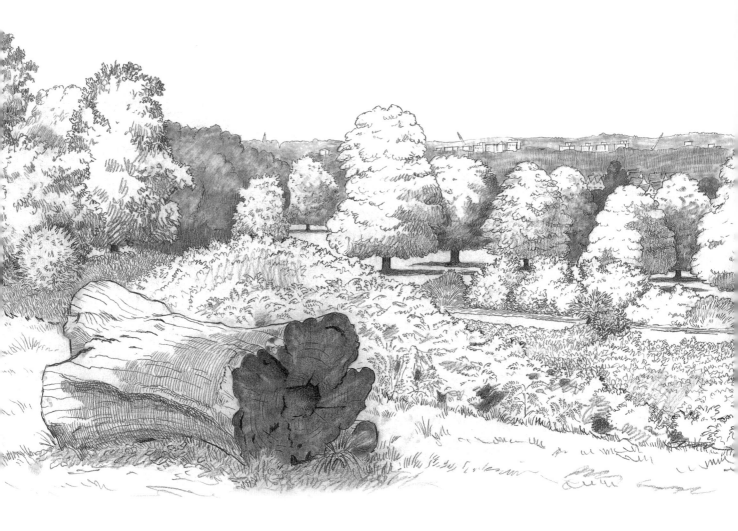

part of the resulting judgement of you as an artist will be based on how well you can produce finished drawings. Although talent can bring that extra special touch to a work, a great deal can be accomplished with persistence and endeavour. Indeed, talent without these other two qualities will not go far. It is only through hard work and a willingness to learn from our mistakes and the example of others that any of us improves.

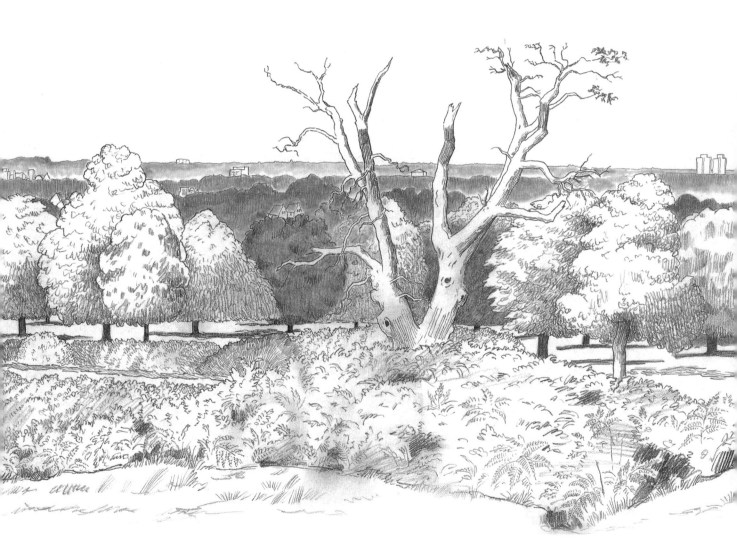

# Portraits

Capturing a likeness: the phrase hints at an element of magic in the business of portraiture. And why not? We all value our sense of individuality and instinctively admire anyone who can pin it down successfully in the form of a visual image.

In their day, the talents of Thomas Gainsborough (1727–88) and Jean-Auguste Dominique Ingres (1780–1867) were in constant demand throughout high society. Ironically, both artists complained bitterly of ceaseless portrait commissions, which prevented them from doing what they really wanted. In Ingres' case it was fashionable history painting, and in Gainsborough's it was landscapes. Gainsborough struck a happy medium by persuading his rich clients to pose against the background of their country estates, while Ingres found consolation in depicting wonderfully elegant clothes and accessories.

Portraiture is an opportunity to achieve not only a likeness of your sitter but also to create an entire setting around them, or perhaps to include samples of still life, using some favourite object as an indicator of their character.

Albrecht Dürer (1471–1528) and Rembrandt van Rijn (1606–69) – both consummate draughtsmen – were exponents of the self-portrait. Dürer virtually introduced the concept to Europe with his flattering images of himself as a well-travelled young man of the world. Rembrandt, on the other hand, remained in Holland and documented his poignant decline into old age. Rembrandt and Vincent van Gogh (1853–90) are two powerful portraitists whose concern for the human condition shines through their work and who are appreciated as possibly the most sympathetic of all the great artists.

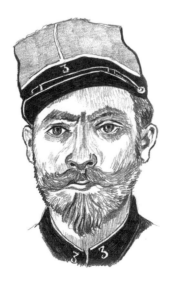

## THE FACE AND HEAD

Usually the most distinctive part of any portrait, the face is where the likeness and characteristics of the sitter are shown most easily and, as such, it should be your starting point. The head should be dealt with as a whole so that the sitter's face has a solid basis.

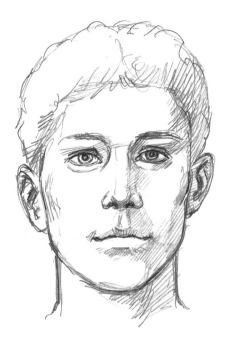

*Full face, from the same eye level as the artist, is excellent for capturing the expression in the eyes, but the shape of the nose is less obvious.*

*The head seen in profile allows clear definition of the features. Generally, though, portraits from this angle are less expressive, because the eyes are not clearly seen.*

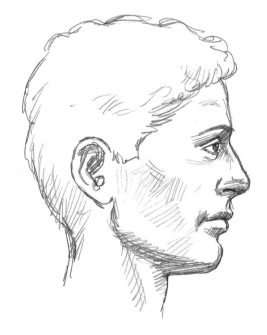

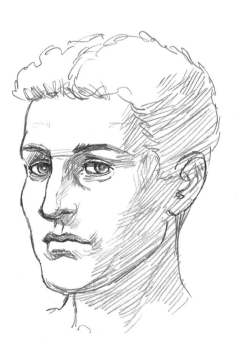

*The three-quarter view is probably the most popular position. It gives a clear view of the eyes and enough of the shape of the nose to give a good likeness.*

## DRAWING THE HEAD: BASIC METHOD

The basic shapes and areas of the head have to be taken into account when you start to draw your portrait. There are five steps. These will give you a strong foundation which you can then work over to get the subtle individual shapes and marks that will make your drawing a realistic representation of your sitter.

*First ascertain the overall shape of the head or skull and the way it sits on the neck. It may be very rounded, long and thin or square and solid. Whatever its shape you need to define it clearly and accurately at the outset, as this will make everything else easier later on.*

*Decide how the hair covers the head and how much there is in relation to the whole head. Draw the basic shape and don't concern yourself with details at this stage.*

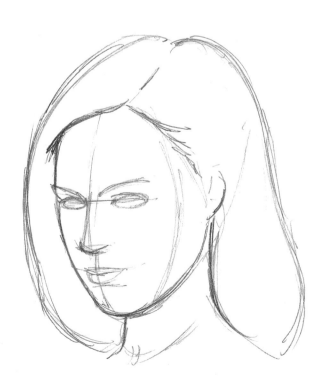

*Now ascertain the basic shape and position of the features, starting with the eyes. Get the level and size correct and their general shape, including the eyebrows.*

*The nose is next, its shape (whether upturned, straight, aquiline, broad or narrow), its tilt and the amount it projects from the main surface of the face.*

*Now look at the mouth, gauging its width and thickness, and ensuring that you place it correctly in relation to the chin.*

*The form of the face is shown by the tonal qualities of the shadows on the head. Just outline the form and concentrate on capturing the general area correctly.*

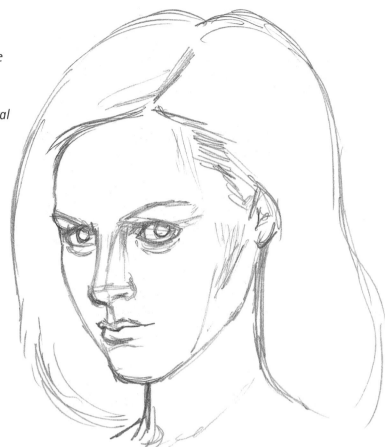

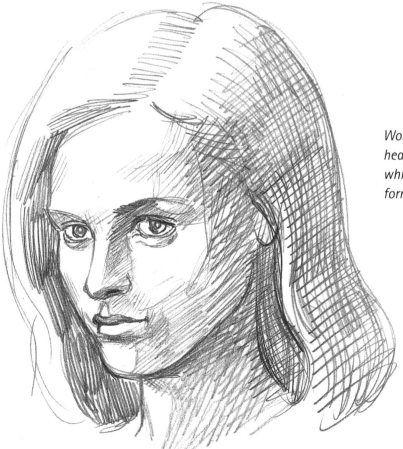

*Work in the tonal values over the whole head, noting which areas are darker and which are not so dark, emphasizing the former and softening the latter.*

## DRAWING THE HEAD: ALTERNATIVE METHOD

An alternative method for beginning a portrait is to work from the centre of the features and move outwards towards the edges. This approach is appropriate for both fairly confident draughtsmen and beginners, and is very helpful if you are not too sure about judging proportions and measuring distances.

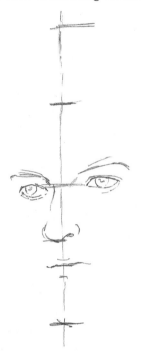

For this exercise we will assume that we are drawing a three-quarter view. Start by drawing a vertical line on a sheet of paper and then make a mark at the top and bottom of it. Now follow the steps shown in the following series of illustrations. Look carefully at your model throughout the exercise.

*Phase One: Marking out the Features*
- *Mark a horizontal line for the position of the eyes, halfway between the top and bottom marks. Roughly draw in the relative position and shapes of the eyes.*
- *Make a mark halfway between the top mark and the level of the eye for the position of the hairline.*
- *A mark halfway between the level of the eye and the bottom mark will give you the position of the end of the nose. Draw in a very simple shape to give you a clear idea of its shape. The top mark denoting the top of the head will appear rather to one side of your vertical line.*
- *The bottom line marks the point of the chin, which will be on the vertical line.*
- *The position of the mouth has to be calculated next. The mouth is nearer to the nose than it is to the chin, so don't put it halfway between them.*

*Phase Two: Defining the Features*
- *Draw in the shapes of the eyes and eyebrows, ensuring they are correctly placed. Notice how the eye nearest to you is seen more full-on than the eye further away. You can try to define the point where the further eyebrow meets the edge of the head as seen from your position.*
- *The nose now needs to be carefully drawn in: its outside shape, and also – in lightly drawn lines – how the form creates shadows on the unlit side.*
- *Positionally the ear fits between the levels of the eye and the nose, but is off to the side. Gauge how the distance between the eye and the ear relates to the length of the nose and put in the outline shape of the ear.*
- *Shape the mouth. The half of the mouth on the further side of the face will not look as long as the half of the mouth on the nearest side. The centre of the mouth must be in line with the centre of the nostrils. Draw in the pointed part of the chin.*

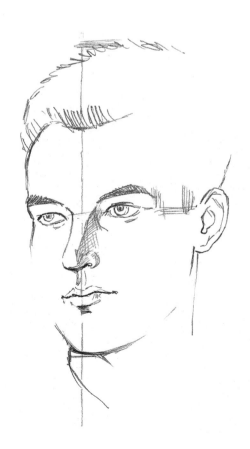

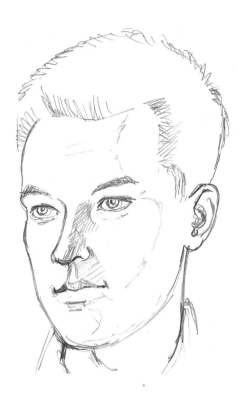

### Phase Three: Outlining Shadows

- *Trace out the shape of the shadows running down the side of the head facing you. Don't make the lines too heavy; just outline the edge of the shadow faintly from the forehead down round the cheekbone, the outside of the mouth and onto the chin. Indicate the neck and its shadow outline.*
- *Put in the shadow around the eyes, nose and, where they are needed, the mouth. Softly shade in the whole area including the hair area and the neck. Define the edges of the back of the head and neck and on the opposite side where the brow stands out against the background. Complete the shape of the top of the head.*
- *Put in the whole of the shape down the edge of the face furthest away from you; be careful not to make the chin jut out too far. Check the accuracy by looking at the distance between the line of the nose and the outline of the cheekbone and then the corner of the mouth on the further side and the edge of the face and chin related to it. Make any corrections. At this stage your drawing should look like an outline version of your sitter.*

### Phase Four: Applying Tonal Values

- *Begin by darkening the areas that stand out most clearly. Carefully model the tone around the form so that where there is a strong contrast you increase the darkness of the tone and where there is less contrast you soften it, even rubbing it out if necessary. Build up the tonal values with care, ensuring that in the areas where there is a gradual shift from dark to light you reflect this in the way you apply tone.*
- *The most highly defined features should be the shape of the eyes, sometimes the eyebrows, and the corner between the nose and eye and around the nostrils. The most defined part of the mouth is where it opens, and sometimes the area just below the lower lip. The edge of the chin is often quite well defined, depending on the light.*
- *Mark in the clearer strands in the hair; and the outer and inner shapes of the ear. Look at the setting of the head on the shoulders, noting how the shoulders slope away from the neck on both sides of the head.*
- *You may find that the background behind the lighter side of the head looks dark and the background behind the darker side of the head looks lighter. A darker background can help to project the face forward. Finish off by applying delicate touches – either with the pencil or a good rubber – to soften the edges of the tones.*

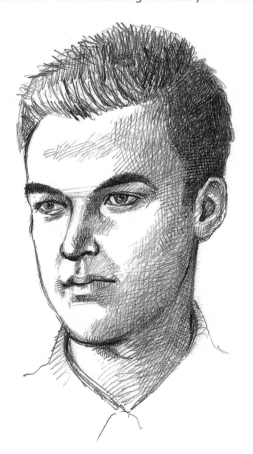

## THE MALE HEAD: WORKING OUT PROPORTIONS

For beginners especially, it can be very helpful to use a grid as a guide on which to map out the head, to ensure that the proportions are correct. Despite the variety of faces found in the world, the proportions shown here are broadly true of all adult humans from any race or culture, and so can be used for anyone you care to use as a model. Obviously there may be slight differences but so minute as to be safely disregarded. The only proviso is that the head must be straight and upright, either full face or fully in profile. If the head is at an angle the proportions will be distorted.

The number of units varies depending on whether you are drawing the head full on or in profile. Study each example with its accompanying notes before trying to use the system as a basis for your portraits.

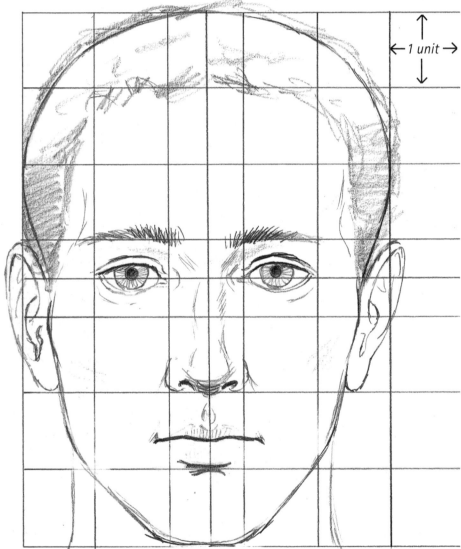

*← 1 unit →*

*Horizontal Reading: Full Face*
*For the full-face examples a proportion of five units across and seven units down has been used. Before you begin to study the individual units, note the line drawn vertically down the length of the face between the eyes, and centrally through the nose, mouth and chin.*

- *The width of the eye is one-fifth of the width of the whole head and is equal to 1 unit.*
- *The space between the eyes is 1 unit.*
- *The edge of the head to the outside corner of the eye is 1 unit.*
- *The outside corner of the eye to the inside corner of the eye is 1 unit.*
- *The inside corner of the left eye to the inside corner of the right eye is 1 unit.*
- *The inside corner of the right eye to its outside corner is 1 unit.*
- *The outside corner of the right eye to the edge of the head is 1 unit.*
- *The central unit contains the nose and is also the width of the square base of the chin or jaw.*

*Vertical Reading: Full Face*
- *Eyes: halfway down the length of the head.*
- *Hairline: 1 unit from the top of the head.*
- *Nose: one and a half units from the level of the eyes downwards.*
- *Bottom of the lower lip: 1 unit up from the edge of the jawbone.*
- *Ears: the length of the nose, plus the distance from the eye line to the eyebrows is 2 units.*

## THE FEMALE HEAD: WORKING OUT PROPORTIONS

This example has been drawn to exactly the same size as that on the facing page. Generally the female head is smaller than the male but the proportions are exactly the same. (Also see page 81 for information on the head proportions of children, which at certain ages are significantly different from those of adults.)

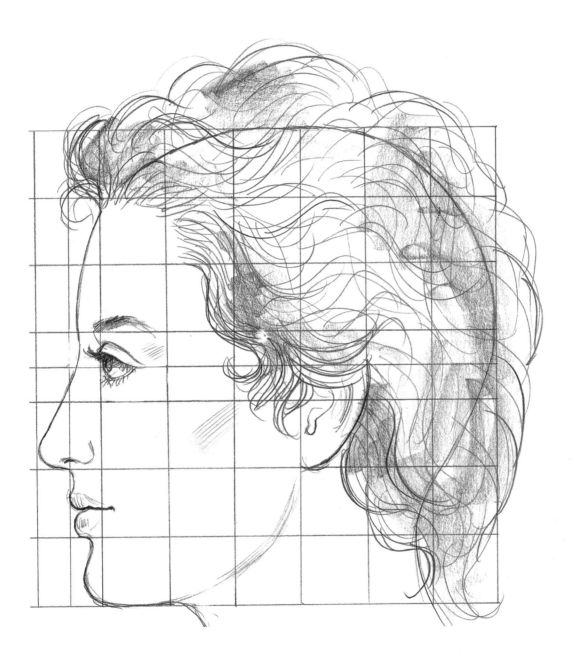

*Horizontal Reading: Profile*

- *The head in profile is 7 units wide and 7 units long, including the nose.*
- *The front edge of the eye is 1 unit back from the point of the nose.*
- *The ear is 1 unit in width. Its front edge is 4 units from the point of the nose and 2 units from the back edge of the head.*
- *The nose projects half of 1 unit from the front of the main skull shape, which is about six and a half units wide in profile.*

## PRACTICE: DRAWING THE HEAD AND FEATURES

In this exercise we are going to practise drawing different views of the heads. You can either use the model shown or choose another to draw. Make sure the features line up horizontally across the three views, otherwise there will be discrepancies in their relationship. Before you begin you will find it helpful to define the form of the face by marking in the edges of the planes on the face, particularly the outlines of the eye sockets and eyelids, the mouth and the formation of the bridge, length and tip of the nose.

This exercise can also be used to practise getting the shapes of the features right. Detailed drawings of the principal features – eyes, nose and mouth – are provided opposite. Periodically check your effort against the drawings and the accompanying annotations.

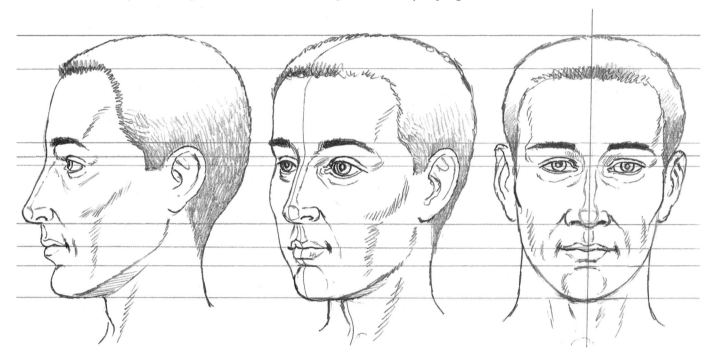

*Profile view*
- *The nose projects much further than the rest of the face.*
- *The jaw projects no further than the forehead.*
- *The ear is positioned well back past the halfway mark of the profile.*
- *From this viewpoint the line of the mouth is quite short.*
- *Study the shape of the eye.*

*Three-quarter view*
- *The farther eye has a slightly different conformation to the nearer eye, mainly because you can see the inside corner of the near eye, so the length of the eye is more obvious.*
- *The mouth shape is shorter on the far side of the central line and longer on the near side of the central line.*
- *The same observation applies to the eyebrows.*

*Full face view*
- *The eyes are one eye-length apart.*
- *The two sides of the head tend to mirror each other.*
- *The widest part of the head is above the ears.*
- *The widest part of the face is at cheekbone level.*
- *The ears are less obvious from this perspective.*

## THE FEATURES CLOSE UP

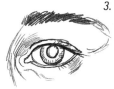

Seen in profile the eye is a relatively simple shape to draw, and yet many people get it wrong, tending to draw something they recognize as an eye instead of the actual shape.

*1. Profile view*
*The eyelids should project beyond the curve of the eyeball: if they didn't project, the eye could not close.*

*2. Three-quarter view*
*Note a marked difference in the shapes. The farther eye is closer to the profile view in that the eyelid projects past the eyeball on the outside corner. On the nearer eye, because the inside corner is visible, the shape appears to be more complete. The far eyebrow appears shorter than the near one.*

*3. Frontal view*
*From this angle the eyes are more or less a mirror image. The space between them is the same as the horizontal length of the eye. Note that normally about one-eighth to one-quarter of the iris is hidden under the upper eyelid, and the bottom edge just touches the lower lid.*

---

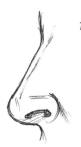
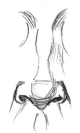

The nose at different angles presents marked differences in shape. In very young people the nostrils are the only areas that stand out.

*1. Profile view*
*The main observation here concerns the shape of the nostril and its relationship to the point of the nose.*

*2. Three-quarter view*
*The outline shape is still evident but notice how its relationship to the nostril has changed.*

*3. Frontal view*
*The only shapes visible are the surface of the length of the nose and the point. The nostrils are the most clearly defined areas, so note their relationship.*

---

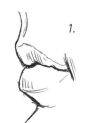

Mouths come in myriad shapes. Start to notice them, and sketch the many types around.

*1. Profile view*
*The line of the mouth (where the lips part) is at its shortest in this view. Note whether the upper lip projects further than the lower lip, or vice versa, or whether they project similarly.*

*2. Three-quarter view*
*The angle accounts for the difference in the curves of top and bottom lip. The nearer side appears almost as it does straight on, whereas the farther side is shortened due to the angle.*

*3. Frontal view*
*This view is the one we are most familiar with. The line of the mouth is very important to draw accurately – you need to capture its shape precisely or the lips will not look right.*

## MEASURING THE HEAD

The surest way of increasing your understanding of the head, and becoming adept at portraying its features accurately, is to practise drawing it life size, from life. It is very difficult to draw the head in miniature without first having gained adequate experience of drawing it at life size, but this is what beginning artists tend to do, in the mistaken belief that somehow it will be easier.

Getting to know the head involves mapping it out, and this means taking measurements from clearly defined points to clearly defined points. For the next exercise you will need a live model, a measuring device, such as a ruler or callipers, a pencil and a large sheet of paper.

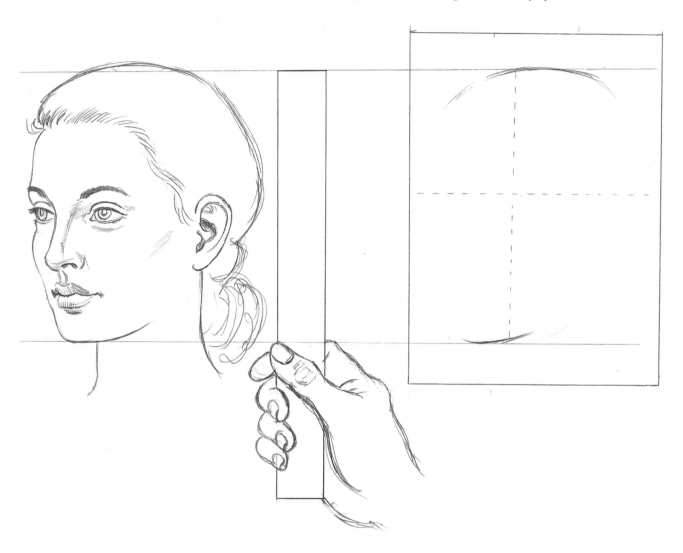

*Measure the length of the head from the highest point to the tip of the chin. Mark your measurement on the paper. Measure the width of the head at the widest point; this is usually across the area just above the ears, certainly if viewed full on from the front. Mark this measurement on the paper. The whole head should fit inside the vertical and horizontal measurements you have transferred to your drawing paper.*

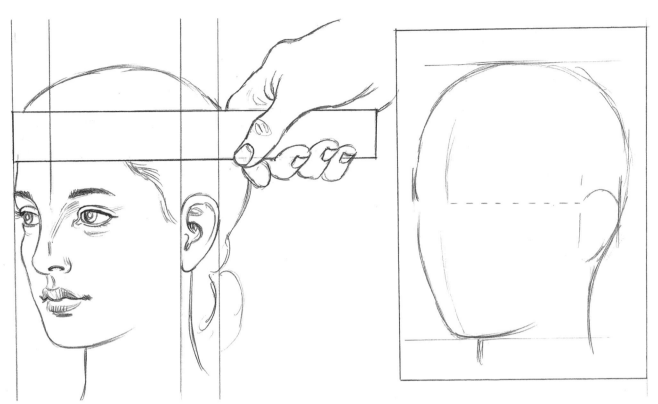

Measure the eye level. This should be about halfway down the full length of the vertical, unless the head is tilted. Decide the angle you are going to look at the

head. Assuming it is a three-quarter view, the next measurement is critical: it is the distance from the centre between the eyes to the front edge of the ear.

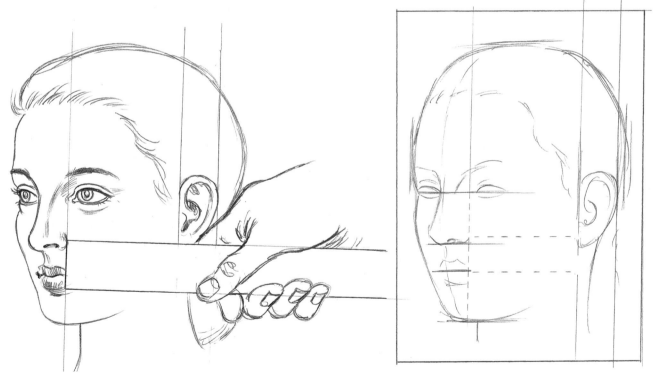

Measure the distance from the outside edge of the nostril to the front edge of the ear. Mark it and then place the shape of the ear and the position of both eyes. Check the actual length of the nose from the inside corner of the eye down to the base of the nostril. Next

measure the line of the centre of the mouth's opening; you can calculate this either from the base of the nose or from the point of the chin. Mark it in. Now measure from the corner of the mouth facing you to a line projecting down the jawbone under the ear. Mark it.

## ASSESSING THE FEATURES

The measurements you have taken in the previous exercises will provide very accurate proportions for you to work to when drawing the features. When you have sketched out roughly where every feature begins and ends, look carefully at the shapes of each of them and then draw them in.

The eyes are paramount, because often they are what makes a person recognizable to us. The mouth and nose are next. The pecking order of the rest depends on the characteristics of your subject. The illustrations below show the main points and relationships to consider when drawing the features.

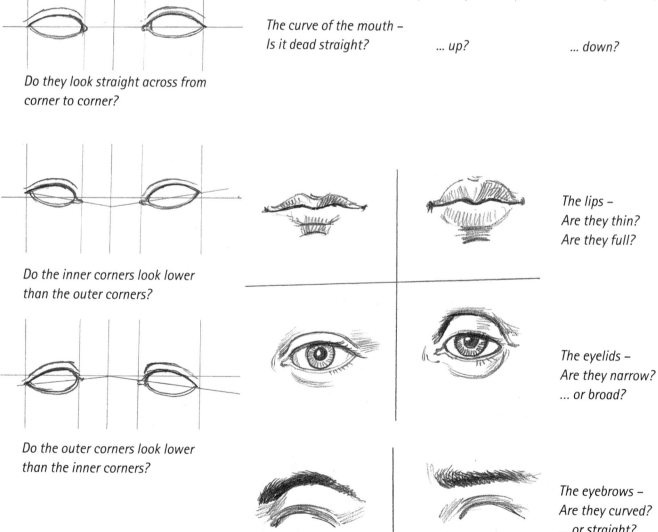

*The angle of the eyes as they appear in relation to each other –*

*Do they look straight across from corner to corner?*

*The curve of the mouth –*
*Is it dead straight?*

*... up?*

*... down?*

*Do the inner corners look lower than the outer corners?*

*The lips –*
*Are they thin?*
*Are they full?*

*Do the outer corners look lower than the inner corners?*

*The eyelids –*
*Are they narrow?*
*... or broad?*

*The eyebrows –*
*Are they curved?*
*... or straight?*

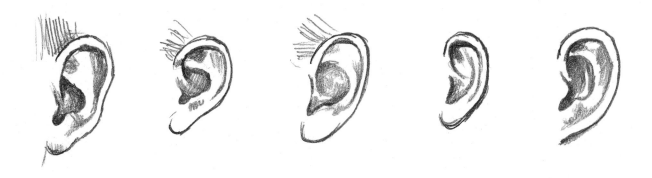

*The ears –*
*These come in a variety of permutations; here are a few for you to consider.*

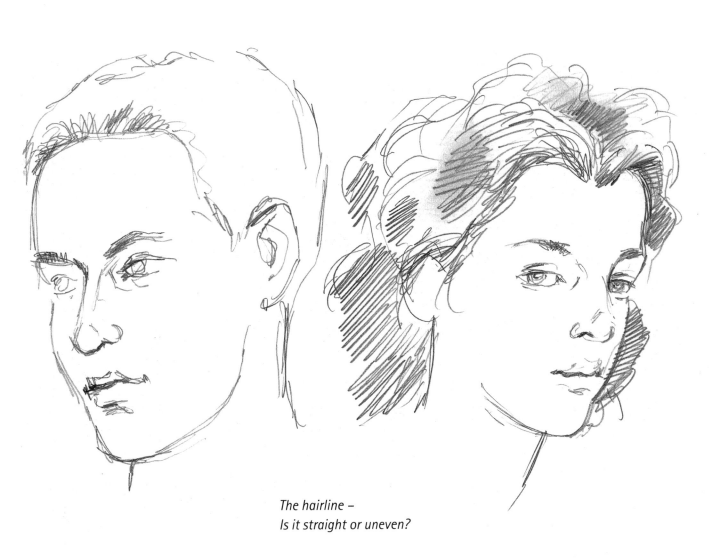

*The hairline –*
*Is it straight or uneven?*

## BONES OF THE HEAD

We need to remind ourselves frequently when drawing portraits that what we see is due entirely to structures that are for the most part hidden from view. An understanding of the landscape of the skull is necessary if we are to draw good portraits. Look at the features identified on the drawings below and see if you can feel them on your own head.

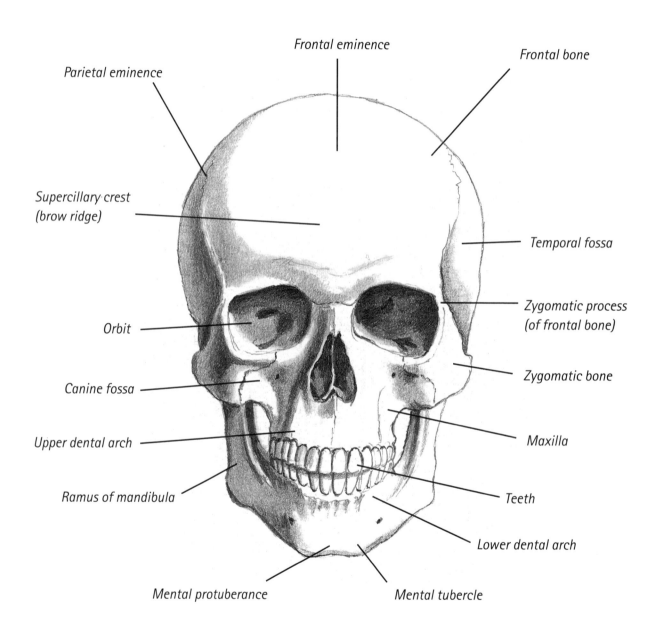

Frontal eminence

Frontal bone

Parietal eminence

Supercillary crest (brow ridge)

Temporal fossa

Zygomatic process (of frontal bone)

Orbit

Zygomatic bone

Canine fossa

Maxilla

Upper dental arch

Ramus of mandibula

Teeth

Lower dental arch

Mental protuberance

Mental tubercle

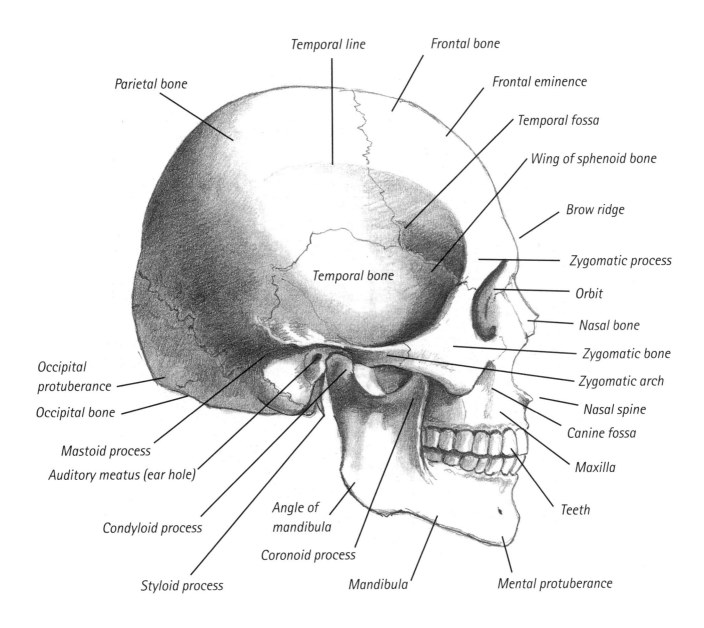

Temporal line

Frontal bone

Parietal bone

Frontal eminence

Temporal fossa

Wing of sphenoid bone

Brow ridge

Zygomatic process

Orbit

Temporal bone

Nasal bone

Zygomatic bone

Zygomatic arch

Nasal spine

Occipital protuberance

Canine fossa

Occipital bone

Maxilla

Mastoid process

Teeth

Auditory meatus (ear hole)

Condyloid process

Angle of mandibula

Coronoid process

Mandibula

Mental protuberance

Styloid process

## SKULL AND FACIAL MUSCLES

Movement and expression are two principal elements of portraiture and both are governed by the muscles. It is important to know where the bones and muscles are and how they behave if we are to produce portraits of character and individuality. Study the following illustrations and the accompanying annotations. Don't worry about learning the names, although you may find that giving each muscle an identity helps you to remember where it is and the function it performs.

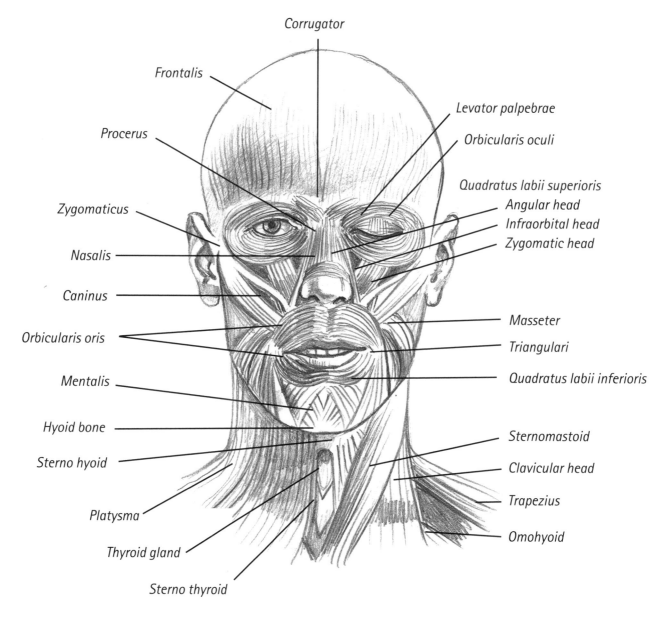

Corrugator

Frontalis

Procerus

Zygomaticus

Nasalis

Caninus

Orbicularis oris

Mentalis

Hyoid bone

Sterno hyoid

Platysma

Thyroid gland

Sterno thyroid

Levator palpebrae

Orbicularis oculi

Quadratus labii superioris
Angular head
Infraorbital head
Zygomatic head

Masseter

Triangulari

Quadratus labii inferioris

Sternomastoid

Clavicular head

Trapezius

Omohyoid

*Corrugator:* Pulls eyebrows together
*Orbicularis oculi:* Closes eyes
*Quadratus labii superioris:* Raises upper lip
*Orbicularis oris:* Closes mouth and purses lips
*Mentalis:* Moves skin of chin
*Masseter:* Upward traction of lower jaw; energetic closing of mouth

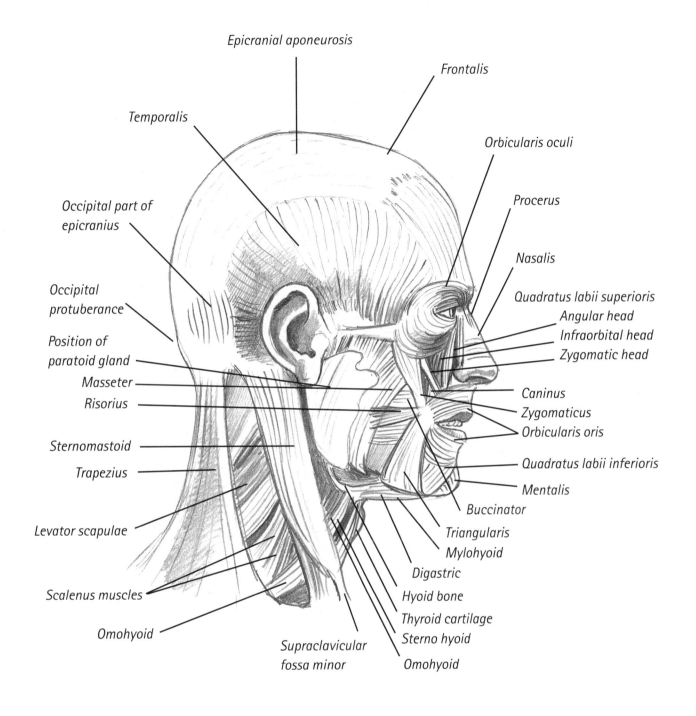

Epicranial aponeurosis

Frontalis

Temporalis

Orbicularis oculi

Procerus

Occipital part of epicranius

Nasalis

Quadratus labii superioris

Angular head

Infraorbital head

Zygomatic head

Occipital protuberance

Position of paratoid gland

Masseter

Caninus

Risorius

Zygomaticus

Orbicularis oris

Sternomastoid

Trapezius

Quadratus labii inferioris

Mentalis

Levator scapulae

Buccinator

Triangularis

Mylohyoid

Digastric

Scalenus muscles

Hyoid bone

Thyroid cartilage

Sterno hyoid

Omohyoid

Supraclavicular fossa minor

Omohyoid

*Occipital part of epicranius:* Backward traction of epicranial aponeurosis and skin
*Frontal part of epicranius:* Moves skin on top of head
*Compressor nasi:* Narrows nostrils; downward traction of nose
*Levator angulis oris:* Raises angle of mouth
*Zygomaticus major:* Energetic upward traction of angle of mouth
*Depressor anguli oris:* Downward traction of angle of mouth
*Depressor labii inferioris:* Energetic downward pull of lower lip
*Trapezius risorius:* Lateral pulling of angle of mouth
*Temporalis:* Similar action to that of masseter – see opposite
*Buccinator:* Lateral traction of angle of mouth; evacuation of fluid or air from between teeth and cheeks

## YOUR FIRST PORTRAIT STEP-BY-STEP

When you are confident of your ability to draw the features accurately, you are ready to try your hand at a full-scale portrait. If you are very lucky someone may commission you, but it is more likely you will have to initiate the event yourself, especially in the beginning.

You will need to agree on a number of sittings with your sitter, and how long each of these should last; two or three sittings of between 30 minutes and one hour should be sufficient. It is advisable not to let your subject get too bored with sitting, because dullness may creep into their expression and therefore into your portrait.

Once the schedule has been decided, it is time to start work. First, make several drawings of your subject's face and head, plus the rest of the body if that is required, from several different angles. Aim to capture the shape and form clearly and unambiguously. In addition to making these drawings, take photographs: front and three-quarter views are necessary and possibly also a profile view.

All this information is to help you decide which is the best view of the sitter, and how much of their figure you want to show. The preliminary sketching will also help you to get the feel of how their features appear, and shape your ideas of what you want to bring out in the finished work. Changing light conditions and changing expressions will give subtle variations to each feature. You have to decide exactly which of these variations to include in the drawing.

*Draw the face from left and right and also in profile.*

*Take photographs from left and right.*

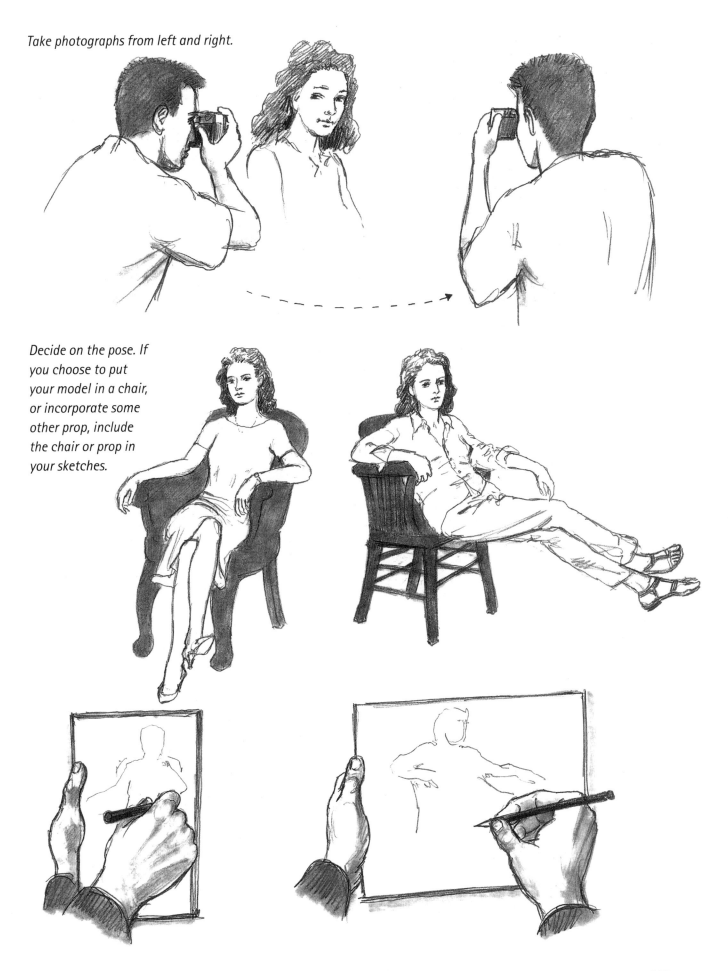

*Decide on the pose. If you choose to put your model in a chair, or incorporate some other prop, include the chair or prop in your sketches.*

## LIGHTING YOUR SUBJECT

Any portrait can be affected by the sort of lighting used, whether natural or artificial. Natural lighting is usually the softer of the two types and is the better if you want to see every detail of the face. However, this can have its downside, especially if you want to draw a sympathetic portrait and not highlight the sitter's defects.

Leonardo said that the ideal set-up was in a sunlit courtyard with a muslin sheet suspended above the sitter to filter the daylight and give a diffused light. This type of arrangement will be beyond most of us. However, we can aim to get a similar effect with a cool, diffused light through a large north-facing window.

The artist Ingres described the classical mode of lighting as, 'illuminating the model from an almost frontal direction, slightly above and slightly to the side of the model's head'. This approach has great merit, especially for beginners in portraiture, because it gives a clear view of the face, but also allows you to see the modelling along the side of the head and the nose, so that the features show up clearly.

Artificial lighting is, of course, extremely flexible, because you can control the direction and amount of light possible and you are not dependent on the vagaries of the weather. You

*The light coming from precisely side on produces a dramatic effect, with strong, well-marked shadows to the left giving a sharp-edged effect to the shadowed area.*

*The three-dimensional aspect of the girl's head is made very obvious by lighting coming from directly above, although the whole effect is softer than in the previous example. The shadows define the eyebrows, cheekbones and gently soften the chin and lower areas of the head.*

*Lighting the face from the front and to one side (as advocated by Ingres) gives a very even set of shadows – in this example on the right side – and clearly shows the bone structure.*

don't have to invest in expensive equipment to achieve satisfactory results: several anglepoise lamps and large white sheets of paper to reflect light will do very nicely.

Lighting from behind the subject has to be handled very carefully and while it can produce very subtle shadows there is a danger of ending up with a silhouette if the light is too strong.

Usually some sort of reflection from another direction creates more interesting definitions of the forms.

The only directional lighting that is not very useful is lighting from beneath the face, because light from below makes the face unrecognizable, which rather defeats the point of a portrait.

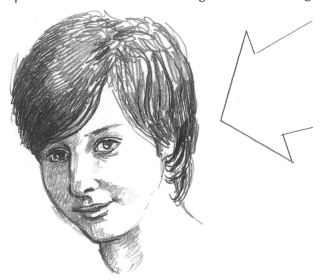

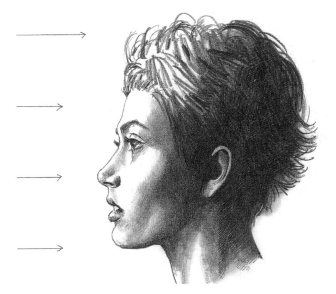

*Lit frontally and from above, this example also owes a debt to Ingres. The slight tilt of the head allows the shadows to spread softly across the far side of the face.*

*Lighting the model from directly in front shows the features strongly, subsuming the areas of the hair and the back of the head in deep shadow.*

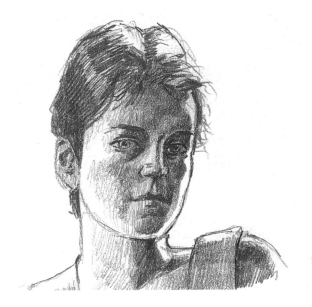

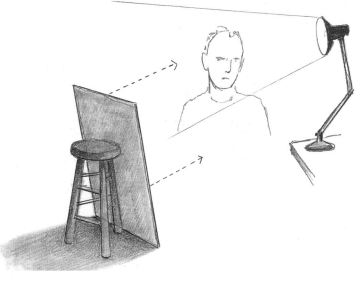

*Lighting from behind is not usual in portraiture although it has been done quite effectively. The trick is not to overdo it and end up with your subject in silhouette.*

*Reflected light can be used to flatten out too many shadows cast over the face. If you want to try this, place a large white sheet of card or similar opposite your light source.*

## SPONTANEOUS PORTRAITS

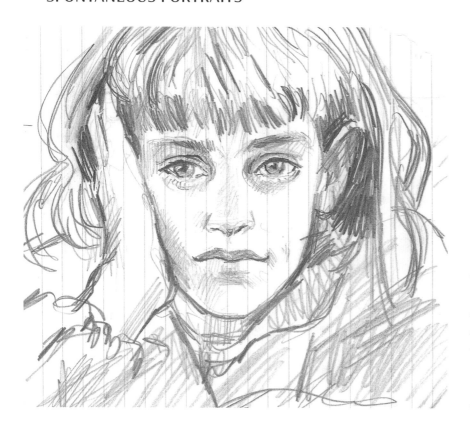

*You don't need first-rate materials to produce an effective portrait, as this next example proves. Although I would always advise you to buy the best you can afford, don't make their absence a reason for not drawing something that catches your imagination. I was on a train journey with my family when I had an impulse to draw my youngest daughter. After borrowing a leaf from my wife's notebook and a battered old soft pencil from my daughter it took me about fifteen minutes to complete her portrait. The motion of the train prevented subtlety, forcing me to use slashing strokes. As a result the texture is quite strong, mitigated only by the few softer marks for the tonal areas around the eyes, nose and chin.*

*Another example using toned paper, this time with a 2B pencil that was not particularly sharp. I opted for the simplest exposition of form and let the paper provide much of the medium tone. After putting in the strongest dark tones I added a few in-between tones, particularly on the hair, and left it at that. The entire portrait took about six minutes. This sort of spontaneous drawing works best if you can see what you want to achieve in one glance and then put it down immediately without deliberation. The result may not be ideal, but taking a chance is what this kind of drawing is all about. It is akin to taking a snapshot with a camera. Practising drawing spontaneous portraits will increase your expertise enormously.*

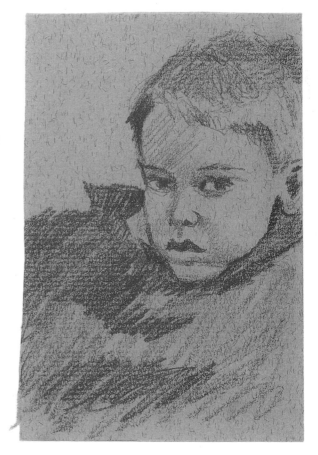

## PEN AND INK

*Pen and ink is ideal for producing minimalist yet revealing studies, such as this copy of a David Hockney drawing of Sir Isaiah Berlin. The spare lines, broken and tentative, are carefully placed to get the shape and character of the features. Each line is a one-off chance, perfectly judged so as not to overweight the surface, as some artists might do.*

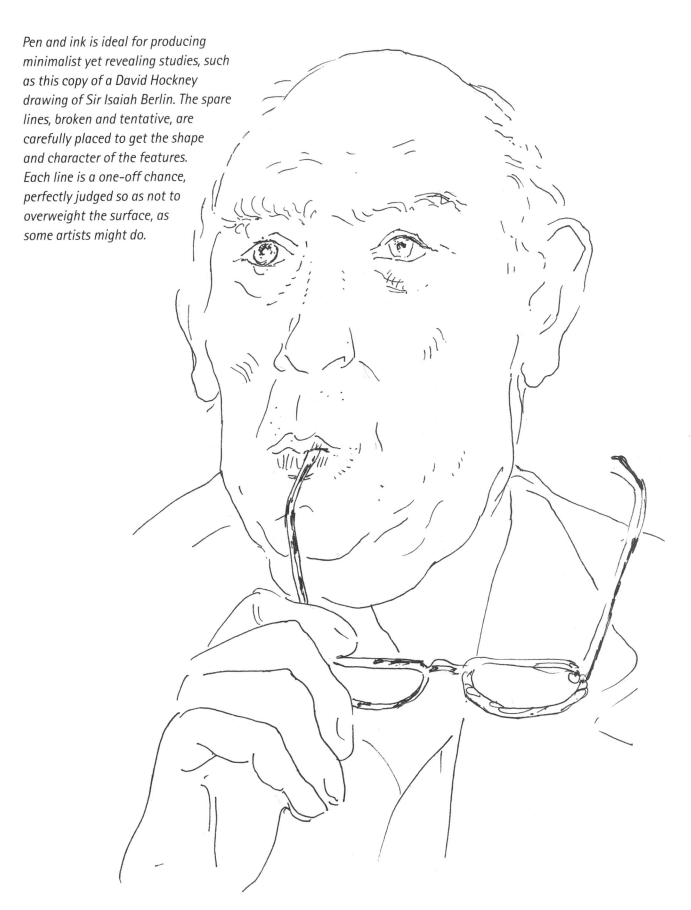

## CHALK

Chalk always gives a soft, attractive finish and is very popular for portraits, although you need to keep your drawing as clean as possible, otherwise you are liable to end up with a mass of smudges. Chalk makes a mark whether or not you press, so it is important to keep your touch light.

In this copy of a David Hockney, the eyes say it all. The other features are rendered very simply, almost as outlines. The texture of the hair serves to give an impression of the shape of the head. The key to Hockney's brilliant minimalist style is sound judgement of emphasis: nothing is overworked.

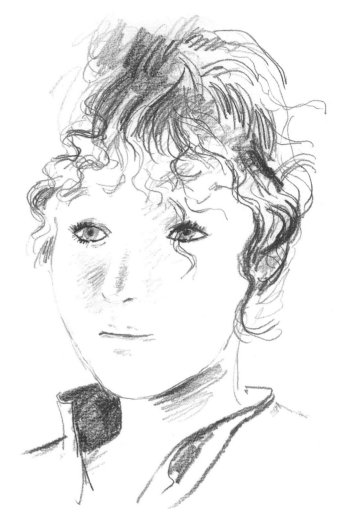

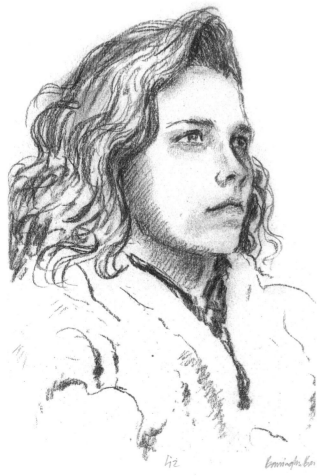

This black chalk drawing on a tinted paper took about 20 minutes. The style is fairly simple and the technique quite easy. The face has been drawn in without much modelling and with the emphasis on placing the features correctly. Interest has been created by the texture of the chalk line and the model's attractive longish hair.

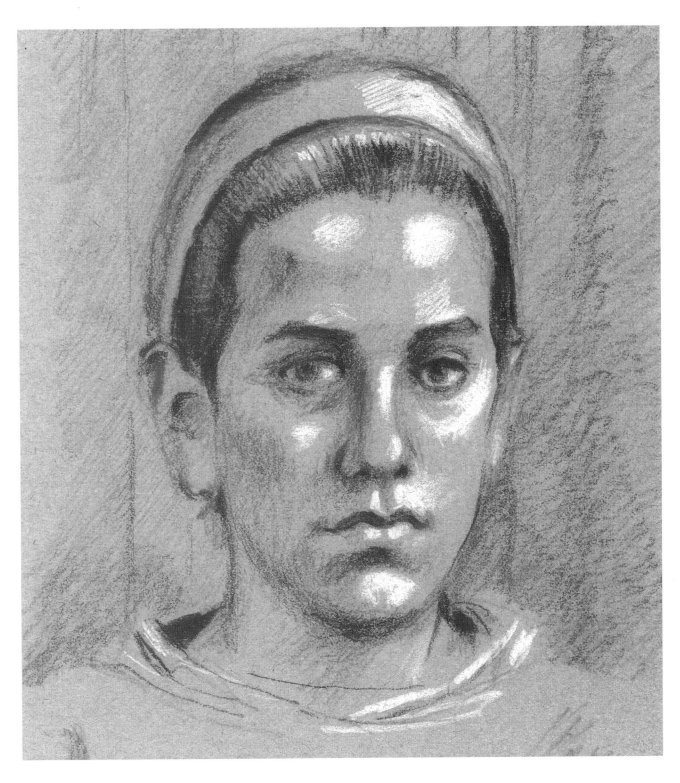

*The most dimension is achieved for the least effort in this example. The reason is the use of three materials in combination: brown and terracotta conté pencil, white chalk and toned paper. These give such a range of tones that they obviate the need to work a drawing too heavily. Notice how the strong emphasis provided by the darker of the conté pencils is kept to a minimum, sufficient to describe what is there but no more. Similarly the chalk is used only for the strongest highlights. The mid-tone is applied very softly, with no area emphasized overmuch. The toned paper is a great asset and does much of the artist's work, enabling rapid production of a drawing but one with all the qualities of a detailed study. Often you will find it effective to include some background to set off the lighter side of the head, which in this example is the right side as we look at it.*

## BRUSH AND WASH

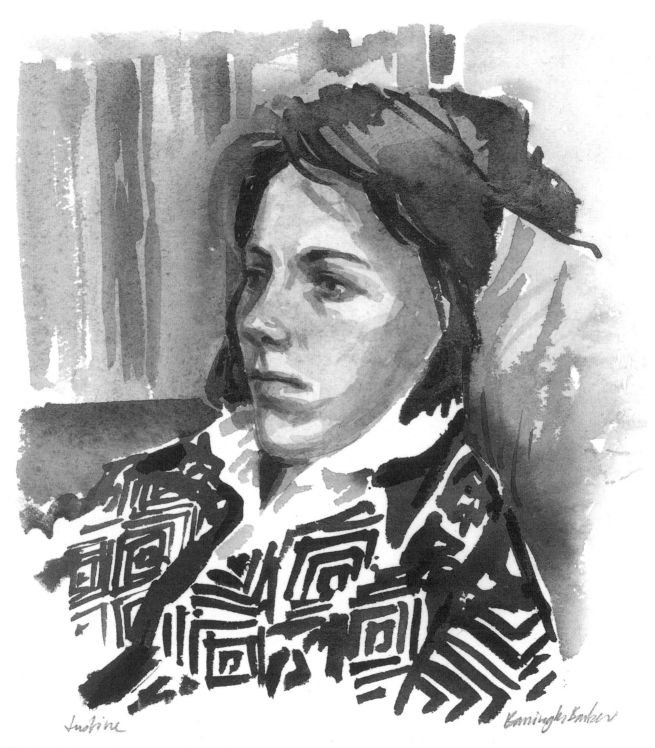

Plenty of water has been used to keep the tones on the face and the background soft in this example of watercolour on watercolour paper. The strength of colour on the jacket and hair is greater than elsewhere in the picture. The eyes, nose and mouth need touches of strong tone, especially the line of the mouth where it opens and the upper eyelashes, eyebrows and pupils of the eyes. This type of drawing can be built up quite satisfactorily, with the lighter tones put in first all over and then strengthened with the darks.

# SCRAPERBOARD

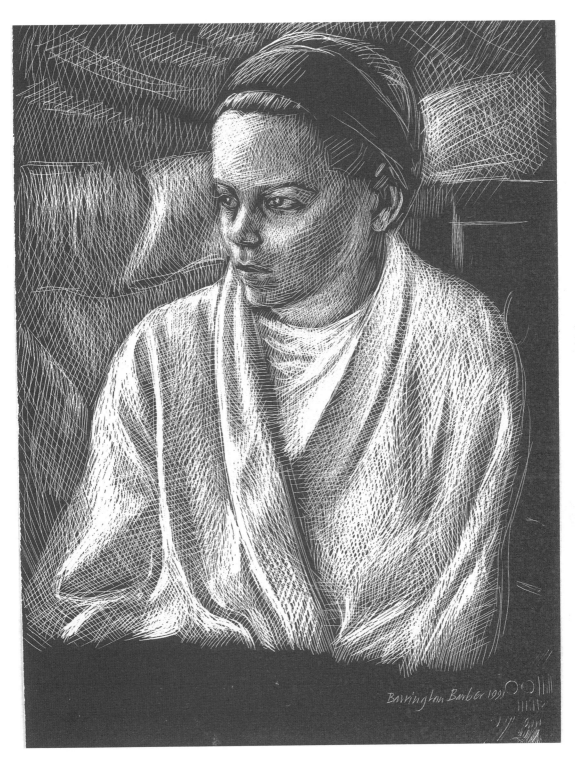

With scraperboard technique the artist has to draw back-to-front, revealing all the light areas and leaving the dark ones. Usually it is the other way round. This subject was ideal for the purpose, her white bathrobe ensuring there were plenty of light areas, although it was difficult to judge how much to work the face. The hair and hairband were made up of dark tones, and so required only the addition of highlights.

Similar effects to scraperboard can be obtained with white chalk on black paper. Try it as an exercise; it will teach you a great deal about gauging the balance of light and dark.

## PLACEMENT IN THE FRAME

Once you have chosen a subject to draw the next step is to look at composition. The most basic compositional consideration is how you arrange the figure in the frame of the picture. The pose or attitude you choose will have a large bearing on this. There are many compositional permutations that can be brought to a portrait, as you will quickly discover when you start to look at the work of other artists. Each of the arrangements shown here conveys an idea or mood associated with the subject. Before choosing a composition you must be sure it is right for your purposes. Good composition is never accidental.

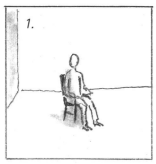
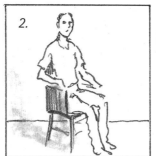
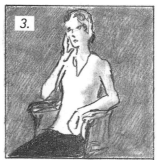
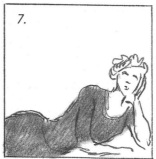

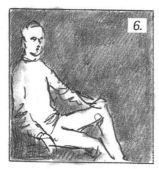
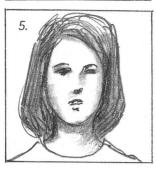
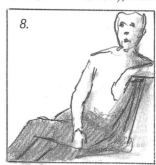
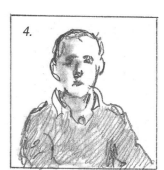

1. This figure is set well back in a room with lots of space around him. In order for the sitter to be clearly recognizable the picture would have to be huge. There would be a reason for choosing this degree of detachment from the viewer.

2–5. In this series of viewpoints the onlooker gets a progressively closer picture of the sitter. Generally longer views give a more detached picture. A tight close-up of the head demands that the artist achieve an accurate likeness, both physically and in terms of psychological insight.

6–8. An off-centre position can produce a dramatic, unpredictable effect. The picture becomes more than just a recording of someone's likeness, and we begin to consider it as an aesthetic, artistic experience. The space in the picture acts as a balance to the dynamic qualities of the figure or face. It can also be used to indicate qualities

about the sitter, especially if they have a retiring personality.

9. Not many faces can stand such a large, detailed close-up and not many people would be comfortable with this approach. However, it is extremely dramatic.

10. In this unusual and interesting arrangement, enough is shown of this figure turning away from the viewer for him to be recognizable.

11. Showing a half figure to one side of the picture with a dark background is a good approach for colourful characters or if you want to add some mystery to a portrait.

12. Firmly placed centre stage in an uncompromising pose, this sitter comes across as very confrontational. The well-lit background and

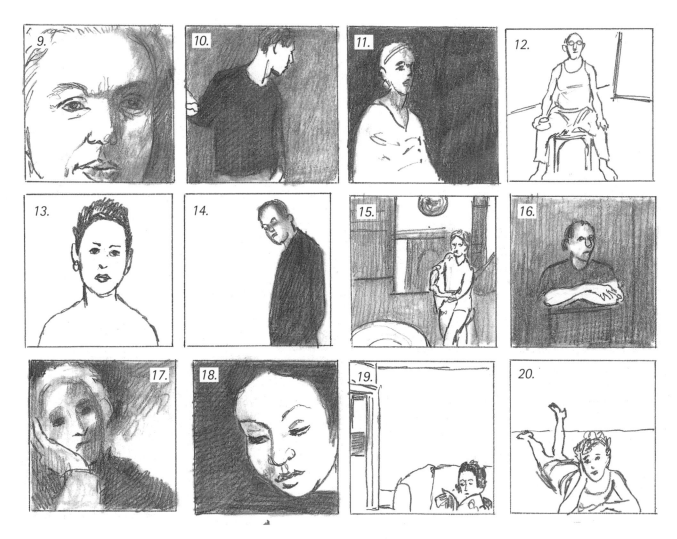

foreground ensure that nothing is left to the imagination, accentuating the no-nonsense direct view of the subject.

13. This head and shoulders view is evenly lit with little or no tonal values and absolutely no decorative effects. As such it demands a very attractive face.

14. The rather indirect positioning of the figure suggests a diffident character, and an almost reluctant sitter.

15. The figure takes up only one quarter of the frame, with most of the space given up to the sitter's domestic surroundings. The emphasis here is on lifestyle and the ambience of home.

16. This sitter is made mysterious and moody by the device of posing him so that he is not looking at the viewer.

17. A soft, slightly out-of-focus effect can be very flattering, and in this example gives a sympathetic close-up of an elderly woman.

18. This close-up of a face floating in a dark void gives a dream-like effect.

19. An off-beat dramatic twist has been brought to this portrait by placing the sitter at the bottom of the picture, as though she is about to sink from our view.

20. This sitter is presented as playful, by placing her along the lower half of the picture in a relaxed reclining pose.

## PLAYING WITH CONVENTION

Here we look at examples of composition from two undoubted contemporary masters of portraiture, David Hockney and Lucian Freud. While Hockney has chosen to borrow from past conventions, Freud has more obviously struck out on his own. Both approaches make us either question the situation or provoke our curiosity, either of which is a good response to any portrait.

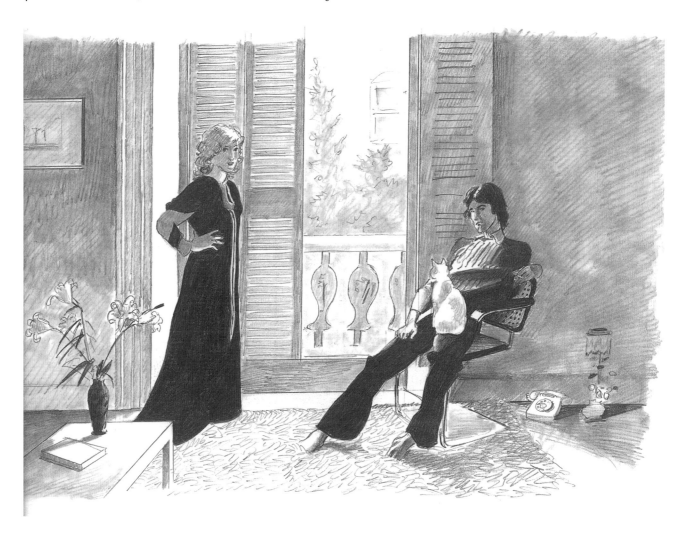

David Hockney's ability to echo the fashionable colour schemes of modern life in his work made him an obvious choice as portraitist of a fashion designing couple. In this copy, Ossie Clarke and his wife Celia Birtwell and their cat, Percy, are shown at home in their flat. The positioning of the figures is formal, almost classical, accentuated by the very dark dress of the woman and the dark legs of Clarke himself with Percy, outstanding in white, making three. There is minimal furniture, which might be as it was or because the artist arranged it that way. The white lilies in the vase on the table could be intended as symbols of purity. Cats were often symbols for lust, so although Percy's colour might qualify him as another icon of purity, tradition suggests otherwise. The position of both the flowers and the cat is interesting in relation to the main subjects. The shadowed walls adjacent to the bright slot of the window give both space and a dramatic tonality which contrasts well with the two figures.

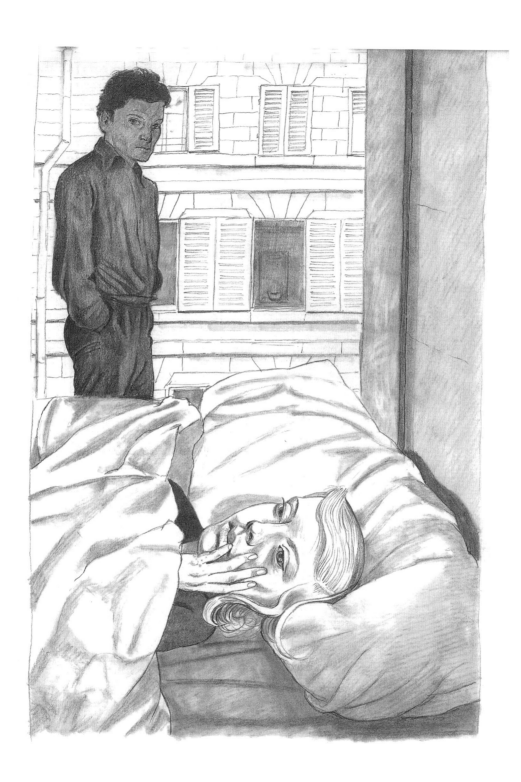

In Lucian Freud's double portrait of himself and his wife in a Parisian hotel bedroom the poses are as informal as the situation is ambiguous. Why is she in bed and he standing by the window? Obviously he needed to be upright in order to produce the portrait but he hasn't shown us that he is the artist. There is no camera, sketchbook or easel and brushes in his hands. So what could be his intention? There is an explanation that Freud's wife was ill in bed at the time, so it may have been that he hit on the arrangement because it was the only way he could paint them both. In the hands of a first-class artist this unusual approach has become a ground-breaking idea. The slightly accidental look of the composition is very much of the period in which it was painted (the 1950s).

## POSING

When arranging your subject, notice should be taken of the hands, arms and legs because they will make quite a significant impression on the overall composition. Portrait artists have always been interested in the relationship of the limbs because it can make a definite statement about a sitter's character or state of mind.

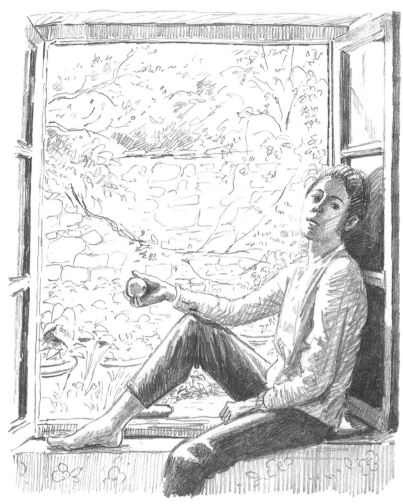

*In this seemingly very relaxed portrait the frame of the window is also the frame of the portrait. The angles of the limbs make for a very interesting composition within this frame. It is not an easy pose to hold for any length of time, and so quick sketches and photographs were needed as reference for the final portrait.*

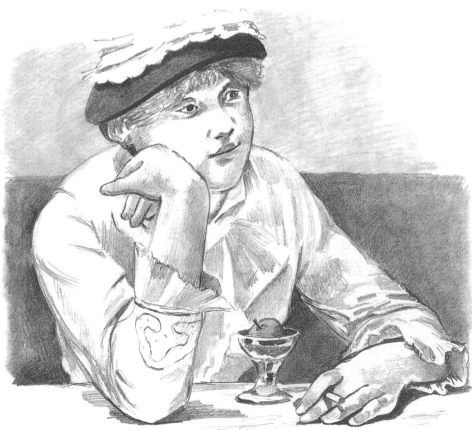

*In this copy of a Manet, a young woman is sitting draped around her plum dessert, a cigarette in her left hand while her right hand supports her cheek. The naturalistic pose gives a gentle, relaxed air to the portrait.*

## HANDS

Hands lying in the lap in a passive fashion give an impression of peacefulness and poise. Hands touching the face or hair can bring the attention of the viewer to interesting features of the head.

And, of course, by showing hands placed on specific objects in a picture the artist is giving information about the interests, status or profession of the sitter.

*This detail is taken from a portrait of Lady Dacre by Hans Eworth. Here the hands tell the viewer not just about the learning of the scholarly lady (note the thumb keeping her place in the book in her left hand), but about her creative ability as she moves to write in her journal. Literary and educational pursuits were becoming fashionable in the 16th century and so these compositional props are very obvious symbols of the sitter's status. If the book she holds is a scriptural work, this would also reflect the lady's piety, in an age when religion was a serious part of the life of the ruling class.*

*The hands of the elderly Catholic prelate Cardinal Manning, after a painting by G. F. Watts. The pose is appropriately peaceful and non-aggressive and is similar to one done much earlier by Raphael of Pope Julius II.*

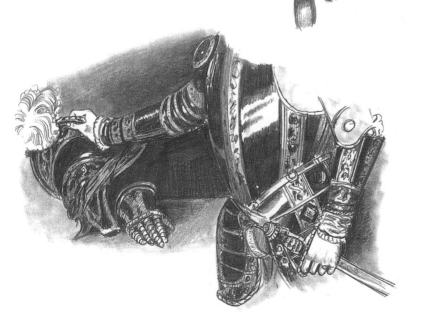

*Phillip II of Spain, by Titian, grasps the crest of a helmet while his left hand holds the scabbard of his sword just below the hilt. As he is also in half armour, the inference is clear that this king will not flinch from taking military action to defend and expand his kingdom.*

## POSING: ARMS

Arms often betray a strong attitude that gives the sitter an individual strength. The artist may use the arms to create balance in an off-centre picture, or as a strong statement to reinforce the structure of the position of the sitter.

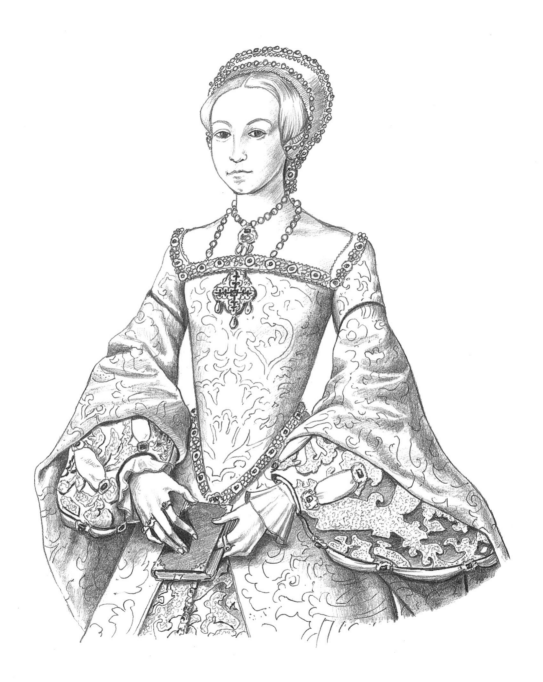

*The young Princess Elizabeth before she became England's greatest queen, demurely holding her book with a finger keeping the place where she is studying. She was a good scholar in scripture and languages. The arrangement of the arms in their fashionably ornate sleeves suggests some power in the stance. The direct stare is challenging, and she looks every inch a royal personage. The position of the arms is formal and balanced, which gives strength to her slight figure.*

Joshua Reynolds' painting of the dashing Duchess of Devonshire with her little son was in its time a ground-breaking picture. The hands and arms held up in delight and fun by the child in response to the mother's playful gesture was a remarkable novelty in portraiture.

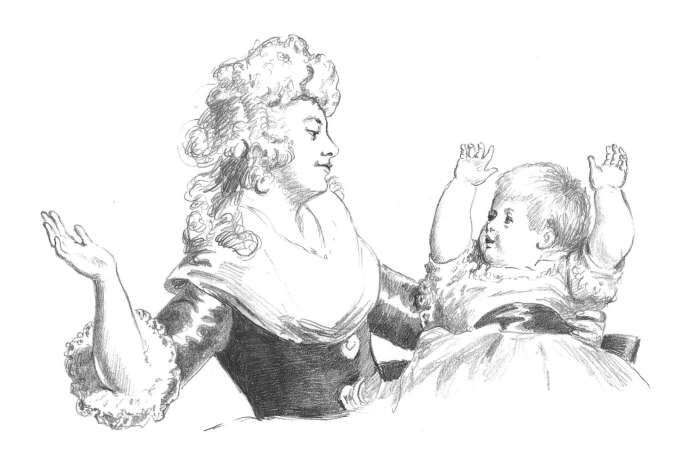

*The naturalness of the interaction between the subjects stops this being just another fashionable portrait and turns it into a study of the interplay that occurs between any mother and her infant.*

## POSING: MALE LEGS

Legs rarely receive the attention accorded the other limbs and only come into their own in a full-length portrait. They can, however, be more than just a pedestal for the rest of the body. In the days when men wore close-fitting nether garments the showing off of the legs was a very masculine statement. An aristocrat rode a horse and so his legs were often more elegantly proportioned than those of the lowly peasant, whose limbs generally would be shown as more muscular and solid. Many Renaissance paintings use the male form of the legs to tell you something about power, status or wealth, or how fashionable the subjects were as courtiers.

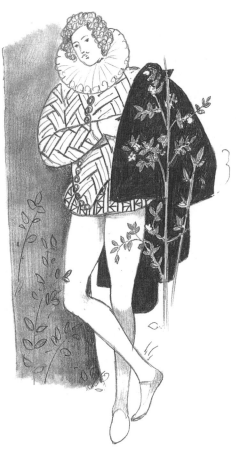

*The insouciant pose of this young man leaning against a tree in a rose garden (after Nicholas Hilliard) suggests a moment of romantic, aristocratic idleness. His casually crossed elegant legs stand out against his dark cloak and embroidered doublet. Although we don't know who he is, he has become an icon of the lyrical poetic image of the Elizabethan court.*

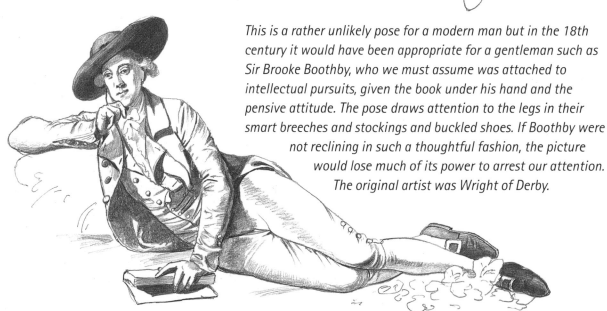

*This is a rather unlikely pose for a modern man but in the 18th century it would have been appropriate for a gentleman such as Sir Brooke Boothby, who we must assume was attached to intellectual pursuits, given the book under his hand and the pensive attitude. The pose draws attention to the legs in their smart breeches and stockings and buckled shoes. If Boothby were not reclining in such a thoughtful fashion, the picture would lose much of its power to arrest our attention. The original artist was Wright of Derby.*

## POSING: FEMALE LEGS

Until the 20th century, female legs were not much evident in portraits. The first glimpses came in the 19th century, many of them courtesy of Henri de Toulouse-Lautrec, who made a study of the Parisian demi-monde and the famous cabaret dancers of his day. The sort of display we see in the example on the right of a woman's legs was only acceptable at this time if the girls were either actresses or courtesans. Note the energy and movement, and how the legs can be central to the impact of a portrait.

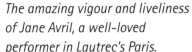

*The amazing vigour and liveliness of Jane Avril, a well-loved performer in Lautrec's Paris.*

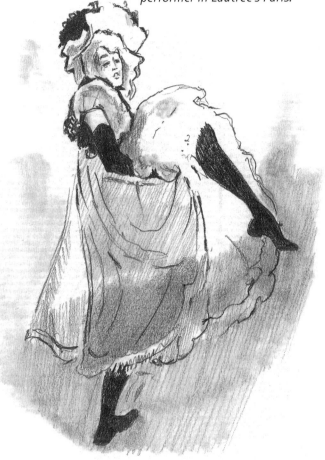

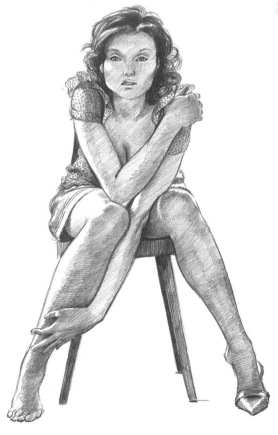

*Popular singer Sophie Ellis-Bextor in a leggy pose that any young girl might adopt; this copy was made from a photo-portrait that appeared in a Sunday newspaper. Although it is unlikely that a model sitting for a painting would remain in this position for long, the pose itself – elegant and gamine – is one that touches modern sensibilities.*

## CLOSE GROUPINGS

All sorts of arrangements can make good compositions, and in the process tell us a great deal about the sitters. It used to be the case that a portrait would include clues as to the sitter's position in society or would show to what he (invariably) owed his good fortune. Most artists, however, are more interested in incorporating subtle hints about the nature of the relationships between the subjects in the groups they portray. You may choose to introduce an object into your arrangement as a device to link your subjects.

There are many ways of making a group cohere in the mind and eye of the viewer. In these two examples, both after realist painter Lucian Freud, the closeness of the arrangements is integral to the final result.

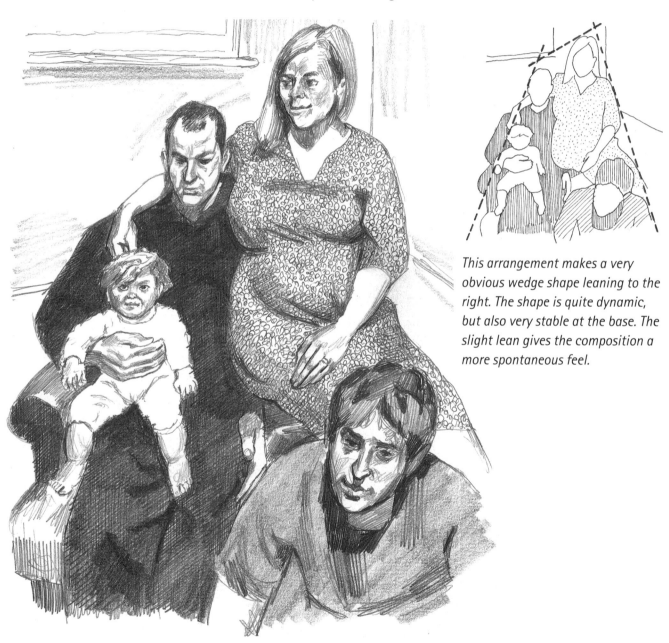

*This arrangement makes a very obvious wedge shape leaning to the right. The shape is quite dynamic, but also very stable at the base. The slight lean gives the composition a more spontaneous feel.*

*The central interest is shared between the baby and his parents. Our eye travels from the infant to the couple as they support him and each other on the armchair. In front, the elder son is slightly detached but still part of the group. The connection between the parents and the baby is beautifully caught, and the older boy's forward movement, as though he is getting ready to leave the nest, is a perceptive reading of the family dynamic.*

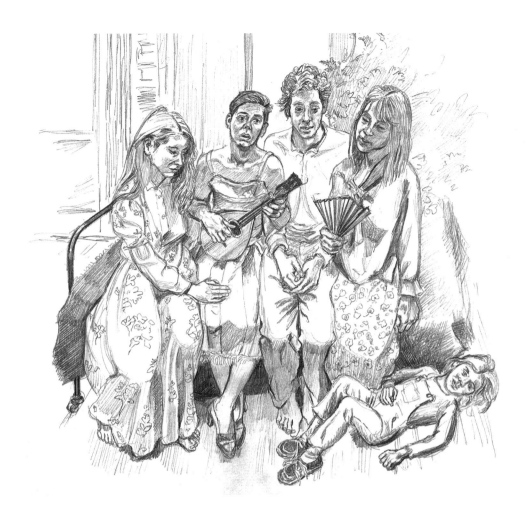

Large Interior *(after Watteau) is reminiscent of that artist's* fêtes champêtres *compositions in which young courtiers are depicted listening to music and enjoying each other's company. Freud transmits the outdoors to a well-lit indoor scene with three young women, a young man, and a child lying at their feet. As in many Watteau paintings the girls are wearing rather flowery, pretty dresses and the boy is dressed in a white shirt* and trousers, rather like a Pierrot. While the whole ensemble makes for a very friendly grouping, there is an element of a more formal mode of arrangement. In Freud's original the space around the figures produces a very posed, almost artificial effect. Here, even the child lying at the feet of the quartet seems very conscious of her position in the scene.

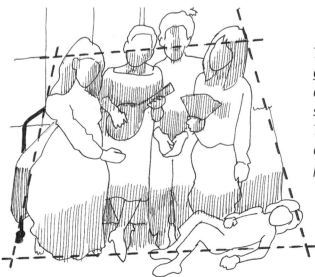

*This is a very solid, stable, composed group. The individuals are just lined up along the same base with some squashing together of the upper bodies. The lying down figure is almost like an afterthought and contributes to the portrait's spontaneity.*

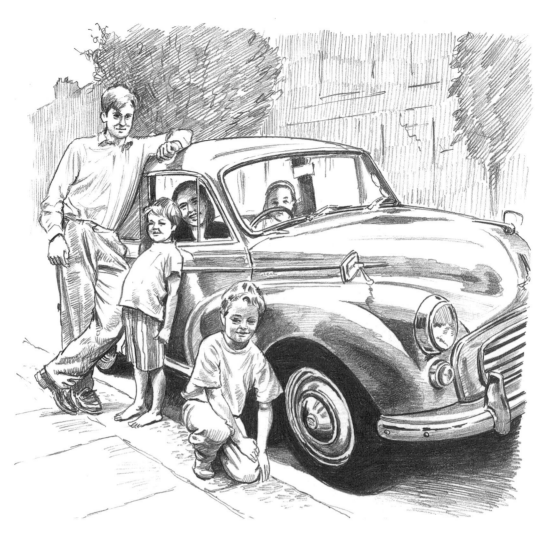

This example might almost be a portrait of the car as much as it is of the family. Obviously very well looked after, polished and shining, it is the centrepiece of the arrangement, if not quite the head of the household. The pride of possession is very evident among the males. The females inside the car are less obvious, although the mother is in the driving seat. This sort of casually posed arrangement is more often found in photo-portraiture. The style makes the drawing of the figures more difficult than it might have been in a different arrangement.

This composition is unusual and rather dynamic, partly due to the position of the car. The three figures outside the car form an acute angled triangle which also gives perspective. The bulge of the car against the longer side of the triangle produces a stabilizing element.

# FORMAL ARRANGEMENTS

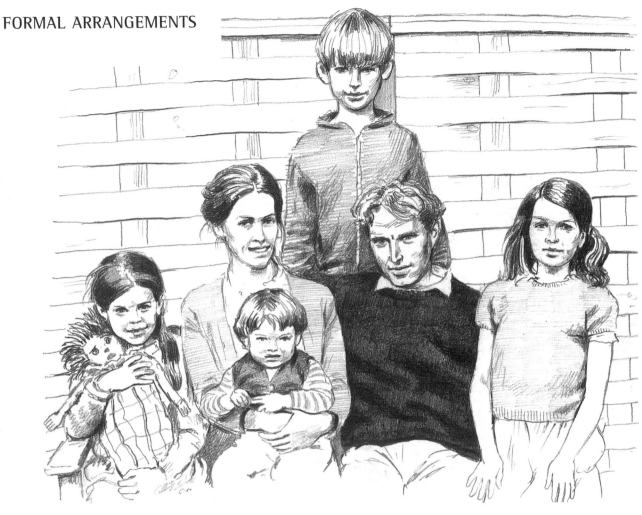

In this example there is an attempt to create a formal pose, but of the kind you get when people have gathered for a snapshot. The father is sitting, as is the mother, who has the youngest child in her lap. The two daughters are perched either side of their parents. The oldest boy only seems to be standing because there is not enough room for him on the same bench, and he is obviously the only one tall enough to look over the top of his father's head.

*Another simple enough composition, with a large triangular shape like a pyramid, with the individual figures radiating outwards from the wide base, like the arms of a fan. Very static and symmetrical.*

## OBVIOUS DOUBLES

An artist rarely draws a double portrait unless someone specifically asks for it. Very often parents with two children will choose to have their offspring painted or drawn in this way, and it is a favourite method of married couples celebrating important anniversaries.

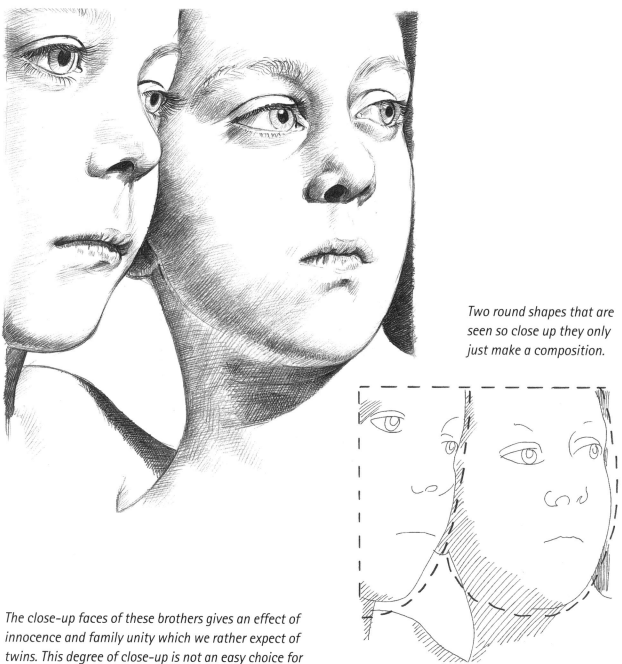

*Two round shapes that are seen so close up they only just make a composition.*

*The close-up faces of these brothers gives an effect of innocence and family unity which we rather expect of twins. This degree of close-up is not an easy choice for the artist, however. Because the skin of children of this age (eight years) is always so smooth and the bone structure is largely hidden by the rounded flesh, there are no lines of stress or tension to help give an accurate rendering. In such circumstances you have to measure out the face – and quickly, because the average eight-year-old will not sit still for very long, and their faces are also very mobile.*

*This drawing was made from an excellent photograph by Jane Chilvers which won a photographic portrait award and now hangs in the National Portrait Gallery in London. The original was a very detailed and rather cool image. I didn't attempt to put in too much surface detail because, to my eye, the smoothness of the facial surface is part of the charm.*

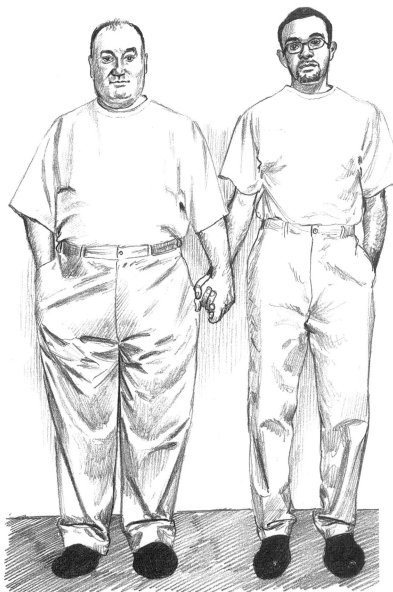

The pose in this father-and-son portrait – taken from a photograph by John Nassari – suggests a sense of humour in the artist and a sort of family complicity about the portrait. However, despite the humour, the effect is fairly cool and detached. The uniform clothing gives the pair an oddly dressed-up quality although what they are wearing is very ordinary. The drawing is simple and mainly concerned with the outline. It demonstrates that if you get the main shape right, individual qualities can shine through.

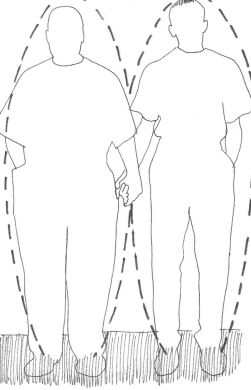

The two vertical ellipses overlapping in the centre make this a stable and uncomplicated arrangement.

## COUPLES

The reason behind the vast majority of double portraits is that there is a personal or professional connection between the two sitters. Unsurprisingly, most double portraits are of husbands and wives.

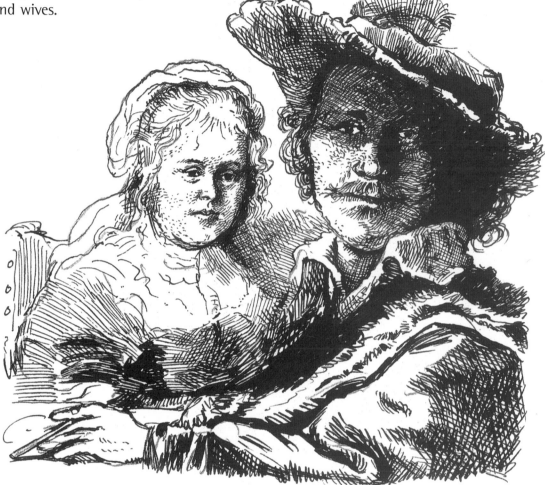

*This double portrait of Rembrandt and his wife looks a bit odd because she is set back behind her husband. Possibly the artist had to use a mirror to assist in drawing them both and as a result she would necessarily be a bit behind him in perspective. He has tried to balance the effect by showing his own face in shadow and highlighting that of his wife.*

*The composition is not very obvious. The front shape of the head and arm of Rembrandt acts like a holding shape for the smaller shape of his wife, who gives the appearance of a ventriloquist's doll.*

In Gainsborough's marvellous portrait of the Duke and Duchess of Cumberland the arrangement does not attempt to disguise the fact that the young wife is much taller than her princely military husband. The full-length figures stop the picture being intimate. There is a definite 'swagger' effect, as the pair seem to be stepping out in public to show themselves off.

This sort of drawing needs a feathery, rather impressionistic touch with the pencil, using loose lines but observing the shapes as accurately as possible so that the lines don't become too arbitrary. A considered effort to draw in the soft, feathery lines works better than making swift, dashing strokes.

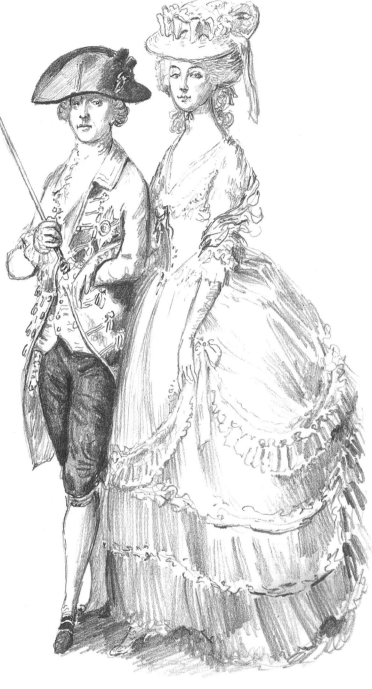

*The tall elongated triangle of the duchess makes a strong, vertical base shape for the rounder ellipse of her husband.*

## PORTRAYING DIFFERENT AGES

As a portrait artist you have to assess correctly the age of the face in front of you so that it can be shown without causing the sitter to feel that you have made them look older or younger. Making people look younger is not normally a problem because most of us have an image of ourselves as younger than we are in reality.

The hardest individuals to draw, oddly enough, are the very young. First and foremost, they can't pose for you. Secondly, baby faces have very little in the way of distinctive features and therefore are very difficult to make interesting. As I hope you will see from the following series of drawings, the older we become the richer are the opportunities for the artist.

(Unless stated otherwise, a B grade pencil was used for all the pencil drawings in this series.)

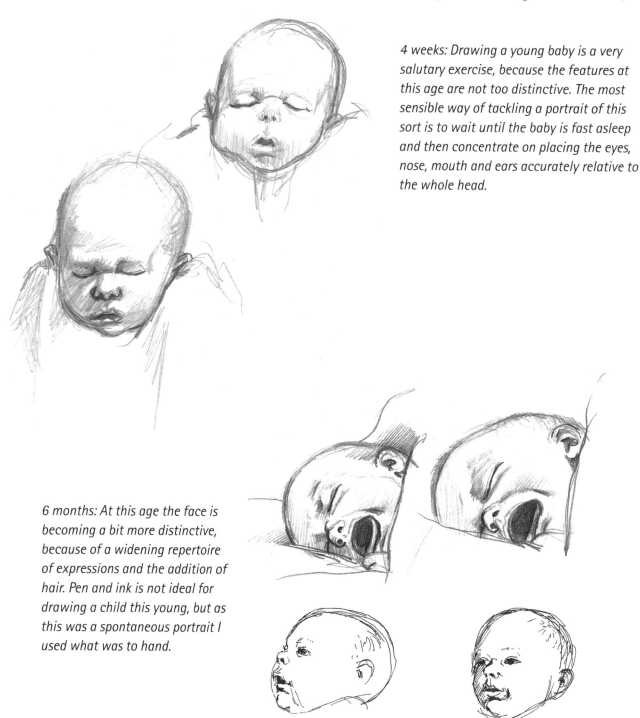

*4 weeks: Drawing a young baby is a very salutary exercise, because the features at this age are not too distinctive. The most sensible way of tackling a portrait of this sort is to wait until the baby is fast asleep and then concentrate on placing the eyes, nose, mouth and ears accurately relative to the whole head.*

*6 months: At this age the face is becoming a bit more distinctive, because of a widening repertoire of expressions and the addition of hair. Pen and ink is not ideal for drawing a child this young, but as this was a spontaneous portrait I used what was to hand.*

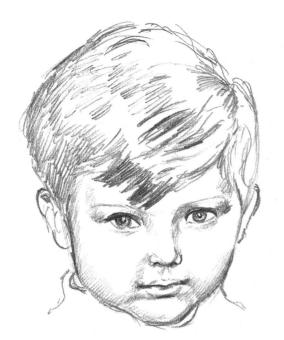

*3 years: It is not easy to get young children to sit still for long, which is why drawings of them are often small. Luckily this model managed not to wriggle for about five minutes at a time, giving me just long enough to capture his clear, bright, lively expression. His eyes and mouth moved a lot, so I also took a photograph to help me in the finished pencil drawing. The technique is careful and as exact as possible. The expression is easy enough if you get the proportions of eyes, nose and mouth correct within the shape of the head. Note the large area of the top of the head; the proportion at this age is unlike that of the adult head, the chin being much smaller in proportion to the rest of the skull.*

*4 years: Two tones of conté pencil were put in carefully with as light a touch as possible to produce this example on toned paper. The hair is smooth and relatively easy to draw. The main interest is in the face, with the eyes particularly arresting, and the soft blurred look of the snub nose and soft mouth. The tone over the side of the face and around the nose and mouth had to be put in fairly lightly to prevent the surface looking harsh or angular. The absence of sharp edges in the features meant that the pencil had to be gently stroked onto the paper.*

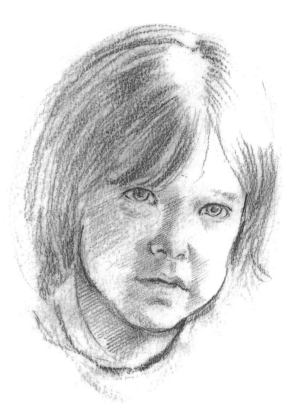

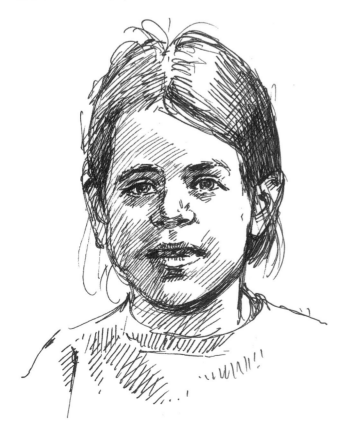

*5 years: Ink is a difficult medium for a face as unformed as this and so the style had to be fairly loose and fluid. I used sweeping lines to prevent them looking too dry and technical. Ink does not allow a lot of subtle variations but its very simplicity can give a drawing great strength.*

*6 years: In this small sketch with a ballpoint pen I was interested in capturing the shape of the head and the dimensional effect of the large area of shadow and the bright areas catching the light. The features are drawn simply in line to show through the overall texture of shadow. At this age the features are becoming better defined, allowing the use of a stronger line.*

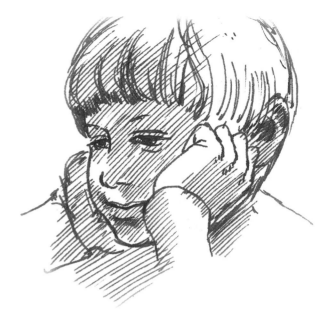

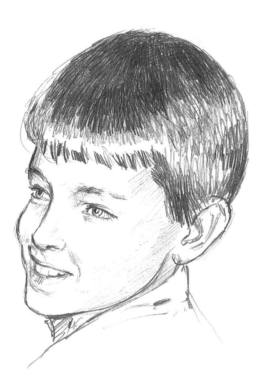

*10 years: Although the face is still very young at this age the lines can be drawn more crisply and definitely. The shiny, short hair produces a nice contrast with the face. The features are clearly drawn but with little tone to capture the fresh, clear look which is typical of children of this age.*

*13 years: In this example in ink the toned paper gives a slightly heavy look to the face which, although still soft and relatively unmarked by experience, has a slightly stronger bone structure and a look expressive of the mood swings that beset adolescents.*

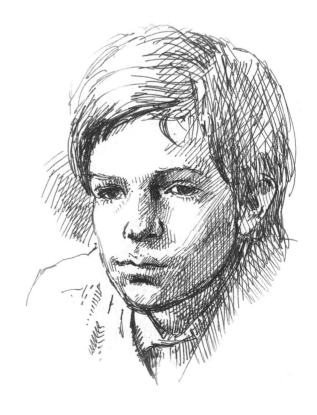

*15 years: The face has the clarity and charm of youth but in the expression there is a hint of deeper knowledge. Drawing a portrait of this age group is not easy for the artist and is largely a question of what you leave out rather than what you put in. Often you can end up making your subject look older than young adults who are several years their senior. The beauty of the form demands clarity in the drawing. Further than this you have to try to express in some way the expectant feelings that girls of this age experience.*

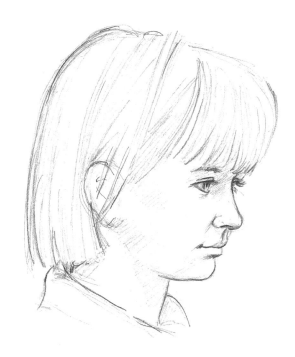

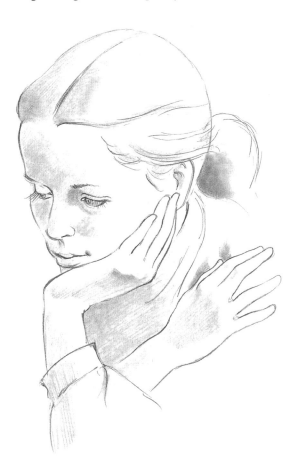

*16 years: At this age the features are complete in form and full of life, strongly marked but still fresh and untouched by real anxieties. A light touch is required. Here the features are clearly drawn and there was an opportunity for making much of the hairstyle.*

*20 years: There is plenty of form to draw at this age and the greater maturity in style and carriage provides opportunities for interest. The beard growth and sculpted bones showing through help to define the age nicely. A 2B grade pencil was used in addition to a B grade.*

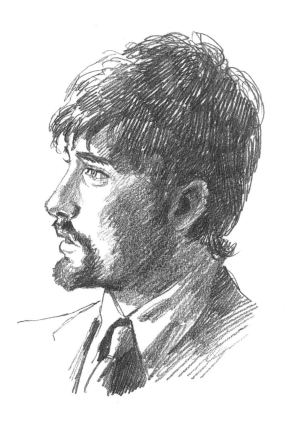

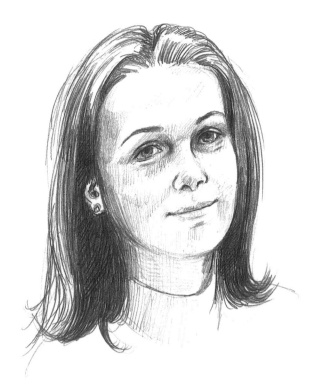

*25 years: The personality is now developed and tends to come through in any drawing in any style. As before the features and head shape have to be kept clear and definite, but you will have to pay careful attention to detail to convey distinctive nuances of expression and attitude.*

*33 years: In the thirties, experience of the world begins to tell on the face. The artist needs to identify the main characteristic of the subject and then bring into it all the subtle psychological variations that are shown in expression, habitual lines on the face and ambiguity in the projection of personality.*

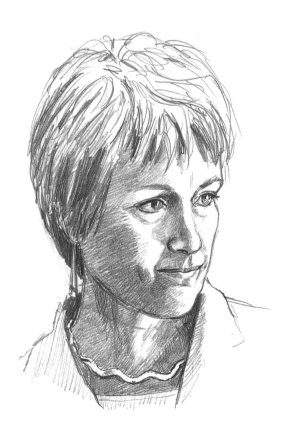

*50 years: At the half century mark the artist is presented with a range of experience to emphasize or play down. You can opt for craggy weathered surfaces, volatile expressions of emotion, the more benign influences registered on the face or a more generalized form that reduces the wear and tear to a texture of soft marks. Whatever you decide, it will not be difficult to see how to put down the structure. At this age there is plenty to draw. The media used were B and 2B grade pencils.*

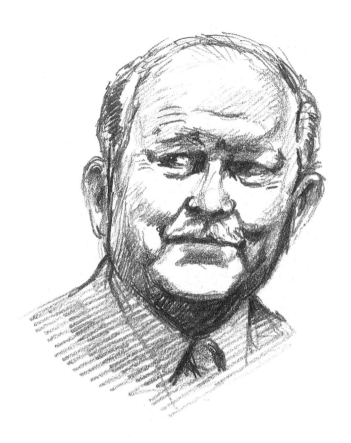

*70 years: The features show very definite marks by this age. Lines are firmly engraved on the face and dilapidation of the surface textures and hair is very evident. However, if the person's experience has been in the main of a pleasant nature the face will have wisdom, benignity and, often, good humour. All is revealed and is not difficult to draw.*

*80 years: This particular subject is very well preserved and sprightly, but with all the lines and wrinkles associated with old age. Her expression shows what she is like; it is almost as impossible to dissimulate at this age as it is at the very youngest. The artist is presented with a map of a whole career, which can be fascinating to draw. Careful drawing is required to get across the texture of the features and the expression. The media used were B and 2B grade pencils and a stub.*

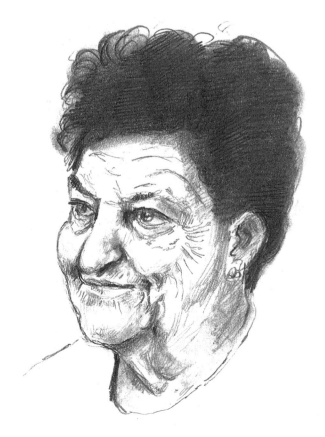

## MASTER STROKES

In the following pages we look at some examples of the changing ages of humanity as seen through the eyes of some of the great artists. In earlier periods people may have aged more quickly because life was physically much harder, and so someone depicted in their middle years will look far older than they would now. However, if you study these remarkable portraits purely for the way the subtle signs of youth or age are shown on the human face, you will find them immensely instructive. Some will look almost elementary in their simplicity. Closer examination will reveal the tremendous skill it takes to reduce complex subtle effects to such a degree.

Every mark you make on a drawing gives some information, even if it is just that you are unsure of what you've seen. In every portrait you attempt your observation is paramount. Never forget this: the best results always derive from observation and attention to detail, as the work of the great artists proves.

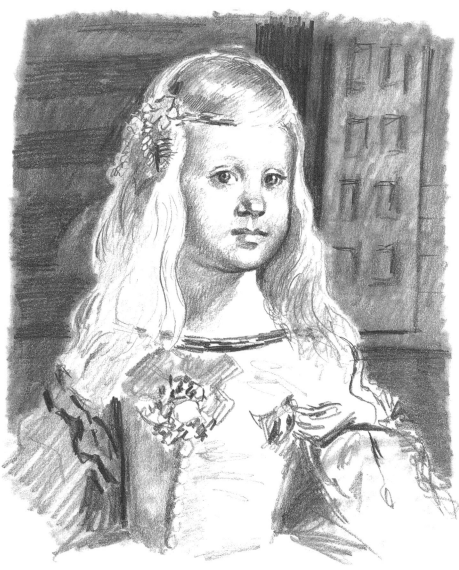

*Velázquez's portrait of the five-year-old Infanta of Spain captures the innocence of early childhood. The sweetness of her expression contrasts with the dark background and her stiff formal dress, accentuating her innocence. Soft black pencil (B) and graphite stick (2B) were used for this copy. With the exception of the edges of the eyes and the dress, the lines were kept sparse and light. The broad edge of the graphite produced the dusky background tones.*

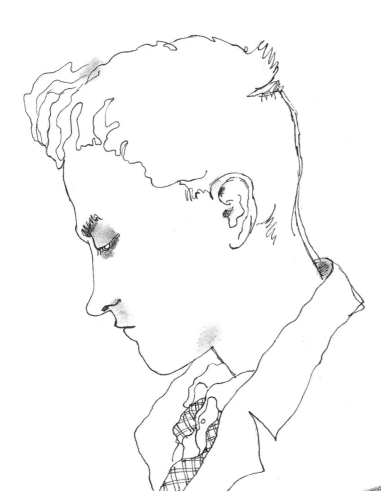

Jean Cocteau's brilliant line drawing
of Jean Desbordes, who was about 17
at the time, captures the softness of
youth together with a certain gangly
self-consciousness in the downcast
head and glance. The slightly wayward
hair and loosely tied necktie adds to
the air of youthful carelessness. The
key to the drawing is the absence of
tone and the thin, continuous wavy
lines. My copy was drawn with a .01
Japanese pigment ink pen.

This copy of a portrait of Gabrielle
d'Estrees by a follower of François
Clouet was executed by carefully
stroking on lines of soft B and 2B
pencil. In some areas chalk was
carefully put in. Sharp lines have
been applied only around the
eyes, nostrils and mouth. Clouet
reveals her as wary and self-
composed beyond her 18 years,
and yet we are not convinced this
is more than a pose.

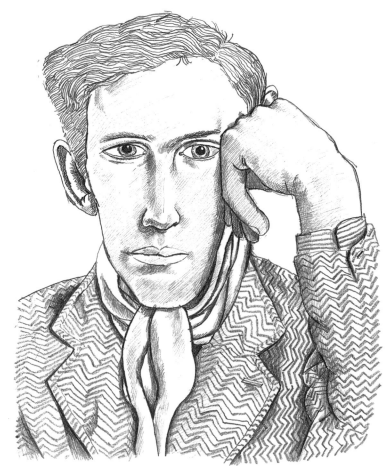

*Lucian Freud's drawing of a young man in his early twenties emphasizes large hands and long features, giving an angular awkwardness to an otherwise composed and calm portrait. In this copy the pencil lines are incisive with minimal shading. The herringbone pattern on the jacket was done with a blunter point to achieve softer lines.*

*Henry Fuseli drew this self-portrait when he was in his thirties. It shows the anxieties and self-doubt of someone mature enough to be aware of his own shortcomings. B and 2B soft pencils were used for this copy to capture the dark and light shadows as well as the sharply defined lines depicting the eyes, nose and mouth.*

We happen to know that the sitter in this portrait by Jan Van Eyck, the Cardinal of Sante Croce, Florence, was 56 years old. The lines of the eyes, ears, nose, mouth and outline of the face are precise and give clear signs of the ageing process. The technique is generally smooth and light with some cross-hatching in the tonal areas. Although Van Eyck portrays his subject as still powerful, there is also a sense of resignation.

Rembrandt drew himself throughout his life, from early adulthood until just before his death, and has left us an amazing record of his ageing countenance. In this copy of a self-portrait done when he was about 60 years old, a smudgy technique with a soft 2B pencil was used in imitation of the chalk in the original.

## DRESSING FOR CHARACTER

Some compositional set-ups or styles of dress just ask to be drawn, no matter who is the wearer.

*Csorati's Silvana Cerni is wearing a white silk garment that is almost habit-like in its plainness. The sitter appears to be meditating or contemplating. Note how the folds in the clothing help to draw attention to her stillness.*

*This portrait by Meredith Frampton is a superb statement of fashion without fuss. The white silk dress is completely devoid of ornament to distract from the alert gaze and elegant figure. The cello suggests the young woman's interests, but it is the dress which tells us about her.*

*Lady Caroline Scott looks as though she is enjoying wearing this cosy costume in Reynolds' portrait of her, and was probably much more amenable to posing because of the chance of getting to show off her super clothes. Apparently this infant scion of the aristocracy was also adept at keeping the painter and his friends amused by her chatter.*

Edward Carpenter, the charismatic
Victorian socialist speaker, was drawn
and painted by Roger Fry, the Bloomsbury
artist. The idea of wearing the overcoat
was probably the artist's. He referred to it
as 'anarchist' because of the slightly
raffish air it gave Carpenter, who
probably played up this aspect.

Putting a sitter in sporting kit can be a
very good way of giving a portrait extra
individuality. John Biglin was an American
rower who was drawn and painted by the
famous 19th-century American artist
Thomas Eakins. Biglin's outfit is quite
practical and yet it looks almost like fancy
dress, especially the dramatic, almost
piratical scarf around the head.

## ADDING A HEADDRESS

A headdress can radically change the appearance of a sitter as well as bring a lot of drama and unusual interest to a portrait. Unless someone wears a hat out of habit or because of their occupation, it is difficult to know beforehand whether it will work in a portrait, but don't be afraid to suggest it because the results can be very impressive. Such an addition can provide insights into character, as these examples show.

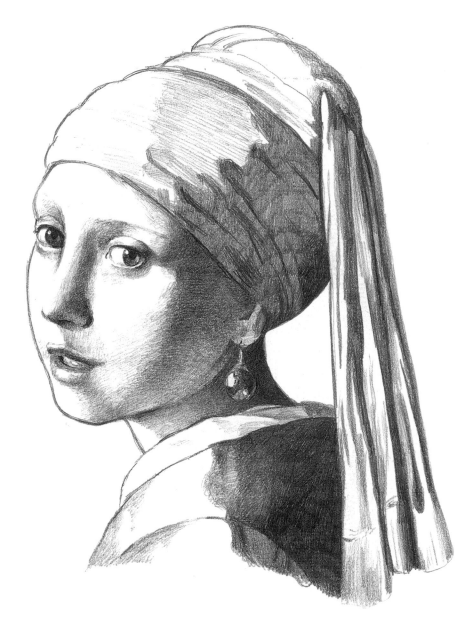

*In this copy of Vermeer's famous painting of the girl with the pearl earring, the turban neatly obscures her hair and helps to show off the jewel, which might have been less noticeable if her head was uncovered.*

T. E. Lawrence was acting as advisor to Emir Feisal at the Paris Peace Conference held at Versailles in 1919 when he was captured in a drawing by Augustus John. A passionate and active supporter of the Arab cause, Lawrence wore this style of dress as a matter of course and not as an affectation.

This extraordinary plumed hat is part of the dress denoting a Knight of the Order of the Bath. Instead of following convention and having the headdress shown on a table adjacent to him, the 1st Earl of Bellamont has decided to wear it, perhaps concerned that otherwise his membership of that august company might be lost on the viewers of his portrait (after Sir Joshua Reynolds).

The perky yachting cap sitting on the head of Dr Gachet (after Van Gogh) rather contradicts the melancholy expression on his face. Van Gogh remarked of this portrait: 'Now I have a portrait of Dr Gachet with the heartbroken expression of our time.'

## HAIR STYLES

The great masters used the styles of their day to emphasize the femininity of their subjects. Good features can enhance the dramatic effect of elaborate dressing of the hair. However, where the gods have been more sparing in their distribution of looks, artists have to employ more subtle means of portraying their sitters. An elegant hairstyle, assisted by good lighting, can help give substance to the plainest individual.

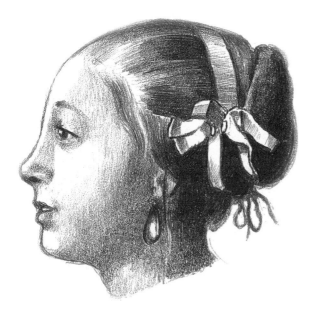

*Vermeer used the ribbons and curled hairstyles of the 17th century with great skill to emphasize the femininity of his subjects, as these two examples show.*

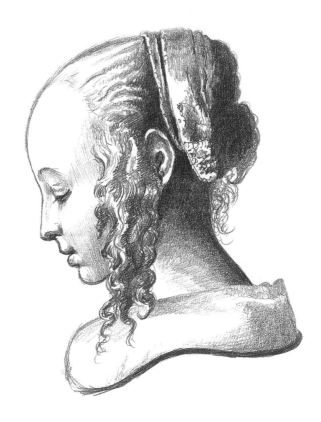

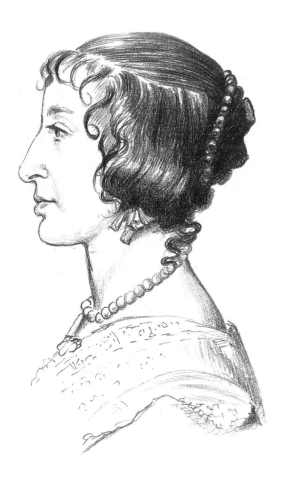

*The ribbons and jewellery of this period enabled hair to become an architectural element in portraiture, which artists had to capture by paying attention to the intricacies of the design.*

*Notice how Van Dyck produces a similar effect to Vermeer with his portrait of Queen Henrietta Maria. When people saw the queen at close quarters they were rather disappointed with her looks, so it is a tribute to Van Dyck's skill that in this profile she appears gracious and elegant.*

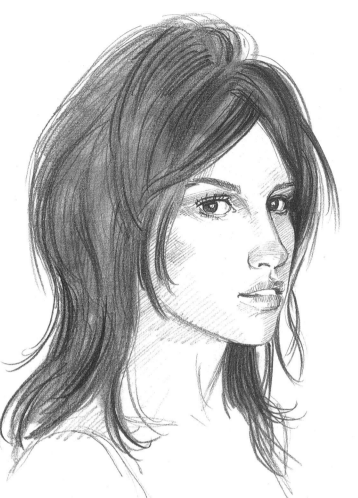

By contrast modern hairstyles are less fussy and less structured than styles from earlier periods. Usually you need only to observe the direction of the combing or, in a more dishevelled look, just allow your pencil, brush or pen to move freely. The direction of the hair is important, but as there is usually less in the way of braiding or curling the problem is simpler.

This example of a modern hairstyle, taken from a fashion magazine promoting hairdressing, gives a seemingly natural look, although this is sometimes attained at some effort and after a great deal of careful work.

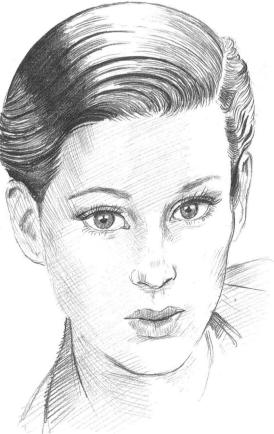

Short hair has been very popular with women since the 1920s, and like most modern hairstyles is not difficult to draw.

## ORGANIZING THE COMPOSITION

When it comes to featuring a favourite animal in portraits, art most certainly does mirror life. The golden rule is: animal first, human second. The composition may be agreed between you and the owner but the animal then has to be coaxed into position, preferably one that it can keep long enough for you to make a satisfactory drawing.

When the situation is as you want it, draw the animal. Don't worry about the owner at this point, except for making a very rough sketch of the relation between pet and owner. Once you have a good drawing of the animal – and it may take more than one attempt – turn your attention to the owner. If the animal is content to stay put, continue. If it isn't, just put the owner roughly in the pose wanted for the final drawing, without the animal, and carry on.

You can work the two drawings together at this time or later. Obviously it is better if you can progress immediately from drawing the animal to drawing the person, because that will give you a very spontaneous record of the event. If circumstances force you to put the two drawings together afterwards, it is usually better to re-draw the animal in the correct position in relation to the owner rather than re-draw the owner. The reason for this is that a portrait of an animal is much easier to reproduce in a second drawing than a human being because the animal's expression is unlikely to change.

It can be very helpful – and in some circumstances essential – to make a photographic record of the animal. Certainly it is easier to draw an animal from a photograph than it is a human being.

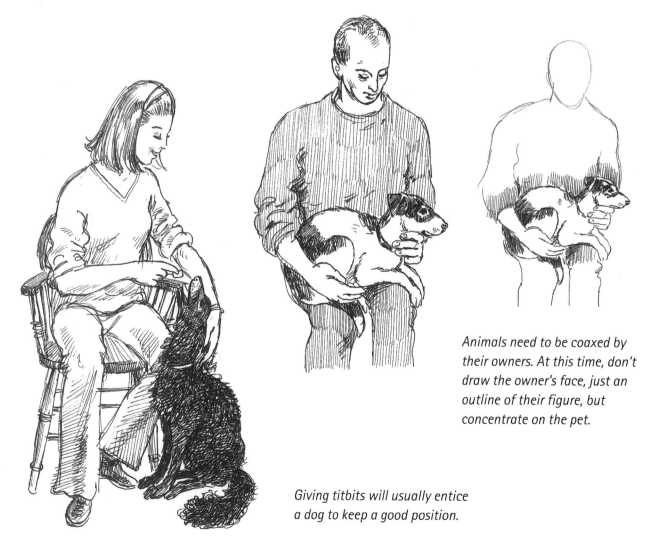

*Animals need to be coaxed by their owners. At this time, don't draw the owner's face, just an outline of their figure, but concentrate on the pet.*

*Giving titbits will usually entice a dog to keep a good position.*

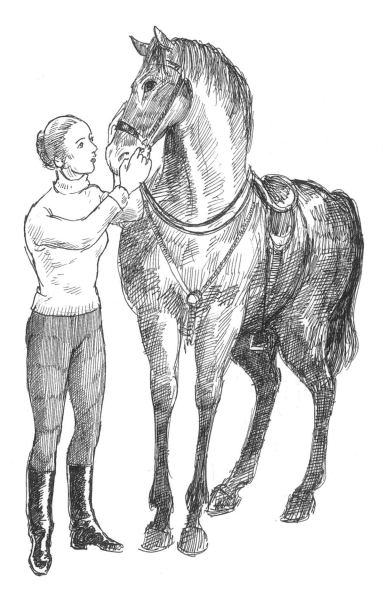

*Cats are easier to draw when they are asleep and unaware of your studying gaze on them.*

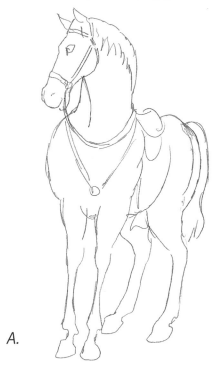

A.

*If you are portraying a horse you will probably need several attempts to find a good position in relation to the owner. Some horses are very twitchy and will only stand still when they are in their stall, where it is very difficult to get a good view of them. Photography can come to the rescue in these circumstances.*

*When you have positioned the animal and drawn it (A), the drawing of the owner can go ahead. Take into account the position of the animal and link your sitter with it, perhaps by using a mock-up, as in our example (B). After you've tried this several times, the composition will begin to look more natural.*

B.

## USING THE CHAIR AS A PROP

The convention of using furniture in portraits has not changed dramatically over the centuries, as the similarities between the following examples show. Sitting back to front on a chair was as popular in the 17th century as it is in modern portraiture. Furniture is not sacrosanct. Use it to your advantage.

*Frans Hals' subject, Willem Coyman, seems very aware of having his portrait painted. The pose of arm resting very lightly across the back of the chair gets across the rather insouciant quality of the sitter. Coyman's social pedigree is pointed up by the family coat of arms hanging on the back wall.*

*This copy of* Mum *by Benjamin Sullivan (2002) shows a room in the artist's house, judging by the brushes in jam jars on the mantelpiece and the paint on the bare boards. However, the chandeliers and convex mirror on the wall behind the sitter remind us of Van Eyck's portrait of the Arnolfini marriage (see pp 338–9), as does the extreme tilt of the floor's perspective. The armchair with tartan rug thrown over it might have made a more comfortable perch than the hard kitchen chair she is sitting on, but it would not have contributed the edge that comes out in the woman's direct gaze. The bookshelves on either side of the chimney-breast help to give space, tone and texture to the background so that the final result looks like a working portrait and not especially posed. The table in the foreground with its opened crisp packet adds a touch of almost humorous texture to the portrait.*

## MIRROR IMAGES

Reflecting a view of a sitter in a mirror is a device that many artists have used, sometimes repeatedly. Although by taking this approach you have to produce two drawings for the price of one, the effect achieved is very often worth the extra effort. Somehow the viewer becomes more involved and the method offers opportunities for the artist to include additional information to the benefit of the finished picture. Quite apart from bringing an intriguing quality to a portrait, this approach can also add depth.

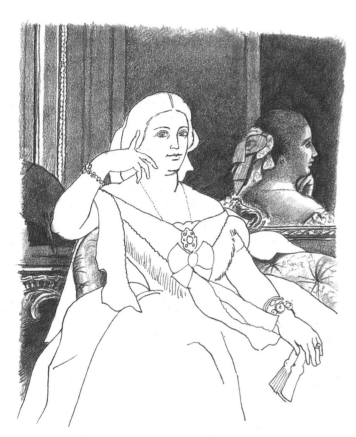

*Ingres seated his subject, Mme Moitessier (1856), on a chaise longue and placed the mirror behind, enabling us to see her both from the front and in profile.*

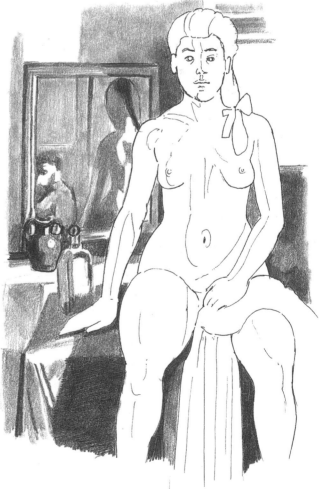

*For his portrait of Carmeline (1903), Matisse introduced an interesting variation on a theme he used several times in his work. The model's back is strongly reflected in the mirror and beside it we see the artist himself, painting his sitter. This device greatly increases the immediacy of the portrait.*

## SETTINGS WITH A HISTORY

Historic characters have a built-in list of props that could be used to show their importance. The modern portraitist has to try to emulate this example by working out which objects will enhance the history of his subject. If your subject has done something celebrated, you need to show or at least allude to what this was. The achievements of sportsmen, scientists, artists and soldiers are relatively easy to convey visually. More difficult are those of politicians, local worthies and businessmen, and their portraits have to be approached with great imagination.

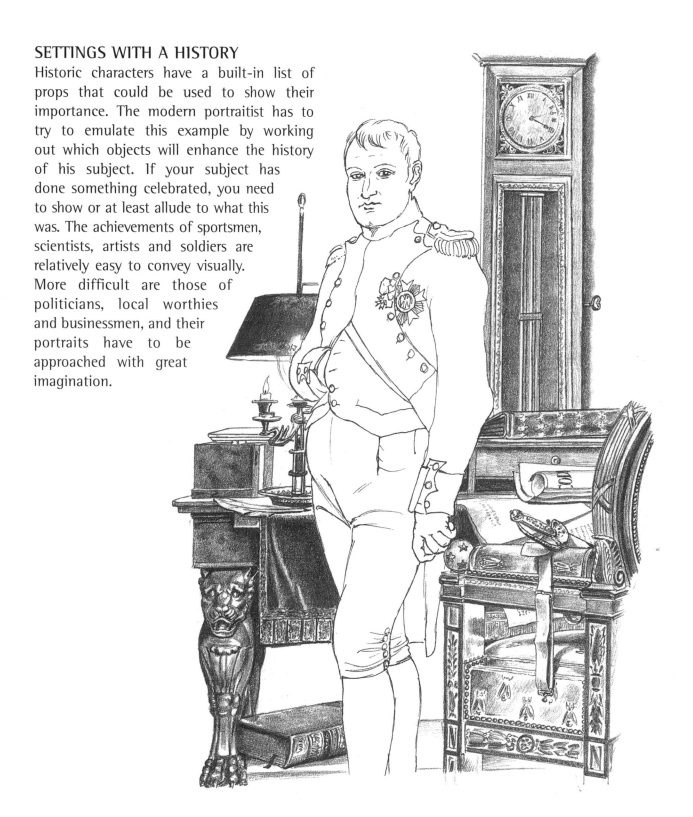

*Napoleon was said to have been very pleased with the original of this portrait of himself by Jacques Louis David (1812). The furniture and props have been carefully manipulated to get across the message of the emperor's dedication. The hands of the clock are pointing to past four and the candles in the desk lamp have burnt down. Unrolled on the desk is the cause of his toiling through the night – the* Code Napoléon. *The emperor's sword is shown nearby, inferring that his role as defender of the French nation is not being neglected as a consequence. When shown the finished work, Napoleon said that 'the French people could see that their emperor was labouring for their laws during the night and giving them "la gloire" by day.'*

*In the 16th century, when François Clouet painted the original of this portrait, a bathroom setting was very fashionable. The bath was not an ordinary daily ablution but a special event at which quite a few people would be present. The soft silk cloth draped inside the bath of this gentlewoman was to ensure that her skin would not be abraded by the rough wooden or woven surface of the tub. Remember, this is long before the introduction of smooth coatings for baths. The draped material to her left is a rather theatrical device, hinting perhaps that what is a private action has become public.*

*The sitter is thought to be Diane de Poitiers, mistress of Henri II, although there have been other attributions, including Mary, Queen of Scots.*

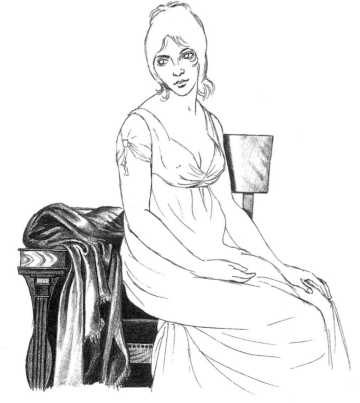

*If a portrait lacks background detail it stands to reason that any furniture will take on more significance. The neo-classical painter Jacques Louis David used this lack, together with sharply defined lighting, to increase the focus on his sitters. The original of this portrait of a young girl is by a follower of David who has copied the master's approach. The sideways position on the chair increases the informality of the pose, as does the shawl casually thrown on the table behind her.*

## SOCIAL MORES

Symbolism can be used to tell truths about society, individuals or a situation. The way the artist chooses to portray these truths will be down to his style and personal approach to drawing, as the following examples show. A good artist will make his values clear in his work, even if he has to present them in code, which is what symbolism provides, as the following examples demonstrate.

*The American realist painter Grant Wood used a careful craftsmanlike style to imbue his images with a strong formal element. The couple of Mid-Westerners portrayed in* American Gothic *symbolize the uprightness and friendly homemaking attitudes that made the infant United States such an attractive place for immigrants. The composition is direct and uncompromising although we see in these people both kindness and humanity.*

*In this copy of* The Meeting *or* Have a Nice Day, Mr Hockney, *Peter Blake is parodying Gustave Courbet's painting,* Bonjour, Monsieur Courbet *(1854) with his revolutionary Pop-art effects. Courbet showed himself walking across country with his painter's gear on his back, being greeted respectfully by his friend and patron.*

*In its artless composition the painting challenged the very posed norms of academic art. In his punning take on the Courbet, Blake places himself at the centre of the image with Harry Geldzahler, David Hockney's main patron in California, standing deferentially behind him and Hockney himself on the right.*

## ROYAL IS AS ROYAL DOES

Symbolism has always been used as a vehicle for reinforcing the images of the powerful. Absolute monarchy became a hot topic in the 17th century, especially in England where it cost a king (Charles I) his head. Here we see a depiction of kingship reflecting political reality.

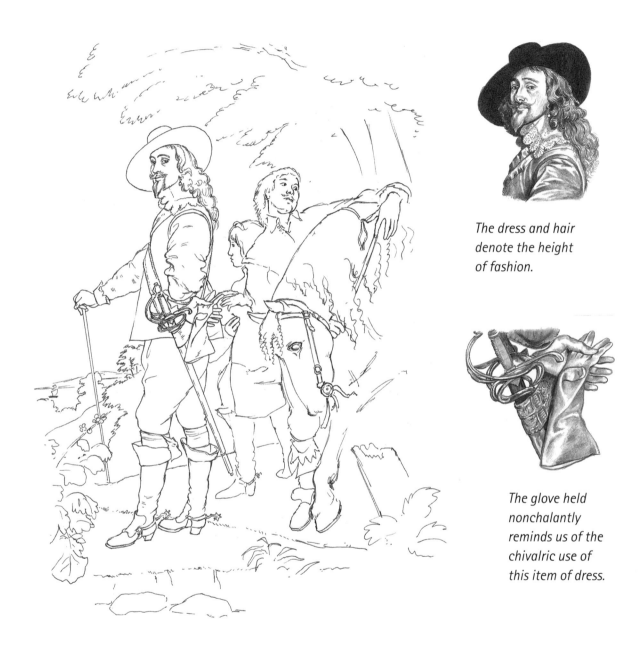

*The dress and hair denote the height of fashion.*

*The glove held nonchalantly reminds us of the chivalric use of this item of dress.*

*Typical English understatement has gone into this portrait of Charles I by Anthony Van Dyck. The symbolism is subdued, as you would expect from a monarchy under attack. The English king was not as powerful as his continental neighbour, Louis XIV, and here he is shown dressed as a cavalier, devoid of the paraphernalia of state. However, his royal status is underlined by the pose – hand on hip, walking stick held almost as a sceptre, the cool, haughty appraising look. The attendance of a groom and a page carrying a coat or blanket for the king's pleasure, and the horse's gesture almost of obeisance, suggest this is more than a portrayal of a country gentleman. Van Dyck was an expert at making the apparent casualness of the setting into a statement of symbolic power and elegance.*

## MAKING THE MOST OF THE MUNDANE

The symbolism in Jan Van Eyck's *Arnolfini Marriage* (1434) is so complex that art historians are still unsure of the meaning attached to some of the picture's content. It is quite certain, however, that the original represents both a blessing and a legal affirmation of the union of the couple portrayed, thought to be Giovanni Arnolfini and Giovanna Cenami. Every movement, position and object in this room underlines the theme of marriage. It is, in effect, a marriage contract produced by an artist.

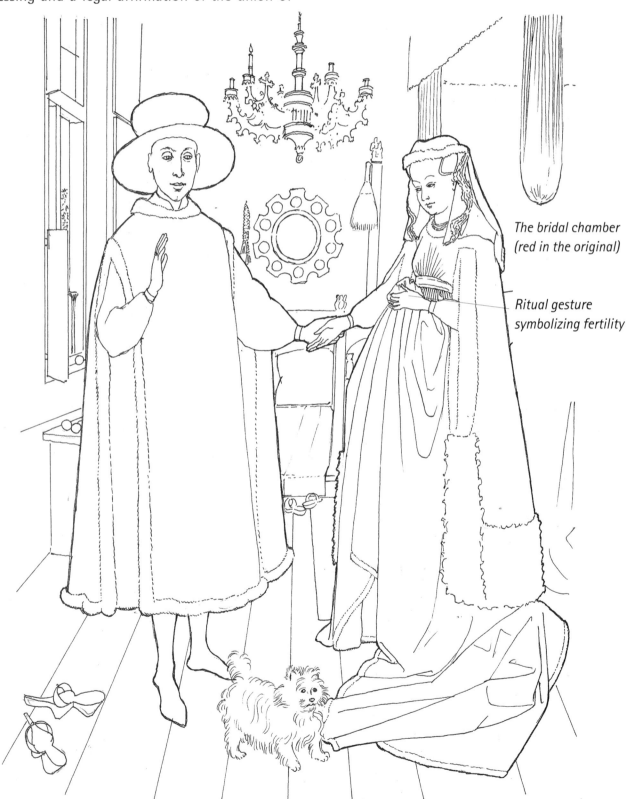

The bridal chamber (red in the original)

Ritual gesture symbolizing fertility

*The single wedding candle burning in the chandelier cites traditional Annunciation iconography.*

*The brush is a pun on Virgo/Virga to emphasize virgin purity, as well as an allusion to the 'rod of life', symbol of masculine fertility and strength; bridegrooms were ritually beaten with a switch to ensure couples were blessed with large numbers of children.*

*The 'immaculate mirror' (speculum sine macula) signifies the purity of the Virgin and the bride. In the mirror, which is surrounded by scenes from the Passion, you can see two figures, one the artist and a second witness to the marriage.*

*Van Eyck signed the painting as a witness, giving it the legitimacy of a legal document.*

*Promising marriage without the presence of a priest was customary in the 15th century by the joining of hands. The pledge was considered legally binding. The bridegroom holds his other hand up very deliberately. He may be about to place it over the bride's open palm or perhaps make the sign of the Cross.*

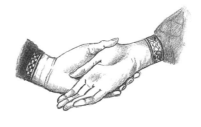

*Fruit alludes to the Fall and warns against sinful behaviour. The light coming through the window suggests that the ceremony is taking place under the eye of the Creator.*

*The dog is a symbol of devotion and conjugal fidelity.*

## MODERN VALUES

In this first example of modern symbolism, the figures are very expressive and expressionistic, as many American works were at this time. The reduction in physical solidity emphasizes elegance and vibrancy.

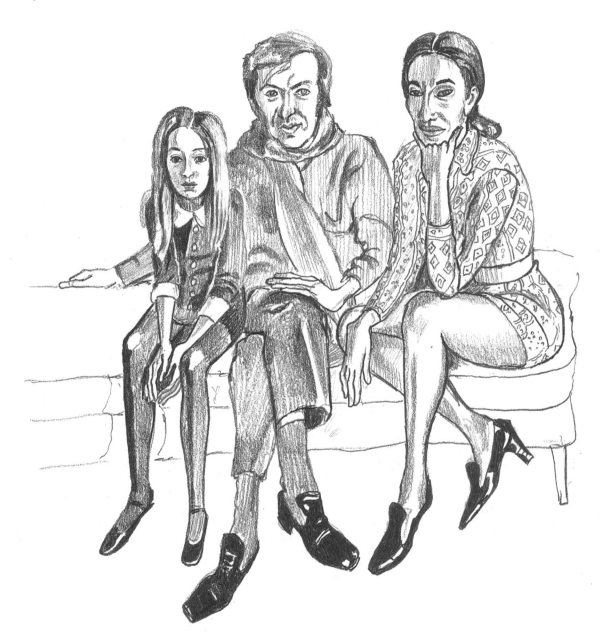

*Alice Neel's* The Family *can be read as a genuine exposition of the values of the New York artistic scene in 1970. The girl and the woman share many traits that set them in their milieu: long hair, long-sleeved short-skirted dresses, thin pared-down legs and elongated fingers. These point to a specific view of cutting-edge fashion. Although less obviously trendy the man is part of the same scene, with his casual scarf, longish hair and long hands with thin fingers. Posed close together, the three of them eye us unflinchingly and not favourably. Their look says, 'We are here, notice us'. Their slightly angular shapes heighten our awareness of their significance as representatives at the cutting edge, more so than their features or what they are actually wearing. One feels that after seeing this picture the sitters would probably grow to be more like Neel's depiction of them.*

The significance of the Goodman picture below would be lost on most viewers. The symbolism relates directly to art itself and the fact that this is a modern version of a school of painting last seen in revolutionary France at the beginning of the 19th century.

Harking back to the work of earlier artists is a constant theme in the history of art. Most artists have taken this path at some point, as a way of discovering new possibilities in their ways of working. The insight gained by trying to incorporate a work that you admire into your own can be of immense benefit to the development of your own style.

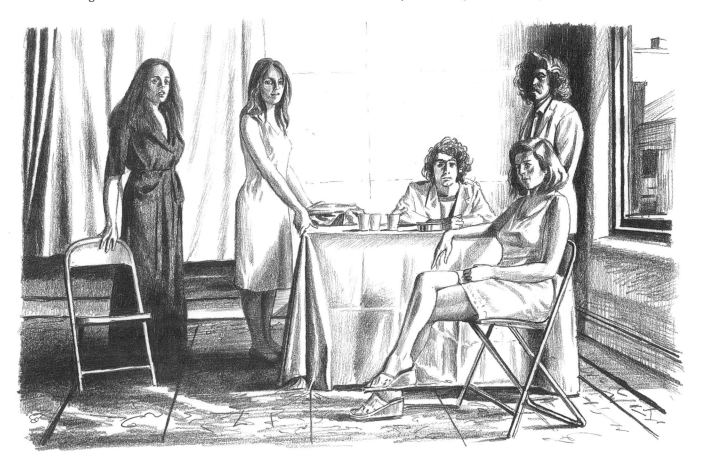

*In this copy of Sidney Goodman's Portrait of Five Figures (1973) we see a neo-classicist emphasis on what is a very contemporary composition. The effect with the carefully arranged figures is akin to that achieved by the 19th-century French painter Jacques-Louis David in a painting called The Death of Socrates, which is grouped and lit in a similar way. However, in this example the people are looking at the viewer, so it is obviously meant to be a portrait.*

*rather than a depiction of an historic event. In another bow to David, this time to his portrait of Mme de Vernice, Goodman has also put in a seated figure. By using the techniques and qualities of early 19th century French painting in a portrait in which the sitters are shown in contemporary dress supported by contemporary furnishings, Goodman seems to be prompting anyone with enough knowledge of art history to make the connection.*

## POSING FOR YOURSELF

The most difficult aspect of self-portraiture is being able to look at yourself in a mirror and still be able to draw and look at your drawing frequently. What usually happens is that your head gradually moves out of position, unless you have some way of making sure it always comes back to the same position. The easiest way to do this is to make a mark on the mirror, just a dot or tiny cross with felt-tip pen, with which you can align your head. You might ensure the mark falls between the centre of your eyes, corner of an eye or your mouth, whichever is easiest.

You can only show yourself in one mirror in a few positions because of the need to keep looking at your reflection. Inevitably, the position of the head is limited to full face or three-quarters left or three-quarters right of full face.

In these positions you can still see yourself in the mirror without too much strain. Some artists have tried looking down at their mirrored face and others have tried looking upwards at it but these approaches are fairly rare.

If you want to see yourself more objectively you will have to use two mirrors, one reflecting the image from the other. This way you can get a complete profile view of yourself, although it does make repositioning the head after it has wandered out of position slightly more awkward. However, this method is worth trying at some point because it enables us to see ourselves the right way round instead of left to right as in a single mirror. It will also give you a new view of yourself.

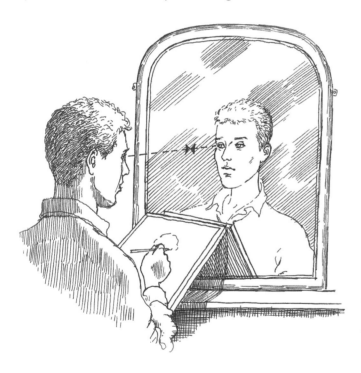

*Drawing your own reflection in a mirror is not too difficult, but you have to learn to keep your head in the same position. It is very easy to move slightly out of position without noticing it and then find your features don't match up. Use a marker spot on the mirror and line up something on your face with it.*

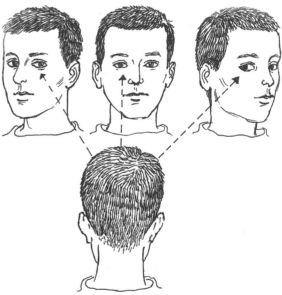

*The angles of looking are restricted and whichever way you turn the eyes will look straight at you. This means there will be a similar effect in your finished drawing whatever the angle.*

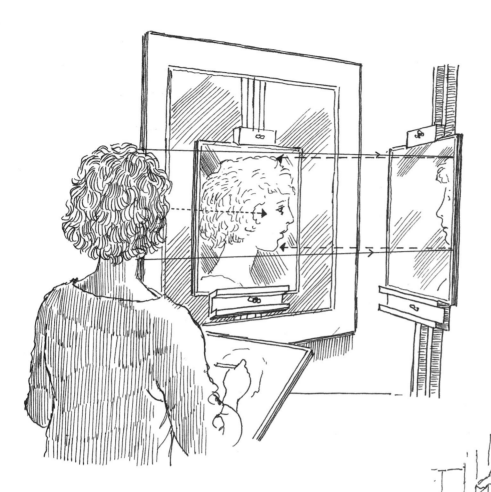

*Using two mirrors in order to draw your own profile image. Rarely do we see ourselves in this perspective, so it can be quite interesting visually.*

*Although a self-portrait is often just an exercise for the artist to learn how to draw, it can also be useful in pictures of large groups. Many Renaissance artists painted themselves into their large-scale figure compositions, partly because they wanted to include a signature but more importantly because a face shown looking out at the viewer – as in this detail from a Botticelli – helped to draw the viewer into the picture.*

In this example by Francisco Goya, the artist is shown looking sideways at himself (1799). The original etching on which this copy is based was produced much later in his life and gives a very clear idea of his rather quizzical and wary personality, although not of the deafness which was besetting him with difficulties. The inclusion of the hat is interesting because its sheer size must have caused problems when he was drawing himself.

Peter Blake was well schooled in traditional techniques before he made his name as a Pop artist. His self-portrait with badges (1961) could be read as an ironic comment on formal approaches to portraiture.

The artist Frida Kahlo was married to Diego Rivera, another famous Mexican painter of the 20th century. She portrayed herself in every conceivable situation and never painted anything without including her own image at the centre. Each one of her portraits conveyed some deep psychological view she had of her own sufferings in symbolic form. In this example (1940) she shows herself wearing a thorn necklace.

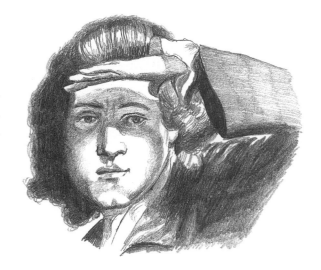

*The first president of the Royal Academy, Sir Joshua Reynolds (1747), is shown here peering from under a raised hand, shielding his eyes from the light. This is not an easy pose for the self-portraitist to draw, but it probably appealed to Reynolds as an opportunity to show how expert an artist he was. It certainly makes an unusual portrait.*

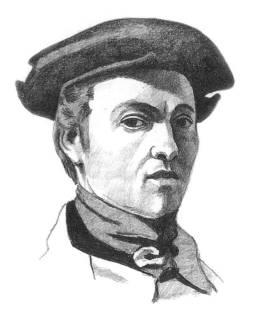

*The young Camille Corot (1835) here portrays himself in a dark hat as though poised for painting. His vigorous and economical style gives a very clear and direct view.*

*Gwen John produced the original of this while she was a student at the Académie Carmen in Paris (1899). She comes across as very self-possessed and confident, even challenging. At the time of this portrait she remarked that 'shyness and timidity distort the very meaning of my words in people's ears. That is the one reason why I think I am such a waif.' So does this self-portrait represent bravado or the real woman?*

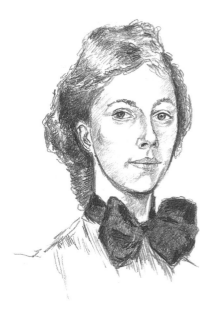

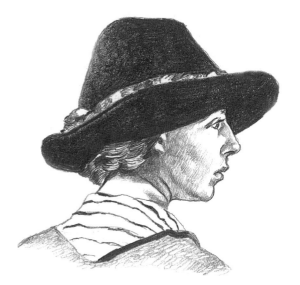

*Two aspects in one of British artist Dame Laura Knight (1913). The bohemian rakish hat and loose sweater seem at odds with the well drawn, rather elegant profile and look of penetrating attention.*

Taken together, these portraits relay some basic truths about the art of the portraitist. In the two Spencers we are confronted by penetrating honesty; in the Melendez by a plea for a chance to work more fully; and in the Hockney we appreciate how maximum effect can be achieved through minimal means.

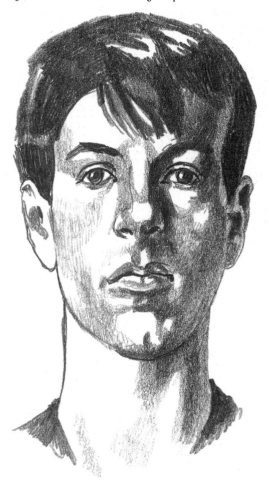

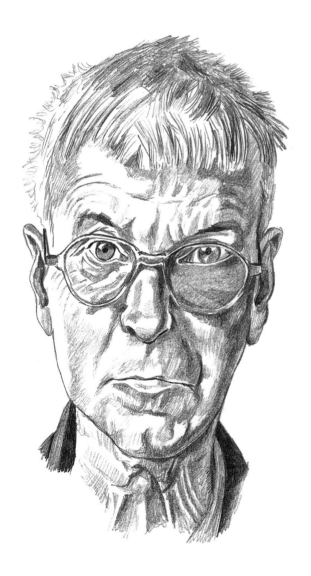

*These portraits represent two different stages of Stanley Spencer's career, but despite the distance of 46 years between them both demonstrate the artist's honesty and his lively interest in the visual world he was recording. The younger Spencer is portrayed as a more expectant and confident individual. The second drawing was done in the year of his death and there is a clear sense of mortality as well as humility.*

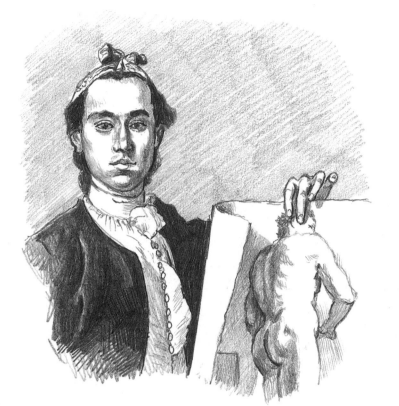

*Luis Melendez was a brilliant still-life painter in 18th-century Spain who never succeeded in reaching the heights of artistic achievement. This self-portrait (1708) looks like an attempt to convince his public that his drawing of figures is a good reason to let him move into the more lucrative and prestigious area of history painting where the human figure was the main feature. Notwithstanding the skill evident in this portrait, he was denied the chance by the Spanish Academy and went on painting mainly still-life subjects.*

*One of the most successful of contemporary artists, David Hockney has been able to follow his delight in drawing the human face in an age when many artists have all but forgotten how to even produce a likeness. In this copy of an original he made in 1983, the intense gaze makes it clear that he misses nothing. His handling of the form is very spare and yet highly effective.*

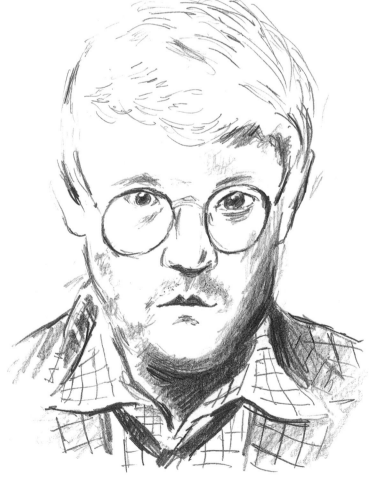

## NOVEL APPROACHES

When an artist draws himself using a mirror, quite often he sets up the pose to enable him to make a detailed study of the face he is so familiar with. The serious practising artist will experiment with this set-up so that he comes to see himself in a new way. In the following examples we suggest approaches that will give unusual views and the potential for producing interesting results.

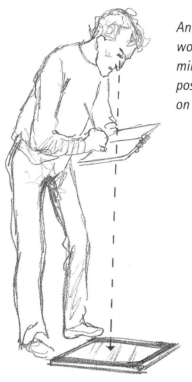

*An obvious recourse would be to place the mirror in an odd position, for example on the floor.*

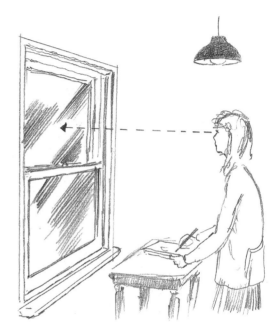

*After dark in a well-lit room, draw your reflection in a window. With this approach you can see objects through the glass at the same time as reflections in it, and this can make for very interesting compositions.*

*A shaving mirror might also provide intriguing distortions.*

*Artists have often had recourse to drawing their reflections in a convex mirror, which distorts what is seen in an interesting way.*

*A full-length mirror will give another view of yourself and is useful because of this.*

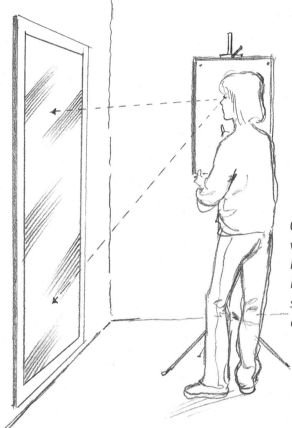

*One other way to get a new view of yourself is to take a Polaroid snapshot from arm's length. The resulting picture should give you a good basis for a self-portrait.*

*A variation on the Polaroid approach is the multiple passport-type photograph that you can take of yourself in a photo booth. The results are often quite unexpected. Be sure to adopt slightly different angles for each of the shots you are allowed.*

Once you get into drawing, you will find it adds a whole new quality to your life. After you have been practising for a while, you will actually begin to see the world differently. Shapes, colours, light, shade, movement – all these elements go into making this world a feast of experience. I hope by this stage you have gained a sense of this richness and that it will carry you forward and encourage you to keep practising and keep experimenting. And don't forget – have fun.

# Index